COGNITIVE APPROACHES TO CULTURE

Frederick Luis Aldama, Patrick Colm Hogan, Lalita
Pandit Hogan, and Sue Kim, Series Editors

RESILIENT MEMORIES

Amerindian Cognitive Schemas in Latin American Art

ARIJ OUWENEEL

THE OHIO STATE UNIVERSITY PRESS
COLUMBUS

Library of Congress Cataloging-in-Publication Data
Names: Ouweneel, Arij, 1957– author.
Title: Resilient memories : Amerindian cognitive schemas in Latin American art / Arij
 Ouweneel.
Other titles: Cognitive approaches to culture.
Description: Columbus : The Ohio State University Press, [2018] | Series: Cognitive
 approaches to culture | Includes bibliographical references and index.
Identifiers: LCCN 2017057747 | ISBN 9780814213667 (cloth ; alk. paper) | ISBN 0814213669
 (cloth ; alk. paper)
Subjects: LCSH: Collective memory in art. | Collective memory—Social aspects. | Art, Latin
 American. | Indians of Mexico—Social life and customs. | Indians of North America—
 Social life and customs. | Indians of Central America—Social life and customs. | Indians
 of South America—Social life and customs.
Classification: LCC NX650.M45 O99 2018 | DDC 700.98—dc23
LC record available at https://lccn.loc.gov/2017057747

Cover design by Angela Moody
Text design by Juliet Williams
Type set in Adobe Minion Pro and ITC Officina

CONTENTS

ILLUSTRATIONS

ACKNOWLEDGMENTS

This book is the result of years of work on the subject. Of course I was lucky to work at the Cedla in Amsterdam—the Center for Latin American Research and Documentation—because: where else could you spend so much time reading and writing without being pushed around to publish work in ISI-ranked journals? I thank the Cedla Board and its director, Professor Michiel Baud, for this wonderful academic liberty. Today, however, the Cedla is turned into a Department of Latin American Studies of the University of Amsterdam, with its own bachelor's and master's degree students. Over the past few years it has already meant more work in teaching and supervising, with the inevitable result that the present book was finished a few years later than I had foreseen. Nevertheless, I am very grateful indeed that Frederick Aldama, one of the editors of the Cognitive Approaches to Culture series, saw the point of publishing it. I'm also happy to have worked with the open-minded and professional staff of Kristen Elias Rowley and Rebecca Bostock, who guided me through the complicated matter of publishing in the United States. The cognitive approaches to culture have a great future ahead of them, and I'm really thrilled to be part of this.

This is also the place to register my gratitude for the work of the late Jan de Vos, a Belgian historian of Chiapas, Mexico. Jan introduced me to the history of Chiapas and its Maya population in the 1990s. Without him, I had a much less developed knowledge of that region. The same should be said for the late Mariana Yampolsky, the Mexican photographer, and her husband, Arjen van

der Sluis, who took me and my wife around Mexico. We also remember the travels and long conversations with Dra. Cristina Torales Pacheco and her partner, Dr. Luis Vergara Anderson, and with Laura Pérez Rosales and the late Ricardo Rendón—all from the Universidad Iberoaméricana, Mexico City. We would never have come to know Mexico that well without them. Finally, a word of gratitude to an anonymous dancer in Almoloya del Río, who gave me the postcard of *El Señor del Burgos* on a sunny day in his village. I was trying to take a picture of the painting, which proved too difficult due to the light. The postcard would serve me well, he said. Indeed, it did.

When I saw *Madeinusa* on Dutch television in 2008, I soon realized that I could use it for a book. To complete my material I needed a viewing of Llosa Bueno's second feature film, *La teta asustada,* or *The Milk of Sorrow.* This was made possible by the generous stance of Jessica de Jaeger, the artistic director of the Utrecht Latin American Film Festival, and Stien Meesters, in charge of the production and the program of the Festival. I am deeply indebted to them. The second chapter would not have been possible if I had not been warmly received in the home of Joaquín Ventura Unocc, the leader of the JADAT youth movement. He gave me the JADAT films I discuss, and he explained to me the situation in his neighborhood.

I'm also very grateful to Peruvian painters Jorge Miyagui and Claudia Coca, who both received me heartwarmingly in their Lima homes to talk about their work and show me their paintings. They immediately gave me permission to publish their paintings. All reproductions of the paintings are used by permission of the artists; Figures I.2, I.3, 1.1, 2.1, 4.1, 4.2, 5.1, 5.2, 5.3, 5.4, 6.1, 6.2, 6.3, and 6.4. Also, the gifted illustrator Carlos Castellanos Casanova, the illustrator of the 1990s Supercholo Comic, granted me this permission. I remember the pleasant conversation we had in a coffee café in the center of Lima. I never had the chance to meet Rosmery Mamani Ventura, but my talented Bolivian student Tania Montes Eguino did, and she had a nice conversation with the painter during the opening of one of her expositions in La Paz. Mamani Ventura wholeheartedly also granted me permission to use her work. I strongly believe that these masters in art—Coca, Miyagui, Castellanos, and Mamani Ventura—deserve a wide international audience.

Finally, I thank both anonymous reviewers for the helpful and astute criticism I received. Beyond any doubt, the manuscript profited well from their reviews. In the process of rewriting, it was inevitable to change the title, to be more precise, to change and even delete parts, but also to add parts and move parts of the manuscript. I'm grateful that the Press was willing to tolerate a longer text than the original. In all, it was a very valuable experience and it

improved the book profoundly. I hope the readers will enjoy the book as much as I did in writing and rewriting it.

Of course, this book is dedicated to the two women of my life, who make all my reading, thinking, and writing possible in the first place: Virginie and Lucila. And I promise Virginie not to talk about Freud anymore.

THE PONGO'S SPIRIT

1

This book is a history of the present. It develops a hypothesis about the mediation of collective memory by works of art. In general, historians work with public sources. Because of its research question, this book uses as its principal sources images. The still images are painted by Peruvian artists Jorge Miyagui and Claudia Coca and by an anonymous Mexican artist in the Spanish era. Also, some stills from fiction films are discussed, as well as a well-known Peruvian comic. The moving images are fiction films made in Peru, Mexico, Chile, and Colombia. To interpret the results, historians originally had to work with auxiliary sciences. As auxiliary for historical research, scholarly disciplines like archeology, chorography, cliometrics, epigraphy, philology, or toponymy help evaluate and use historical sources. Later, other sciences were included, depending on the research topic. For example, an economic historian uses economics; a social historian might prefer sociology. This book explores a cognitive approach to memory studies and uses works from cognitive sciences to look at the workings of the mediation of collective memory.

Memory, of course, "has become one of the buzzwords in today's humanities and social sciences."[1] In fact, the 2000s have witnessed a true *memory boom,* which created, in the words of historian Jay Winter, a *generation of*

1. Võsu, Kõresaar, and Kuutma, "Mediation," 243.

memory.[2] In the introduction to *The Collective Memory Reader,* the editors
Jeffrey Olick, Vered Vinitzky-Seroussi, and Daniel Levy offer this explana-
tion: "Following the decline of postwar modernist narratives of progressive
improvement through an ever-expanding welfare state, nation-states turned
to the past as a basis for shoring up their legitimacy. The decline of utopian
visions supposedly redirected our gaze to collective pasts, which served as a
repository of inspiration for repressed identities and unfulfilled claims. With-
out unifying collective aspirations, identity politics proliferated. And most
often, these identities nursed a wound and harbored a grudge."[3] The contem-
porary interest in memory, they believe, "is no mere fad,"[4] although: "In the
commercial sphere, these transformations in political legitimation were sup-
posedly matched by a commodification of nostalgia, a popularization of his-
tory, and an interest in 'memory,' both individual and collective. Both of the
latter—individual memory and collective memory—are seen to be at risk, the
former by neurological decay and sensory overload, the latter by dying gen-
erations and official denial."[5] Nevertheless, as they conclude, memory studies
have developed into "an increasingly important paradigm that unifies diverse
interests across numerous disciplines, and consolidates long-standing per-
spectives within them, in perspicuous ways."[6]

In exploring a cognitive approach to collective memory studies, this book
focuses on the mediation of memory. Most studies agree that, in the words
of literary scholar Ann Rigney, memories must swim: "As the performative
aspect of the term 'remembrance' suggests, collective memory is constantly
'in the works' and, like a swimmer, has to keep moving even just to stay afloat.
To bring remembrance to a conclusion is de facto already to forget."[7] In one
way or another, memories must serve the present or will be forgotten. Mem-
ory needs mediation. Explaining how this works, philosophers Andy Clark
and David Chalmers also use the swimmer's metaphor: "The extraordinary
efficiency of the fish as a swimming device is partly due, it now seems, to
an evolved capacity to couple its swimming behaviors to the pools of exter-
nal kinetic energy found as swirls, eddies and vortices in its watery environ-
ment. These vortices include both naturally occurring ones (e.g. where water
hits a rock) and self-induced ones (created by well-timed tail flaps). The fish
swims by building these externally occurring processes into the very heart of

2. Winter, "Generation."
3. Olick, Vinitzky-Seroussi, and Levy, "Introduction," 3.
4. Ibid., 5.
5. Ibid., 4.
6. Ibid., 5.
7. Rigney, "Dynamics," 345.

its locomotion routines."[8] As humans, we live in a sea of signs, they continue, created by us of course but individually experienced as an environment that envelops them from birth. The human brain—our "inside"—treats semiotic structures as reliable resources to be factored into the shaping of on-board cognitive routines. Where the fish flaps its tail to set up eddies and vortices it subsequently exploits, humans intervene in multiple semiotic systems, creating ecological enclosed structures and disturbances whose reliable presence drives their ongoing internal processes. Artifacts, words, and other semiotic devices are thus paramount among the cognitive vortices that help constitute human thought. It is not sufficient to understand communication between human agents about their beliefs and discourses; we must also understand the communication between the signs "out there" and these agents, and the role these particular signs play in constituting and recreating these beliefs and discourses themselves. One important task for these signs "out there" is to articulate between "out there" and what is "inside" in their task to mediate memory.

The exploration of a cognitive approach to collective memory studies brings us also to analyze mnemonic communities. Mnemonic communities share common memories, a common past, a common heritage. They are classified as "mnemonic" because the identities are triggered by encounters with mnemonic aids in the world, like specific artifacts, types of behavior, cultural expressions, and the recognition of being with other members of a mnemonic community. Therefore, mnemonic communities are held together by both narratives ("discourses") and specific practices based on structured and even ritualized interactions ("doings"). No person, no group, no organization, no nation, no people can constitute an identity without memory. Memory "stands not only for the mental act of remembering," as Amos Funkenstein famously said,[9] "but also for the objective continuity of one's name—the name of a person, a family, a tribe or a nation." Because the present does not exist without a vision of the past, this vision or "memory"—real or imagined; or a combination of both—forms crucial ingredients of the mnemonic communities' identities—individual or collective.[10] They are the ones who swim in a sea of signs to keep the memories afloat. The sociologist Jeffrey Olick signals: "Collective memory has been used to refer to aggregated individual recollections, to official commemorations, to collective representations, and to disembodied constitutive features of shared identities; it is said to be located in

8. Clark and Chalmers, "Extended"; the example of the fish by Michael and George Triantafyllou, "Efficient."

9. Funkenstein, *Perceptions*, 30.

10. See, for instance, the chapters in *Mediation, Remediation, and the Dynamics of Cultural Memory*, edited by Astrid Erll and Ansgar Nünning.

dreamy reminiscence, personal testimony, oral history, tradition, myth, style, language, art, popular culture, and the built world."[11] Probably, every single reference has been with good reason. But it is useful to make the concept more concrete. Changing "collective memory" to "mnemonic communities" transfers it from the "inside" of "memory" to the "out there" of the "mnemonic," because the latter swirls and swerves by artifacts, including texts, films, and art, both triggering individuals' memories of a certain past experience or a present-day identity and the actions that come with it. This is in line with one of the classical universals of psychologist William James, one of the leading psychologists of the late nineteenth century, published in his *Principles of Psychology* (1890): "My thinking is first and last and always for the sake of my *doing*."[12] The concept of mnemonic communities brings together the individual and the collective, the cognitive and the group. This study focuses on the interplay between them.

Mnemonic communities decide consciously or unconsciously which part of their past experiences should be remembered by individual "members" and what should be forgotten. As humans we have multiple identities, and therefore we most commonly operate in many different mnemonic communities. Some mnemonic communities are small, formed by particular events. Others are quite large and span a nation (an "imagined community") or a people. An example of a large transnational mnemonic community is the women's rights movement. Sometimes we have to deal with multiple memories in a conflictive way, for example when we experience a situation with participation of members of different mnemonic communities. Because of the close articulation of memory and identity, both are of course social in origin and influenced by the experiences of the mnemonic communities. Changes in one usually change the other. Due to the mnemonic communities' specific traditions, a particular cognitive bias marks their identities. Often this bias expresses essentialized truths and representations about them and equips them with emotionally laden cognitive scripts about their "doings" in the world. Therefore, cultural memories and their subsequent cultural identities are different from the sum total of individuals' recollections of the past or their expressions of contemporary identities. "In other words, it involves the integration of various different personal pasts into a single common past that all members of a community come to remember collectively."[13] Mnemonic communities bias common denominators.

11. Olick, "Collective," 336.
12. James, *Psychology*, 222–23; italics added.
13. Zerubavel, *Social*, 96.

Cognition, says film scholar Carl Plantinga, "simply put, is the mental activities of gaining knowledge and understanding through thought, experience, and the senses, plus the results of such activities—comprehension, intuition, insight, perception, and so on. Cognition is neither singular nor linear, with multiple cognitive processes occurring simultaneously and connected in complex ways. Neither is cognition necessarily either conscious or rational."[14] Occurring *"beneath consciousness,"* cognition is "affected by emotions and moods" and "has a firm grounding in bodily experience." In short, making "sense of the world around us, we employ body metaphors, we gauge physiological feedback, and we are influenced by emotion," and the audience's "understanding of characters, narrative events and progression, and narrational point of view is fundamentally cognitive in nature."[15] A full account of cognition, Plantinga concludes, encompasses affect, the Cognitive Unconscious, and bodily and automatic processes: "We experience movies with our bodies."[16]

2

A look at the mediation of memory for mnemonic communities may demonstrate that the mediated artifacts, including texts, pictures, and moving images, are only meaningful for a limited number of people. More than often, one directive pillar of memory studies, the one on "identity politics," is focused on minority groups, mainly seen as ethnicities. In Latin America, identity politics is concerned with the *indigenous* past. The *indigenous* in the region are known as the (formerly) colonized people of the Americas. They stand at one side of the Colonial Divide created between colonizers and colonized. Instead of *ethnicities* I like to use the concept of *ethnotypes.*[17] Ethnotypes are based on stereotyping of "ethnically" labeled categories of Self and other in communication. Under Habsburg and Bourbon rule, the colonized were legally classified as *indios*—the indigenous inhabitants of Las Indias, as the Americas were known at the time. To organize their legal position properly, all over the Americas the *indios* were grouped together in a larger administrative and official legal community called the *república de indios.* I believe that their descendants today form a transnational mnemonic community that can be addressed as *Amerindian.*

14. Plantinga, "Moving."
15. Ibid.; all preceding quotes from this source, paragraphs 6, 7, and 8.
16. Ibid., paragraph 9.
17. Leerssen, "Imagology."

The Amerindian mnemonic community includes today's ethnotypes of *indígenas, cholos,* and *mestizos* because they share a joint history of colonization—and internal colonization—and because I treat these groups as ethnotypes I write their names in italics. In their turn, *indígenas* constitute a transnational mnemonic community in their own right as country dwellers, protectors of forests and nature, or as victims of military powers—the latter in Peru with the *cholos.* Therefore, the members of the Amerindian transnational mnemonic community—or from now on simply Amerindians for short—include more than only *indígenas.* In fact, based on its wider transnational genealogy, I believe the *cholos* and *mestizos* are in the majority; although in many cases some anthropologists may speak of *indígenas* where others ethnotype them as *mestizos* or *cholos,* or even as *indigenous mestizos.*[18] This book discusses local cases that can be articulated to the transnational context to demonstrate that for *indígenas, originarios, mestizos,* and *cholos* the word *Amerindian* represents this type of transnational cultural memory best. The cases also highlight a series of key features that constitute the *Amerindian* as a mnemonic community. In short, *Amerindian* serves as the *name* for the transnational mnemonic community that shares the colonial history under Spanish rule as members of the *república de indios*—which are discussed later on in this book—and the history of internal colonialism of the late nineteenth and early twentieth centuries.

In exploring a cognitive approach to collective memory studies, this book argues that the mediation of *amerindianness* or *indigeneity* builds on cognitive schemas, using schema theory.[19] The Japanese psychologist Hiroko Nishida defines schemas as "generalized collections of knowledge of past experiences which are organized into related knowledge groups and are used to guide our behaviors in familiar situations."[20] In different scholarly fields these cognitive mental representations are also known as mental models, cultural scripts, or frames. Cognitive schemas are the building blocks of memory, using real or imagined knowledge of a class of people, objects, events, situations, and behavioral codes. They are used to act and behave. Schema theory suggests that memory consists of shared cognitive representations, including status, socialization, and relationship in the minds of individuals. The theory pro-

18. De la Cadena, *Indigenous Mestizos.*

19. See D'Andrade, *Development,* 122–49. The word "Theory" here might be, as D'Andrade notes, "a little grandiose" (126n5). Reading Jean Mandler's *Stories,* 1, he also prefers to be modest, and might speak of a Schema Framework. Nevertheless, a similar position can be taken toward the Evolution Theory: a coherent all-inclusive theory has not yet been developed, but step-by-step results suggest that we may be able to do so in the near future, and the term "theory" has been privileged for some time.

20. Nishida, "Cognitive," 775.

poses further that there is some truth in William Shakespeare's monologue of Act II Scene VII in *As You Like It*: "All the world's a stage / And all the men and women merely players."[21] Humans are actors and any role on a stage is scripted—such scripts form parts of cognitive schemas, a script is a schema for an event.[22] We recognize the "actors" around us, both as real-life people but also in pictures, images (moving or still), and written or published texts.

The Amerindian transnational mnemonic community may "act" like this, triggered by the cognitive schemas they share. Historically, *indígenas, cholos, mestizos,* and the like share a genetic *and* cultural genealogy with the descendants of former colonized *indios*. Their *amerindianness* will be articulated closely to specific cognitive schemas—a very small minority of all possible cognitive schemas—and because cognitive schemas are about behavior, the word will refer to their *doing*. The Amerindian will not be treated as an integrated personality, as a *being*. Personality theories tend to create discursive constructs about what people *are*. It is, however, extremely difficult to establish for academics to be sure who *is* in person *indígena, mestizo,* or *cholo*. To develop beyond set ethnotypes toward new interpretations of diversity, it might be useful to bring back into mind that before the "ethnic turn" of the late twentieth century—which entered the academic world shortly after the "linguistic turn" did—people labeled today as *indígenas* were generally called *peasants*.[23] This classification was about what the people in question *were doing*. As in several countries, also in Peru their position led to legislation. What many now see as "indigenous communities" were codified as *comunidades campesinas* (peasant communities) and their inhabitants as *comuneros* (community members).[24] Here, a specific cultural and historical memory was articulated with class relations.

Among others, Frederick C. Bartlett was among the first to take up this question of culture and memory. In his book *Remembering* (1932), Bartlett assumed that cultures are organized collectivities with shared customs, institutions, and values, of which members form "strong sentiments" around valued, institutionalized activities. These values and their expression through culture shape psychological tendencies to select certain kinds of information for remembering. Over time, cultures have assimilated knowledge. Next they constituted cognitive schemas to be able to work with reconstructive remembering. Over the past eight decades, many scholars from psychology,

21. Shakespeare, *Comedies*, 194.
22. Schank, "Scripts."
23. See for example: Wolf, *Peasants*.
24. See the instructive "Appendix B: The General Law of Peasant Communities," in O. González, *Unveiling*, 238–39.

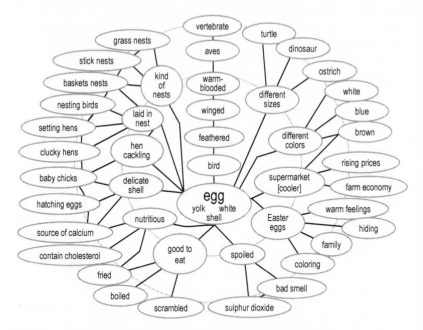

FIGURE I.1. Example: Schema of the concept "Egg." Source: Davis, Cognition, 21.

linguistics, philosophy, anthropology, and sociology have adapted, improved, and developed these thoughts into a proper theory.[25] "The idea is," says the anthropologist Victor de Munck, "that the deeper a schema is internalized, the greater one self-identifies with it, and the greater the motivational force of the schema."[26] Eventually, things learned in the past by groups or cultures of people over time become part of the "natural way" of doing things. Unconsciously motivated this way, people seek to act according to the cognitive schemas in their mind. This motivation, firmly embedded in cognitive schemas, is social.[27]

Although cognitive cultural schemas are actively constructed neuronal networks, the word "schema" is of course only a metaphor. Anticipating chap-

25. On schemas or schemata, among many others: Atkinson et al., *Hilgard's*, 289–90; Bordwell, *Making*, 129–204; Cole, *Cultural*, 58; D'Andrade, *Development*, 122–49; J. Mandler, *Stories*; Markus, "Self-Schemata"; Michalak, "Schema"; Minissale, *Psychology*, 44–50; Neisser, *Cognition*, 51–78; Nishida, "Cognitive," 755; Ouweneel, *Freudian*, 2, 217–24; Rumelhart and Ortony, "Representation"; Sumbadze, *Social*; Widmayer, "Schema." For the use of schemas in the literary sciences, see Patrick Colm Hogan, *Cognitive* and *Mind*, 21–23, 84–86.

26. de Munck, *Culture*, 80.

27. Literary scholar Astrid Erll makes a distinction between the cognitive as individual and the social and medial or collective levels of cultural memory; see her *Memory*. In contrast, as I will try to show, I believe that the cognitive is social and the social, cognitive.

ters 3 and 4, it could be useful to discuss briefly how a schema works. My students browsing the Internet tend to come up with the Egg Schema drawn by Patricia Davis some thirty years ago (see figure I.1).[28] The Egg Schema helps them imagine why this type of thought is called a schema in the first place—it is diagrammatically simplified.[29] Each schema has a main category, the "slot." When a slot is triggered, it quickly connects to a wide network. A schema is not typically activated by words, but we may draw one on a semantic base with slots for all the components, or features, included in it. Imagine that one or a combination of our senses triggers the Egg Schema: seeing one in real or an image, smelling one, hearing someone talking about eggs, feeling one. It must be stressed that each schema is unique to the person's personal experience. What is triggered at first is the feeling or sight of its form, including the white shell, the touch, taste, or smell of its yoke, and perhaps its temperature. This is connected to several lines and slots in the schema which run from the center outwards like a drawing of a star (see figure I.1): Egg → Bird → Feathered → Winged → Warm Blooded → Aves → Vertebrate. Another line, with slots from this center outward, is Egg → Hen Cackling → Baby Chicks. This last slot is connected to other slots separately like Egg → Delicate Shell → Hatching Eggs and → Clucky Hens. Each of these slots stands at the end of another line. There is a line Egg → Supermarket: Find in Cooler → Economy, but also connected to → Price Rising; or to → Brown Eggs. The line Egg → Good to Eat is connected to → Scrambled, → Boiled and → Fried; the latter also to → Nutritious and through this one to → Contains Cholesterol and → Source of Calcium—which in turn is connected to → Hatching Eggs and → Delicate Shell. The line Egg → Easter Eggs is connected with → Warm Feelings, → Family Fun and → Colorings Eggs. Each of these slots may serve as a trigger of the entire schema as well—or each slot may trigger a new schema of its own. Triggering occurs automatically and fast, usually bringing all this to mind in an instant, but soon concentrating on the line that is most relevant.

Schematic encoding or re-encoding usually follows after experiences in or with the world around us. The Egg Schema, for instance, is triggered by what we see, smell, hear, taste, and feel. Clark and Chalmers assert that the human thinking evokes an active externalism, "based on the active role of the environment in driving cognitive processes."[30] They add: "By embracing an active externalism, we allow a much more natural explanation of all sorts of actions. It is natural to explain my choice of words on the Scrabble board, for example, as the outcome of an extended cognitive process that centrally

28. P. Davis, *Cognition*, 21.
29. Bordwell, *Making*, 136.
30. Clark and Chalmers, "Extended."

involves the rearrangement of tiles on my tray. Of course, one could always try to explain my action in terms of internal processes and a long series of 'inputs' and 'actions' characterizing the interaction with an external object, but this explanation would be needlessly complex. If an isomorphic process were going on in the head, we would feel no urge to characterize it in this cumbersome way. In a very real sense, the re-arrangement of tiles on the tray is not part of action; it is part of *thought*."[31]

Feasibly this means that our thinking includes a kind of extended phenotype. In biology, phenotypes are the outward, physical manifestation of an organism; anything "in the world" that is part of the observable structure, function, or behavior of a living organism. That extended phenotype is essential for the evolution of the organism and must therefore be part of the organism itself.[32] For humans, the creation and reading of signs might fit into this modeling, language in particular. Signs are embedded in cognitive schemas and probably co-evaluated.[33] This means that although they are learned from others, the cognitive schemas people live with may have very ancient origins indeed. Once it is recognized that the environment plays such a crucial role in constraining the "phenotypic" character that a cognitive system evolves and develops, it should be agreed that extended cognition is no simple add-on extra but the core cognitive process itself. Because we could regard all remembrance as a social activity, recollection from memory improves when several persons participate. A single person usually retrieves less information from personal memory than two or more people do.[34]

Perceiving and thinking in terms of cognitive schemas enables people as individuals and as groups to process large amounts of information swiftly and economically. Instead of having to perceive and remember all the details of each new person, object, or situation someone encounters, they are recognized as an already encoded cognitive schema, so that combining the encoding of this likeliness with their most distinctive features is sufficient. Cognitive schemas are set, stored, reset, and maintained by encoding and decoding. This occurs rapidly, automatically, and unconsciously.[35] It works within an experienced world of real or assumed agreement about the meanings of words, gestures, and other signifiers, or signs in general. Although the number of

31. Ibid.
32. See Dawkins, *Extended*.
33. Deacon, *Symbolic*.
34. Kansteiner, "Finding," 180.
35. The price to be paid of course is distortion, if the schema used to encode it does not fit well. Research over the past decades has confirmed Bartlett's suggestion. In her college note, "Schema," Widmayer mentions interesting examples and some links that can be followed easily.

schemas is infinite, some may be easily foregrounded.[36] Written down or dis-
cussed, cultural meaning or the implication of a hidden or special signifi-
cance in behavior, works of art, texts, semiotic signs, and the like, is usually
indeed metaphorical. Metaphors are cognitive functions that serve to create
and extend structure in experience and understanding, which are cultur-
ally embedded, humanly embodied, and imaginatively structured. And so is
meaning: "A theory of meaning," says philosopher Mark Johnson, "is a the-
ory of how we understand things."[37] And: "We cannot understand the nature
of meaning, therefore, without a theory of understanding that explains how
we can experience a shared, public world."[38] The event schema or script con-
tains encoded sequences of events in particular situations, places, or between
groups of people—believed likely to occur and used to guide our behavior in
familiar situations.[39] That is the reason we may recognize complexes of local
schemas as the culture people inherit and may describe these as "living" at a
certain spot in space and time.

3

In view of the broad scope of this book, it seems best to restrict our scope
from the Amerindian mnemonic community in general to only a few cogni-
tive schemas that "swim in their sea of signs." I suggest beginning with two
short examples from the Latin American corpus of cultural texts. Therefore,
first, recall the well-known short story by Peruvian writer José María Argue-
das about an Andean *pongo*. Arguedas had introduced the story in 1965 as a
tale told to him in Lima by an Andean *comunero* "from Qatqa or Qashqa" in
the Quispicanchis District of Cusco, who had learned it from an old *comunero*
from Umutu (Junín). Retelling the tale, Arguedas pictured a humble man, one
of the serfs of a hacienda in the Paucartambo area in Cusco, who offered him-
self to his master. The humble man had to perform the obligation of pongo

36. Fiske, "Thinking"; Hogg and Vaughan, *Social*, 49; Atkinson et al., *Hilgard's*, 598–600;
Hilton and von Hippel, "Stereotypes," 240, 248–51; Kunda and Thagard, "Forming"; Spears et
al., eds., *Social*; Nishida, "Cognitive."

37. M. Johnson, *Body*, 176.

38. Ibid., 175–76.

39. Even the experience of illness may be conceptualized as schematic. Hawai'ian psychol-
ogists Jeanne Edman and Velma Kameoka have showed how event schemas exist that provide
information pertaining to illness events. Illness schemas, they write, "can be viewed as mental
representations of the illness concept." Illness is the interpretation of disease, and a person's ill-
ness schema is the "conceptualized link" between disease and illness. And so is cure. See Edman
and Kameoka, "Cultural," 252.

or household service. It was a man of small, frail stature. In front of all other hacienda workers, the hacendado received him, laughing: "What are you? A person or something else?"[40] The hacendado checked his hands and ordered him to clean the place of garbage. That was his task anyway, and he did it well. However, the pongo always had frozen eyes, a slight look of horror on his face. Others thought his heart must have been full of sadness. Furthermore, quiet and obedient, the pongo rarely spoke to anyone. Now and then, he only said: "Yes, *papacito,* yes, *mamacita.*" Probably because of this humble attitude, the hacendado began humiliating him in front of all the other workers, especially at dusk around the daily religious service in the hacienda house—the *casco* or *casa-hacienda.* He forced the pongo to bark, or to walk around on his knees. Apparently the pongo had learned to run like the small dogs of the *puna.* The others would look and say their *Ave Marías* quietly, with a cold wind in their hearts. In the end, the pongo was hardly ever among them, there in the casco; he would never say his own Hail Marys in the hacienda chapel.

However, one afternoon the pongo suddenly asked permission to speak. The hacendado could not believe his ears. The little man told him that he had dreamed that the two of them had died. They had been standing naked before Saint Francis, next to each other. The saint had observed them closely and intensively. The pongo had felt that the saint had recognized the hacendado as a rich and powerful man. "And you?" the hacendado asked. The pongo answered that he did not know, because he could not judge his own worth. The saint had asked some angels to come forth, the pongo continued. The audience of *indígenas* listened, worried, with increased terror. What would be the end of this tale? The pongo told that one angel returned with a golden cup filled with the most delicate and translucent honey. Another angel covered the hacendado with it. "In the splendor of the heavens," the pongo told the hacendado, "your body shone as if made of transparent gold." "That is the way it must be," the hacendado replied. But what happened to the pongo in that dream? The most ordinary angel brought a gasoline can filled with human excrement. A very humble, old angel covered the pongo with it. "In the midst of the heavenly light," the pongo continued, "I stank and was filled with shame." "Just as it should be!" crowed the master. Was that the end? No.

40. Based on Arguedas, *Sueño del pongo,* and "Pongoq mosqoynin." "The *indio* failed to keep his promise to visit me again," Arguedas explained, "but it remained almost engraved in my memory." (I left the word *indio* untranslated: "El indio no cumplió su promesa de volver, pero ella quedó casi copiada en mi memoria.") After the first publication in 1965, the story was reprinted in Chile in 1969; and in Arguedas's *Obras Completas* in 1983. Several editions followed, including the well-known translated version published in *The Peru Reader* by Orin Starn, Carlos Iván Degregori, and Robin Kirk in 1995 and 2005; English quotes are from the 2005 version. See: Arguedas, "Pongo's," 273.

For a very long time, Saint Francis looked at the two men before him: the hacendado covered with golden honey, the pongo with human excrement. Finally the saint said, "Now, lick each other's bodies slowly, for all eternity." And an angel was entrusted to make sure that the saint's will was carried out, forever and ever.

What does the "Pongo's Dream" tell us? The story is about a rigid order victimized by the internal colonialism that still prevailed in many parts of Peru around the 1960s. "But the denouement," the editors conclude, "where the world turns upside down [. . .], suggests the existence of *a spirit of independence and opposition* [. . .]."[41] Elaborating on the author's words, the editors of the *Peru Reader* introduce Arguedas as a "modern Quechua man," who was interested not just in Andean traditions but above all in questions of migration, modernity, and cultural pluralism. In his own introduction to the story, Arguedas claimed that despite some "home-grown" elements (of his "propia cosecha" or his "own harvest"),[42] the "Pongo's Dream" was a widely known Andean Quechua folktale. Nevertheless, after talking to the anthropologist Oscar Núñez del Prado in Cusco and the painter Emilio Rodríguez Larraín in Rome (Italy), he had realized that there were different versions. Therefore, he was not certain that the story was an original Quechua tale. Expressing the necessity of creating a literature in Quechua, Arguedas wanted it published in that language for its literary, social, and linguistic value.[43] Arguedas suggests with his texts that if we look for a schema in art, articulated to the Amerindian transnational mnemonic community, we will find it as a "spirit of independence and opposition."

That a Quechua literature hardly existed at the time was unfortunate in the light of its extensive oral tradition. The written version of the "Pongo's Dream" should reflect the spoken one, which meant the inclusion of loan words from Spanish and some linguistic hybrids. Contrary to a purist's approach, Arguedas believed that the adoption of Spanish ways of expression was "not negative,"[44] because this reflected the language as a modern and living instrument. The written form of Quechua presents its particular style, demonstrating that it still maintains and "defends triumphantly" all its "mysterious characteristics of being alive."[45] Arguedas saw the dissemination and partly creation of Quechua literature as an important task for himself. Accepting the Inca Garcilaso de la Vega Award in October 1968, he told his audience that the wall between the

41. Arguedas, "Pongo's," 258 or 273; italics added.
42. Arguedas, "Pongoq," 125.
43. Ibid.
44. Ibid., 126.
45. Ibid.

urban *white* culture of cities like Lima, Arequipa, and Cusco and the Andean world should be demolished. Apparently, he saw the two worlds being able to coexist next to each other and himself as an example of this: talking and writing happily in both Spanish and Quechua. The virtual wall between the two worlds of the Colonial Divide "should have been destroyed," Arguedas continues, "because the copious streams [of wisdom and art] from the two nations could have and should have been united."[46] He also saw no reason why "the conquered nation should renounce its soul (*even if only formally appearing to do so*) and take on the soul of the conquerors, that is to say, that it should become acculturated."[47] Next, Arguedas famously expressed: "Yo no soy un aculturado," "I am not acculturated."

Interestingly, the pongo's "spirit of independence and opposition" is not simply found in the denouement where the world turns upside down. This would mean a "colonization of the imaginary,"[48] especially by the missionaries of the Roman Catholic Church. We realize that the pongo plays a role, "formally appearing" to believe in the teachings of the Church. His tale is an act of resistance in words the hacendado understands only too well. And if we realize that Arguedas was convinced that the "conquered nation" had not renounced its soul—only playing a role that it did: "even if only formally appearing to do so"—Arguedas denied also the acculturation of the Quechua-speaking nation he knew so well. They would even reach out to the other side of the Colonial Divide: "Being here [in Peru] and imitating others would turn out to be rather shameful. In technology [the *whites*] will surpass us and dominate us, for how long we do not know, but in art we can already oblige them to learn from us and we can do it without even budging from right here."[49]

4

The second text is a popular comic from mid-twentieth-century Peru. A little earlier than the pongo had appeared on the stage, another character had arrived in the *limeña* mind. The inhabitants of Peru's capital city could read every Sunday in the supplement of the major daily published in their city about Supercholo. Originally created on November 3, 1957, by Austrian immigrant Victor Honigman as illustrator and Francisco Miro Quesada Cantuarias a.k.a. Diodoros Kronos, Supercholo was an *indio*, an impoverished and simple

46. Arguedas, "I Am Not," 269.
47. Ibid.; italics added.
48. Gruzinski, *Colonisation*.
49. Arguedas, "I Am Not," 270.

rural dweller, speaking a poor and childish Spanish, and traveling with his llama Chaccha. The first Supercholo looked a lot like the pongo. His adventures were published as "El Supercholo: una historieta peruana para todos los peruanos" ("The Supercholo: A Peruvian Comic for All Peruvians") in *El Dominical* until 1966. The tone was comical but the idea was rooted in an indigenist and nationalist background. A second series was published between 1985 and 1989, illustrated by Antonio Negreiros in an even more childish style. The last version of the Supercholo comic—see figure I.2—was to be published first as "El reencuentro con el Supercholo" or "A Reunion with Supercholo," also entitled "El Regreso del Supercholo" or "The Return of Supercholo" in a sequence of one page a week in the Sunday supplement *El Dominical* of the daily Lima newspaper *El Comercio*. Supercholo was now portrayed by illustrator Carlos Castellanos Casanova. The illustrator had received some broad ideas about the story he needed to develop, and on the basis of this he wrote a script. Castellanos was free to modulate the characters in his own way.[50] Because there are relatively few Peruvian comics, he chose to imagine his characters as Peruvians: he designed them as urban *indígenas*, transforming Supercholo from the *indio* to the *cholo* because Castellanos refused to make a caricature of an Andean boy.[51]

The meaning of terms like *indios, indígenas, mestizos*, or *cholos* depends on the context in which they are used—by whom and to whom. In Peru, the *cho-*

50. Information recorded during an interview with Carlos Castellanos in Lima, August 11, 2013. Subsequently, we also had e-mail exchanges about his work. He told me that he was inspired by Harold Foster (*Prince Valiant*, 1937) and Alex Raymond (*Flash Gordon*, 1934). When *El Comercio* invited him to illustrate new episodes, the illustrator knew his hero from the previous versions. Castellanos was known for his comic "El Fugitivo" ("The Fugitive") published in the daily *Diario Ojo* in 1985 and the Suplemento Nazca Comic of the daily *Diario Página Libre* in 1990, for "Los Niños de la Calle" ("Street Children"), published daily also in the daily *Diario Página Libre*, his chronicles of everyday life "Crónicas Urbanas," "Urban Chronicles," published in *Última Hora* in 1991–92, and the final stages of the series "La Araña No" ("Not the Spider") created by Juan Acevedo, for the daily *El Mundo* in 1995. Castellanos submitted every week a large page line drawing, thirty by forty centimeters and colored with ink. One complete version of "A Reunion with Supercholo / The Return of Supercholo," written in 1996, was published in the progressive monthly magazine *Etiqueta Negra*, no. 79 of 2009—"A Reunion with Supercholo" changes on page 16 into "The Return of Supercholo." Additional information was provided by an interview with Castellanos posted on YouTube by Sonia Obregón, "El Supercholo según Carlos Castellanos," broadcast by "Identidades Peruanas," identidadesperuanos. com, July 26, 2014, at http:// www.youtube.com/watch?v=oC6liads7ko. Also: Interview in the Cuban website *La Jiribilla*, at http://www.lajiribrilla.co.cu/ 2004/n152_04/vidacuadritos.html and at Castellanos' own blog, http://castellanoscomics.blogspot.nl/ 2009/04/entrevista-en-la-jiribilla-2004.html (both accessed 7/14). See also: Ledgard, *Supercholo* (2004).

51. The term *cholo* is also known in the United States and Mexico, where it has connotation with being a gang member or being "filth." In Mexico, a *xolo* is a dog; "xoloitzcuintli" is a dog with no hair. Also: Nugent, *Laberinto*, 34.

los are *indígenas* who are not seen as straightforwardly "indigenous" *anymore*: they are, for instance, modern, new, progressive, urbanized, and globalized but still connected to their roots. In contemporary anthropological language we may understand them as *mestizo indígenas*.[52] The *cholos* are the children of a New Peru, almost in the sense Arguedas would have liked. Indeed, the migrants of Andean origins who arrived in Lima since the 1970s usually self-identified increasingly as *cholos*. At the time, the "*cholo*" as a political and ethnic issue lay on the table when Supercholo returned in the press. It is interesting to realize that the 1995–98 years fell in the period of the authoritarian presidency of Alberto Fujimori (1990–2000). Fujimori, who had recently won re-election in 1995 with almost two-thirds of the votes, had sought the "cholo vote," whatever he meant by that. Soon after the inauguration, however, things turned bad for the president because of allegations of corruption and abuses of violence: Peruvians demanded more freedom of speech. Fujimori was succeeded by Alejandro Toledo (in office: 2001–06), who had actively campaigned as El Cholo, both during the 1994 campaign, which he lost, and the one in 2000. Generally, Toledo is seen as a person of Andean descent, born into an impoverished family of Quechua-speaking peasants. In this atmosphere of incipient *cholo* empowerment at the end of a time of war and authoritarian politics, Castellanos's Supercholo shared this national Andean heritage. He had his family and a few friends in the Andes, most of his readers in the city.

Castellanos's version of *Supercholo* appeared between October 1995 and November 1998 in 51 pages. His protagonist now spoke an excellent Spanish and was very intelligent. In the comic, Supercholo was known as a true super-hero with incredible powers by all kinds of people whom we may classify as aliens. They needed him and his friend Juanito Pumasoncco, also known as Capitán Intrépido or Captain Fearless, to help them out. Juanito is a young Andean shepherd and a master in the lethal arts. Reading the comic today, we learn from the story that the "Super" and his dog Aljo have been in outer space for a few years, accompanying Juanito. The readers of Castellanos's comic are informed that the *cholos* are in power. Invited by the people of the planet Geos, Supercholo had traveled to its capital city, Cosmopolis. But he has unexpectedly returned to Earth on a very secret mission. Wandering the *puna* highlands near Huancayo looking for him, Juanito's parents soon meet him. Playing the quena (an Andean flute), Supercholo has been traveling with llamas, vicuñas, a puma, and a condor through the highlands. He tells

52. Reminiscent of de la Cadena's *Indigenous Mestizos,* but closer to the *indígena* than the *mestizo*—however we may measure this.

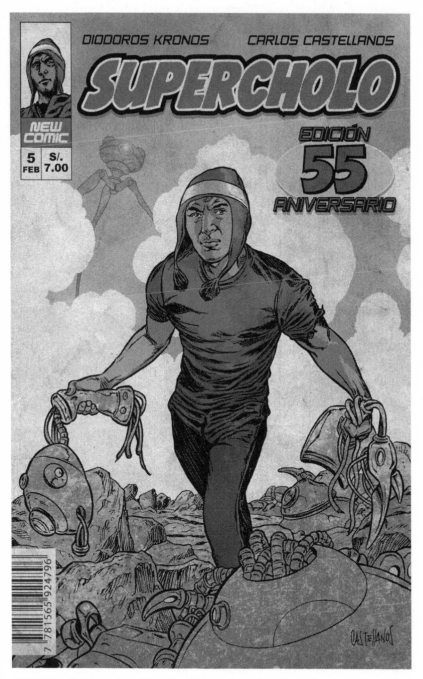

FIGURE I.2. *El Supercholo, edición 55 aniversario,* Carlos Castellanos Casanova, 2012, pen on ink, unpublished.

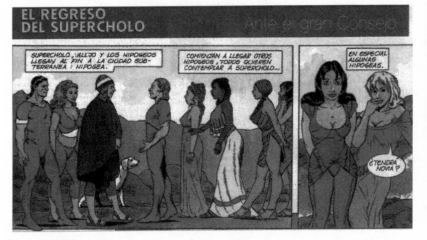

FIGURE I.3. *El regreso de Supercholo,* página 19: "Ante el Gran Consejo," Carlos Castellanos Casanova, 2012, pen and ink.

Juanito's parents that he has returned from a mission to pass through a black hole with Juanito. The two heroes were fighting an appalling dictator called Deinos, the ruler of the planet Megas. In Cosmopolis, a multicultural and well-developed Western type of city, Supercholo is given a hero's reception and a few *white* girls wonder whether Supercholo has a girlfriend; see figure I.3. Of course, Supercholo and Captain Fearless triumph in the end. Geos and the entire universe are saved. The story ends with major festivities. Captain Fearless and Supercholo, the two Andean astronauts, were the great heroes of this adventure. The fate of the multicultural planet of Geos, and our own planet Earth of course, had been in their capable and valiant hands. Courage, cleverness, and wisdom had been their major assets. The Peruvian readers could be proud of them, and their "race." Castellanos's Supercholo takes down the Colonial Divide, as if Arguedas's wall between the urban *white* culture and the Andean world was effectively demolished in a true "spirit of independence." The world of Supercholo is a multicultural Peru, with a prominent role for the Andean hero.

5

The Pongo and Supercholo stand at the extremes of a dichotomy. This suggests that their spirit of independence and opposition may indeed be mapped

between attitudes of shy-but-smart (Pongo) and self-confident (Supercholo). Also significant is that these two examples are taken from different historical periods. The Pongo's spirit was independent and oppositional in a time of deep discrimination against the Andean population. The Andeans in Peru were set aside as secondary citizens; at the time scholars, journalists, and politicians argued that they had to be "civilized." Although the Pongo's situation is still recognizable for many Andeans today, the Supercholo operates in a time when the social, economic, and cultural gaps with the *white* upper classes—Euro-Peruvian—are nevertheless slowly shrinking, as if we witness a development from neocolonial Pongo to the Supercholo hero of our times. What the two stories immanently share is the feeling that the attitude of independence of opposition is deeply rooted in the Andean mind, and not simply as an isolated cognitive schema but articulated to the complex of cognitive schemas that motivate Andean Amerindian action and behavior. Cognitive schemas are encoded in the neuronal network of the brain, from working memory (including short-term memory) to long-term memory (deep memory). Because they work unconsciously (out of consciousness), we look at a series or complexes of cognitive schemas as forming the building stones of something we may metaphorically label the Cognitive Unconscious. If we can identify a series of Amerindian cognitive schemas, shared memories, operating within specific mnemonic communities, there is a ground to tentatively speak of an Amerindian Cognitive Unconscious. I believe that the Pongo and Supercholo were informed by this Amerindian Cognitive Unconscious. Among other things, in this book I further discuss the gridiron pattern of urban planning, the intervening agent operating in cyclical time-frames, the idea of nondefeat, and a kind of disregard as resistance to ethnotyping.

We all know what I mean with the notion "Unconscious": many of us, perhaps even all of us, have experiences about actions that seem to have been guided out of conscious will, being guided by unconscious forces. Some believe that these could have been guided by a kind of *homunculus,* an entity that knows how to hide from Consciousness but guides our behavior. In his overview of the free will and the science of the brain, *Who's in Charge* (2011), cognitive neuroscientist Michael Gazzaniga affirms that many of us think we indeed believe this: "Do you remember the telling scene in the movie *Men in Black,* when a corpse is undergoing an autopsy?" he asks us.[53] Followed by: "The face popped open only to reveal the underlying brain machinery, and right there was an extraterrestrial-looking homunculus pulling levers to make it all work. It was the 'I,' the 'Self,' the phenomenal center and take-charge we

53. Gazzaniga, *Who's,* 43.

all think we have. Hollywood captured it perfectly, and we all believe in it even though we may understand that that is not at all how it works."[54] *Men in Black* was a 1997 film; in 2015 Hollywood Pixar Animation Studios produced *Inside Out,* a computer-animated comedy drama, basically set in the mind of a young girl. The unconscious agents here guiding the girl's behavior and actions are five personified emotions: Anger, Disgust, Fear, Joy, and Sadness.

The coming chapters offer an investigation into a series of cognitive schemas as mediators of the Amerindian Cognitive Unconscious. However, a first disclaimer is in order, even one that warrants an entire chapter. The idea of the Unconscious is still very much associated with psychoanalysis and the notions of Sigmund Freud. A few years ago, writing a critical evaluation of psychoanalysis in film criticism—*Freudian Fadeout* (2012)—I came to agree with the general tone of Freud history that the theories of the doctor from Vienna do not work and do not explain, perhaps as a consequence of not being stooled on proper academic work. The problem is that psychoanalysts in general tend to believe the Freudian legend, fabricated by Freud himself around 1914 and confirmed and disseminated by biographers like Ernest Jones, Peter Gay, and Élisabeth Roudinesco to justify his writings and the organizational politics within the Freudian movement. For that matter, Freud's self-analysis especially served institutional politics: "The self-analysis, always described by Freud's biographers as heroic, unprecedented and superhuman, is at the core of the Freudian legend."[55] "The *solitary* hero surmounting the obstacles placed across his route by malicious adversaries and that of the absolute *originality* of the founder."[56] However: "The heroic self-analysis never took place—or at least, it never took place in the manner in which it has been recounted. What transpired was a retrospective construction, aimed at immunising psychoanalysis from conflicts within it. It was a legend, but one with a very precise function: to silence opponents, to end the mutual diagnoses and to reestablish the asymmetry of interpretations in Freud's favour. To anyone who objected to the arbitrariness of his interpretations, he could now oppose his privileged, solitary and incomparable experience of the unconscious."[57] And: "the myth of the immaculate self-analysis had already taken root and become embedded and enshrined in the literature of psychoanalysis and spread to other disciplines, including in figures as sophisticated as [Jacques] Derrida and [Paul] Ricoeur."[58]

54. Ibid.
55. Borch-Jacobsen and Shamdasani, *Freud,* 40, 192.
56. Ibid., 20, reference to the work of Henri Ellenberger; italics in original.
57. Ibid., 54.
58. Ibid., 256.

As these quotes attest, anyone interested in the Freudian edifice should at least consult the particularly well-researched and well-argued history of psychoanalysis by Mikkel Borch-Jacobsen and Sonu Shamdasani, *The Freud Files* (2012). Throughout their book, Borch-Jacobsen and Shamdasani discuss three key elements of the legend: "the peremptory declaration of the revolutionary and epochal character of psychoanalysis [completely new ideas and concepts], the description of the ferocious hostility and irrational 'resistances' which it gave rise to [everyone in the university and the clinics refused to recognize psychoanalysis], the insistence on the 'moral courage' [of Freud during his self-analysis]."[59] Moreover, as with most legends, the structure is open, elements of it can change, specific ideas or concepts can be abandoned and be kept under wraps, others can be added, making it difficult to grasp in total. As teasers to read *The Freud Files,* a few key conclusions:

The Freudian legend is not an anecdotal or propagandist supplement to psychoanalytic theory. On the contrary, it is the theory itself. Questioning the Freudian legend leads to questioning the status of psychoanalysis itself.[60]

The legend of the immaculate conception of psychoanalysis played the role of epistemological immunization against internal as well as external critiques.[61]

The legend maintained the identity of the movement, portraying its mythic independence from and superiority over all other psychological and psychiatric theories.[62]

Ultimately, the legend of Freud's self-analysis was a means to justify the argument from authority.[63]

And as we know now: none of it is true.

Nothing new here, of course, were it not for the popularity of Freudian notions among the so-called Decolonialists—the Proyecto Modernidad/Colonialidad or Modernity/Coloniality Project—which began operating during a conference in Caracas, Venezuela, organized by the sociologist Edgardo Lander in 1998. Among the participants were Walter Mignolo, Aníbal Quijano, Enrique Dussel, Arturo Escobar, and Fernando Coronil, who became the

59. Ibid., 12–24, quote from 12.
60. Ibid., 23.
61. Ibid., 119.
62. Ibid., 119.
63. Ibid., 54, 119.

core members of the M/C Project. One central idea defended by the project's major spokesperson, Walter Mignolo, is to bring the "repressed culture" back into the Latin American Consciousness. The "repressed" here is the egalitarian indigenous community, living in harmony with nature. To underscore this, Mignolo frequently refers to the work of Enrique Dussel, whose work is firmly rooted in Freudian psychoanalysis.[64] However, as I argue throughout the book, I confidently believe that this impedes academic and political progress.

Therefore, before answering the question how an Amerindian Cognitive Unconscious may operate, I need the first chapter to move around the Freudian quagmire. Nonetheless, as is well known in Latin America Studies, the foundations of the *comunidad indígena* ("indigenous community") may indeed be an important feature of the Amerindian Cognitive Unconscious. My attitude here is strongly inspired by what the radical Bolivian sociologist and Aymara activist Silvia Rivera Cusicanqui recently stated in a keynote speech at the Sociology Conference at the University of Buenos Aires (2016), Argentina: "We are all *indios* as colonized peoples. Decolonizing one's Self is to stop being *indio* and to become people [*gente*]. People is an interesting word because it is said in very different ways in different languages."[65] She also spoke against the term *originario* (native): "It is a word that divides, that isolates the *indios,* and, above all, negates their condition as the majority so that they recognize themselves through a series of rights that restricts them to being a minority from the state's point of view." As I discuss in chapter 5,

64. Dussel, *Ética* and *Filosofía.* Dussel, born an Argentine but naturalized Mexican, is a philosopher and theologian. Inspired by the theology of liberation—or, indeed, by the "liberation" in the Freudian sense as "liberation" from repressed thoughts—he tries to systemize theoretical tools to substitute Hellenocentrism ontological Eurocentrism for a philosophy inspired by authors from around the globe. As most philosophers do, Dussel builds his system on the shoulders of previous philosophers. These predecessors include almost all well-known European philosophers and some theologians, and Freud—who never saw himself as a philosopher but as a therapist. Reading volume 6/III of the series *Filosofía ética latinoaméricana,* on *De la erótica a la pedagogía* (1977) I found it difficult to understand why this is Latin American philosophy. Dussel does not question the universality of Freud's "discoveries." He mentioned his name in consent 74 times in 168 pages. Also, hardly any historical or anthropological research on Latin American communities is being mentioned and certainly not discussed. Although Dussel questions the universality of these philosophies, he maps his philosophies among his European predecessors. For example: Mignolo, "On Pluriversality," October 20, 2013, http://waltermignolo.com/on-pluriversality/ (accessed 4/16).

65. Verónica Gago, "Contra el colonialismo interno," *Anfibia Revista Digital de Crónicas, Ensayos y Relatos de No Ficción,* October 2016, http://www.revistaanfibia.com/ensayo/contra-el-colonialismo-interno/; English version in *Viewpoint Magazine* (*Online Militant Research Collective*), October 25, 2016, https://viewpointmag.com/2016/10/25/silvia-rivera-cusicanqui-against-internal-colonialism/ (both accessed 10/16). She used the word *Indian* in English, *indio* in Spanish; I prefer to stick with the Spanish word in this situation.

this approach is similar to the work of the British philosopher Kenan Malik.[66] Consequently, I return to the Amerindian community and the decomposition of colonial structures at the end of the book.

As said, today the transnational Amerindian mnemonic community stands at the formerly colonized side of the Colonial Divide. Its memory consists of cognitive schemas—which are unconscious. Studying these schemas opens the doors to the features of Amerindian memory, or, differently voiced, the Amerindian Unconscious. It begins with the draft of a theory of art as a mediator of that memory in the second chapter. The book takes up the challenge of Arguedas's dictum that Amerindian memory in art "can already oblige" people "to learn" from it by studying cultural products. It locates the "spirit of independence and opposition" in the production of visual art rooted in an Amerindian Cognitive Unconscious. The hypothesis about its workings is the implication of the cognitive approach. However, although chapter 2 builds the foundation for the rest of the book, the theory is further clarified throughout the other chapters of the book with additional discussions as its building stones. Due to a lack of space—only a limited number of cultural products can be discussed of course—the Latin American Amerindian Cognitive Unconscious considered throughout the book is a hypothesis, based on a few specific memory survivals that have been passed on from one generation to the next over many centuries; but not without adopting new elements constantly—referred to as *amerindianization*—without affecting their core features. In the second chapter the theory is discussed, and illustrated with an analysis of a few short fiction films made by a youth organization based in the outskirts of Lima, the Peruvian collective JADAT. Furthermore, a folk painting is discussed; a popular anonymous Mexican colonial work *El Señor de Burgos* ("The Christ of Burgos") presenting the audience with both Christ at the cross and the pre-Hispanic Face of the Earth. Another typical deep memory that was passed down the generations by telling stories and simply following traditional building instructions as cultural customs in common is the gridiron city planning. Chapter 3 offers more building stones of a theory on the Amerindian Cognitive Unconscious, using the metaphor of the theater of the mind. From a single case, one of Peruvian artist Jorge Miyagui's paintings about the remembrances of the Internal Armed Conflict combined with Josué Méndez's feature film *Días de Santiago* (Peru, 2004; Days of Santiago), I discuss how resilient cognitive schemas can be; and also, as in the latter case, how they may cause troubles for the film's protagonist.

66. Malik, *Strange.*

Chapter 4 focuses on one interesting feature that may have rooted as a cognitive schema in the Latin American transnational mnemonic community: a typical way stories are told following ancient conventions. Many stories told in the Amerindian mnemonic community are built on cyclical schemas, beginning where the protagonist experiences a deterioration of life that seems unstoppable. In this schema, a step-by-step downhill can only be stopped by an intervening agent and turned into something positive. The intervening agent comes with feelings of increased deception, depression, frustration, and anger. It brings hope, perhaps even the confidence in improvement. Every depressed, frustrated, and angry person may also feel hope and expectations at the same time, because there *will* be an intervening agent; and if it does not show up soon enough, the protagonists may compel it by intervening themselves. This has happened in Chiapas in 1994, where a Maya army of Faceless Warriors acted out an intervention that was to improve the life of their communities. As the Zapatistas show, the intervening agent can also be a group of people and the intervention is to bring the "others," for example the community, in movement. In short, the cycle commands at least someone to *do* something. This is also a good reason to include the Mexican films *Y tu mamá también* (2001) and *Temporada de patos* (2004), the Chilean feature *La nana* (2009), and *Karen llora en un bus* (2011) from Colombia as typical cases here. Also Miyagui's paintings fit, not only for a discussion of deep memories but also because he unwittingly styled his art as a Japanese *butsudán*—another intervening agent.

Discussing the work of Miyagui, we may note that he builds on the embodied memory of local activists who brought their communities into movement. His work stimulates the viewer not only to recognize the crucial role of these local heroes but also to consider acting like an intervening agent themselves. Being moved by such agents is a crucial consequent of the art as agent in culture. This theme stands central in chapter 5, dedicated to paintings by Peruvian artist Claudia Coca. She comments on both the colonial legacy of Casta paintings and contemporary race relations. The chapter offers a possibility to work with an important cognitive instrument in human thinking: ethnotyping. The chapter also takes the analysis a step further: in all previous chapters the key feature constituting the Amerindian mnemonic community in Latin America was its colonial and neocolonial (1830–1990) history. In the final chapter, some work of the Peruvian YouTube artist Wendy Sulca is included, as is the work of Bolivian pastellist Rosmery Mamani Ventura. That chapter of course contains a discussion to bring the lines followed in the book together but also to take an extra step. It seems that if the "spirit of independence and opposition" can indeed be articulated to contemporary movements, a wider

view on *commoning* is inevitable. There and then, at the end of the book, the "politics of memory" arrives on the screen, and a plea to include the relevant cognitive schemas in that discussion because they constitute the drives and motivation of the Amerindian mnemonic community.

In all, after the wider aspects of the theory, these last chapters zoom in on a few specific examples because of the general question about the work-ings of the Amerindian Unconscious posed by the M/C Project. These cases circle around the agency provided by the paintings by Miyagui, Coca, and Mamani Ventura; by the fiction films of JADAT; and the films from Mexico, Colombia, and Chile just mentioned, as well as the Peruvian *Días de Santiago* (2004). In the interest of thematic unity, Peruvian art is somewhat privileged. Because the study has a modest and tentative approach, the selection is no doubt one-sided and limited to mainly products of visual culture like paint-ings and fiction films that demonstrate the workings of these schemas. In every chapter, the cultural production is contextualized within the society in which it is rooted. This brings me, finally, to a few disclaimers. The paintings and fiction films discussed in this book are used as *sources* for investigating Amerindian cognitive schemas—as their agents. Therefore, and in line with the cognitive approach, the book does not consider cultural products as "cul-tural texts."[67] Neither are the paintings and fiction films treated as symptoms of hidden elements of some Latin American "indigenous" culture in a wider sense. This is not a book about contemporary "indigenous" art or filmmaking. Finally, looking at the context of the encoding process of the cultural prod-ucts, this book avoids speculations about the role of cultural consumers. In all, the chapters below argue that because older memories are also the realities of every new generation—who let them "swim"—every ancient memory sub-jectively singled out is also always very modern and belonging to the present.

6

A spirit of independence and opposition. Colombian Nobel laureate Gabriel García Márquez realized where it came from. His short novel *Del amor y otros demonios* (1994) is based on the legend his grandmother told him as boy about "a little twelve-year-old marquise with hair that trailed behind her like a bridal train, who had died of rabies caused by a dog bite and was venerated in the

67. Many cultural scholars focus on the production of cultural meaning as metaphorical and textual and are concerned with a semiotic, narrative, and rhetoric look at the world, which allows them to "read" it. For a discussion of Discursive Idealism, see Aldama's *Why.* But see also: Korsten, *Lessen,* 302–5.

towns along the Caribbean coast for the many miracles she had performed."[68] In the book the novelist tells about copper-haired Sierva María and the bookish priest Father Cayetano Delaura, who amid the lush, coastal tropics of eighteenth-century Cartagena de Indias were caught in a chaste, ill-fated love affair. The girl, much younger than the priest, was believed to be possessed by Satan and hence, by order of the local bishop, incarcerated in a convent, much to the dislike of the convent's abbess. One day, the new viceroy paid a short visit to the convent. Witnessing the girl, he could hardly believe the accusations. He went to the bishop to discuss the matter. The bishop is gifted with skeptical wisdom: "By the end of the visit, it became evident that the Viceroy's greatest interest was the case of Sierva María. For its own sake, he explained, and for the peace of mind of the Abbess, whose suffering had moved him to pity. 'We still lack definitive proof, but the acta of the convent tell us that the poor creature is possessed by the demon,' said the Bishop. 'The Abbess knows this better than we do.' 'She thinks you have fallen into a snare of Satan,' said the Viceroy. 'Not we alone, but all of Spain,' said the Bishop. 'We have crossed the ocean sea to impose the law of Christ, and we have done so with Masses and processions and festivals for patron saints, but not in the souls of men.'"[69] *Not in the souls of men.*

68. García Márquez, *Of Love*, 3.
69. Ibid., 102.

FIGURE 1.1. *Colonialidad*, Jorge Miyagui, 2014, oil on canvas, 1.50 × 1.20 m.

CHAPTER 1

DEEP

THE DYNAMIC UNCONSCIOUS

1

Jorge Miyagui Oshiro (1978), one of the guiding artists in Peru, works with art to mediate memory. In his 2014 canvas *Colonialidad,* the artist tries to recall the long roots of misconduct against the *indígenas* in the Andes (see figure 1.1).[1] In his blog explaining his motivation, Miyagui refers to the 1992 article "Colonialidad y modernidad/racionalidad,"[2] published by the Peruvian sociologist Aníbal Quijano in the journal *Perú Indígena* as part of the 500-year anniversary of Columbus's arrival in the Americas. In *Colonialidad* Miyagui illustrates the deep roots of coloniality by articulating the brutal activities of the Spanish invaders with the massacres of the Peruvian Internal Armed Conflict, waged between the National Army of Peru and the soldiers of the infamous insurgent army of the Partido Comunista del Perú por el Sendero Luminoso (PCP-SL) or the Communist Party of Peru Following the Shining Path to Revolution,[3] led by former philosophy professor Maoist Abi-

1. Jorge Miyagui is active in the public domain by his anime-type painting avatar Sr Miyagui.

2. Quijano, "Colonialidad"; see also his "Coloniality."

3. "El Marxismo-Leninismo abrirá el sendero luminoso hacia la revolución," or "Marxism–Leninism will open the shining path to revolution"—a maxim of José Carlos Mariátegui (who, by the way, had nothing to do with Sendero).

mael Guzmán or Comrade Presidente Gonzalo.[4] Sendero Luminoso waged a
twelve-year insurrection, which claimed some 70,000 lives (1980–92; followed
by the dictatorship of President Alberto Fujimori; in power 1990–2000). In
the painting's foreground we see Mamá Angélica Mendoza de Ascarza—the
lady in blue—with one of her companions. During the so-called Internal
Armed Conflict in Peru (1980–1992 [–2000]), mothers, women, and other
family members began marching in the Andean city of Ayacucho against the
violence, the rapes, the abductions, the disappearances, and the killings. The
victims had organized themselves in the Asociación Nacional de Familiares de
Secuestrados, Detenidos y Desaparecidos de las Zonas Declaradas en Estado
de Emergencia del Perú (ANFASEP; National Association of Kidnapped, Dis-
appeared and Detained Relatives of Zones that were Officially Declared in
a State of Emergency). Since 1984, Mamá Angélica has been one of its lead-
ers. ANFASEP marched through Lima and Ayacucho with crosses in front of
them, on which were written: "¡Verdad, justicia!" or "Truth, Justice!" and "¡no
matar!" "No more killings!" On the painting we also read "Vivos los llevaron;
vivos los queremos": "They took them alive, we want them back alive."

Typically, the approach to studying cases of transnational mnemonic com-
munities begins with a "politics of location."[5] Accepting that "God is in the
details," academics study local cases rigorously to situate them constantly in
relation to other scales—local, regional, national, global.[6] Miyagui also begins
from a more local perspective. He places the two "independent and oppo-
sitional" ladies from Ayacucho in the center of a circular stage, in the spot-
light of attention. The stage is quartered by two *qantutas*, flowering plants
found in the high valleys of the Andean slopes and chosen as the national
flower of Peru.[7] *Qantutas* were used in pre-Hispanic ritual practices as mark-
ers of sacrality and were depicted in religious paintings in the Andes (Cusco).
Although since Spanish times the flowers have also indicated the celestial
paradise that awaits the faithful, the original Inca meaning had more to do

4. Jorge Miyagui, "Interculturalidad: arte, migración y diálogo. Testimonio de trabajo,"
signed May 2007, also at his blog http://jorgemiyagui.blogspot.nl/2007/07/interculturalidad
-arte-migracin-y.html (accessed 9/13).

5. Rich, "Notes."

6. Rothberg, "Afterword," 652; De Cesari and Rigney, "Introduction," 3; Ford, "Introduc-
tion," 2. This is of course in line with experiences in other fields, for example with *microstoria*
or microhistory; see Ouweneel, *Flight*, 9–20.

7. As a symbol, the flower also refers to the so-called La Cantuta case of 1992, investigated
by Peru's Democratic Constituent Congress. On the night of July 18 that year, army soldiers
had abducted nine students and a professor from Cantuta University and handed them over
to a death squad. Their bodies were burned to prevent any subsequent identification. See Kirk,
"'Good,'" 78.

with the unity of the people and reconciliation after fighting and warfare. The latter meaning may be preferred here, because Miyagui's painting mediates in the memory of the victims of one of the major battlegrounds in Peru. The Andean population had been the major victim of the racist attitudes of both armies. Miyagui follows Quijano in explaining that the racist attitudes of the soldiers and insurgents involved are a memory of conquest, colonialism, and violent segregation which Quijano labeled *colonialidad del poder*—the coloniality of power.

Here the mediation of memory dives deeper and wider into history. The center stage occupied by the two ladies of ANFASEP stands in the Peruvian *puna*—the grasslands situated in the Andes above 3,200 meters. Directly behind the stage in the center of the painting we see the army's torture center, the Cuartel Los Cabitos, near Ayacucho, where during the years 1983–85 prisoners who entered alive left the building dead. The building transforms the grasslands into a "guilty landscape," a memory site that was witness to a horrendous history. As ghosts from the past, an Inka delegation and Spanish Conquistadors reinforce the impression that this history has truly deep roots indeed. In citing the drawings of the late sixteenth-century author Felipe Guamán Poma de Ayala in the background of the painting, Miyagui suggests that the Andeans have been victims of violence ever since the sixteenth-century Spanish Invasion. This is a memory that the Andeans share with other groups in Peruvian society, like the *mestizos* and the *cholos*. In fact, it is a transnational memory that they share with *indígenas* and *mestizos* from other Latin American countries as well. Following schema theory, memories are encoded in cognitive schemas. This is the basis of the Amerindian mnemonic community in the Americas. Nevertheless, Miyagui's landscape is populated by sad but brave women. The guilty landscape of the Andes keeps not only the memory of Peru's prejudiced attitude toward the *indígenas* in the Andes alive; Miyagui tries above all to highlight the population's spirit of independence and opposition. By diving deep into Peru's history, Miyagui's *Colonialidad* transcends the memory of the Internal Armed Conflict diachronically.

2

The academics of the Proyecto Modernidad/Colonialidad (Modernity/Coloniality Project) also took Quijano's *colonialidad* as their personal maxim. This M/C Project functions as a working group of mainly Latin American cultural scholars who can be mapped within the current anticolonialist movements taking the stage at the Latin American Left, looking at the history of Latin

America's prolonged colonization, first by Spain and Portugal (roughly 1500–1820s) but then more profoundly by internal colonization (1830s–1980s) as the coloniality of power. This notion had been Quijano's answer to interpret the persistent presence of internal colonialism in Peru:

> With the conquest of the societies and cultures living in what we now call Latin America began the formation of a world ordering which, 500 years later, has developed into a world power that spans over the entire planet. This process implied, for a part, the ruthless concentration of the world's resources under the control and to the benefit of a small European minority of the human race and, above all, to its dominant classes. [. . .] The "Western" European oppressors and their North-American descendants still are profiting the most of the system, together with parts of the world that have not been colonized by Europe, like Japan. And again, above all their ruling classes. The exploited and oppressed of Latin America and Africa are the principal victims.[8]

In short, Latin America, not just Peru, is still governed in a colonial style.

This is important for my question about the mediation of memory. Key members of the M/C Project believe that the persistence of the coloniality of power stretches out into the mental sphere. It has entered the encoding system of memory. One of them is Argentine Walter Mignolo, a semiologist residing in the United States. Recently, I saw Mignolo speaking on the features of *colonialidad* in a video posted at Bioecon Media (BIOdiversity and Economics for Conservation) by the Argentinian web-based Occidente TV; in 2012, or so it seems. The video presents what they call a "portrait" of Mignolo in which he explains the crux of his work and that of the M/C Project at large. At one point he addresses Quijano's concept:

> Coloniality is the darker side of modernity. There is no modernity without coloniality. What does this mean? Modernity sells a project of salvation, progress, civilization, happiness, et cetera. But in order to do this, it inevitably wants to repress, exploit, expropriate, appropriate, *ningunear* as the Mexicans say. We write modernity/coloniality—with a slash—because these are the two sides of the same coin. [. . .] *Coloniality is like Freud's Unconscious: you cannot see it, but it works.* Or it is like Marx's surplus value: you

8. Quijano, "Colonialidad," 11; translation is mine.

cannot see it, but it works. Therefore, coloniality is the unconscious logic of Western civilization, and that includes psychoanalysis and globalization.[9]

It must be said that at this point Mignolo remains quite sparing in his further elaborations. He seems to understand Freud's Unconscious as a given—as if we all know what is meant by it. But one way or another, the question is: If *colonialidad* is so important for Miyagui's imaging of the Amerindian "spirit of independence and opposition," do we look at the mediation of memory through Freudian eyes? Is there something like a Collective Unconscious, as Carl Jung thought some hundred years ago? In fact, is there even something like an individual Unconscious, as Jung's one-time master Sigmund Freud alleged we all have? And is this Unconscious guiding us like an agent? How could this work?

Mignolo's lack of clarity motivates us to go deeper into the Freudian heritage. This is a heritage of issuing psychoanalytical notions by decree; notions of which no scholarly evidence could be found. The Freudian "data" cannot be observed without the psychoanalytic decrees. People can only "see" them if they agree with the decrees and with Freud's work. One of his decrees is about the Dynamic Unconscious, which is about inner forces at work in all the minds of people directing their behavior *fully outside of their awareness*. This is crucial. No open contact is possible. The Dynamic Unconscious does not include all unconscious thoughts. Freud also decreed a Preconscious. Although most of us go with popular psychology in believing that most of our actions, beliefs, and feelings guide us unconsciously, we rarely realize that the majority of those are "capable of entering consciousness" and must therefore be mapped in the Preconscious and not in the Dynamic Unconscious. The latter is different from the former, because Freud postulated that the Dynamic Unconscious cannot be entered directly. It was reserved for thoughts that are actively repressed from conscious thought because the person is averse to knowing them consciously. Furthermore, Freud decreed that thoughts that are outside of consciousness but that could easily be brought into it are "preconscious," better described as "capable of entering consciousness." Therefore the Dynamic Unconscious serves as a kind of garbage bin for repressed thoughts. The repressed material could be brought back into consciousness by way of a

9. Published on Vimeo, https://player.vimeo.com/video/39840006, also at Bioecon TV's YouTube channel at https://www.youtube.com/watch?v=oR_qA6R4lns (posted June 28, 2012; accessed several times in June, hence: 6/12); I accessed both sites several times, last on May 2016 (hence: 5/16); italics added. The interview was conducted by Occidente TV, Occidente: testimonios, visions y utopía, http://www.occidentetv.com. Translation is mine. See also Alcoff, "Mignolo's."

talking cure; the patient is cured. Within the mind Freud posited a dynamic struggle between a kind of rational, socially accepted thought in the Preconscious and the pressures from "repressed thoughts" escaping the Dynamic Unconscious. To avoid confusion, I will continue to call Freud's version the Dynamic Unconscious—and vice versa regard the Dynamic Unconscious as a fundamental part of Freud's edifice. Because of all the postulations and figments, there is no Dynamic Unconscious outside the Freudian discourse.

This is how a defender of Freud, the British psychiatrist David Stafford-Clark, explained it in his *What Freud Really Said* (1965): "If consciousness is then the sum total of everything of which we are aware, pre-consciousness is the reservoir of everything we can remember, all that is accessible to voluntary recall: the storehouse of memory. This leaves the unconscious area of mental life to contain all the more primitive drives and impulses influencing our actions without our necessarily ever becoming fully aware of them, together with every important constellation of ideas or memories with a strong emotional charge, which have at one time been present in consciousness but have since been repressed so that they are no longer available to it, even through introspection or attempts at memory."[10] Stafford-Clark uses a theater metaphor: "Consciousness is the spotlight which, sweeping the arena, lights up just that area upon which it falls. Everything outside its illumination, but within its range, is preconsciousness."[11] However, "there will always be areas beyond the range of the spotlight altogether: these can never normally be illuminated and so are unconscious." Stafford-Clark also understands how Freud thought he could intrude there anyway: "Sleep, dreams, hypnosis and free association widen and extend the spotlight's range, but may distort or diffuse its illumination."[12]

Next to the Dynamic Unconscious that cannot be brought into the Conscious, "repression" is crucial. In Freud's thinking, the Dynamic Unconscious was pathological. It functioned first and foremost as a repository for ideas, wishes, or desires that were socially unacceptable. Next, it contained painful emotions and "repressed" traumatic memories. As one of the "defense mechanisms," perhaps the major one, "repression" or *Verdrängung* is one of Freud's core concepts. In a way, there is no Dynamic Unconscious without "repression." Utterances from the Dynamic Unconscious are seen as "symptoms" of its content, and that content is usually based on forbidden, or unacceptable, feelings of pain, anxiety, or thoughts on conflict, fears, and shame, and conventional, social, or cultural thoughts, desires, motivations, and the

10. Stafford-Clark, *What*, 114.

11. Ibid., 115.

12. Ibid.

experiences of traumas. These thoughts are too unpleasant, embarrassing, or emotional to think consciously and are therefore "repressed." The idea was that the defense mechanisms serve to keep desires and wishes that invoke too much emotion out of conscious awareness. If such desires and wishes lead to behavior, they could also clash with society.

By analyzing the "symptoms" with the help of Freudian theory, the analyst can bring back into the Conscious the disorder in the individual's mind by inferring, discovering, and translating into the Conscious. However, removing these negative thoughts from the Dynamic Unconscious will meet very strong resistance. Eventually, the "patient" or analysand is "liberated." This "liberation" is needed because tucked away in the Dynamic Unconscious, repressed desires, wishes, or experiences and traumas might *haunt* the unconscious mind in dreams, or cause fears and aggression, and return in the conscious mind disguised as errors, jokes, or unaccountable or "automatic" behavior. This haunting is seen as the "return of the repressed." The ability to haunt consciousness gives the "repressed thoughts" their destructive powers: the Freudians believe that they cause "neuroses." Again, the psychoanalyst at home in Freudian philosophy would be able to cure the patient by bringing the "repressed thoughts" into the Conscious. Note that in classical Freudian theory repression is not the same as being silent about things, it is not just not wanting to talk about things; it means that "repressed thoughts" are truly forgotten—they remain forever outside the Conscious and the Preconscious.

At first sight, Mignolo seems to disassociate himself from Freud. "The human unconscious as described by Freud is based on a particular kind of man and woman," he paraphrases the Martinique-born Afro-Caribbean French psychiatrist and writer Frantz Fanon, "in a particular kind of society, in a particular language structure (German, Indo-European languages) that proved difficult to *translate* into Arabic, in the tension between Arabic and French."[13] Both in a contribution to a reprint of Fanon's *Piel negra, máscaras blancas* (2009; English: *Black Skin, White Masks,* 1967, originally in French, *Peau noire, masques blancs,* 1952)[14] and in his own monograph *Local Histories / Global Designs* (2012), Mignolo allows us a glimpse of his vision on the Unconscious by referring to the work of Fanon, who was concerned with the psychopathology of colonization in books like *Black Skin, White Masks* and *The Wretched of the Earth* (1963, originally in French, 1961). Reading *Black Skin, White Masks,* Mignolo notes that Fanon's observation that his colonized patient "is suffering from an inferiority complex" is articulated to the conclu-

13. Mignolo, *Local,* 86; Fanon, *Wretched,* 249–310; italics by Mignolo. See also, Mignolo, "Fanon."

14. Mignolo, "Fanon."

sion that "the discoveries of Freud are of no use to us here."[15] Interestingly, Freud's work is here only partly under discussion: his "discoveries" are beyond question, but the way he elaborates on them is very much questioned. This has always been typical for psychoanalysis. Freud's followers accept his claim to have discovered much about the human psyche but express doubts about his theories about them. It is as if they accept that there is a difference between Freud's "discoveries"—of, for example, the Unconscious, "repression," "regression," "castration anxiety," and the Oedipus Complex—and the theories of how these "mechanisms" work. Nevertheless, recognizing the colonized patients' inferiority complexes is to bring it into their Conscious and therefore to liberate them.

Recently, however, Mignolo has added a crucial point. On December 16, 2015, the bookshop Alamut Libros in Buenos Aires host an evening with Mignolo, entitled "Decolonial Healing" ("La sanación decolonial"). The event was announced accompanied by two of his statements to attract people: "In psychoanalysis, a cure can only come from the intervention of a psychologist during analysis, whereas decolonial healing is a process of *community formation*. The process of release is not just a personal process. In fact, it is not only mine; on the contrary it is a subjective process that takes place in communities."[16] This is indeed Freudian language. Bring the "repressed" into the Conscious. Perhaps, in Mignolo's thoughts, Latin American colonized societies have repressed negative experiences so deeply that they are fully *outside of their awareness*—in this case: perhaps primordial community organization. That is, he suggests, how *colonialidad* works. Therefore, putting himself in the chair of the analyst, analyzing the symptoms of *colonialidad*, a decolonialist like Mignolo or Dussel may eventually stimulate Latin America's liberation. The patient needs the analyst, the master, to be liberated from "repressed" thoughts. Modernity and Coloniality need philosophers who talk about decolonization to initiate a movement of community building. Apparently, for Mignolo psychoanalysis is about both individual memory and the collective. Healing is not simply individual but also collective, cultural. Although Mignolo is not clear about coloniality as Unconscious—"You cannot see it, but it works"—as a variety of the Dynamic Unconscious it must be *out of consciousness* and therefore *forgotten*. It seems that the "primordial community" is among the collectively "repressed" thoughts. As embers of the past, the

15. Mignolo, *Local*, 85–86, quote 86; Fanon, *Black Skin*, 104.

16. The event had its own page on Facebook; see https://www.facebook.com/events/925902354152337/ (accessed 5/16) (also: https://www.facebook.com/events/925902354152337/?active_tab=highlights); italics added.

symptoms haunt the present.[17] Decolonial healing comes from an "analysis," which would make the disorder "conscious," and eventually society would be liberated from its disorders.

Curiously enough, there is another link with decolonization, articulated to the fact that psychoanalysis can be seen as a typical product of the age of modern imperialism, expressing in all of its details the romantic century.[18] During the romantic era the idea of individuals having their own personalities became hegemonic. People began talking and writing about their imagination, their emotions, and their desires, which, by the way, classically remained unfulfilled—lovesick in vain, deception and despair, *Paradise Lost*. One major arena for the romantics to revolutionize European culture was the attitude toward nature, landscape, and forests. Europeans began walking through the woods for recreation but also to find their "inner selves": the forest as a mirror of the soul. The romantics witnessed a radical transformation. They began departing from the image of an organized humanity, structured and collectively embedded in an ordered community; from the idea that people have to identify with a functional roles, to find an attitude, to present their external; and began looking for the *self*-image of *being* someone—or better: *becoming* someone—meaning their so-called inner, authentic inward-looking selves. The collective opened to the individual, the group to the person, and the universal to the private. The romantics preferred feeling above thinking, subjective above objective, ironic above explicit, synthesis above analysis, qualitative above quantitative, art above science, the organic above the mechanic, spiritual above material, the hybrid and ambiguous above division and partition, suggestion above contours, difference above blending, dark above light, night above day, absence above presence, the concealed above the exposed, the unconscious above the conscious, and man as part of nature and not above nature. Romanticism transformed, for example, marriage arrangements: from the public interests of families and communities to love and personal happiness. Romanticism brought alienation of happiness, of being, of health, of nature, of the past, of memory, perhaps even of culture itself. And thanks to postmodernism, its last successor, for most of us in the academy this is still our daily discourse.

Hand in glove, cheek by jowl, romanticism belongs to colonialism. This makes major theories and theorists of the time accessories to the practice of the age of modern imperialism and the greed of its colonial powers—except,

17. *Embers of the Past* is also the title of a recent book by literary scholar Javier Sanjinés, a cultural analyst, with a foreword by Mignolo. That book seems to be written from the perspective indicated here.

18. Ouweneel, *Freudian*, 14–19.

of course, for a few major critics. Although the International Psychoanalytical Association under the authoritarian rule of Freud claimed to be apolitical, literary scholar Ranjana Khanna demonstrates that there are many grounds indeed for reading Freud's work, and other writings of psychoanalysts, as a colonial discipline. Together with ethnology and archaeology, psychoanalysis was contaminated with the same racism and ethnocentricity as colonialism. "Psychology, psychiatry, and psychoanalysis had all been employed by European colonizers in the service of European nation-states to assist in the analysis, pathologization, and repression of colonized peoples, sometimes reworking the basic assumption of [their] fields to achieve this."[19] It is well known that Freud's favorite reading lists include antimaterialistic, and perhaps even reactionary, publications like the novels *She* (1887) and *Heart of the World* (1896), by the British colonialist author Henry Rider Haggard, who voiced the "civilizing mission" of the British Empire in the non-European world. Haggard's creations served some of the authoritarian ideological and psychological needs of British imperialism.[20] Psychoanalysis, Khanna continues, "brought into the world an idea of being that was dependent on colonial political and ontological relations, and through its disciplinary practices, formalized and perpetuated an idea of uncivilized, primitive, concealed, and timeless colonized peoples. As a discipline, it formalized strategies to normalize a form of civilized being constituted through colonial political dynamics."[21] Curiously, Khanna regards herself as a psychoanalyst and tries to demonstrate that a reading of Freud's work and that of followers like Fanon is needed to constitute a postcolonial feminist critique of decolonization.

It is the type of thickly philosophized utopianism in the M/C Project that rubs many activists the wrong way. Reacting to the writings of the M/C Project, Silvia Rivera Cusicanqui, for example, recently questioned the scholarly foundation of currently popular decolonialist theories or theorists:

> I want to state frankly that I do not agree with the term decolonial, nor with all the redundant literature that has stemmed from it, to the point that it has almost become a school of thought and theory, with more followers in the South than in the North. For me, it is a rather infelicitous Gallicism that hurts my ears, and since I mistrust all forms of branding, I have come to dislike the unintelligible, elitist, and utterly boring debate that it has provoked up to now. Above all, I find the term practically useless for action in the streets and for engaging with concrete indigenous struggles. It has,

19. Khanna, *Dark*, 26.
20. Ouweneel, *Freudian*, 21.
21. Khanna, *Dark*, 6.

nevertheless, been cleverly adopted by new aspirants to internal colonialist power, in Bolivia and elsewhere, and this is an even more pressing reason for remaining outside its lure. When somebody asked me what alternative terms I would suggest, I frankly and impolitely said that along with many Bolivians, I prefer to speak about "demolition" instead of "deconstruction," and "anticolonial" instead of "decolonial," because I think it is more coherent to try to connect with the direct language of subalterns, rather than with the word-games of high-brow afrancesado intellectuals.[22]

According to the Rivera Cusicanqui, this is above all discriminating toward the *indígenas* since the Spanish Invasion, because it denies them their own agency toward the colonial powers and the coloniality of the present.[23] In 2016 she added: "The postcolonial is a desire, the anticolonial is a struggle, the decolonial is an obnoxious fashionable neologism."[24]

Commenting on the politics of identity in Bolivia and the epistemic influence of the M/C Project's theorists and other cultural and financial powers from the Global North, Rivera Cusicanqui was unable to shake off a feeling of concern. She notes how these authors, sending messages from their "Palaces," as the Global North universities can be described in comparison to those of the Global South, are functioning as think tanks of countries, banks, and NGOs—indeed, precisely those powers of *colonialidad* in Quijano's terminology. The discursive domination of the M/C Project not only rests upon a specific jargon, typically taken from French poststructuralism, and other elements of the "economy of ideas, it is also an economy of salaries, convenience and privileges,"[25] leading to a situation of legitimacy based on Global Northern academic titles, stipends, visitor professorships, and access to publishing houses in English. As true colonizers they harvest local ideas in the Global South, work them over with their own modes of neutralizing production—in this case, for example, poststructuralist jargon—and then earn a living and status by publishing about them. This is why Rivera Cusicanqui resists the use of a concept like *pueblos originarios*, "native peoples" or "first nations":

22. Rivera Cusicanqui, "Potosí." The author had already referred to this position of the Decolonialists in her tiny book *Ch'ixinakax*, 57–59, 63–69.

23. Rivera Cusicanqui, *Ch'ixinakax*, 58–62; this also in Fabricant, "Good."

24. Verónica Gago, "Contra el colonialismo interno," *Anfibia Revista Digital de Crónicas, Ensayos y Relatos de No Ficción,* October 2016, http://www.revistaanfibia.com/ensayo/contra -el-colonialismo-interno/; English version in *Viewpoint Magazine* (*Online Militant Research Collective*), October 25, 2016, https://viewpointmag.com/2016/10/25/silvia-rivera-cusicanqui -against-internal-colonialism/ (both accessed 10/16). She used the word *Indian* in English, *indio* in Spanish; I prefer the Spanish word in this situation.

25. Rivera Cusicanqui, *Ch'ixinakax*, 65.

members of the M/C Project and their allies try to domesticate the agency of the *indígenas*.[26]

As Rivera Cusicanqui's stance demonstrates, decolonization is a complicated matter indeed. However, her complains about "word-games of highbrow afrancesado intellectuals" is justified by the fact that members of the M/C Project, despite their personal Latin American nationalities, wander around in the world of European philosophers; especially referring to Frenchmen disputing each other's work and German authors from the Frankfurter Schule; Michel Foucault, Jürgen Habermas, Walter Benjamin, Gilles Deleuze, G. W. F. Hegel, Martin Heidegger, Max Horkheimer, Jacques Lacan, Karl Mannheim, Friedrich Nietzsche, and even Immanuel Wallerstein. Many of these authors are heavily indebted to the legacy of Sigmund Freud. Karl Marx would label this a scholastic position. His often-quoted "Second Thesis on Feuerbach" reads: "The question whether objective truth can be attributed to human thinking is not a question of theory but is a *practical* question. Man must prove the truth, i.e., the reality and power, the *this-worldliness of his thinking in practice*. The dispute over the reality or non-reality of thinking which is isolated from practice is a purely *scholastic* question."[27] This means that we need grounded theory and not a kind of scholastic, too abstract, and *afrancesado* a theory.[28] This points to Rivera Cusicanqui's belief that the work of anticolonial struggle will result in an undoing of colonialism, not in a return to some pre-Hispanic situation, whatever that would be in our times.

3

The position of Mignolo and the others of the M/C Project depends on the trust we can invest in Freud as a competent scholar and academic. Judging psychoanalysis, it is crucial to stick to Freud, because there cannot be psychoanalysis without Freud; all psychoanalyst schools are branches from the tree he personally created—and as we will see: thereby using material that was already there to be used. Stafford-Clark explained it as follows: "Psychoanalysis was and will always be Freud's original creation. Its discovery, exploration, investigation, and constant revision formed his life's work. It is manifest

26. Rivera Cusicanqui, *Ch'ixinakax*, 58–62; a similar conclusion can be found in Aldama, *Why*, 20–43.

27. Marx, "Theses," 6; my emphasis. The text was first published in German as an appendix to *Ludwig Feuerbach and the End of Classical German Philosophy* in 1888.

28. Of course, there are several Practice Theories published to date. Classics are by Pierre Bourdieu (1972); Anthony Giddens (1984); and, Sherry Ortner (2006).

injustice, as well as wantonly insulting, to commend psychoanalysis, still less to invoke it '. . . without too much of Freud."[29] Therefore, Freud's personal attitude mattered. The Freudians are involved in a kind of personality cult which for critics Mikkel Borch-Jacobsen and Sonu Shamdasani is "a profound epistemological necessity."[30] We read in *The Freud Files* (2012):

> If it wasn't possible for Freud to lie, it's simply because, in the absence of the thing itself, we have only the witness's good faith to rely upon. As [Jacques] Lacan might have said: the Freudian field is structured by a symbolic pact with the founding Father, whose Word, which his sons constantly return to, is the sole guarantor of their practice. This is what explains, for example, why the question of knowing whether Freud cheated on his wife with his sister-in-law is so significant for psychoanalysts. In any other scientific discipline, such a preoccupation with the vulgar details of the founder's biography would seem trivial and inappropriate; but not in psychoanalysis, where such questions stir up a tide of polemics and erudite commentaries. They go directly to the reliability of the Witness of the Unconscious: how could we believe someone whose soul and desire weren't pure?[31]

Here, problems loom. Over the past decades, historians of psychoanalysis have unearthed a series of serious problems that need to be addressed. Most authors critical of Freud's work tend to be accused of "Freud bashing" or of arbitrarily adopting a shotgun approach to attacking the Freudian edifice. Over the past years, I have worked my way through Freud's work, that of other psychoanalytic authors, their followers and their critics, and I have concluded that critical Freud historians like Borch-Jacobsen and Shamdasani and many others stand on firm ground. It appears that the Freudian edifice rests in a quagmire.[32] Even Freud himself acknowledged to friends and family that his theories did not work. At first Freud wanted a scientific psychoanalysis, but when he failed to create one, he split off from the university world and created his own organization, including his own type of education of psychoanalysts. No wonder that today many psychiatrists have stopped working with Freudian concepts. Moreover, the foremost psychiatry manual *Diagnostic and Statistical Manual of Mental Disorders,* or *DSM-III,* published by the American Psychiatric Association in Washington, DC, dropped the psychoanalytic neurotic

29. Stafford-Clark, *What*, 17. See also especially Borch-Jacobsen and Shamdasani, *Freud*, 30–115.
30. Borch-Jacobsen and Shamdasani, *Freud*, 192.
31. Ibid.
32. Ouweneel, *Freudian.*

conditions from its guide of psychiatric disorders as early as 1980, in its third edition. Freud is ever since absent in the psychology of disorders. Later editions, from the *DSM-IV* (1994) onwards, proved even more radical rejection.

Precisely because other theories and medication proved to be better, for many psychologists Freudian notions like bisexual birth, early childhood determination, the Oedipus Complex, irrational drives, haunting nightmares, neuroses, repression, regressions, castration anxiety, transference, and resistance have ostensibly little scholarly value anymore.[33] For example, cognitive neuroscientist Michael Gazzaniga mentions Freud only three times. He spends more words discussing the contribution of the English Victorian author Francis Galton, for example, probably because Galton was "interested in basing his theories on concrete findings and statistical methods," "*unlike Freud.*"[34] Regardless of its enormous success in the decades after the Second World War in academe, says writer Richard Webster, psychoanalysis has become severely discredited over the past decades because it "has not only failed to redeem us from [. . .] social ills; it has failed to do the only thing we ultimately have a right to demand of explanatory theories—*it has failed to explain.*"[35] "My evaluation shows," writes Australian psychologist Malcolm Macmillan, "that at none of the different stages through which it evolved could Freud's theory generate adequate explanations."[36] This is noteworthy, because "neither the defenders of Freud's psychoanalysis nor its psychoanalytic critics doubted the objectivity of the psychoanalytic method."[37] Where psychologists are concerned, it seems the "unconscious agent" who *haunts* the human mind is dead.

Reading the recent findings of some of the Freud historians, I had a feeling of déjà vu. In the late 1970s I took a university course on Soviet psychology, and among others we read a book just published in English by Valentin N. Vološinov, *Freudianism: A Marxist Critique* (1976), which was originally published in the Soviet Union in 1927. The book was part of a series of newly published translations from the SU, which included books by Mikhail M. Bakhtin, Alexander R. Luria, and Lev S. Vygotsky, linguists and psychologists, all very much interested in the articulation of language, discourse, and cognition. The editors of Vološinov's critique on Freud summarized it well:

> Vološinov went to the root of Freud's theory and method, arguing that what
> is for him the central concept of psychoanalysis, "the unconscious," was a

33. For a discussion of literature, see Ouweneel, *Freudian.*
34. Gazzaniga, *Who's,* 48; italics added.
35. Webster, *Freud,* 63–64; italics added.
36. Macmillan, *Freud,* 625.
37. Ibid.; also: Atkinson et al., *Hilgard's,* 276, 500.

fiction. He argued that the phenomena that were taken by Freud as evidence for "the unconscious" constituted instead an aspect of "the conscious," albeit one that deviated ideologically from the rest of it, an "unofficial conscious" at odds with a person's "official conscious." For Vološinov, "the conscious" was a monologue, a use of language, "inner speech" as he called it. As such, the conscious participated in all of the properties of language, particularly, for Vološinov, its social essence. And thus Vološinov could argue that the unconscious was linguistic in nature because it was actually an aspect of the conscious, and, in turn, that it was a social phenomenon because it was linguistic. This type of argumentation stood behind Vološinov's charge that Freudianism presented humans in an inherently false, individualistic, aso-cial, and ahistorical setting.[38]

Vološinov's ideas of the Dynamic Unconscious as a linguistic phenomenon were taken up by another Russian linguist, Roman O. Jakobson, who left the SU in the 1920s, went to Prague, next to Copenhagen, Norway, and Sweden, and finally to the United States; to New York and Harvard. Next to the studies of his former Soviet colleague, Jakobson included the publication of the Swiss semiotician Ferdinand de Saussure in his work, and along the way through Europe and the United States he introduced Vološinov's ideas to academics like Louis Hjelmslev, Claude Lévi-Strauss, Franz Boas, and Benjamin Whorf, and therefore directly or indirectly also Jacques Lacan, Roland Barthes, Michel Foucault, Jacques Derrida, and Julia Kristeva—not a bad achievement. What all these followers missed was Vološinov's idea of unconscious thinking as a discursive part of conscious thinking—in Freud's terminology this would be Preconscious activity. Vološinov's ideas fell on fertile ground among the discursive idealists—the academics who believe that meaning can only be grounded in language, discourse, and text, as if we cannot grasp a "real" world of physical things around us, independent of our senses and mental constructs. Reading Vološinov, I doubt that he would have agreed with this development.

In their own work, the Freud historians seriously further undermined the idea of a pathological Dynamic Unconscious. For example, it is now widely acknowledged that Freud did not invent or "discover" the unconscious. It appeared that in Europe the idea of an active unconscious, guiding us through the world or haunting our mind, is almost as old as human reflection on our thinking. The idea that we humans are often driven by motives of which we are not consciously aware of, did not begin with Saint Augustine of Hippo in

38. Vološinov, *Freudianism*, vii; editors' "Preface," by I. R. Titunik and Neal H. Bruss.

the fourth century; perhaps not even with the third-century ancient Greek Plotinus. Since some remote beginnings, most of our art, from drawing and painting to sculpting and writing, is witness to the conscious knowledge of unconscious activity in the brain. But Freud did not go back that far. He took up the discussion from the library. Looking for the unconscious, Rosemarie Sand recently investigated German and Austrian journals from the eighteenth and nineteenth centuries in detail and found that one author stood out: "Freud's German and Austrian contemporaries unanimously credited the fundamental formulation of the concept of unconscious mind to Gottfried Wilhelm Leibniz (1646–1716)—a mathematician physicist, and psychologist [. . .] Leibniz proposed that not only memories, but mental contents of all kinds—thoughts, emotions, and desires—could continue to exert power outside of consciousness."[39] Later on, Sand demonstrates, romantic philosophers like Heinz Hartmann and Jonathan Herbart and especially Arthur Schopenhauer reflected upon conceptions of the Unconscious; indeed, Schopenhauer's came very close to Freud's theory of the Ego and the Id: "Schopenhauer supposed that the perennial struggle was between the intellect and the will; for Freud, it was between the ego and the id. Distinctive of both theories was an absolute dichotomy: thinking was restricted to intellect and ego; will and id were purely instinctual. Moreover, both will and id were unconscious."[40] At least Leibniz, Hartmann, Herbart, and Schopenhauer marked the contours of the Dynamic Unconscious. At the time of Freud's writing, there was nothing new under the sun.

The same harsh fate has befallen that other key notion: "repression." The problem with "repression" is that research has made clear beyond any doubt that, for example, victims of German, Japanese, Yugoslav, Russian, or any other concentration camps; victims of gang violence in cities in the United States; victims of natural disasters, violence, abuse, and other mistreatment *cannot succeed in forgetting* and are suffering *consciously* and persistently from their memories, day and night—hence, again, in consciousness. Their traumas were conscious, and they could not be forgotten or repressed. Interestingly, the people who did forget show physical malfunctions in the hippocampus. Also, sexual wishes, as we all know, are all too consciously present in our daily thoughts. After decades of research into repression, we should accept that researchers have failed to demonstrate repression.[41] In David Funder's significant contribution on personality theory to the *Annual Review of Psychology* of 2001, out of twenty-five pages less than a third of one page is reserved to the

39. Sand, *Unconscious,* xi and 4.
40. Ibid., 111.
41. Erwin, *Final,* 220–22; also McNally, *Remembering.*

status of the psychoanalytic paradigm in clinical personality psychology—and personality theory had been Freud's *par excellence*. What is more, he assigns the trait, behaviorist–social–cognitive, biological, and evolutionary paradigms much more weight.[42] To all Freud historians and psychologists, one thing is perfectly clear: "repression" is beyond the bounds of the possible. Therefore, there cannot be a "return of the repressed" either.

The notion of "repression" was part of Freud's key metaphors, borrowed from the most advanced technology of his time: he chose to use either the steam engine or the electricity aggregator, concluding that psychological processes should be theorized in quantities and flows of energy. Any human being was guided by "energy," labeled Eros or "libido." The libido is "loaded" into the brain like any battery in a car. It does not stop to load, apparently, because Freud argued that it needs to be released or discharged. If this does not happen, it builds up enormous pressures inside the brain, which could cause the mind to burst unless they are channeled into appropriate pathways. Much of this energy was used by instincts that want to reach their aims. Freud labeled this the pleasure principle. In his theory, unsatisfied instinctual desires forced humans to act because they created feelings of displeasure while their satisfactions create feelings of pleasure. Then, the energy level should be manageable again. The releasing of "steam," or the unloading of "electric pressures," from the libido was seen as sexual but could be transformed into love for objects and persons (like mother, father, brother, or sister), passive or active (that is, female or male), or repressed.[43] Note that although the "energy argument" is the product of a nineteenth-century metaphor—articulated to a nineteenth-century level of technology—it remains central to psychoanalytic language as if we were still living in the steam era. The M/C Project's Unconscious is guided not by Eros's pleasure principle but by *colonialidad*. The release of energy so necessary to avoid "neuroses," Mignolo seems to suggest, should be directed toward community building. If, to carry forward the analogy, the pre-Hispanic cultures are the "repressed" of *colonialidad*, and the demand to rebuild the communities of the (formerly) colonized is a kind of "return of the repressed," modernity—Western civilization—must address this by participating in reversing the "process of repression." For him this means decolonization. Indeed, the major object of the work of the M/C Project is "decolonization"—activating for what they see as a state of *decolonialidad* or *decoloniality* by "releasing" or "healing" the "repressed" sense of community.

42. Funder, "Personality," 199.
43. Ouweneel, *Freudian*, 114–15.

That psychoanalysis has an epistemological problem is recognized by psy-
choanalysts themselves: "As today's psychoanalysts freely admit, in the end
what matters in analysis is not so much the 'historical truth' of the construc-
tion proposed by the analyst, but its 'narrative truth'; that is, the fact that
patients make use of it to rewrite their histories in a way that 'makes sense' for
them. In other words, it matters little that this construction is a fiction; it only
matters that the patients accept and understand this fiction as *their* history
and their truth."[44] Borch-Jacobsen and Shamdasani quote Jürgen Habermas's
Knowledge and Human Interest (1971), which states that the analyst "makes
interpretive suggestions for a story that the patient cannot tell. Yet they can
be verified in fact only if the patient adopts them and tells *his own story* with
their aid."[45] They also quote Roy Schafer: "The end product of this interweav-
ing of texts is a [. . .] *jointly authored* work or way of working [. . .]. People
going through psychoanalysis—analysands—tell the analyst about themselves
and others in the past and the present. In making interpretations, the analyst
retells these stories [. . .]. *This retelling is done along psychoanalytic lines.*"[46] In
short, building on Freudian theory and the bits and pieces of the analysand's
stories, the analyst provides the analysand or patient with a fresh new autobi-
ography designed along the ideas thought out by Freud or one of his followers.

For Borch-Jacobsen and Shamdasani this epistemological problem leads
to a few burning questions: "If the final criterion for the fiction proposed by
the therapist is that the patient accept (*veri-fy*) it, why insist on perpetrating
Freudian fictions in accordance with psychoanalytic theory as opposed to any
others? Why the inevitable interpretation of the patient's biography in terms
of desire, repression, resistance or transference—and not, let's say, in terms
of class struggle, astrological constellations, the evil eye, diet or psychophar-
macology? And in what way is the psychoanalytic account superior to others,
especially if its truth value comes not from *what* it recounts, but only from its
assimilation by the one *to whom* it is recounted?"[47] The answer is: "The truth is
that, despite appeals for collaboration with the patients (designated as 'analy-
sands,' to better emphasise their active participation), psychoanalytic theory

44. Borch-Jacobsen and Shamdasani, *Freud*, 180; italics in original. In an endnote they
add: "For a good exposition of this point of view, see Spence (1982)" (335); meant is Spence,
Narrative. Of all the books by Freud historians, Borch-Jacobsen's and Shamdasani's excellently
researched study figures among the best and should be read by anyone interested in psycho-
analysis. Another excellent title is Crews, *Freud*.

45. Habermas, *Knowledge*, 260; italics added by Borch-Jacobsen and Shamdasani.

46. Borch-Jacobsen and Shamdasani, *Freud*, 181; italics in original; this is from two quotes
from Roy Schafer, "Narration," 36.

47. Borch-Jacobsen and Shamdasani, *Freud*, 181; italics in original.

always provides the framework for the stories to be recounted on the couch, and later in the case history."[48] No matter if it has nothing to do with real life.

4

Why indeed continue to work in Freud's edifice? For literary scholar Blakey Vermeule the answer is clear. In her contribution to *The Oxford Handbook of Cognitive Literary Studies* (2015) she states: "The Dynamic unconscious or psychoanalytic unconscious has been so tightly woven into the history and ethos of our field that rejecting it out of hand seems both unduly hostile and perverse."[49] Several fields in the humanities build their argument on the Dynamic Unconscious. Critics work from the Freudian edifice—some include the additions built or restructured by the "French Freud" Jacques Lacan—because they still believe that psychoanalysis tells us something valid about the human mind.[50] They use hermeneutical and philosophically inspired methods and theories. Researchers cannot ignore those cultural producers who take psychoanalysis seriously. They need to consciously choose the Freudian lens through which these artists look at the world, and they have no alternative but to reference the relevant psychoanalytical authors. There is a huge library available with Freudian inspired history, literary criticism, art history, philosophy, sociology, geography, anthropology, and so forth.

But there is a problem if psychoanalytically motivated cultural producers and academics use Freud's heritage to inform the public about emotions and the functions of the mind. Today, many in the humanities recognize these intrinsic problems and look elsewhere for inspiration. One growing group is working with the cognitive alternative. As early as 1995, working in the field of film studies, philosopher Gregory Currie opposes "the old framework" in rejecting the assumption "that psychoanalysis, or some version of it, is correct, and that it is capable of illuminating our experience of film."[51] Currie believes that "psychoanalysis is false, not just in the sense of getting a few things wrong,

48. Ibid., 181–82.

49. Vermeule, "New," 465.

50. For example: from Mexico Armando Casas or Mario Alquicira, see España and Alquicira, eds., *Psicoanálisis*, España and Alquicira, *Tres grandes sueños*, and Casas, Constante, and Flores Farfán, eds., *Escenarios*; from Peru Gonzalo Portocarrero or Javier Protzel, see Portocarrero, *Racismo*, and Protzel, *Imaginarios*; from Colombia Marta Elena Correa or Simón Brainsky, see Brainsky, *Psicoanálisis*, and Correa, *Formas*; from Panamá Samuel Pinzón Bonilla, see Pinzón Bonilla, *Hombres*; from Argentina Gustavo Chiozza or Ricardo Piglia, see Chiozza, *Psicoanalista*, and Piglia, *Crítica*.

51. Currie, *Image*, xiv.

as relativity theory probably does, but in the sense of being wildly, deeply, and unrescuably false, as Aristotle's physics is."[52] Although this may be an example of what Vermeule coined as "aggressively antipsychoanalytic,"[53] she eventually is as noxious as Currie: "The decline of psychoanalysis is by now a familiar story."[54] Next she gives the indeed familiar history of Freud shielding away from evidence that cast doubt on his theories, vaccinating his system against disconfirming evidence, and favoring the increasing complexity of his system, "with its interlocking parts held together by hydraulic pressures, seems more like wishful model building than science."[55]

Many in the humanities praise Joseph LeDoux's insightful book *The Emotional Brain* (1996): "The term cognitive unconscious merely implies that a lot of what the mind does goes on outside of consciousness, whereas the Dynamic Unconscious is a darker, more malevolent place where emotionally charged memories are shipped to do mental dirty work."[56] LeDoux could also have argued that the Cognitive Unconscious is a theory based on empirical research done by many psychologists and philosophers over the past century (or more), and thus bottom-up and grounded in data, whereas the Dynamic Unconscious is a product of Freud's imagination blended with a reading—and copying—of nineteenth-century philosophers like Nietzsche, Hartmann, Herbart, and Schopenhauer. Today we know that what comes out of the Unconscious into Consciousness in the form of words is constructed in hindsight—after the thought, you may say—by a small part of the brain that functions "to keep our life together into a coherent story, a self-concept."[57] LeDoux concludes: "It does this by generating explanations of behavior on the basis of our self-image, memories of the past, expectations of the future, the present social situations, and the physical environment in which the behavior is produced."[58] This is uttered not only to others but also, and perhaps primarily, to oneself, and then encoded in the brain ready to be used on the next occasion. To study this mechanism—what comes out, goes in, comes out—is

52. Ibid.
53. Vermeule, "New," 463.
54. Ibid.
55. Ibid. No wonder that cognitive scholar Frederick Aldama concludes: "Tectonic shifts are fracturing old models of literary analysis and pushing forward approaches anew. Lacanian psychoanalysis, post-Marxist Marxism, Foucaultian new historicism, and Derridean deconstructionism are being radically revised—and/or discarded altogether. Seemingly dissatisfied with endless streams of esoteric speculation, many such scholars today seek *terra firma* in the verifiable and quantifiable" (Aldama, "Cognition," 117).
56. LeDoux, *Emotional,* 29.
57. Ibid., 33.
58. Ibid.

to study the Cognitive Unconscious. It has nothing to do with the ideas of Jacques Lacan, who translated Freud's vision of the mind as a biologically functioning steam engine into a philosophical-linguistic structure based on the rather basic notions of Saussure—signifier and signified—and the Russian-Czech linguist Roman Jakobson. For Lacan, the mind consisted of different compounds, "the Real," "the Imaginary," and "the Symbolic"—curiously based on publications that were already outdated at his time.[59]

In his *Action in Perception* (2004), the philosopher Alva Noë concludes that language, like perception and experience, "isn't something that happens in us. *It is something we do*; it is a temporally extended process of skillful probing."[60] For cognitive scientist Jerome Feldman, in his *From Molecule to Metaphor* (2006), the brain sciences convincingly have showed that the neural basis of language is no mystery. Language comes out of the human brain while it grows. The neural networks develop slowly after the image of the Self has formed. If we take a purely academic argument, this is precisely the opposite of Lacan's axiom about an unconscious structured like a language.[61] In his *Feeling of What Happens* (1999), the neurologist Antonio Damasio writes: "The idea that self and consciousness would emerge after language, and would be a direct construction of language, is not likely to be correct. Language does not come out of nothing. Language gives us names for things. If Self and Consciousness were born de novo from language, they would constitute the sole instance of words without an underlying concept."[62] Paul John Eakin, a literary scholar, adds in his *Living Autobiographically* (2008) that this also means that an assertion made by the famous critic and prepostmodern philosopher Roland Barthes that "in the field of the subject there is no referent" would be untenable.[63]

Contrary to the individualistic Dynamic Unconscious, the Cognitive Unconscious is social. Almost everything that seems forgotten can be retrieved. Psychology and ethnography have showed that recollection from memory improves when several persons participate. A single person usually retrieves less information from personal memory than two or more people do. Research has focused on the "social thought" shared between groups as the expression of cognitive schemas. The "social thought" implies a systematic and essential association between someone's personal and unique use of concepts and others' of that concept on a certain stage and at a specific moment.

59. "We can fault him for not doing his homework," Aldama writes; *Why*, 31–32.
60. Noë, *Action*, 216; italics added.
61. Eakin, *Living*, 67–68; Feldman, *From*, 325–26.
62. Damasio, *Feeling*, 108; which rebuts Lacan's "empty signifier," of course.
63. Eakin, *Living*, 67.

The association must be systematic, so that from the links between individual thoughts made at different times and places people can build up knowledge of the world surrounding them which is shared by the participants-in-communication. "Information may be available in memory but not accessible," writes the psychologist Richard McNally,[64] "because of the absence of potent reminders." And he adds: "Yet seemingly long-forgotten events may immediately come to mind when cues present at encoding are present once again."[65] This happens when people interact; and then even individual memory is adapted. Psychologist Monisha Pasupathi sees the personal past of the Self ("identity") as a co-construction, for example based on the joint influence of speakers and contexts on conversational reconstructions of past events. The "collectivity" involved in the maintenance or fabrication of shared notions about past events is enclosed as a mnemonic community.[66]

This approach includes the study of emotions. The appraisal theory of emotion, wrote literary scholar Lalita Pandit a decade ago, is "the most dominant among cognitive theories of emotion."[67] This is her very useful definition: "In brief, proponents of the appraisal theory of emotion believe that emotions are not caused by events themselves, but by appraisal of events in relation to goals and plans. [. . .] Further, emotions are essentially adaptive. Appraisals can be automatic or self-aware, or models of appraisal can be unique to the individual, influenced by others, or suggested by cultural norms."[68] The cognitive evaluation also includes fear. For example, when people who fear spiders perceive a spider, real or imagined, they appraise it unconsciously by triggering the schemas that make up their fear experiences and then realize their conscious experience of fear because they want to start running. Conscious explanation of what is going on—conscious introspections—might be an interpretation in hindsight. Because the experience triggers cognitive schemas, the model would look like this: *stimulus → appraisal → feeling → schema*.[69] This means, says LeDoux, that "a stimulus can begin to be appraised by the brain before the perceptual systems have fully processed the stimulus."[70] Richard Shweder's classical idea of emotion as an interpretive system, also built into Pandit's work, is still relevant to quote at length:

64. McNally, *Remembering*, 40.
65. Ibid.
66. Pasupathi, "Social"; Kansteiner, "Finding," 180.
67. Pandit, "Emotion," 94.
68. Ibid., 94–95. By the way, the "belief" that Pandit speaks of is founded on hard data and solid research, mainly by psychologists, as her references witness.
69. LeDoux, *Emotional*, 52; also for the example of the spider, which is here a bear.
70. Ibid., 69; also Hogan, *Affective*, 42.

My general claim is that 'emotion' terms are names for particular interpretative schemes (e.g. 'remorse,' 'guilt,' 'anger,' 'shame') of a particularly story-like, script-like, or narrative kind that any people in the world might (or might not) make use of to give meaning and shape to their somatic and affective 'feelings.' More specifically, 'feelings' (both somatic and affective) have shape and meaning of an 'emotion' when they are experienced as a perception of some self-relevant condition of the world and as a plan of action for the protection of dignity, honor, and self-esteem.[71]

For example, Pandit concludes, "anger is an interpretative schema which leads to blame; blaming has social and ethical consequences."[72]

Although the schemas are learned, Shweder points out that evolution should be included as well because, as we know, so much of the basics of emotions like happiness, sadness, anger, fear, and disgust are inborn. We should also realize that emotion elicitors are not perceived by the senses but are imagined or remembered. Patrick C. Hogan refers to this as "the perception theory of emotion."[73] Hogan notes the clear division between the appraisal theory of emotion associated with psychologists like Nico Frijda and Keith Oatley and the perception theory of emotion connected with neuroscientists like LeDoux and Antonio Damasio. He says that "it seems that theorists who focus on episodes and particularly on stories are likely to view emotion in terms of appraisal" but that "theorists who focus on events and particularly on incidents are likely to view emotion in terms of perception."[74] In his book *Affective Narratology* (2011), Hogan develops a possible synthesis that shows that stories reflect emotional structures that give meaning to life in our loves, our strivings, and our disappointments and that enable us to reflect on them. For Hogan, emotions are responses to changes in what is routine, or "normalcy." We will find three periods: *normalcy of baseline feelings → emotional interruption → return to normalcy.*[75] We find these periods in real life and in stories. That is why stories may help us understand the structure of our emotional lives. Indeed, it is also my belief both that "episodes and stories" and "events and incidents" work on the encoding of emotional experiences into cognitive schemas and that the conditions for the triggering of the emotions are inbuilt at the same time. The idea of interpretative schemas covers both, as a mental

71. Shweder, "You're," 32.
72. Pandit, "Emotion," 96.
73. Hogan, *Affective,* 42–43.
74. Ibid., 43.
75. Ibid., 30.

faculty to blend learning and innate features unconsciously and consciously (mostly in hindsight).

5

What if we take our approach a step further and begin looking at psychoanalysis as a cognitive schema? We may call it the Dynamic Unconscious Schema (or DUS).[76] Cognitive schemas can be small, consisting of only a minor series of lines with their slots, like the egg schema, or immense, consisting of many pencils of rays—lines with slots—that also are deeply interconnected. The psychoanalysts project the DUS upon their analysands, who are "successfully" analyzed when they modify their autobiographies according to the DUS. This is quite a job and requires the patients' enthusiastic cooperation and willingness. This is how the schema lingers on. Including all Freud's notions and ideas, it must be an immense schema. Rooted in the mid-nineteenth-century invention of psychotherapy, the DUS builds on a century of dissemination of the Freudian legend. Today it is transferred to contemporary cultural analysis.

The enormous dimensions of the DUS should not discourage us. As political scientist Katja Michalak summarizes: "Examples of schemata include rubrics, social roles, stereotypes, and worldviews."[77] Recently, literary scholar Barbara Simerka referred to one: Don Quijote's chivalric schema. Miguel de Cervantes's "Don Quijote [El ingenioso hidalgo don Quijote de la Mancha (two volumes, 1605 and 1615; The Ingenious Gentleman Don Quixote of La Mancha)]," she says, "both illustrates the utility of current cognitive theories of reading and also offers one of the earliest known examples of a narrative that self-consciously represents norms and aberrations in the reading process as an abject of scrutiny."[78] As we know, reading many old medieval chivalric novels, Don Quijote developed a specific look at the world, a cognitive schema. The reading experiences of Don Quijote resulted in what his environment—and most of the readers of the novel—understood as mental aberrations, because "where normal humans navigate the external world through cognitive schemata that are based upon prior lived experiences, Don Quixote's orientation

76. This approach would respond to the suggestion in Borch-Jacobsen and Shamdasani, *Freud*. Of all the books by Freud historians, this excellently researched study is the best and should be read by anyone interested in psychoanalysis.

77. Michalak, "Schema," 7:2362.

78. Simerka, *Knowing*, 197.

is instead shaped by imaginative experience."[79] He believes every word of the fictional books of chivalry he read to be true. Of course, because of the many types and sources of stimuli, the real world around him causes confusion. Therefore, for humans selective perception is an essential aspect of cognition. But in general, cognitive schemas are modified if new information and experiences makes them untenable. "In Don Quixote's case," Simerka notes, "those modifications are very slow to come. He holds on to his chivalric schema despite very concrete physical evidence that it is unreliable."[80] To maintain his vision, Don Quijote "ignores the clues that Sancho and others find most pertinent" and focuses "upon any detail, however minute, that corresponds to the chivalric schema. It is this aberrant perception that leads him to notice that Maritornes is a female figure who comes near him with stealthy step in darkness, and to disregard the scents and textures that reveal her to be a peasant and prostitute rather than the fair princess of his schema."[81]

Similar to Don Quixote's chivalric schema, the DUS lives on despite evidence to the contrary.[82] It leads, for example, Mignolo to conclude that some ancient "indigenous community formation" appears to have been "repressed from consciousness" into this variety of the DUS he calls *colonialidad*. Talking about community building—"that takes place in communities"—brings the community lifestyle back into consciousness—decolonial healing. Because Mignolo speaks about Latin America, he might have had the "indigenous" communities in mind, as if their "community cultures" are repressed from consciousness—here: by modernity, which arrived with colonialism—and thus "forgotten." Ideas of community building, Mignolo says, are "still within the imaginary of the modern world system, but *repressed* by the dominance of hermeneutics and epistemology as keywords controlling the conceptualization of knowledge."[83] This makes "modernity" in the contemporary world system *pathological*—as if suffering from neuroses. The activities of the M/C Project function like the "analyst" in a Freudian sense: it releases—or better, it liberates—the "repressed material" of community building into the present: "decolonial healing."

79. Ibid. In underpinning her vision Simerka refers to a seminal work by the "father" of cognitive psychology, Ulric Neisser; *Cognition*, 135.

80. Ibid., 198.

81. Ibid.

82. Among many others, see: Borch-Jacobsen and Shamdasani, *Freud*; Erwin, *Final*; Macmillan, *Freud*. See also the chapters of Borch-Jacobsen, Cottraux, Pleux, and Van Rillaer, eds., *Libro*.

83. Mignolo, *Local*, 23; italics added. As said, next to Quijano, Mignolo builds strongly on Dussel's Freudian fed "philosophy of liberation" for an inclusive, egalitarian, and democratic global community.

6

The question remains: is Miyagui's *Colonialidad* about "decolonial healing"? In all his work it is clear that Miyagui refers to a coloniality of power as deeply embedded in history; it cannot be "seen" but *is conscious knowledge*. Note that he is not a historian. A graduate of the Art Faculty of the Pontificia Universidad Católica del Perú (PUCP, Pontifical Catholic University of Peru, studied 1995–2000), today Miyagui is an activist who paints.[84] "I do not believe in a separation between art and life," he told his Dutch interviewer Raphael Hoetmer in 2006. "The struggle for a better world takes place at school, within the family, and in art."[85] In recent years, he made a series of paintings honoring several Peruvian social activists, especially those of Andean background. It is crucial to realize that Miyagui himself is of Okinawan descent. In a chain over a thousand kilometers, the Okinawa archipelago amounts to hundreds of islands called the Ryukyus; Okinawa Island is the largest. The archipelago was colonized by the Japanese beginning in the fifteenth century but only fully incorporated into the Empire of the Sun in the course of the nineteenth century, during the age of modern imperialism—a euphemism for colonial expansion of the European and North American powers in the nineteenth century.

This age of imperialism, now mentioned a few times in this book, was the age of worldwide colonialism that saw European powers like Britain, France, Holland, Denmark, and Prussia carving out or enlarging their colonial empires in Asia and Africa, and at the fringes of Europe itself. The era includes the Great Game in Persia (1813–1907), the Scramble for Africa (1881–1914), the Open Door in China (1885–1949), and Latin America's Export Boom merging with the Cold Wars in the region (1860–1990), and it witnessed not only the colonization of non-European peoples in Africa, the Middle East, and other Asian lands but also the impoverishment and coercion of the Latin American rural population in an ever-increasing dependency. This period was also crucial for the history of Peru. Contrary to Quijano's ideas and also to Mignolo's arguments, for the understanding of *colonialidad* in Latin America I think that the age of modern imperialism was more important than the Spanish era. The subalterns in the colonized lands were confronted with exploitation and

84. In September 2013, for Miyagui's work, I could consult the following three online resources: http://jorgemiyagui.wix.com/jorgemiyagui#!inicio/mainPage; http://www.jorgemiyagui.com; http://jorgemiyagui.blogspot.com; https://www.facebook.com/#!/jorge.miyagui.1/about (all accessed 9/13).

85. Raphael Hoetmer, "'Ik geloof niet in grenzen tussen kunst en leven.' Peruaanse schilder Jorge Miyagui," *La Chispa. Magazine over Latijns-Amerika en de Cariben* 331, 2007, 17–22.

extraction. As one of the new Latin American republics incorporated in this system, Peru also suffered from neocolonial and internal colonial relationships between its elites and foreign investors—supervised by the United States in a way. Even more than under Spanish rule, the elites and the subordinate classes, especially in the countryside, established a situation of European rulers versus non-European, Amerindian, subaltern, based on racist ideas imported from Europe. Hence, in the Americas, under the watchful eyes of the United States following the Monroe Doctrine (1823), the effects of colonization *intensified* long after the Spanish powers had been removed from the continent.

In Peru, historian Alberto Flores Galindo had observed that as a "Western cultural offensive against Andean culture,"[86] the internal colonization between the 1830s and the 1980s—or a decade later if we include Peru's Internal Armed Conflict—resembled a kind of colonization of the imaginary. During the late nineteenth century, in many Latin American countries liberal reforms were carried out, opening the way for large landowners and foreign investors to occupy lands formerly in possession of the *indígenas*. The typical twentieth-century image of an impoverished rural landscape burdened by landlordism had its roots in late nineteenth-century politics. In his important book on the cold war in Guatemala, *The Last Colonial Massacre* (2004; updated edition 2011), historian Greg Grandin concludes: "In many countries, republican [nineteenth-century] governments resurrected a range of colonial coercive mechanism, from debt peonage and vagrancy laws to government-organized labor drafts, in order to secure workers for agricultural commodity production. Forced labor, in one form or another, continued to prevail throughout much of the countryside well into the twentieth century. Intensified forms of racism, in some ways more poisonous than colonial blood strictures, both justified these practices and provided the foundations for exclusionary nationalisms."[87] Written in 1988, historian David Brading's short description of the liberals' nineteenth-century policies is still unrivaled:

> The Liberals discerned two great obstacles to the emergence of a secular, democratic society in Mexico: the wealth and influence of the Catholic Church and the enduring, isolated backwardness of the Indian peasantry. The Reforma thus sought to quit the Church of its property and to deprive the clergy of all public authority. So, too, Indian villages were stripped of their juridical personality [*pueblos de indios*] and their communal lands distributed on an individual basis. The result was to leave many communities

86. Flores Galindo, *Dos,* 16; Kokotovic, *Colonial,* 202n2.
87. Grandin, *Last,* 179.

virtually defenceless against the expansion of neighbouring *haciendas*. Even where Indians continued in possession of land, there occurred a process of concentration of ownership.[88]

In short, in comparison to Spanish rule,[89] the situation had severely deteriorated. It means that remembering "colonialism" today also for the Amerindian transnational mnemonic community became principally a remembering of this particular period—often in opposition to a semiautonomous and somewhat wealthy Spanish eighteenth century.[90]

Novelist Gabriel García Márquez seems to have known when the "real" colonial period of Latin America had been. Grandin recounts García Márquez's Nobel lecture about the novel *One Hundred Years of Solitude* (1967; English edition 1970) and its fictional town of Macondo. Every reader of the novel would agree that the "birth and destruction of [. . .] Macondo, along with the fortunes of the Buendía clan, are an allegory for economic imperialism."[91] The fictional town, we remember, was colonized by the North Americans who founded a banana company at its borders. As anywhere else, these nineteenth-century colonialists brought modernity signaled by railroads, electricity, Western fashions, and other consumer goods from the global market as well as ever-more-intense control by the colonial powers of the company and its supporters of the national state. Macondo, Grandin reads García Márquez, was "transformed into the plantation's appendage, its inhabitants having lost sovereignty over their lives, even over their memories."[92] Next he adds: "The amnesiac quality of Cold War terror—which was aimed not only at repressing political opposition but at obliterating political alternatives as well—is captured in the novel's climax. The beginning of the end of Macondo comes when the national military, in the service of the North American plantation, slaughters three thousand strikers in the town's plaza. The profane fury of modern imperialism is transformed into otherworldly wrath when an interminable whirlwind conjured up by Mr. Brown, the banana company's envoy, washes away not only Macondo but any memory of the massacre."[93] At that moment, Aureliano Babilonia, the last of the Buendías, realizes that he will vanish with the town and that the history of Macondo would be forever "exiled from the

88. Brading, "Manuel Gamio," 76.
89. Also: Ouweneel, *Shadows,* and *Flight.*
90. On this, see: Ouweneel, *Shadows.*
91. Grandin, *Last,* 170. See, for a similar analysis, Ouweneel, *Terug.*
92. Grandin, *Last,* 170.
93. Ibid.

memory of men."[94] Well, due to the power of novelized imagination it was not, of course. Interestingly, in both García Márquez's novel and this Nobel lecture, the Spanish era is irrelevant.

During the Aristocratic Republic, 1895–1919, Peruvian exports of sugar, wool, cotton, and coffee, as well as of various minerals (lead, zinc, copper), profited enormously from Western industrialization. Industrialists, exporters, and miners founded their own associations, and although they plowed much of their profits back into the country's manufacturing economy, they used the country's resources to enhance their own interests. The mining industry revived under foreign investments, especially by a U.S. syndicate. The exports of wool set a rapid expansion of the hacienda economy in motion. The entrepreneurs began manipulating the legislation of landholding and stripping the Andean towns of their lands. Also, many independent smallholders had to deal with the forces of internal colonization. For example, in the southern Peruvian department of Puno alone the number of haciendas increased between 1876 to 1915 from 705 to 3,219; and in Azángaro province from 110 in the 1820s to about 300 by 1920.[95] A class of entrepreneurs, also referred to as oligarchs or *gamonales,* had taken over the country and had changed its face into a neocolonial one. It is not difficult to look for the roots of racism that haunted the country during the Internal Armed Conflict in this internal or neocolonial society. This is Miyagui's *Colonialidad.*

7

The Amerindian mnemonic community that had experienced this past became a home for Miyagui when he realized that his parents' and grandparents' Okinawa experienced similar fates. Miyagui carries its historical memory in his mind. Compared with mainstream Japanese, the Okinawa prefecture has a distinguished language and culture of its own—or: Uchinanchu. It is also Japan's poorest prefecture. Beginning in 1906, with the arrival of the ship *Itsukushima Maru,* most Japanese contracted laborers who entered Peru came from this archipelago. In 1923, 20 percent were Okinawan; today Okinawans make up about 70 percent.[96] In their tiny volume *Okinawa: un siglo en el Perú* (2006; Okinawa: A Century in Peru), historians Doris Moromisato Miasato

94. Ibid.; reference to Gregory Rabassa's 1970 translation of the novel, 383.

95. Klarén, *Peru,* 207–9.

96. Titiev, "Japanese Colony"; S. Thompson, "Survival"; Morimoto, *Población*; Fukumoto, *Hacia,* 79–92; Takenaka, "Japanese," 80; and Moromisato Miasato and Shimabukuro Inami, *Okinawa.*

and Juan Shimabukuro Inami state: "For future investigations, it is impor-
tant to be aware of the fact that the Okinawan immigrants who arrived in
Peru did so during the Meiji era [1868–1912], or its posterior influence, which
means that they were not completely assimilated in the Japanese Empire and
kept their specific characteristics also on Peruvian soil, in fact until today."[97]
This specific context, articulated to the discrimination of the Okinawan first
in Japan and then in Peru, made it easier for them to identify with the Andean
migrants in Lima—and vice versa.

Reflecting upon this personal background, Miyagui saw a close articula-
tion indeed:

> First, the context of poverty of both populations. Second, the background
> of war. Third, discrimination. Like the Andean population in Peru, the peo-
> ple of Okinawa, as a people more colored than other Japanese, were dis-
> criminated in Japan already, which was reproduced after the migration to
> Peru. Investigating into it, other coincidences surfaced. For example, both
> populations place a kind of dragon on rooftops to protect the residents [in
> Okinawa, the *shisa*, a cross between a lion and a dog]; think of the little
> earthenware bulls in [the Peruvian Andean town of] Pucará, where, from
> afar, one may barely notice the difference between de dragons and the bulls.
> Also, Andeans and Okinawans regard deceased family members as potential
> guardian angels.[98]

For Miyagui, taking sides with the poor and the excluded by fighting discrimi-
nation from the painted canvas was just plain logic. Looking at the poor in
Peru, he lines up with a large worldwide "movement of movements"—I will
return to this at the end of this book—who believe that capitalists' contempo-
rary triumph is not the end of history. The task of canvassing the public, mak-
ing them think, still belongs to those who are players in the public arena—like
artists criticizing consumer society.

Miyagui's first solo exposition was in the Centro Cultural El Averno, a
noncommercial center for countercultural artistic expressions located in cen-
tral Lima. It was titled like a manga series: *Sr. Miyagui contraataca desde El
Averno* (Sir Miyagui Strikes Back from the Averno). He saw at the time a
possibility for what he called "consciousness-raising work." The exhibit was
marked *Arte = Vida / Vida = Política / Política = Ética* (Art = Life / Life =

97. Moromisato Miasato and Shimabukuro Inami, *Okinawa*, 7.

98. "Sailor Moon viaja en mototaxi," *El Comercio*, August 17, 2006, c5; see also Miyagui,
"Interculturalidad" (2007), published also at his blog http://jorgemiyagui.blogspot.nl/2007/07/
interculturalidad-arte-migracin-y.html (accessed 9/13).

Politics / Politics = Ethics)—perhaps as a cheeky homage to Joseph Beuys.[99] As an alternative to the official gallery circuit, the Averno gave the artist the opportunity to articulate directly with society, despite the fact that as a countercultural center, it may look like preaching to the converted. This is hard to avoid if you were looking, like Miyagui, at the art galleries as centers of personal lucre: "I believe that when you start asking yourself about the meaning of life: Why are you doing certain things, why are you an artist? Is it to sell paintings, to be famous? It was then that I realized that art for art sake did no move me, but on the contrary the utopia I like to put into it. The utopia to make the world a better place; more equal, righteous, increasing its solidarity. [. . .] I find it difficult to separate my art from my political position. I think, the artist produces feelings. That is what I do: writing texts, producing arguments and emotions for society to read or interpret, in their own way, because art is many-voiced. To be true, the idea is to awaken a critical awareness."[100] Miyagui sees art as an instrument of political education, not as a space for solipsistic contemplation of an individual. Deliberately, he decided to live by teaching graphic design to liberate his art from the market forces. The artist should leave the galleries and intervene in more popular spaces. The Averno exposition was only the first step; later on he exhibited in official galleries as well, where he considered himself an intruder or infiltrator, disseminating his message of social change.

One issue Miyagui perhaps took personally was the silence of the Japanese community about President Alberto Fujimori's authoritarian and corrupt regime. As is well known, Fujimori served as president between July 1990 and November 2000, after being elected by surprise, beating world-renowned writer Mario Vargas Llosa. In 1992 Fujimori carried out a presidential coup. With the support of the military, Congress was shut down and the constitution suspended. The newly established dictatorship arrested the leaders of Sendero Luminoso in December of that year, and passed a new constitution

99. Beuys, "I Am," 34: "I think art is the only political power, the only revolutionary power, the only evolutionary power, the only power to free humankind form all repression. I say not that art has already realized this, on the contrary, and because it has not, it has to be developed as a weapon, at first there are radical levels, then you can speak about special details. [. . .] I describe it 'radically': I say aesthetics = human being. That is a radical formula. I set the idea of aesthetics directly in the context of human existence, and then I have the whole problem in the hand, then I have not a special problem, I have a 'holography,' I don't know exactly what a holography is."

100. "Jorge Miyagui Oshiro: Arte como instrumento de concientización," Perú Shimpo, 2002. The article can be consulted at http://jorgemiyagui.wix.com/jorgemiyagui#!Peru-Shimpo -2002/zoom/c14rj/image1eqo (accessed 9/13). Also the interview with Katherine Córdova, "El arte transformador del Miyagui," Dosis—Cultura Alternativa, March 5, 2014, http://www.dosis .pe/noticia/entre-linea/el-arte-transformador-del-sr-miyagui/2265 (accessed 3/14).

in 1993, which made it possible for Fujimori to run for a second term in 1995. The regime became increasingly unpopular. Corruption crept in progressively and openly, and the president's authoritarian style was repudiated by increasing numbers of people. The announcement that he would run for yet another term in 2000 was met with popular protests, although Fujimori won the elections in a runoff with a bare majority. A little later, Montesinos was exposed on television bribing politicians. In the midst of severe political turmoil, Fujimori announced new elections and left the country—to live in exile in Japan.

Silence can be rooted in complicity. Invited to participate in the exhibition *Del kimono y otros usos* (On the Kimono and Other Customs) by the Asociación Peruano Japonesa (Peruvian Japanese Association) in May 2003 in the Ryoichi Jinnai art gallery, Miyagui presented his work *Kimono contra el olvido* (Kimono against Oblivion), an installation first made in 2003. Red, orange, or yellow kimonos are decorated with pictures of Fujimori and people of his regime. A text on the shoulder pieces reads: "Forbidden to Forget."[101] At the time, Miyagui had been an art student participating in the anti-Fujimori protests. The kimono should have been displayed in the Japanese Cultural Center but was kept from the exposition because the organizers judged it as too critical of Fujimori's presidency. His political ideas were not unknown; only a year before, in 2002, Miyagui had participated in the Concurso de Artes Plásticas Fundación Telefónica, an important contest for young artists, organized by Telefónica Perú, the country's largest telecommunications operator. Although a committee had chosen two of Miyagui's works from among the fourteen finalists, these were soon disqualified by Telefónica because they had been commercially displayed before, at another location. This other location was the *non-commercial* center Averno. Moreover, the painting in question, *Sin luchas no hay victorias* (Without Struggle No Victory), had been substantially altered before Miyagui submitted it. Most probable, this had been censorship, because the painting exposed a critical stance toward Telefónica's labor policies.[102] Miyagui was aware of the Kimono's explosive content: "I wanted to know if they had the guts to expose them."[103] He made several *Kimonos* as a result of his political formation during this period.

101. Jorge Miyagui, "Kimono para no olvidar," published at his blog, http://jorgemiyagui .blogspot.nl/2007/08/kimono-para-no-olvidar.html (accessed 9/13).

102. Interview with the painter in his studio, July 30, 2013. See also the daily newspaper *El Comercio* of Saturday June 29, 2002, C9, also at http://jorgemiyagui.wix.com/jorgemiyagui#!El -dominical-2012/zoom/c1kbe/imagepnd (accessed 9/13).

103. "Por decisión propia, me dedico a la docencia del diseño gráfico para mi sustento material y así no condicionar mi trabajo. Si viviese de mi trabajo tendría que hacer algo que deje una salida comercial, por lógica. En las galerías permanece el sentido del arte como un espacio intimista, contemplativo y difícilmente lo pueden concebir como un espacio de confrontación,

8

Looking at Latin America in the twenty-first century, there is little need to read European philosophers who wrote critical studies of early twentieth-century Europe. Why bother with the nineteenth-century discourse and philosophy of European modernity? Would that not be a mistake similar to working with Freud's energy theory based on nineteenth-century steam engines? Where the default definition of decolonization points at practical politics, the M/C Project expresses a utopian version explicitly fed by European philosophers. After carefully discussing the speculative and idealist formulations of language, knowledge, and the Self of Freud, Lacan, Derrida, and Foucault, Aldama concludes that "rather than continue to perpetuate idealist notions of a resistance everywhere (in the face of rampant exploitation and worldwide oppression of working peoples), or promulgate an anti-Western metaphysics in the gaps, or a perpetual chasing of signifiers, or a miracle to come, perhaps we would do well to leave such textualist-idealism behind."[104] Many scholars have already simply left the books written according to the DUS on the library shelves.

Perhaps we must remove Freud from Mignolo's thoughts: "Coloniality is like ~~Freud's~~ [the] Unconscious: you cannot see it, but it works." From this angle, Mignolo's approach could be saved from the Freudian quagmire. This would open up the possibility that a more accurate definition of *colonialidad* may be one of the guiding forces motivating the spirit of independence and opposition rooted in an Amerindian Cognitive Unconscious. Of course, Amerindian neighborhood inhabitants, peasants, and grassroots social movements and literature, paintings, sculptures, filmmaking, music, and many more works of art do witness the feeling of being guided by unconscious forces. In the coming chapters, a single cognitive schema is theorized on the basis of one or several visual cultural products. First, the spotlight is on some very old structures that are deeply embedded in the theater of the mind.

transformador de una realidad," dice Miyagui, quien sí ha expuesto en galerías y ha puesto algún precio a sus obras por la exigencia de esos locales. "Quería saber si lo exponían o no." See: "Provocador Miyagui," *La República Domingo* October 3, 2004, also online at http://www .larepublica.pe/03-10-2004/con-arte-y-parte (accessed 9/13).

104. Aldama, *Why,* 43.

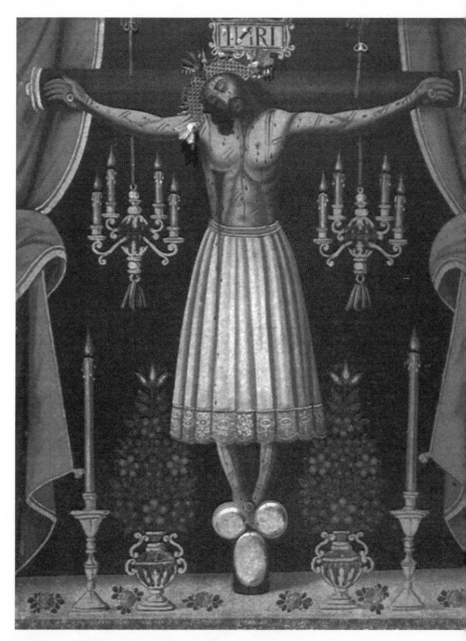

FIGURE 2.1. *El Señor de Burgos.* Postcard sold at Almoloya del Río in 1992.

CHAPTER 2

DOING

THE MEDIATION OF MEMORY

1

On January 6, 1992, in Almoloya del Río, south of Toluca in Central Mexico, I bought a postcard of the probably seventeenth-century painting of the Christ of Burgos, used during the town's typical dancing celebrations (see figure 2.1). Almoloya is a textile-producing town, which would now be considered *mestizo*. The fiesta I witnessed with my wife took a full day at the atrium of the church—which sits on top of a mountain. I must confess, I know nothing of the painter, or of the painting's origins in general. However, it is known that such paintings were commissioned by the leaders of the Nahua settlements during the colonial period for their fiestas. The paintings, and sometimes also statues, were placed on the plazas in front of the churches during the dances, or on a central location in the churches themselves. One of the Almoloya dancers told me that the painting was an image of the Face of the Earth, which could be a reference to their "own" local volcano or mountain. Reacting to my puzzled look, my informant pointed at Christ's arms as the Face's eyebrows, and at Christ's body as the Face's nose, at the two candleholders as the Face's eyes; and the scenery below at the painting as the Face's mouth and chin. In this vision, the curtains in the painting must represent the Face's hair draping around his skull. Had the local Amerindians made Christianity "their own" by painting, in this case, the Lord of Burgos in very ancient semiotics?

Somewhat at home in Maya studies, we may look at Almoloya's *El Señor de Burgos*—and the painting may still be in the town's church—through the lenses provided to us by David Freidel, Linda Schele, and Joy Parker in their widely read *Maya Cosmos: Three Thousand Years on the Shaman's Path* (1993) as well as through their analyses of the well-known reliefs from Palenque, a classic Maya site in southern Mexico. This is purely speculative, but not unrealistic. The Maya reliefs show what is called the World Tree and the Foliated Cross, both representations of Maya cosmology and articulated to the moments of Creation. They show, to be brief and perhaps somewhat one-dimensional, the Face of the Earth, functioning as the base of the upright world tree with a celestial bird on top. The "tree" looks like a Christian cross, of course, but would be connected to the Maize God, a kind of supreme deity articulated to the powers of creation.[1] Almoloya's Christ of Burgos effectively would be Christ *and* the Face of the Earth. The painting is a memory mediator of cultural schemas that has origins over thousands years earlier.

2

How old can historical memory be? How long do memories "swim" before they "duck under" and disappear? To look at a telling example, we travel from Almoloya del Río in Mexico to Cajamarquilla, a subdivision of the peripheral district of Lurigancho-Chosica in eastern Lima, Peru. Or, to be more precise, we look first at a scene of a boy overlooking this neighborhood in Lima. The scene is about halfway through the short film *Ángeles caídos* (2005; Fallen Angels) by the collective JADAT (Jovenes Adolescentes Decididos a Triunfar; Young Adolescents Decided to Succeed; see the still in figure 2.2). The film is directed by Joaquín Ventura and professional activist filmmaker Felipe Degregori. The script was a local group effort,[2] and some of the writers also played major parts.[3] The film depicts the life of a young man, Piter (Jorge Galarreta Mozombite), who decides to escape gangs, alcohol, and drugs after falling in love with Valery (Lizet Quispe). As a result, he joins the youth organization JADAT. In figure 2.2, we see Piter overlooking the Cajamarquilla community. It is a migrant neighborhood, a slum, as it was once customary to say, but orderly, set out along a rectangular gridiron pattern; an ordered arrangement of streets, intersecting at right angles, as if planned this way.

1. See the discussion in Freidel, Schele, and Parker, *Maya,* 75–107, 251–56, 371–72.
2. The script was written by Jhon Oblitas Arriola, Katy Salvador Vega, Lizet Quispe Ñaupas, Joaquín Ventura Unocc, and Jorge Ventura Unocc.
3. Jorge Ventura, Lizet Quispe, and Katy Salvador.

FIGURE 2.2. Piter. Still from *Angeles caídos,* short by JADAT, Peru, 2005.

The places where Piter finds redemption and where the dancers organized their festivities were both on or near the central plaza of the neighborhood and the town.[4] This is no coincidence. The central plaza is indeed a site of *deep memory,* where customs and narratives have been transferred from one generation to the next, century after century. And it does not matter if populations move from one place to another. What always strikes me, walking through much of these neighborhoods—spontaneously created building blocks of the mounting urban culture that can be found all over the Spanish Americas—is their very orderly architecture. In general, no state, no community official, no one forces the settlers to settle along the gridiron pattern shared by most neighborhoods continent-wide. The *deep* here refers to what was called *profundo* in Peru and Mexico, a cultural memory that goes back more than, say, four to five generations and that still actively triggers life today. It is a shared and contested cognitive schema, constantly reproduced and renegotiated.

The idea of "deep memory" is derived from the *profundo* as elaborated by Guillermo Bonfil Batalla in his *México profundo* (1987 [1996]). In this book, Bonfil argues that Mexico's supposed *mestizo* culture is profoundly Amerindian. In his eyes, *mestizo* culture is not a blending of the European and pre-

4. Many parts of this section can also be found in Ouweneel, "One."

Hispanic worlds, and certainly not a whitening society, but a truly old culture with *profundo* or *deep* roots in pre-Hispanic times and only superficially influenced by the Europeans (an influence he calls *imaginario,* "imaginary"):

> The *México profundo* is formed by a great diversity of peoples, communities, and social sectors that constitute the majority of the population of the country. What unifies them and distinguishes them from the rest of Mexican society is that they are bearers of ways of understanding and organizing human life that have their origins in Mesoamerican civilization and that have been forged here in Mexico through a long and complicated historical process. The contemporary expressions of that civilization are quite diverse: from those indigenous peoples who have been able to conserve an internally cohesive culture of their own, to a multitude of isolated traits distributed in different ways in urban populations. The civilization of Mesoamerica has been denied but it is essential to recognize its continuing presence.[5]

This was written in the mid-1980s and could be brought up to date with what we have learned since, but I like to adopt the idea of identifying "ways of understanding and organizing human life" (hence, cognitive schemas) in "a multitude of isolated traits distributed in different ways." This is the *profundo.*

Because the central plaza is a typical "isolated trait" of the *profundo,* the Amerindians who share this with their mnemonic communities—consciously or not—tend to build their dwellings and community houses around an open space to recreate "community" when they resettle somewhere in empty space. The word "around" is not quite correct, because the open space in Spanish American central plazas is square or rectangular. The scene of the boy overlooking his neighborhood in *Ángeles caídos* is related to sequences in the film that depict the close articulation between the inhabitants, their dwellings, and the streets that constitute Cajamarquilla. Perhaps more than the central plaza, the all-inclusive gridironed body constitutes the neighborhood's site of the *profundo.* People do things because they have learned how to build neighborhoods according to the gridiron pattern. Gridiron-designed Cajamarquilla and Almoloya del Río are recreations or replicas of the quintessential way of physically building the city in Latin America. It is the Latin American way of creating order.

Over the past century, or perhaps even longer, Americanists have believed that the gridiron pattern was introduced by Spanish, Portuguese, or British

5. Bonfil Batalla, *México,* 1; italics in original. The *profundo* had been discussed before as *Perú profundo* by the historian Jorge Basadrell; see, for a discussion: Mayer, "Peru," 468, 477–78, 496n17.

compact colonial city contemporary fragmented city

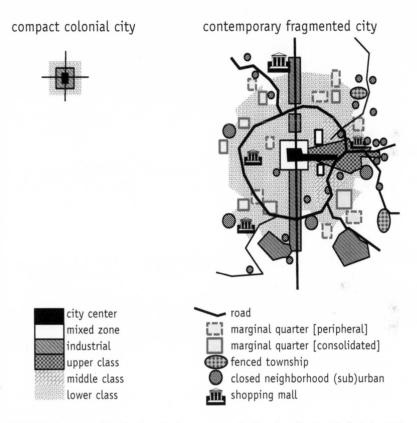

■ city center		∿	road
□ mixed zone		⌐¬	marginal quarter [peripheral]
▨ industrial		☐	marginal quarter [consolidated]
▦ upper class		⬭	fenced township
▧ middle class		●	closed neighborhood (sub)urban
░ lower class		🏛	shopping mall

FIGURE 2.3. Two models of urban development in Latin America after Borsdorf et al., 2002.

colonizers. Therefore, the "quintessential" neighborhood is seen as a Spanish-European renaissance invention. For example, in a paper published in the journal *Cities* half a decade ago, geographers Axel Borsdorf, Rodrigo Hidalgo, and Rafael Sánchez reproduced this image in text and graphically in four models (see figure 2.3 for an elaboration of the first and the fourth models).[6] The story goes from their first model, a "compact city model" from colonial times (1550–1820), to the fourth, the chaotic "fragmented town" or the "contemporary city structure" (ca. 2000). The first of the four models shows a perfect square with several smaller perfect squares inside—the smallest as its center—while the last model consists of chaotic imperfect circles, sliced through or overlapped by smaller circles, squares, and rectangles. The model-

6. Borsdorf, Hidalgo, and Sánchez, "New," 369, figure 1; based on Borsdorf, Bähr, and Janoschka, "Dynamik," 305, Abb 1.

ing by Borsdorf and his collaborators of the twentieth-century fragmented city is much richer. This comes as no surprise. Following an old European narrative—perhaps the *profundo* as well—their argument was to sketch a development from "order" to "fragmentation," to underscore the idea that something had gone wrong over the centuries, that the city had fallen ill. A healthy city is an orderly city, and also a good city. Many authors prefer to look at the city as a body fully intact and functioning well. Because no city today can satisfy this requirement, urbanists will speak of incapacitated cities, fragmented cities, or even "monsters devouring souls and Nature, as animals recovering from the blows meted out to them, or as organisms growing without limit or logic."[7]

Such metaphors are not merely for use in conversation. In *Metaphors We Live By*, George Lakoff and Mark Johnson (1980) tell us that metaphor is one of the most fundamental mechanisms of the human mind, allowing us to use what we know from our bodily existence to understand countless other subjects.[8] The world is categorized to our being moving around on Earth. Metaphors can be recognized behind general political attitudes and specific political practice.[9] Scholars, politicians, officials, journalists, and activists would set out to cure the sick body or even to exorcize the devil within.[10] For Borsdorf and other urban scholars, the metaphor they used provides for a mature body; cities in the past were in some "childhood." Contemporary cities are not treated as children—nor were they in the past, by the way. In the sense that Lakoff and Johnson work, this representation can be understood from a City-as-Body metaphor, or CaB: the unhealthy, sick, or even monstrous city of today was once safe, healthy and nice: innocent as a child. Because the CaB tells us that the city must have grown over time, older cities could be depicted as tiny but "whole" children—not mature but nevertheless well-structured. Borsdorf and his colleagues show us the growing period of the Latin American city. The city "matured" in the twentieth century, but something went wrong: "childhood" unity was lost, the city became fragmented. The ensuing policy was to heal the body—as a whole—and combat fragmentation. That the city was already rather fragmented in the eighteenth century—on a smaller

7. Walther and Matthey, "City," 2.

8. See also: Gibbs Jr., *Embodiment*.

9. Lakoff, *Women* and *Political*.

10. Julie Ha Tran, a literary scholar, asks the correct questions: "How does the city construct itself as an organic entity? Where is its mind, its heart? Who draws the contours of this body and decides on the abject wastes to cast out of it?" See the course website, "Urban Bodies: The City-Body Metaphor in American Literature and Culture," at http://english.ucdavis.edu/courses-schedules/p-ucd/2011/Winter/4/ (accessed 4/13). In 2000, critic Peter Ackroyd, *London*, described London in this way. Also note the Stanford University course website: http://www.stanford.edu/dept/german/berlin_class/index.html (accessed 1/13).

scale than today, but nevertheless—does not fit this model and would ruin the foundations of the CaB metaphor. Following the historical model absorbed in the metaphor, growing older the CaB became ill. Time for urbanists to step in, to heal the city.

Crucial here is the city's "childhood"—its historical roots. Borsdorf and his collaborators believe that, contrary to the contemporary fragmented version, the city had not been of any economic significance in the colonial period because the colonial city was in principle not involved in trade networks. We can read in "A Model of Latin American City Structure," by Ernst Griffin and Larry Ford, that during the colonial period "cities in Spanish America were thoroughly regulated by provisions in the Laws of the Indies that mandated everything from treatment of the Indians to the width of streets."[11] We find this in many other studies as well, for example in Daniel Goldstein's *The Spectacular City* (2004).[12] Again, as with the philosophies of the M/C Project, the colonial past is seen top-down, from what the Spaniards were supposed to have done. However, decades of historical research have demonstrated that a large gap existed between official regulations and historical practice. Historically, urban development has not taken place this way. It is true that sixteenth-century Spanish officials took the well-known ancient Roman gridiron urban planning system to the Americas to fulfill some classical European ideal. As a colonial historian, I feel confident in stating that the colonial city—for the most part—had much more in common with the right part of Borsdorf's model in figure 2.3 than with the left part. First, no city was completely static so as to be modeled as existing from 1550 to 1820. Second, neither is it true that the colonial city in whatever era was mainly administrative. Trade, especially domestic trade, was vital.[13] Of course, there were no modern highways, train stations, or airports, and the cities were much smaller. But this is a matter of scale, not principle. Most colonial cities were neither compact nor squared.[14] Eighteenth-century cities had industrial parts dispersed throughout, sometimes from near the city center to the outskirts. Members of the elite lived in the center, but sometimes also in blocks at some distance. For their entertainment, the population—elite or poor—in Mexico City, Lima, and

11. Griffin and Ford, "Model," 398.

12. Goldstein, *Spectacular*, 6–10.

13. Ouweneel, *Shadows* and *Ciclos*.

14. In two clarifying figures, Adriaan Van Oss demonstrated the tension between real settlement and the official gridiron layout. The figures show the distribution of the population of the colonial city of Tunja, Colombia, in 1623, mapped in a star-like form on an almost perfect gridded pattern. Regulation was acknowledged because everyone lived according to the pattern, but for the traveler entering the city the star-like distribution of the buildings must have been obvious. See: Van Oss, *Church*, 172–73, figures 1 and 2.

Cuzco, to name a few, went to parks outside the city center, not to its central plaza.[15] Moreover, several cities had specific "gated" quarters, set apart for the so-called *indios* (Amerindian), members of the *república de indios* or Amerindian Order (on the *indios* and the *repúblicas* see section 3).

On closer examination, we must conclude that the gridiron plan was not imported from Europe at all. Indeed, the gridiron plan in urban design is indigenous to Latin America. Long before the conquest, Amerindians built their cities according to the dictum "in the four corners, in the center," as it became known in our days.[16] Teotihuacan near modern-day Mexico City is the largest ancient grid-plan site in the Americas. The city's grid covered eight square miles. Thought to have been established as early as 100 BC, at its zenith in the first half of the first millennium the city was the largest in the Americas, counting more than 200,000 inhabitants. Teotihuacan had been a center of industry, home to many potters, jewelers, and craftsmen—its economy was based on the manufacture of obsidian tools and utensils. There were quarters for the rich and the poor, some even described as "marginal quarters" dispersed over the city.[17] In the first half of the sixth century, the center was ritually destroyed by the inhabitants themselves, after decades of deterioration. In the Andes, the grid planning can be recognized in most urban settlements, both in the highlands and on the coast—from early pre-Hispanic times to the Inca period—and continued in town settlements during the colonial era, including settlements founded not under Spanish surveillance. The rigid pattern includes cities, towns, villages, palaces, individual stone buildings, and raised field systems of agriculture. Ollantaytambo, some sixty kilometers northwest of Cuzco, is a well-known example because of its contemporary character as a major tourist attraction. Less visited but more intriguing is the Wari settlement of Pikillacta, twenty kilometers east of Cuzco, with its many walled rectangular compounds. The site is rigid in form, ignoring topographic features. Interestingly, the central plazas of the towns, or the central patio of large buildings, tend to be rectangular instead of square. One notable exception to all this, of course, is the world-famous Machu Picchu, although it does have a rectangular center.[18]

The urbanists' official narrative is wrong. Borsdorf's model, preceded and generally shared by many urbanists, gives us an incomplete picture. Now, *ojo*,

15. For example: Ramos Medina, ed., *Historia*.

16. Freidel et al., *Maya*; Medina, *Cuatro*.

17. Matos Moctezuma, *Teotihuacan*; Manzanilla and Pérez-Duarte, *Teotihuacan*; Arnauld, Manzanilla, and Smith, *Neighborhood*.

18. For the Andes, see: Hemming and Ranney, *Monuments*; Kolata, *Tiwanaku*; Morris and von Hagen, *Inka*; Moore, *Architecture*; von Hagen and Morris, *Cities*.

as the Mexicans say; careful: in 2002, Borsdorf and his group were basically interested in the contemporary fragmented city, not in its colonial roots. Their article consists of fifteen columns of text, and only one of these describes the situation in the colonial period. In all fairness, I have to acknowledge that the works by Borsdorf and his colleagues in Germany and Chile are ultimately rooted in works like Griffin and Ford—also discussing the colonial city in only one out of fifty paragraphs. With so little attention, is it important? Well, in Borsdorf's work the accompanying graph is, because this leaves the impression that we are dealing with an unhealthy or sick mature body that has violently lost its former, almost harmonious childhood. The graph by itself is encoding its image in modern cognitive schemas; and its popularity among urbanists underscores its success. Similarly, in the Spanish Americas the squared formation was an ideal, there inherited from the pre-Hispanic cities—Spanish regulation had confirmed something already in place. This is what we, the scholars, should encode in our cognitive schemas.

In addition to the gridiron pattern, two other typical features of an Amerindian mnemonic community can be discussed. As said, apart from the grid, the pattern is drawn "around" a center and four corners. This was ritually important all over the Ancient Americas. In pre-Hispanic times, creation stories involved the creation of the world by "raising the sky"—terminating a long period of darkness by introducing the Sun and the Moon—and the foundation of human settlement by the unfolding of "four partitions, four corners."[19] This means that there was no center without its corners and vice versa no corners without a center. This principle has guarded community bonding ever since. During my own research into colonial settlement patterns, the *pueblos de indios* or towns administered by the *república de indios*, I recognized similar planning principles.[20] There was always a square or rectangular center, and there were four wards or "areas," stretching out from the center into the four corners. Each ward participated in town government, mostly taking turns by the year, clockwise. Also the Inca Empire is known from its center and the four "corners" or *suyus*—"areas." This was in line with the idea of space as time, with the center representing the present and the future, and the areas farther away representing older periods. In Cajamarquilla, the popular builders had recreated this pattern spontaneously.

19. Freidel et al., *Maya*, 113.

20. Ouweneel, *Shadows* and *Flight*. See also García Martínez, *"Pueblos"* (1990) and *Pueblos* (1987); Hoekstra, *Two*; Haskett, *Indigenous*; S. Wood, *Transcending*; Jarquín Ortega, *Formación*; Velasco Godoy, *Historia* and *Ixtlahuaca*; Gareis, "República"; Zuloaga Rada, *Conquista*; Garrett, *Shadows*; Thomson, *We Alone*; Jones, *Guatemala*.

3

Because it is important to realize that under Spanish rule the Amerindian towns were firmly embedded to a legal system, this is the moment for a short detour. In a certain way, this book is about the enduring remembrance of the *república de indios*—the governing order installed by the Spanish authorities in sixteenth-century Latin America and encoded and re-encoded generation after generation in the minds of the Amerindians. The features of the *república de indios* form a shared memory of the *profundo*. Today, the formerly colonized peoples are usually called "indigenous," but in the Spanish era they were labeled and self-identified as *indios,* and usually proud of it. The Spanish officials created a Colonial Divide by decree and by law as a constitution of two Orders or *repúblicas*: one for the colonists and the matured old Christians— the *república de españoles* or Spanish Order—and one for the colonized as the new and recently converted Christians—the *república de indios* or Amerindian Order.[21] This was *not* a system based on bloodlines and races—as the M/C Project argues—but one based on legal systems combined with lineages; and the *repúblicas* formed the legal system that grouped them together. The Spaniards were a lineage, as were the *indios.* It meant that as a viable reformist project the Crown had granted the indigenous population officially and legally a *status aparte* by creating the legal status of *indio* as key constituent of the Amerindian *república.*

This was a colonial ordering, of course, and in most documents I went through the term *indio* was only used as a legal category, vis-à-vis the *república de españoles,* and rarely if ever as an identity. Neither the *indios* nor the Spaniards were as yet seen as "nations." Despite its geographical origins, the Spanish Crown had created the *indio* as a classification by law. All *non-indios* were categorized in the Spanish Order, which consisted of different social groups like Spaniards, Europeans, Africans, *mestizos,* and several more—whose identities were also influenced by the legal system. Although the viceroy ruled through many local courts called Audiencias, the *indios* formed the *república de indios* under his guardianship. The Amerindians were confined to legally recognized settlements as well, mainly landowning units called *pueblos de indios* or *villas de indios,* and they were governed by their own noblesse, *caci-*

21. More on the *repúblicas*: Ouweneel, *Shadows, Ciclos, Psychology,* and the note "Snapshots of the *República de Indios,*" appendix in Gosner and Ouweneel, eds., *Indigenous,* 259–62, online at http://www.cedla.uva.nl/50_publications/pdf/OnlineArchive/77IndigenousRevolts/pp-259-282-Appendix&Bibliography.pdf. Also: Garrett, *Shadows,* 25–34. See also Farriss, *Maya.* For a recent contribution with similar conclusions, see Rappaport, *Disappearing,* and, for example, Baber, "Categories."

ques or *principales* in the offices of *gobernador, alcaldes,* and others, forming their own *cabildo de indios.* The system was supervised by the *Juzgado de Indios* or the General Indian Court of the Audiencias,[22] and the viceroy and his local provincial official (*corregidor* or *alcalde mayor*). The Church worked with a similar structure.

The second typical feature of the Amerindian *profundo* relevant for the interpretation of Andean culture is the mechanism of *hanan* versus *hurin.* In the Andean mind, this oppositional pair juxtaposes Upper Worlds versus Lower Worlds, including superior versus inferior, latter versus former, majority versus minority, present versus past or future, light versus dark, sunrise versus sunset, outside versus inside, on top versus underlying, and all this mostly all at the same time. *Hanan* was also associated with the elder brother (firstborn), male qualities, the right hand, and anything that comes from above, including, for example, an eagle or a condor, the largest of all birds in the Andes. In short, a culture of upper hand and subaltern, *hanan* and *hurin,* more than a thousand years old, seems still rooted in the Peruvian mind. Furthermore, older periods are also regarded as "below," "under," *hurin.* The center is "current" and therefore "upper," "above," *hanan.* If the town is falling apart, the groups living in *hurin* need to join hands and take over the powers in *hanan.* This pattern blends time and space, story and settlement.[23] The central plaza including its inhabitants is *hanan,* the corners of the city and their inhabitants are *hurin.*

4

Hanan and *hurin* play a role in JADAT's films. *Ángeles caídos* is based on a true story. In the year 2000, tired of gang violence and saddened by the loss of friends, a group of adolescents of Cajamarquilla founded the youth organization JADAT. One of the initiators was former gang leader Joaquín Ventura Unocc, then in his early twenties. His main goal was bringing the adversaries together for positive action. The group did so through drama workshops, the filming of shorts, and the organization of a football competition. They began as a group of approximately twenty young adults and adolescents, children of Andean migrants, who had been encouraging the youth to participate in local activities to improve their community. JADAT originated from a pilot project to work with young people which was initiated by the Peruvian NGO CEPRO-

22. Borah, *Justice.*

23. Among many studies, for example: Arellano Hoffman, *"Hanan/urin."* See also Gose, *Invaders*; Gow, "Inkarrí."

DEP (Centro de Promoción y Desarrollo Poblacional) guided by psychologist
Juan Carlos Contreras Velásquez. Filmmaker Héctor Gálvez acted as assessor
of most films. Some professional actors had given workshops based on the
scripts, including Aldo Miyashiro, a leading television personality. Ventura
Unocc began as scriptwriter; later on he switched to directing. He became the
group's senior member. Soon, the fictionalization of their past through col-
lective storytelling had a real-life impact. Gang violence ceased to exist in the
community. Art had been an active agent in the communities' peacebuilding.
The major success, however, was not the demise of the gangs but the resurrec-
tion of neighborhood community life in Cajamarquilla.

Ventura Unocc told me that two factors had been crucial for JADAT's
success: working on the spot in the neighborhood itself, and including girls.
Gang violence had been generally a male activity, he said; an effective solu-
tion needed to include boys on stage acting but with the girls as transforming
agents. For sure, the context of the group's neighborhood activity had been
violence. Gang strife triggered their work. Ventura Unocc said to me that they
had had no previous theory about what to do against the gang violence in the
district, but unknowingly in their films JADAT has perhaps replicated a well-
known psychological intervention method, originally formulated by Gordon
Allport in 1954: the contact hypothesis.[24] It says that contact with members of
disliked groups, under appropriate conditions, would improve relations and
decrease prejudice against them as well. The "appropriate conditions" consist
of four features: equal status among the groups and members, the pursuit
of common goals, intergroup cooperation, and institutional support. Psy-
chologist Cordula Strocka describes a camping expedition with rival *manchas*
(groups, in fact: gangs) in Ayacucho, with similar results.[25]

In 2003–04, there were about thirty-five gangs in the city of Ayacucho—
locally called by its colonial name of Huamanga—with thousands of members
in all. Most of them were children of rural migrants and were living in the
marginal neighborhoods of the city. All gangs were attached to territories in
the neighborhoods. They fought each other with stones and knives. Among
the mostly male members, a strong sense of unity and adherence to a sym-
bolic cult of honor prevailed. They caused a lot of inconvenience for the city
through petty and violent crime. The camping expedition focused on the lead-
ers of these gangs. The organizers brought together leaders of four rivaling
groups. They were quite successful, because after the camping trip was over—
it had included the design of common rules, football games and several other

24. Strocka, "Piloting," 108.
25. Ibid.; also, *Unidos*, 269–323.

activities, and a collective fear of ghosts at night time—the gang leaders had indeed strongly bonded and had even developed a common group identity and several cross-group friendships. The participants were positive about the interaction between the groups and the reduction of intergroup anxiety. However, although some personal friendships lasted, the violence in the neighborhood could not be prevented. The reason for this failure, I think, is that the interaction had taken place in a different area of the city and between the leaders only, not in the neighborhoods themselves—not on the spot—and had excluded the majority of the thousand gang members, and most certainly also the girls.[26] Compared with this Huamanga experiment, JADAT did a much better job.

All four features of the "appropriate conditions" were present during JADAT's projects. Their first short film, *Días en la vida* (2001; Days in a Life; 19 minutes), is about the life and death of Che Loco, the leader of one of the most frightening gangs of Cajamarquilla. He had been a personal friend of Ventura Unocc, and his death had launched the idea of the neighborhood project. The script of the film was written by locals Kike Cangana, Karla Heredia, Edgar Lifoncio Sullca, Joaquín Ventura Unocc, and his brother Jorge Ventura Unocc, all of whom had roles in the film. The DVD says that the film narrates the circumstance of the death of Che Loco, here called Carnal (played by Edgar Rivera): "Despised by his father, Carnal participates increasingly in local gang life. He promised his girlfriend to change his behavior, but perhaps it is too late. . . . After his death, at the cemetery, the girlfriend thinks out loud: 'What a waste. Why does the world not change?'" In 2003 JADAT made *Historias marcadas* (Marked Stories; 34 minutes) with a similar group based in nearby La Florida. The script was written by locals Maricela Ambrosia, Alan Arancibia, Javier Farfán, Joaquín Quispe, and Percy Quispe. Maricela and Percy also took on leading roles, Joaquín Ventura played another leading part, and his brother Jorge directed along with Javier Farfán. This film is based on the life of a group of young people—their love stories, their problems, their illusions regarding the future, the friendships that keep them together, and the violence that surrounds them. Two years later JADAT made *Ángeles caídos* (2005; 30 minutes). They consider this to be their best short film. The fourth project, *De niña a mujer* (2006; From Girl to Woman), deals with adolescent pregnancy; and a fifth, *Un mundo sin colores* (2007; A World without Colors), pictures the impossibility of a romance between a poor boy from Lurigancho-Chosica and a rich girl from southern Lima. Several of the films are supported

26. On the crucial role of girls in ending gang violence, see Brenneman's book *Homies* on the *maras* of Central America.

by the United Nations Population Fund (UNFPA) and the German technical social cooperation service DED (Deutscher Entwicklungsdienst).[27] The participants—former adversaries turned friends—saw to it that gang violence disappeared from the neighborhood.

A number of narrative themes return in almost every JADAT film. First, of course, the stage is set in Cajamarquilla Paraíso. JADAT wants to portray life in the neighborhood. Boys and girls are filmed walking and chatting on the major street of the district—a kind of dusty promenade with shops and bus stops. Regularly, boys are hanging out on street corners at the edges of the community, somewhat removed from the promenade. They drink and, in some sequences, take drugs, usually inhaling adhesives. Girls generally walk in groups as well but rarely hang around out of boredom as the boys do. Their focus is on the basketball and football field that functions as the district's central plaza; sometimes they go to a party or an improvised disco. The adolescents sometimes meet in their houses. Although the boys and girls do have their own rooms, so it seems, they receive their friends in the living room, which is directly connected to the front door. The dwellings are poorly built, with adobe bricks that are whitewashed on the inside. Furniture is sparse, old, and usually in a bad state. Curiously, adornment is mostly limited to illustrated calendars. There are television devices and, occasionally, simple sound equipment. The roofs are poor; it almost never rains in this desert area. There are no showers; people use buckets to wash themselves. Water is brought in by huge trucks and sold to the people. It is obvious that the adolescents' parents, with the exception of one or two, have no resources to improve their dwellings.

A second theme is the generation gap. The films are not about poverty per se. All boys and girls have something to do. They go to school or little by little they earn a living. They own relatively little and even for drinking they need to borrow coins from someone who has earned a bit more. In sequences depicting the supposed bad boys of the district, the viewer is confronted with robbery and assaults for them to get money and clothing. These bad boys drink and sniff drugs out of despair over their relationships with their parents. Girls also continually complain about this. Although we learn about the lack of respect and recognition, arguments are rarely shown. Boys complain about their fathers, girls about their mothers. This is in line with recent findings in human development psychology,[28] which suggest that a boy's self-esteem is influenced by both his mother's and father's parenting behavior, whereas a

27. As informed at the JADAT website at http://jadat.spaces.live.com/ (accessed 10/09).
28. Bámaca et al., "Latino."

girl's self-esteem is mainly influenced by her mother's behavior. In addition, the findings provide partial support for the notion that parenting influences on psychological outcomes vary based on neighborhood context. It is striking that JADAT reserves little room for parents in their films. Sometimes a father is shown, usually drunk and violent toward his son. Mothers are filmed working in the house in the background or, interestingly, defending their sons against their fathers. The adolescents in the films conclude that they have to earn respect from each other by moving on in life—*superar* (overcome)—by their own initiative. Nothing can be expected from their parents.

The notion of respect is crucial for understanding adolescents' behavior, including gang life. In his pivotal book on the idea of the crucial social emotion that holds societies together, *The Presentation of Self in Everyday Life* (1959), sociologist Erving Goffman speaks of embarrassment as the master emotion of social life. Goffman preferred this word—says Thomas Scheff,[29] another sociologist—due to a taboo against the concept of shame in Western culture. Intricately linked to shame/embarrassment is respect. Psychologists would think in terms of high or low self-esteem. If we look at respect and pride, attunement with others would be their fundamental basis, and lack of attunement would result in shame and lack of respect or even disrespect. "One is rewarded by pride to the extent that one participates, level by level, in the cognitive structure of mutual awareness," says Scheff,[30] referring to the pride/shame continuum of social emotions, "and punished by shame." In his formulation, respect is "an emotional/relational correlate of the pride end of the pride/shame continuum." From her research on "young men of a violent life" in the poorer districts of Caracas, Venezuelan sociologist Verónica Zubillaga also concludes that the discourses of violent life focus on a "search for respect."[31] Strocka deduces from this research among gang members in the city of Ayacucho, Peru, that one of the major reasons why gangs fight each other is "that by presenting themselves as tough and aggressive and by taking over a territory, *mancheros* [group/gang members] acquire a certain degree of respect and status, which they feel unable to achieve by nonviolent means such as education or employment."[32] The Andean highlands, the region of origin of the parents of the Cajamarquilla Paraíso adolescents, stand out as a typical shared experiential world, where the future of the young resembles that of their parents.[33] In the city this may also be the case, but not so if the

29. Scheff, *Goffman*.
30. Ibid., 84.
31. Zubillaga, "Gaining."
32. Strocka, "Piloting," 129.
33. Bolin, *Rituals* and *Growing Up*.

migrants have arrived in the city with a rural culture in mind while needing to raise their children for the urban world. In such cases where deinstitution-alization of family life prevails, mutual generational respect, inevitably impor-tant in social attunement, might fail.[34] JADAT shows that in Cajamarquilla Paraíso it did.

The third theme of JADAT's films is change. They argue that the world was at a dead end in Cajamarquilla Paraíso, especially because of drinking, gang life, and the generation gap. Something had to happen. Gang life had to end and peace must return to the district. As the characters express, the problems originate from the lack of respect the boys earn from their fathers and from the continuous quarrels at home between daughters and mothers. The "edges" of the four corners—where the boys hang out in despair—must be drawn toward the center again: the central plaza, where football is played and the girls chatter. In fact, the girls play a decisive role in pulling the strings again. They try to persuade the boys to change, to move from *hurin* to *hanan*—and mostly with success. JADAT offers the boys an instrument for regaining respect and participation in organized football teams with their professional gear. The intensity to force change reminds me of the Andean concept of *pachacuti*, cataclysms or turning of the times. A *pachacuti* was a turnover from *hurin* into *hanan* in quite a short period and was experienced as an epi-sode of turmoil, usually consisting of prolonged periods without fixed dura-tions, extending over several decades. This typical Andean concept combines time and place. In the Andean *profundo*, time is cyclical, in which linear time has little meaning. Every cycle begins with creation after a reversal or inver-sion of time (*pachacuti*). The changing force is called *wiracocha* or *wiracochas*. The end occurs at the edges, at the fringes—in JADAT's films where the boys hang out, drinking and robbing—whereas the new beginning starts at the cen-ter, where JADAT holds office and organizes events, including football games and theater performances. The behavior of the adolescents in Cajamarquilla Paraíso shows that they experience their life today as part of a *pachacuti*.[35]

The change that the girls want has to do with the defeat of the edges by the center; change from *hurin* to *hanan*. At a *pachacuti*, a lower world is turned into an upper world, and inferior becomes superior, former latter, minority majority, past a present or future, dark turns into light, inside becomes out-side, and all this mostly at the same time. During the *pachacuti* the center is also dark; dark is *hanan* then. This means for Cajamarquilla Paraíso that vio-lence and gang life had taken the center for a while. During this period, the

34. Zubillaga, "Gaining," 87–94.
35. Randall, "Qoyllur Rit'i," 48–49; Urbano, "Mythic," 342; Allen, "Patterned."

girls were in danger of being harassed or even raped and were kept at home. In most JADAT films this is the case in the earlier sequences. However, their "former *hanan*" must become *hurin* through the *pachacuti* procedure, sitting in the antechamber to take over *hanan*—taking it back—whenever possible, in these gang-based times of deep trouble, disarray, and chaos. Through JADAT and the "conversion" of key boys to the juvenile course, the girls succeed in changing Cajamarquilla Paraíso. The films indicate that behavior here was deeply informed by the *profundo,* which the youngsters had adopted from the generation of their parents—who had taken it with them of course during their migration from the Andes to the coastal city. We may speculate that all members of JADAT and possibly the inhabitants of their neighborhoods had encoded a *hanan-hurin* schema, learned from previous generations; and the films demonstrate its workings, including the attitude of respect and the belief in a *pachacuti.*

5

At first sight, the *profundo* is about collective memory. Nonetheless, as a concept "collective memory" appears to be difficult to define. How is collective memory encoded in the neurons of individual memory? Jeffrey Olick argues that one way is to look at collective memory as the aggregation of socially framed individual memories.[36] A second way refers to collective phenomena sui generis. The difference lies in either stressing the workings of the brain and how they are socially influenced or even constituted, or focusing on the latter without referring to individual psychological processes. Olick suggests that we bridge the two by seeing the "collective" also as "individual." "There is no individual memory without social experience nor is there any collective memory without individuals participating in communal life. [There is] no personal memory outside of group experience."[37] In order to do justice to a "wide variety of mnemonic processes, practices, and outcomes, neurological, cognitive, personal, aggregate, and collective,"[38] Olick proposes to reframe collective memory studies into social memory studies. This would stress the fact that "all remembering is in some sense social, whether it occurs in dreams or in pageants, in reminiscences or in textbooks."[39] However, I feel that also in the previous "collective memory" proposal this was part of the deal, despite

36. Olick, "Collective."
37. Ibid., 346.
38. Ibid.
39. Ibid.

the fact that discussions tend to focus more on the "collective" than on the "individual," or vice versa.[40]

In this section I will adopt an approach that looks at interaction. I am not sure if that is a different approach, but instead of talking about widely defined "collectives" and their cultural tools—the "products" of collective memory-making—the discussion will be concentrated on the mediation of memory as an interaction between individuals and these cultural tools. It is the process of mediation that keeps the memories afloat. It is a *doing* in the sense of William James.[41] As a *doing* collective memory never *exists*; it is always and constantly in the making at specific spots (places) by specific people (interaction). Similarly, in the early twentieth century the Russian psychologist Lev Vygotsky argued that the development of higher mental processes like memory building depends on the presence of mediating agents in human interaction with the environment.[42] Cultural memory evolves through the elaboration of complex *artifacts of remembering,* associated with historically new forms of artifact-mediated experience. According to recent insights, artifacts are not just material objects but are simultaneously material and ideal or conceptual. The corpus of artifacts comprises physical traces of humans, such as any materials manufactured or modified by people, as well as narratives, life histories, communication structures; such objects, concepts, and stories have meaning for people in historical and contemporary communities. Generally, these artifacts remain from past communities. Manufactured cultural resources include tools, images, individual buildings, groups of buildings, concentrations of structures, and other forms of manipulated landscapes. Because the Cognitive Unconscious is built on memory-making, encoding, and using schemas, also the Cognitive Unconscious must be constantly in the making in reaction to the information received through the senses. It would of course follow that also an Amerindian Cognitive Unconscious is never static, as if it exists as a product. It must be something in continuous creation and recreation by the people who move *within* its parameters.

For humans—and other animals—the mediating artifacts are signs. Describing signs as human-made ideals *and* as material cultural resources designed to mediate goal-oriented behavior, the philosopher Marx W. Wartofsky and the cultural psychologist Michael Cole teach us to examine artifacts

40. See, for instance: A. Assmann, *Erinnerungsräume;* Erll, *Memory;* Kenny, "Place"; Rothberg, "Afterword"; Schama, *Landschap;* Schank, "Scripts"; Wertsch, *Voices.*

41. James, *Psychology,* 222–23.

42. Vygotskiï, *Mind,* 57.

at different levels.[43] For example, words, music scores, and tools are primary artifacts; as are dwellings, buildings, and plazas, cultural rituals, and material traces of the past, social networks, organizations, and family relationships. Some share at least certain material components, such as ink on paper and sound waves through the air, or are entirely material. Instruction books, sheet music, fictional stories, guides, life histories, treatises, and the like are secondary artifacts because they contain instructions about what to do with primary artifacts or how to read and experience them. Tertiary artifacts work at a more abstract and still more implicit level and include statues and works of plastic art, as well as visions of ideal worlds, rules, law, and political goals. Interpreting artifacts as signifiers connects people to the signified world—in general: the explicit and implicit institutions that formed them. By looking at explicit and implicit institutions as primary or secondary artifacts, research on the use of cultural resources will eventually concentrate on seemingly imaginary worlds or tertiary artifacts. These imagined entities have been "created in the course of aesthetic and theoretical knowing,"[44] which was needed to form 'embodied representations' to "color and change our perception of the 'actual' world." Hence, by looking at their primary or secondary form, the researchers of the mediation of memory eventually look at the artifacts in their tertiary form.

The mediation of artifacts as an active interaction on a specific place by several people present at that site shares many features of what the sociologist Randall Collins would theorize as an interaction ritual chain (IRC). As a social species, humans do things within the context of interaction—even if done seemingly completely alone—thereby invoking "a mechanism of mutually focused emotion and attention producing a momentarily shared reality, which thereby generates solidarity and symbols of group membership."[45] The interaction ritual is a *doing*—from the lone individual interacting with virtual others to larger groups on a specific place and a specific moment—and it produces, if done well, feelings of participation and community. The interaction must be discussed by four essential ingredients: co-presence, barriers, mutual attention, and shared mood; the latter is also called a collective consciousness.[46] We would see it as a new self-schema articulated to the interaction group. Intensive participation in social interaction creates a lot of emotional energy, says Collins, or EE, and perhaps a stronger bonding than much lower-

43. Wartofsky, *Models*, 200–209. Cole, *Cultural*, 118–21, 122. At the end of this paragraph, ideas from Wells, *Dialogic*, 69.

44. Wartofsky, *Models*, 208–9.

45. Collins, *Interaction*, 7.

46. Ibid., 47–64.

intensity social interaction. The most effective interaction ritual bolsters insti-
tutional stability through EE as its major product.

Humans are hardwired to experience emotions—without emotions we
cannot take even the simplest of decisions. Because the gathering of EE is
such a central motivating force, affect must be viewed as the engine of social
order—and where failed rituals in turn drain emotional energy, the "society"
may collapse. This means that where people interact, the emotions show off,
are attractive to other people, including bystanders, and inspire next interac-
tions. Collins explicitly presents the IRC as a chain of interactions holding on
to the cognitive schemas as long as they are useful to the group. This means
that every new social interaction between neighbors, for example, can mod-
ify, change, or replace the cognitive schemas in operations between them at
any moment and in any capacity. If the participants of such a real or virtual,
conscious or unconscious, interaction ritual "circle" mediate memory, thereby
creating the articulated EE, they are moving *within* that circle, profiting from
the mediation tools.

6

Although the mind is not an archive and our thinking is not designed to
keep the historical picture accurate, cultural memory is probably integrated
in almost every network of the brain. In other words: many members of the
audience keep it alive, afloat. The field of cultural memory studies came into
being at the beginning of the twentieth century with the works of Maurice
Halbwachs (*mémoire collective*), followed by a second wave, which took off
in the 1980s, inspired by Pierre Nora's *lieux de mémoire* and Jan and Aleida
Assmann's *kulturelles Gedächtnis* or cultural memento.[47] Slowly but surely,
the field expanded into the present third wave, and a handbook appeared
a decade ago edited by Astrid Erll and Ansgar Nünning, *Cultural Memory
Studies* (2008). In fact, we may witness a veritable boom in various countries
and disciplines, way beyond European countries like France and Germany,
or disciplines like history and sociology. Groups of scholars can now also be
found all over Europe, Canada, and the United States. In Latin America this
includes the violent past of the 1980s but also the preceding "internal colonial
heritage" of the region—of the period 1830–1990. Furthermore, although both

47. Halbwachs, *Cadres*; A. Assmann, *Erinnerungsräume*; or, Nora, *Lieux*, xxv, xxxv, xvii–
xlii (translation: *Realms* [1996–98], 3 vols.); the introduction was also published as "Between."
The French "*lieux*" is here translated as "realms," although among the scholars working in the
Cultural Memory Studies world "sites of memory" is more established.

world wars and periods of recent violence and wars appear obviously as the key to understanding this scholarly activity, scholars also began asking questions about the "past in the present" more in general. What is studied today are the practices in which culture is grounded in the creation, manipulation, and dissemination of memories, articulated to the role played by memory in collective and individual identity construction—indeed, as Egyptologist Jan Assmann said, the "outer dimension of human memory."[48]

Still, the overwhelming impression is that we are dealing with a European field. Discussing its origins in her introduction to *A Companion to Cultural Memory Studies* (2010; a reprint of the 2008 edition), Erll points at the contribution of authors like Halbwachs, Frederick Bartlett, Walter Benjamin, Henri Bergson, Emile Durkheim, Karl Mannheim, Aby Warburg, and Arnold Zweig. Most of these authors precede the Second World War but were strongly influenced by the horrors of the First. However, apparently isolated from the developments in Western Europe, the Russian linguist and philosopher Mikhail M. Bakhtin had similar thoughts. Working from the idea of a social language, Bakhtin phrased a theory on genre, first in *Problems of Dostoevsky's Poetics* (1984 [1929]) and later in *Speech Genres and Other Late Essays* (1986 [1979]). More than social memory, I think that Bakhtin's genre expresses well what unites JADAT's films, the gridiron pattern of Latin American towns and cities, the Face of the Earth in Almoloya's *El Señor de Burgos,* and the works discussed below as rooted in the *profundo.* Two of Bakhtin's writings deserve a place in our discussion: "Characteristics of Genre and Plot Composition in Dostoevsky's Works" and "The Problem of Speech Genres."[49] The latter was written in the early 1950s, when Bakhtin was teaching at the Mordovian State University in Saransk (now the capital city of the Russian Republic of Mordovia) after several years of forced exile.[50] Of course, Bakhtin writes about literature, texts, and discourse. For our purposes we have to translate this into painting, filmmaking, or, indeed, any other cultural activity. Sometimes this can make the word "genre" itself out of joint. It is here that we may find a different approach to the "collective" in memory studies, something more concrete.

When we speak or write, Bakhtin argues in both essays, our utterances of course reflect individual use of language to express individual thoughts. However, "each sphere in which language is used develops its own *relatively stable types* of these utterances," which "we may call *speech genres.*"[51] As expressions

48. J. Assmann, *Kulturelle,* 19.
49. Bakhtin, *Speech,* 60–102.
50. Bakhtin, *Problems,* 101–80.
51. Bakhtin, *Speech,* 60; italics in original.

of human thoughts, speech genres are boundlessly diverse, Bakhtin argues, but they develop into repertoires of speech genres "that differentiate and grow as the particular sphere develops and becomes more complex."[52] They range from short rejoinders of daily dialogue to the diverse discourses of political commentaries and the like. However, in order to understand each other we need to follow specific rules, and these rules are embedded in the genres and carry with them the history of those genres. They accumulate experiences: "A genre possesses its own organic logic which can to a certain extent be understood and creatively assimilated on the basis of a few generic models, even fragments. [. . .] Each new variety, each new work of a given genre always enriches it in some way, aids in perfecting the language of the genre."[53] However, "there is not a single new phenomenon (phonetic, lexical, or grammatical) that can enter the system of language without having traversed the long and complicated path of generic-stylistic testing and modification."[54] By accretion, say Gary S. Morson and Caryl Emerson in their book on Bakhtin, "genres carry with them the layered record of their changing use."[55] In short, (1) what we say or write is individually unique but also at the same time unconsciously located *within a speech genre,* and (2) that genre is being modified through time but at the same also keeps its key features while, in fact, domesticating new influences and practices into its core characteristics.

It is here that we touch on the crux of Bakhtin's theory. Being in use for over centuries, speech genres carry a memory of the past within them:

> Always preserved in a genre are undying elements of the *archaic.* True, these archaic elements are preserved in it only thanks to their constant *renewal,* which is to say, their contemporization. A genre is always the same and yet not the same, always old and new simultaneously. Genre is reborn and renewed at every new stage in the development of literature and in every individual work of a given genre. This constitutes the life of the genre. Therefore even the archaic elements preserved in a genre are not dead but eternally alive; that is, archaic elements are capable of renewing themselves. A genre lives in the present, but always *remembers* its past, its beginning. Genre is a representative of creative memory in the process of literary development.

52. Ibid.
53. Bakhtin, *Problems,* 157.
54. Bakhtin, *Speech,* 65; italics in original.
55. Morson and Emerson, *Bakhtin,* 292. I must admit that after finishing this chapter and therefore revising my literature on this topic and going through articles and books one last time, I found out that Jeffrey Olick, "From," came to the same conclusion I did and also refers to the same literature—which is understandable because these are the quotes to make here.

Precisely for this reason genre is capable of guaranteeing the *unity* and *uninterrupted continuity* of this development.[56]

I think that also genres of imagining a worldview, acting out bodily movements or gestures, whistling and humming tunes, making paintings, building houses, temples, and churches, preparing food, dressing to suit the occasion, filming stories, and many, many more, live in the present and at the same time *always remember their past,* their beginning and subsequent developments. Taken out of the restricted confinement of language, genres make us think, feel, move, act, smell, hear, and so forth, in specific ways, among specific people in specific places. We move within those genres, uniquely and individually but also as if plugged into a motivating model. In short, genres are cognitive schemas.

Independently from the Russian publications, the idea to look at genres in art as schemas was brought forward in 1959 by the well-known art historian Ernst Gombrich in *Art and Illusion.* At that time the work of Bakhtin was as yet unknown in the German-, French-, and English-speaking world. Gombrich had worked with Warburg. The latter had founded the private Kulturwissenschaftliche Bibliothek Warburg in Hamburg as a library for cultural studies. The Bibliothek was moved in 1933 to the University of London and refounded as the Warburg Institute. After fleeing Nazi Germany in 1939, Gombrich had taken a post as a research assistant at the Institute, followed by posts as a senior research fellow, a lecturer, and a reader. Finally, in 1959 Gombrich was appointed the Institute's director. In 1970 he published an "intellectual biography" of Warburg, with a strong focus on Warburg's *Mnemosyne,*[57] "a large collection of images recapitulating and expounding Warburg's vision of the forces that had determined the evolution of the Western mind."[58] Still in Germany, Warburg had begun composing the *Mnemosyne* or *Mnemosyne Atlas* in 1927, but he left it unfinished when he died in 1929. Warburg arranged the pictures according to fourteen themes to demonstrate the mediation of memory through art and literature.[59] He believed that images, pictures, and the plastic arts had a central role to play in this mediation. "Rather than turn-

56. Bakhtin, *Problems,* 106.

57. Full title: *Mnemosyne. Bilderreihe zur Untersuchung der Funktion vorgeprägter antiker Ausdruckswerte bei der Darstellung bewegten Lebens in der Kunst der europäischen Renaissance.*

58. Gombrich, *Aby Warburg,* 2.

59. The themes are: coordinates of memory; astrology and mythology; archaeological models; migrations of the ancient gods; vehicles of tradition; irruption of antiquity; dionysiac formulae of emotions; Nike and Fortuna; from the muses to Manet; Dürer: the gods go north; the age of Neptune; "art official" and the baroque; re-emergence of antiquity; the classical tradition today.

ing to narrative," literary scholar Christopher Johnson writes in his study of Warburg's atlas, "memory often figures the past with the immediacy of images, images that may be borrowed, say, from Homer or Praxiteles, from the television, the Web, or our own experiences."[60] Writing about memory studies, Erll argues in favor of acknowledging the role played by Warburg: "Whereas the sociologist Halbwachs and the psychologist Frederick Bartlett (who popularized the notion of cultural schemata) laid the foundations for cultural memory studies with a view to social and cognitive levels, Warburg's legacy to present-day research is to have given an example of how cultural memory can be approached via the level of material objects."[61]

Building upon this, Gombrich argued that painters and sculptors, before sketching, painting, or sculpting the world before their eyes, had triggered what he called *schemata*, which brought the artists into contact with the conventions of the genre they had chosen or were developing. The artist interprets what he sees in the world with his encoded knowledge about the landscape, the buildings, the animals, and the people, et cetera. The observation is compared with one of his cognitive schemas and then, perhaps, corrected during the artistic process according to the schema or vice versa; encoding the new knowledge about the world, the schema is adjusted. Artists are specialists in adjusting and correcting these cognitive schemas. Other artists then build on them in their attempts to influence them. In this way cognitive schemas develop a history. Gombrich recognized the value of these ideas and developed Warburg's hypothesis on the Pathosformeln further in his *Art and Illusion*. He demonstrated that artists are agents who create their works standing firm in certain cultures, going over previous knowledge on how to solve certain technical problems.

In producing works of art, artists work from their encoded cognitive schemas. They reproduce or replicate visual memory. In fact, they try to adapt through trial and error what they are making to what they have in mind. Gombrich famously labeled this "step-by-step process" the pair of "making and matching," in which the "making comes before matching."[62] Curiously, recent research confirmed that the reproduction or replication of cognitive schemas in memory not only has strong visual characteristics but also

60. C. Johnson, *Memory*, 4.

61. Erll, "Cultural," 9. This is supported by several contributions in the *Companion* volume, among others by Siegfried Schmidt's excellent essay "Memory and Remembrance," Jürgen Straub's "Psychology, Narrative, and Cultural Memory," and Hans Markowitsch's "Cultural Memory and the Neurosciences."

62. Gombrich, *Art*, 24, 62–63, 99; also 100. See also Bordwell, *Making*, 132; or, Changeux, "Art."

includes words as images: "When we look at a known word, our brain sees it like a picture, not a group of letters needing to be processed," said a press release from the Georgetown University Medical Center in 2015: "We are not recognizing words by quickly spelling them out or identifying parts of words, as some researchers have suggested. Instead, neurons in a small brain area remember how the whole word looks—using what could be called a visual dictionary," senior author Maximilian Riesenhuber says.[63] Eventually, because this small area of the brain is tuned to recognize complete words as pictures, our reading is working with a visual archive of both images and known words.

In Bakhtinian language, a schematic template would be a genre. Apparently, similar ideas had been developed in early twentieth-century Europe. In the late 1920s Warburg had invented the *mnemosyne* as a key concept in his work, mentioned after the Greek goddess of memory and remembrance. Johnson says that the goddess is known to make "the unfamiliar familiar, the strange less so. A paradoxical creature, even as she would annul temporal and spatial distances, she reminds us how 'long' time is."[64] And he adds: "Time grows both longer and shorter when images of great pathos are involved."[65] Warburg recognized that momentous events create vivid memories, as do personal experiences of great emotional value—positive and negative—as well as structural or enduring experiences shared by generation after generation in the large. The results in visual art, Warburg thought, were *Pathosformeln* or pathos formulae; his second key concept. He described these Pathosformeln as morphological symbols encoding emotional intensities. They were constantly re-encoded in different works of visual art throughout different times and nations as mediations of culturally important memory. As Gombrich says: "The *pathos formula* embodied in ancient sculpture and revived in the Baroque is really a deposit of an emotional experience which is derived from [earlier ones]."[66] Images loaded with pathos are stamped in the memories of the participants. The gestures depicted by the statues and the persons painted mediate movements and actions. Thus, Gombrich contends, the messages that artists want to pass on to their audience are embedded in their art by means of schemata. This is encoding; most of it would have been included without conscious strategies. Next, the audiences decode these messages and perhaps even largely unconsciously using their own schemata or adjusting their previously

63. Press Release, Georgetown University Medical Center, "After Learning New Words, Brain Sees Them as Pictures," March 24, 2015, http://gumc.georgetown.edu/news/After-Learning -New-Words-Brain-Sees-Them-as-Pictures (accessed 12/15). See Glezer et al., "Adding."

64. C. Johnson, *Memory,* 4.

65. Ibid.

66. Gombrich, *Aby Warburg,* 239; italics in original.

encoded ones. This way, because the work of art mediates memory, artists and audiences recreate elements of the past in the present.

Over a decade ago, psychologist James Wertsch, a specialist on the work of Vygotsky, published his theory of the schematic template. It is a return to narratives and discourses. In *Voices of Collective Remembering* (2002), Wertsch articulates collective remembering with "a generalized narrative tradition defined in terms of schematic narrative templates."[67] Schematic narrative templates belong to particular "narrative traditions that can be expected to differ from one cultural setting to another."[68] Furthermore, as I understand him, the schematic narrative templates work from the Cognitive Unconscious—*you cannot see it, but it works*—based on experiences and stories with specific settings, characters, and events. They are "cultural tools that mediate what can be termed deep collective memory,"[69] but they do not give specific information: "They are cookie-cutter plots that can be used to generate narratives that contain concrete settings, actors, and events."[70] Schematic narrative templates need to be distinguished from "specific narratives," Wertsch says, which are about concrete events, with concrete actions, characters, dates, and circumstances.[71] More than with specific narratives, Wertsch believes that "members of a collective tend to have a strong emotional attachment to it [because questioning one] is often tantamount to a personal attack on the members of the collective."[72] This is rarely the case with cognitive schemas or with Bakhtin's genres. To me, schematic narrative templates are cognitive schemas and specific narratives correspond to cognitive scripts. Therefore, I will use schematic narrative as synonymous with cognitive schemas.

In sum, from the point of view of schema theory, we may rephrase Bakhtin's critical paragraph quoted above. It would begin with the assertion that always preserved in a cognitive schema are undying elements of its history. True, these historical elements are preserved in it only thanks to their constant revitalization, which for Bakhtin was their *contemporization*. A cognitive schema is always the same and yet not the same, always old and new simultaneously. Cognitive schemas are reborn and renewed every time it is triggered in the brain. Therefore, even the oldest elements preserved in a cognitive schema are not dead but eternally alive; that is, historical elements are capable of renewing themselves. A cognitive schema lives in the present, but

67. Wertsch, *Voices,* 62, also: "Specific," 54–60, and "Narrative," 123–24.
68. Wertsch, *Voices,* 62; the adjective "schematic" derives from Bartlett's theory on schemas.
69. Wertsch, "Clash," 49.
70. Ibid.
71. Wertsch, *Voices,* 60–62, also: "Clash," 49, and "Specific," 51–54.
72. Wertsch, "Clash," 49.

always remembers its past, its beginning. Schemas are representative of creative memory in the process of literary development. Precisely for this reason schemas are capable of guaranteeing the unity and uninterrupted continuity of this development.[73]

7

To initiate its schematic motivation, art needs to be "active" in a way. People need to be confronted by art, have an encounter to be triggered to activate their cognitive schemas. Remember what Ann Rigney said: "Collective memory is constantly 'in the works' and, like a swimmer, has to keep moving even just to stay afloat."[74] The British anthropologist of art Alfred Gell thought that for a reason like this art has some kind of agency. In his *Art and Agency* (1998) he says, "I view art as a system of action, intended to change the world rather than encode symbolic propositions about it."[75] And he adds: "The 'action'-centred approach to art is inherently more anthropological than the alternative semiotic approach because it is preoccupied with the practical mediatory role of art objects in the social process, rather than with the interpretation of objects 'as if' they were texts."[76] Dutch art historian Caroline van Eck recuperates that works of art "thus considered are the equivalents of persons, more precisely, the equivalents of social agents."[77] According to archeologist Bill Sillar, agency "is the ability to both imagine and enact different actions while continually re-evaluating the efficacy of these actions within changing situations."[78] And he continues that it "requires self-awareness and volition, but it is socially embedded and constrained within wide-ranging economic and social structures."[79] This embeddedness is, as I would read it, the complex of cognitive schemas that guides our behavior in a specific environment on a specific moment. "One of the primary outcomes of our individual agency is to reproduce these structures, often as the unintended outcome of our actions."[80] In short, despite self-awareness and volition, humans act out cognitive sche-

73. Again: Bakhtin, *Problems,* 106, for the original; also above.
74. Rigney, "Dynamics," 345; also above.
75. Gell, *Art,* 6.
76. Ibid.
77. Van Eck, "Living," 644.
78. Sillar, "Social," 369.
79. Ibid.
80. Ibid.

mas preferred at the moments of their actions and in the specific places where they are on these moments.

Agency, of course, is a real or supposed active involvement in the world. We know that like stories, artifacts evoke memories, ideas, and meanings in our minds, thereby engaging our emotions, giving the artifacts a "social life," even when we know that they lack volition or intentionality.[81] We also know, especially if we are at home in Latin American anthropology and archeology, that people in the Andes "consider places and things to be sentient entities that have the power to act"—a very common human activity of course, throughout all centuries and all cultures.[82] Through their agency, works of art have "the power to influence their viewers, to make them act as if they are engaging not with dead matter, but with living persons."[83] For Gell, any study of art is about the "social relations in the vicinity of objects mediating social agency."[84] People would recognize this agency of the art work, not because works of art are some kind of sign—visual codes to be deciphered or symbolic communications—but because their message is semiotically mediated by indexes, "material objects which motivate responses, inferences or interpretations."[85]

From Warburg, Gombrich, Gell, and recently also from art historian Luisa Catoni in her *Schemata: Comunicazione non verbale nella Grecia antica* (2005),[86] we learn that art communicates with us through the recognition or interpretation of the cognitive schemas of behavior and thinking that the painter or sculptor had put into it.[87] By recognizing these cognitive schemas we encode them in our brains as well, ready for use in practice. Following Gombrich and perhaps Warburg, Catoni analyzes postures and gestures represented in images and statues. As explained, these works of art transmit them as information that the audience can pick up through perception and then activates their cognitive schemas, which in turn guides their attention, leading to the search for additional information or to decisions to direct action.

81. Ibid., 370.

82. Ibid.

83. Caroline van Eck, "Art, Agency, and Living Presence in Early Modern Italy. Humanities. Gell's Theory of Art as Agency and Living Presence Response." Online note published at http://www.hum.leiden.edu/research/artandagency/subprojects/deel-proj-eck.html (accessed 11/14).

84. Gell, *Art*, 7.

85. Van Eck, "Living," 645; Gell, *Art*, 66–72.

86. Catoni, *Schemata*, for example 71, 123; also her "From."

87. Despite this active role as agents, however, Van Eck disputes the position of art as equivalent to living beings. They lack the *experiential* character: the art work as agent is abstract. See: Van Eck, "Living," 645.

That last phase can be experienced consciously, especially if bodily action is involved and the "left-hemisphere interpreter" finds a discourse to explain for it. In case texts are involved, that "interpreter" will be activated almost from scratch. Some media communicate narratives this way. Although the experience of fiction films is much more than a simple "reading" of the images, as David Bordwell has explained to us so well,[88] the interpretation of narrative in still images like paintings is more problematic. From a narratological point of view, pictures, "left by themselves, lack the ability to articulate specific propositions and to explicate causal relations. [The pictures] rely on what cognitive psychologists regard as standard narrative schemata: the market script; the drinking party script; the music-making script."[89] Therefore, says media scholar Marie-Laure Ryan, the principal narrative option of still pictures is illustrative.[90]

At this point it is interesting to consult James Gibson's and Ulric Neisser's theories of visual perception by and of visual culture, phrased in the 1970s.[91] At the time, they were involved in rejecting a picture theory of natural perception that said that we perceive things the way they are and then translate them with the help of our cognitive schemas. This makes perception meaningful. Neisser: "They afford [hence: *affordances*] possibilities for action, carry implications about what has happened or what will happen, belong coherently to a larger context, possess an identity that transcends their simple physical properties."[92] These meanings are perceived with the artifact, person, animal, or plant. These days we suspect evolutionary motives behind this. We look at them with questions in mind: Is it dangerous what I see; do I need to fight or flee? Can I have sex with her or him to reproduce myself? Can I eat it? Can I use it for something? The last question, about affordances, is as important as the other three. It means that we do not see culturally free—our cognitive schemas indeed are lenses. In fact, our own embodied possibilities are also included. "Research has shown that perception of affordances for a given behavior reflects both the person's anthropometric properties and the means of performing that behavior. [. . .] In addition, [. . .] perception is lawfully constrained by structured stimulation patterns. This guarantees that perception of affordances for a given behavior reflects a person's action capabilities

88. For instance, Bordwell, *Making*.
89. Ryan, "Still," 139. This short text is an introduction to two contributions by other authors in the volume.
90. Ibid.
91. Gibson, *Ecological* and "Ecological"; Neisser, *Cognition*.
92. Neisser, *Cognition*, 71.

such that the behavior can be performed online and in real time."[93] The idea of affordances refers to an ecological approach to the cognitive cultural studies.[94] "The ecological model proposes an interactive model of the brain, individual psyche, and environment," says Barbara Simerka. "This approach is embodied but resolutely anti-deterministic."[95] It is about active perceivers, agents, who interact with stimuli from the environment—and sometimes from "within" as produced by the brain, as in dreams. The environment, Simerka notes, provides "affordances" as possibilities of actions. "This ecological model goes beyond the Cartesian model of the brain as the dominant cognitive force, and simple models of environmental determinism as the determining factor."[96]

Neisser concludes: "Perceiving is not a matter of assigning objects to categories."[97] It is not simply "signifier-signified"; not simply semiotics as the interpretation of signs, of the signified or the concepts behind a sign—that are culturally constructed every time a sign is read and would therefore change over time—and of the signifiers or the forms of the sign. Because the details of our schemas are in a sense unique to us, to our own experiences, our world-views, and our characters, perception "depends on a flux of stimulation that changes uniquely over time."[98] For example, the chair as perceived object is constituted by its affordances. The chair itself—the physical unit—and the symbols that represent chairs carry the "instructions" for future actions, because a chair is to sit on, to stand on (if we want to paint the ceiling, for instance), to sleep in, to burn a fire, to throw to someone, and so forth. Perception, and also hearing, feeling, and smelling, makes us *do* things. Paintings and fiction films are "loaded" or encoded with cognitive schemas from an explicit cultural ecology and ready to be decoded in the same or a different cultural ecology in order to motivate us to do things. If the same, people may use similar cognitive schemas as the encoder; if different, people would use their own cognitive schemas. It does not matter if we are talking about European, Asian, African, North American, or Latin American art; neither if it is about figurative or abstract art, paintings, statues, theater plays, novels, and so forth.

As the embodiment of these schemas, material artifacts will also be experienced as cultural players. Precisely because it both provokes and resists human actions, the material world is not conceived as passive. A statue or

93. Wagman, Taheny, and Higuchi, "Improvements," 277.
94. Simerka, *Knowing*, 228–30.
95. Ibid., 228.
96. Ibid., 229.
97. Neisser, *Cognition*, 74.
98. Ibid., 74–75.

a character in a painting or on a photograph is recognized by the observers as another "person." And because "all thinking is for doing," as psychologist Susan Fiske echoed James,[99] and because cognitive schemas are to guide behavior, the observers stipulate that these characters are *doing* something. They participate in their actions. This position puts the "characters" of the plastic arts on equal terms with characters in other forms of fiction, like stories, novels, theater plays, television films, and cinema feature films. As a figure of speech wherein private or human characteristics are credited to an item or abstraction, or when an individual is viewed as symbolizing or embodying some quality, thing, or concept, personification and *prosopopoeia* are quite well-known instruments of speech and thought of course. In Roman Catholicism, precisely in Gell's sense of agency, every statue of a saint is thought to be capable of helping the believer. In contemporary Mexico, the followers of the heretical cult of Santa Muerte or Holy Death believe that the statues they made or bought of wood, stone, or plastic hold the spiritual essence of the saint after being "empowered" by the followers' rituals.[100] The followers know very well that the statues themselves are only "empty" artifacts. They believe, however, that the artifacts are mediating between them and the supernatural powers and vice versa, because spirits "housed" in statues, paintings, or natural elements like rocks may use the artifacts to intervene in the life of the living. If benevolent or malevolent spirits or powers can do this, why not regard all images as potentially empowered like this?

Some forty years ago, Gibson defined two aspects of what he thought at the time a picture was. First, it was an "array of persisting invariants of structure that are nameless and formless."[101] By "invariants" he meant "that when the young child sees the family cat at play, the front view, side view, top view, and so on are not seen, and what gets perceived is the *invariant* cat."[102] In a picture only one aspect of a form is shown. "The point of observation is fixed, not moving."[103] Today, we think somewhat differently. As far as we know now, the spectators moved by their schemas fill in what is not seen. The narrative psychologist Richard Gerrig writes that although we cannot see her lower torso, "we are quite willing to infer that Mona Lisa has legs."[104] Even when

99. Fiske, "Thinking."

100. T. M. Kail, "Crime Scenes and Folk Saints: The Cult of Santa Muerte," *Countercult Apologetics Journal* 1.1 (2009), http://www.rctr.org/journal; and http://www.apologeticsindex .org/1834-tony-kail-worldview-consulting (accessed 8/14).

101. Gibson, "Ecological," 228; was in italics in original. See also the description of perception in Aldama and Hogan, *Conversations,* 116–18.

102. Gibson, "Ecological," 228; italics also in original.

103. Ibid.

104. Gerrig, *Experiencing,* 29.

we interact with what seems to be a complete still picture or film, we show a systematic bias toward expanding its boundaries and toward imagining a continuation outside the frame or the diegesis, filling in around the edges. The second aspect of a picture, Gibson adds, is that at least the invariants "that have been extracted by an observer" can "be stored, saved, put away and retrieved, or exchanged."[105] Because: "A picture is also a *record*."[106] "Any picture, then, preserves what its maker has noticed and considers worth noticing."[107] This allows the artist to communicate with future observers.

The illustrative role of pictures as narrative instrument "is admittedly a rather weak and subordinated mode," Ryan explains.[108] But "this does not mean that it should be dismissed as entirely parasitic [. . .]; they return visualizations, emotional coloring, or facial expressions that may provide a clue to the motivations of characters."[109] With ballet and music, still pictures share the power to evoke, to recall from memory, what is more or less already known by the audience. That is the reason to study art from a cognitive perspective. Discussing the *Mnemosyne Atlas,* historian Carlo Ginzburg notes that to Warburg a pure esthetic judgment of the art was of no relevance.[110] Historian Perry Anderson notes that also in Ginzburg's historical work, literature "is taken not as a standard of styles, nor a repertoire of genres, but as a tool of knowledge."[111] To work with art, like literature, like this, says Anderson, can bring us for scrutiny "cognitive instruments: techniques of estrangement as social critique in Tolstoy, free direct style as passage to a new interiority in Stendhal, ellipsis as at once suspender and accelerator of time in Flaubert, unmediated visualisation as access to fresh insight in Proust. But, of course, these are instruments to be found within what remain fictions."[112] The visualization strengthens the existing schemas or, at best, modifies them according to the new visual-emotional experience.

105. Gibson, "Ecological," 229.

106. Ibid.; italics also in original.

107. Ibid.; was in italics in original.

108. Ryan, "Still," 139.

109. Ibid.

110. Ginzburg, *Clues*, 17–59; see also 27–28.

111. Perry Anderson reviews Carlo Ginzburg on the use of literature as historical source: "The Force of the Anomaly," *London Review of Books* 34.8 (2012), at http://www.lrb.co.uk/v34/no8/perry-anderson/the-force-of-the-anomaly (accessed 12/16).

112. Ibid.

8

At the end of this chapter it would be interesting to listen to the words of Diego Chávez Petzey, a sculptor from the Tz'utujil Maya town of Santiago Atitlán in Guatemala. He was involved in the reconstruction of the sixteenth-century altarpiece of the town's Roman Catholic church that took place around 1980. The altarpiece had collapsed during a series of severe earthquakes. Diego Chávez executed the assignment with his younger brother Nicolás Chávez Sojuel. Rather than following the original arrangement of the altarpiece, they replaced the damaged panels with new ones, based on their beliefs and rituals. They had discussed this with the local elders and Maya who still lived the "old ways."[113] According to anthropologist Allen Christenson in his *Art and Society in a Highland Maya Community* (2001), Chávez "hoped to make a permanent record of the beliefs and history of his people so that they would not be lost to future generations."[114] And "his original intent was not a simple repair of the sculpted monument but an assertion of the living presence of ancestral faith in the life of his community."[115] Christenson learned that by adding certain motifs and modifying pre-existing ones, Chávez Petzey transformed the altarpiece from a Euro-Christian representation of heaven with the saints emerging from the clouds, to one that envisioned the altarpiece as sacred mountains. "The result is an amalgam in which Christian forms and images are shaped in such a way that they reveal uniquely Maya meaning, while Maya motifs and rituals are harmonized with Roman Catholic orthodoxy."[116]

This is where we recognize the workings of the locally encoded Maya cognitive schemas leading directly to a *doing*. Diego Chávez said to Christenson: "I wanted to show the continued power of the past. You cannot destroy the past, only add new things to it. I took what is good of Christianity and the Maya religion. My ancestors in ancient times knew the truth of all things, but much has been lost since their day. But still my people, the Maya, remember the old customs and ceremonies and the great things that our ancestors have left to us. I tried to create something that would show what I could of the beliefs of my people and show that they are just as alive as those of the Christians."[117] To discuss the altarpiece, Christenson worked with the social agency of the art work, using visual cues to initiate conversations—drawings, photographs, videotapes, and direct observations of the art work—because he

113. Christenson, *Art*, xiii, 6.
114. Ibid., 6.
115. Ibid.
116. Ibid.
117. Ibid.

found it "nearly impossible to elicit useful responses from verbal questioning [because they] are unaccustomed to rhetorical methods of expressing cultural information."[118] It was clear that the work had been a *samaj* or "burden" (or *cargo,* in Spanish) for the sculptor; something they had to do for the community. They refused to be paid because they did not want to offend the ancestors who had made the sacred object. The altarpiece was a living entity endowed with a *k'u'x* or heart. The sculptors believe that the living power of this sacred object and of the ancestors who were overviewing their work had also sometimes guided their hands.[119] This is an eloquent way of referring to learned skills that had been encoded as proper schemas deep in their brains.

118. Ibid., 13; see also 14–16.
119. Ibid., 4, 58.

FIGURE 3.1. Santiago Román. Still from *Días de Santiago,* feature by Josué Méndez, Peru, 2004.

DESIRE

THE THEATER OF THE MIND

1

The mediation of memory using artifacts that motivate a *doing* works unconsciously, no doubt about it. But as an agent, how does art mediate memory? And how can we, in our case, articulate this to the Cognitive Unconscious of the Amerindian mnemonic community? A good illustration of this experience is *Días de Santiago* (2004; Days of Santiago), the first feature film of Peruvian filmmaker Josué Méndez. The film is about Santiago Román, a 23-year-old Peruvian male (played by Pietro Sibille). He is "formed" by military education—many of his cognitive schemas are set in the barracks—and a few years of military practice in the Andes fighting Sendero Luminoso (or the PCP-SL) during the Internal Armed Conflict (1980–1992 [–2000]) and the Cenepa War in Peru's Eastern jungle fighting drug traffickers and invading soldiers from neighboring Ecuador (February 1995). Back in Lima, he wants to fit in and be at peace with himself; in short, he wants order in his life. This means that he needs to change his cognitive schemas or, better, trust that the military schemas are of no use in the city so that he can live with new or recoded schemas of urban life.

One particularly interesting scene reveals Santiago Román's desire: to get rid of the chaos of city life, he wants to impose his orderly military schema on his daily life at home. The shot is in black and white; we see Santiago Román

taking something from a small kitchen cabinet and starting to talk to his wife, Mari (Alheli Castillo): "Me? You ask me how I'd like it to be?" He turns to the table, where his partner seems to sit: "You really want me to tell you? Listen, Mari, this is this . . . the table is the table. . . . It is not anything else; the floor is the floor; here we eat, there we walk. Everything has a reason for being; without order, nothing exists. I was thinking now . . . and wrote down a plan here." He takes a piece of paper out of his trousers and starts reading it to his wife (see figure 3.1): "Starting tomorrow . . . we will sleep until seven. We will make breakfast in half an hour. We will have it between seven-thirty and eight. Then I go to class, you go to the market, buy all you need for lunch, and we have lunch at 14 hours when I get back. For breakfast we can have whatever you want. Always with some soy or cereal. For lunch on Mondays: *ceviche*; Tuesdays: chicken; Wednesdays: beans; Thursdays: noodles; Fridays: *quinua*; Saturdays: you do whatever you want. Do not think I am trying to impose things on you. Sundays we eat out. Then I take the car. You do whatever you have to do." Then, the camera moves away from him, showing that Santiago Román had been talking to an empty chair. "This is this, the kitchen, the table . . . everything has an order, a reason . . . without order, nothing . . . I am the man, you are the woman." He looks at his note again and continues rehearsing more privately: "I prepared something here. I was just waiting for you to ask. Seven . . . wake up . . . seven-thirty . . . breakfast . . . to class . . . market . . . lunch . . ." The door opens and Mari enters, returning from her work. Santiago Román puts his note away in his trousers again. "You want bread?" she asks him. The conversation goes in a different direction. He cannot pluck up the courage to explain his desire.

2

If we want to understand how cognitive schemas work, like the one scripted by Josué Méndez for Santiago Román, we need a theory of the Cognitive Unconscious. One pillar of that theory is already known: memory is cultural and social, not simply individual. The other pillar needs to answer how it works, because although we like to think that we make our decisions consciously and willfully, talking about the unconscious "continues to exert an influence over how many people think of 'the unconscious,' especially outside of psychological science," psychologists John Bargh and Ezequiel Morsella say.[1] Cognitive neuroscientist Michael Gazzaniga adds that we "all feel we are wonderfully

1. Bargh and Morsella, "Unconscious," 73.

unified, coherent mental machines and that our brain structure must some-
how reflect this overpowering sense we all possess." But: "It doesn't."[2] The phi-
losopher Daniel Dennett wrote in *Consciousness Explained* (1991) that "the
trouble with brains, it seems, is that when you look in them, you discover that
there's nobody home."[3] And he explains: "No part of the brain is the thinker
that does the thinking or the feeler that does the feeling, and the whole brain
appears to be no better a candidate for that special role."[4] There is no central
command center, no homunculus or group of personified emotions, but mil-
lions of highly specialized decision-making local processors. In fact, Gazza-
niga concludes, the absent boss also counts for us: "You are certainly not the
boss of the brain. Have you ever succeeded in telling your brain to shut up
already and go to sleep?"[5]

Introducing the collection of essays *The New Unconscious* (2005), the psy-
chologist James Uleman states that over "the past decade or two, a new picture
of unconscious processes has emerged from a variety of disciplines that are
broadly part of cognitive science. Unconscious processes seem to be capa-
ble of doing many things that were, not so long ago, thought of as requiring
mental resources and conscious processes. These range from complex infor-
mation processing through behavior to goal pursuit and self-regulation."[6]
Uleman defines unconscious thinking as the "internal qualities of mind that
affect conscious thought and behavior, without being conscious themselves."[7]
This includes computing of the information recorded by the senses; like light
and vision, sound and hearing, smell and scent, taste, and touch. This makes
unconscious thinking *cognitive*. It also includes affect, motivation, control,
and self-regulation. And most of it functions automatically as not controlled
and conscious processes,[8] which range for instance from deliberate to unin-
tentional, from critical to simple-minded, from determined to impulsive, from
selfish to social, and from open-minded to prejudiced.

Perhaps a metaphor may serve us well. A good candidate is the classical
theater metaphor invented in the eighteenth century by philosopher David
Hume and elaborated by psychologists like Bernard Baars some twenty years
ago.[9] In reality, it is a model of consciousness, called Global Workspace The-

2. Gazzaniga, *Who's*, 44.

3. Dennett, *Consciousness*, 29; italics in original.

4. Ibid.

5. Gazzaniga, *Who's*, 44.

6. Uleman, "Introduction," 3.

7. Ibid.

8. Ibid., 6–7.

9. For a detailed discussion, see Ouweneel, *Freudian*, 170–73.

ory, or GWT. The theater of the mind metaphor posits a dark theater with a stage in the middle or up front where a spotlight is representing consciousness. This stage is working memory. We may map it in the center of the theater, surrounded by a huge audience in the dark. According to Baars's GWT, consciousness is a spotlight on the stage of the theater of the mind. To keep the metaphor simple, we may say that in the spotlight we find "actors" who initiate conscious actions, motivate them, and reflect on them. Literary scholar Patrick C. Hogan, who published two books in 2003 on cognitive cultural studies to discuss works of music and literature, made me realize that within the theater of the mind the audience works in two compartments. One is near the stage and must be seen as the direct assistants of the actors on stage: working memory. The second compartment is further off and consists of long-term memory.[10] The stage as working memory is constantly active. Next to the stage with its working memory players and the player in the spotlight, the theater is filled up with a very interactive audience that can also take initiatives to inform the actors and other members in the audience with material from memory already encoded in the brain (dreams, hallucinations, and the like). Messengers representing the five senses introduce incoming information to the audience, not directly to the actors of consciousness on stage.[11]

Networks of members in the audience send a representative toward the spotlight to initiate action. The actors in the spotlight—representing a conscious thought in working memory—make available or "visible" to the rest of the system in the audience what could or needs to be done. Action should be taken; the body moved. But it is an eccentric theater. Contrary to what we expect, the audience is not silent and the actors on stage are not fully in charge. Indeed, the GWT's audience is constantly in connection and dialogue with the actors on stage and is not working unseen by the players there, haunting their actions in the dark. This active audience, openly intervening or reiterating comments and suggestions to the players on stages, is what we could call the Unconscious. It ventures goals and knowledge out loud; perhaps so close to the stage that we may speak of a subconscious automatic level. The entire system of connections between the players on stage and their active contacts and supporters in the audience are the connections in the brain we call memory. Note that the conscious contents of the brain are in this image limited to a brightly lit spot of attention on stage only. The rest of the stage remains in the dark. This expressive metaphor is particularly interesting because Freud's Dynamic Unconscious assumes a closed-off site within

10. Hogan, *Cognitive*, 13.

11. Perhaps this is in line with the theories forwarded by Barrett, *Beyond*, and Chemero, *Radical.*

the brain trying to reach out to consciousness. Baars's theater of the mind, however, connects to cognitive research that demonstrates that unconscious thinking reacts immediately on incoming information from the senses and tries to find the spotlight of consciousness also immediately if circumstances require so.

In the theater of the mind, well informed by the actors, the audience is seriously multitasking—something that the actor on stage cannot perform. All our decisions are made unconsciously, even the ones we think we deliberately chose. Reading this text is a conscious activity, but you need your entire brain to understand the meaning of "You cannot see it, but it works." We cannot read two words at the same time, but the unconsciously working part of the brain can try to understand that sentence and turn the page, and try to sit a little differently, remember to buy some milk for the cat later that day, and move your head a bit to avoid direct sunlight, and think of other things like "Why is Santiago Román so impotent?" all at the same time. Where consciousness (the actor on stage) works serially (one thing at a time), the Cognitive Unconscious (the audience) works in parallel (many things at the same time). The stage in the theater of the mind where the spotlight of consciousness can be attracted is only a very tiny part of that theater indeed. The articulation between the theater of the mind and the cultural world outside the human body can be established by looking at the networks in the theater of the mind as cognitive schemas. Above, I explained that we may recognize complexes of local schemas as the culture that people inherit and may describe these as "living" at a certain spot in space and time. This is the articulation.

The audience of the theater of the mind forms networks with members on the stage and members a long way in the back of the theater. These networks constitute open connections between conscious thinking and unconscious processing if it wants but it can also activate the motor system of the brain—and begin doing something—before the actor on the stage is being involved. Note that this means in Freudian terms that the Cognitive Unconscious as presented by the theater metaphor would be a Preconscious and that there is no Dynamic Unconscious. The activities by the audience in the far back of the theater of the mind correspond to networks of long-term memory. The networks are constituted of audience members in possession of memory items, usually specialized, and knowledge of skills like language. Most of it rests on encoded memories of previous experiences—real or virtual. These experiences have been "real" if the persons have been in specific situations and they encoded them as they have interpreted them consciously and unconsciously. Think of Santiago Román's life as a soldier. The experiences have been "virtual" if they consist of reading or listening to stories told by others,

or experiencing stories in the theaters, the cinema, on television screens, from the Internet, or a film like *Días de Santiago*. The outcome is basically the same: the experiences are encoded at large if they are new; or in parts, if similarities to previous experiences exist.

It is an illusion to think that the actor in the spotlight ("consciousness") rules the brain like some chief executive officer. On the contrary, it contains many module-like neuronal networks that are all executing their own type of special activities and can easily come to decisions about initiating actions of the entire body or not without even informing the actor in the spotlight on stage—who then has to come up with its own interpretation. Research suggests that consciousness is mostly behind the times. Take for example the experiment set in a dressing room with panties. In the late 1970s the researchers Richard Nisbett and Timothy D. Wilson asked customers to choose one of four identical Nylon stockings on a table. The customers were asked which article was the best quality and, after choosing, why they preferred the one in their hands. "There was a pronounced left-to-right position effect, such that the right-most object in the array was heavily overchosen. [In fact], the effect was quite large, with the right-most stockings being preferred over the left-most by a factor of almost four to one."[12] When asked about their choices, customers mentioned not the position of the article on the table but an array of other reasons about quality and color. Remember: the stockings were identical. Everyone denied that it had something to do with the position on the table, "usually with a worried glance at the interviewer suggesting that they felt either that they had misunderstood the question or were dealing with a madman."[13] The literature is full of cases like this. Indeed, it will be difficult to believe that the answers to questions like "Why do you like him?" "How did you solve this problem?" or "Why did you take that job?" can be taken seriously. This means that many actions person undertake are designed and initiated in the theater of the mind by the audience outside the spotlight—and that the actors on stage make something up to explain what is occurring.

Make something up? We know that humans are the storytelling animal, as Jonathan Gottschall tells us.[14] Stories make us human; like fish in the ocean, we live in a sea of stories. The better we can deal with stories the better we can "swim." Or, said differently, stories—based on real experience or fictional—can make us behave better. Through simulations, they prepare us for future behavior because they provide us with an assortment of actions. Recorded in memory—among the audience of the theater of the mind—stories are

12. Nisbett and Wilson, "Telling," 243.

13. Ibid., 244.

14. Gottschall, *Storytelling*.

attached to emotions, which help us decide what to do.[15] Following Gazza-
niga, the actor on stage in the theater can—sometimes?—be the "brain's left
hemisphere interpreter." This is a module of the brain that is designed to seek
logical explanations or causes for events that a person experiences. It provides
us with a comprehensible vision of the world and us in it. Gazzaniga met
him in split-brain patients—people who suffered so horribly from epilepsy
that the surgeon decided to cut the links between the two hemispheres of
their brains. Investigating the effects, Gazzaniga and his collaborators found
that the left hemisphere put experience into words and was designed to do
so. The right hemisphere could do it as well, but only with a lot of difficulty.
Furthermore, the story that the "interpreter" uttered seemed in all cases to
have been fabricated. "It made up a post hoc answer that fit the situation,"
Gazzaniga concluded.[16] "It interpreted the response in a context consistent
with what it knew, [. . .] using the inputs that it has from the current cognitive
state and cues from the surroundings."[17] Gazzaniga passed a clear judgment:
the "interpreter" "fudges." It never said: "I don't know,"[18] which would have
been the correct answer in many of the experiments. This has consequences
for social and cultural science research, of course, because even in normal
circumstances, the "interpreter" would saddle us with illusions. "It is the left
hemisphere that engages in the human tendency to find order in chaos, that
tries to fit everything into a story and put it into a context."[19] The "interpreter"
on stage helps us find an explanation in hindsight. Author and journalist Tom
Wolfe lets his character Charlotte Simmons explain: "Let's say you pick up a
rock and you throw it. And in midflight you give that rock consciousness and
a rational mind. That little rock will think it has a free will and will give you a
highly rational account of why it has decided to take the route it is taking."[20]
Making something up can be healthy for the situation in the theater of the
mind. By generating "explanations about our perceptions, memories, and
actions and the relationships among them,"[21] the left hemisphere interpreter
creates a coherent identity.

15. Ibid., 95–103.
16. Gazzaniga, Who's, 83.
17. Ibid., 82.
18. Ibid., 83.
19. Ibid., 75–103; quote from 85.
20. Wolfe, Charlotte, 283.
21. Gazzaniga, Who's, 102.

3

Despite the efforts of the left hemisphere interpreter to fool us with a coherent identity, our activities are strongly articulated by place and time. Through our senses, networks in the brain are activated that bring back from memory potential actions to do in that place and that moment. Within the theater metaphor we may say that these networks are built by the theater's audience, the actor(s) and others in the theater of the mind, and may be identified as cognitive schemas. Indeed, cognitive schemas determine who we are, *depending on* where we are and with whom. "A schema is what is learned (or innately given) about some aspect of the world, combining knowledge with the processes for applying it," says the neuroscientist Michael Arbib.[22] "Each of us is defined by a multitude of schemas," Arbib continues,[23] and each of us "has sets of schemas with some sort of coherence between them (this is not to claim that all of an individual's schemas are coherent); and the style of such a set of schemas can change over time to provide some sort of unity."[24] Indeed: "Who we are is the totality of these schemas, yet *the self we present to the world depends very much on the circumstances.*"[25] These include the roles we play in different parts of the world, as son *or* husband *or* father *or* professor *or* tourist *or* cinema-visitor, whatever. Each role has its own set of schemas and therefore its own stage.[26] Like any one of us, Arbib has learned "how to behave in many different contexts—at home, at the university, at the shops, at a restaurant—and even there the schemas that [he] deploys can be even more finely graded, so that [his] behavior varies greatly depending on whether [he is] in the bedroom, bathroom, kitchen, or study." His "various roles are played out through [his] ability to deploy appropriate schemas, respecting current circumstances to set expectations and meet goals."[27]

Behavior, acting out, our performance, our *doing* functions are motored by cognitive schemas. Think of a musician in a band or orchestra, Hogan suggests, who experiences (hears and feels) an incoming stream of sound of which elements "serve as probes to activate structures—more technically, *sche-*

22. Arbib, *How*, 13.

23. Ibid., 18; also 7.

24. Ibid., 19. Arbib estimates that there are "perhaps tens of thousands of schemas corresponding to the totality of what a human knows, with perhaps hundreds of these active at any time to subserve the current interaction of the organism with its environment."

25. Ibid.; italics added.

26. Goffman, *Presentation*.

27. Arbib, *How*, 19.

mas—from long-term memory."[28] He adds: "These structures are then used by working memory to organize the pitch and rhythm sequences still further. There are numerous schemas in long-term memory that help guide our assignment of structure to the incoming stream of sound. One particularly important set of schemas bears on the determination of the scale position of the notes."[29] Hogan then continues to describe the workings from determining the tonic or tonal center of the incoming sound and then the relative scale positions of the notes. "Most of us have schemas in long-term memory that represent particularly common note and chord sequences. (Depending on experience, we will have more or fewer schemas of this sort.) Any piece of music is likely to activate some of these schemas. More exactly, a piece of music *primes* these schemas, which is to say, it makes them ready for access. Then particular, encoded features of the stream of sound activate particular schemas from the primed set."[30] It is not difficult to imagine that a similar system works in reacting to feeling matter and fluids, reading texts, watching images, or being touched by the colors of a painting.

Hogan also points to the obligatory or optional possibilities in applying such schemas. For certain genres in writing, composing, sculpting, or filmmaking, techniques for making things are obligatory if the artist wants to stick to a genre. Think of the use of end rhyme in a certain genre, "then end rhyme is obligatory in the schema for that genre."[31] An optional technique, for example, is alliteration in writing sonnets. Despite the two compartments as working places of the audience in the theater of mind, the networks they build within the audience and with the actors are still strong and open units—the cognitive schemas. However, most schemas are not consciously processed this way. More often cognitive schemas follow more or less automatically certain protocols that are already encoded in them. Some of these protocols are of a general kind. For example, *priming*, Daniel L. Schacter and Rajendra D. Badgaiyan argue, "involves a change in the ability to identify an object or generate a word as a consequence of a specific prior encounter with it, and often occurs outside of awareness. In a typical priming experiment [. . .] participants might be asked to identify a briefly flashed picture of a piano or a chair, or to produce a word in response to a three-letter stem. Priming occurs

28. Hogan, *Cognitive*, 18; italics in original.
29. Ibid.
30. Ibid.; italics in original.
31. Hogan, *Mind*, 21.

when accuracy or speed of task performance is influenced significantly by prior study."[32]

Important in understanding the resilience of cognitive schemas is the *repisodic effect* in looking at, naming, and experiencing the world around us. This effect describes that memory retrieval is hindered by an increasing number of similar inputs, like the endless repetition of small details. The memory system works using retrieval cues based on sensory inputs, and over the years memories which share retrieval cues with other memories are *not* encoded. This would normally cause the loss of one specific memory connected to one specific cue. The next step is to combine the series of retrieval cues from separate past and present inputs. These are connected to neuronal systems specialized to compute sensory information all over the brain—from the stage deep into the audience in the theater of the mind. This is what makes any memory a *reconstruction*; triggered by cues, built on guesses about what combination of experiences goes with what series of retrieval cues. Compare the experience of someone who has only traveled by air once with someone who is a frequent flier. The single flier may well tell a vivid story about the flight, whereas the frequent flier, whose memories of each flight will tend to blend together into a generic memory of "flying on airplanes," will find it difficult to remember individual flight details unless something very unusual happened. Nevertheless, according to the psychologist Richard McNally, the personal experience of this generic memory "will be just as vivid as the memory of the person who has flown only once."[33] Enough details remain encoded to give frequent fliers the idea that they can remember what it was like to fly on different flights. Furthermore, cognitive schemas also re-encode these reconstructions every time they have been stimulated to influence conscious and unconscious behavior.[34] Schemas triggered in the Amerindian world would trigger the history of Amerindian experiences as long as they serve to act in the world. For example, if some Andean man sees a *white* man in his Andean mountain village, the repisodic effect would automatically cue the narratives of this town about *white* people in past and present.

Often, the repisodic effect would lead to *stereotyping*. Stereotypes are cognitive schemas of covariation with knowledge people have learned. However, it is not easy to detect much accuracy in these covariations. This supports the idea that cultures think about people in terms of person types, with fixed traits, like culturally valued positive and negative ones. Each person type com-

32. Schacter and Badgaiyan, "Neuroimaging," 1; also, Trafimow, Silverman, Fan, and Law, "Effects."

33. McNally, *Remembering*, 35–36.

34. Ibid.; also, Crombag and Merckelbach, *Hervonden*, 56; Schacter, *Searching*.

prises several personality traits, and the constructed knowledge of a given trait of a person type can be used to infer the presence of other traits in the same person type. The resulting picture is in general well organized and internally coherent. It resists, like other cognitive schemas, inconsistencies and fluctuations, as long as these are not too gross. Individuals who do not fit are at first seen as exceptions to the rule. Belgian psychologist Vincent Yzerbyt and his co-writers speak of it as *psychological essentialism*: "In other words, we function on the basis of surface level similarities as if some deeper properties of the object support the decision process. When people adopt a psychological essentialistic stance, their working hypothesis is that things that look alike tend to share deeper properties."[35] For these authors, this is reason enough to argue for a subjective essentialist view of social categories. This subjective essentialism is likely to prevail when seemingly objective indicators are available. Differences between groups are thus seen to be phenotypic surface characteristics, resulting from some supposed existence of genotypic deeper features defining the group.

Stereotypes are part of *self-schemas*, positive and negative, where we speak of "me" and "I." This apparently works to maintain the social structure in its existing and perceived state. Although psychologist Lee Jussim warns against exaggerating the mechanism and advocates leaving more room for the adaptation of factual situations than is prescribed by standard schema theory,[36] the picturing of the other is generally conceptualized both in terms of the "real" and of the "stereotyped" other—or "ethnotype"[37]—with a preference for the latter. But this preference never goes beyond the point at which social reality is transformed by erroneous social beliefs. It has to be relevant within the context. The context-limited social reality both creates and reflects reality. Jussim concludes that people's "errors, prejudices and misbegotten beliefs" do sometimes create or construct a social reality but that people's perceptions are more often accurate reflections of social realities.[38] Nevertheless, beyond direct contacts, stereotyping prevails persistently in speaking about and thinking of other people in general terms. In the theater of the mind, a self-schema works both on stage and in the audience. We do things the way we do following our encoded schemas, but we also try to provide some coherence to ourselves

35. Yzerbyt, Rocher, and Schadron, "Stereotypes," 34.
36. Jussim, "Social."
37. Leerssen, *National*, 17. See also: Flynn, Leerssen, and van Doorslaer, "Translated," 1.
38. Jussim, "Social"; Atkinson et al., *Hilgard's*, 598–600; Kunda and Thagard, "Forming"; Spears et al., "Introduction"; Jost and Banaji, "Role." It is as if—as Susan Fiske, one of the leading psychologists of our time, and many others emphasize—people are good-enough perceivers; Fiske, "Thinking."

and others for why we do these things and even for who we think we are. Even here, parameters direct the outcome. The cultural psychologist Michael Cole stresses that in the "narratives-people-tell-themselves" a *story schema* is at hand. The story schema consists of sets of expectations about how stories progress.[39] It refers to any kind of stories, from telling the flight of a bird from one tree to another or the graph representing economic decline, to the fairy tale of Red Riding Hood or the novel *One Hundred Years of Solitude*. With the aid of artifacts, narratives are transferred through learning to the next generation. Each narrative survives generation after generation, until "something better" is found. As more instances are encountered, story schemas become more abstract and less tied to concrete instances. They also become richer and more complex, as more data need to be processed. Because cognitive schemas are interrelated, forming a network of cognitive schemas to generate interactive behavior, a change in one schema causes changes in all the others and finally in the entire system. Nevertheless, specific changes, for example in the self-schemas, are made only after continued experience of severe failure in particular situations. Once cognitive schemas are formed, people tend to keep them intact and to protect them as long as sustainable, by uncritically relying on their own previous judgments.

Cognitive schemas drive and motivate the activity of the body and learn from this *embodiment*. In his *Embodiment and Cognitive Science* (2005), Raymond Gibbs explains how this works. Particularly relevant are "mental imagery" and "memory."[40] Considerable empirical studies, Gibbs continues cautiously, "show, at the very least, that imagining our bodies moving has some relationship to subsequent real-life human action."[41] Next he demonstrates that the ability to imagine ourselves in specific ways through space(s) influences the way we perform. "Ideomotor action refers to the fact that just thinking about an action can make people perform the action without any special influence of the will. [. . .] Merely thinking about a kind of person can induce ideomotor mimicry of that person's behavior. [. . .] People appear to think ahead about their embodied movements not by activating a completed motor plan, but by planning the simulated action."[42] Because the embodied experience affords ease of remembering, this brings us inevitably to the recognition of memory as embodied action. Gibbs reviews a body of scholarly work that all points to the conclusion that motoric activity is quite important

39. Cole, *Cultural,* 119–20, 125.

40. Gibbs, *Embodiment,* 124–57. For recent surveys, see: Glenberg, "Embodiment"; Meier et al., "Embodiment"; Niedenthal et al., "Embodiment."

41. Gibbs, *Embodiment,* 125.

42. Ibid., 125, 127.

to working memory. "Various bodily actions, including private speech, covert looking, and motor activity, enhance short-term memory. [In fact,] working memory is more a collection of performative strategies (touching, speaking) than it is a separate, architectural component of mind."[43] The simulations that are triggered to imagine ourselves acting, or that really do bring us in motion, function using image schemas.

Mental imagery is triggered in consciousness. It is, in a way, the spotlight on the stage of the theater of the mind. The image schema as a dynamic analog representation of spatial relations and movements in space has been discussed intensively by cognitive linguists George Lakoff, Mark Johnson, and Mark Turner,[44] who claim and demonstrate that many of our concepts, or perhaps all, are grounded in, and structured by, various patterns of our perceptual interactions, bodily actions, and manipulations of objects.[45] They differ from the cognitive schemas that are encoded in long-term memory—the audience of the theater of the mind. The former are abstract conceptual and propositional event structures, whereas the latter, in order to organize experience at the level of bodily perception and movement, are imaginative and nonpropositional, articulated to all real and virtual (simulated) sensorimotor coordination. Gibbs concludes that "image schemas are at once visual, auditory, kinesthetic, and tactile."[46] Much of it can be traced back in the way we use metaphors; like the SOURCE-PATH-GOAL schema, which helps us track our bodies, other bodies, and objects from one point to another and further—in real spaces around us or in the virtual spaces in our minds.

Another example of embodied action is *empathy*. "Empathy," says the neuroscientist Vittorio Gallese, "is the result of a direct experience of another person's state (action, emotion, sensation), thanks to a mechanism of embodied simulation that produces within the observer a corporeal state that is—to some degree—shared with the person who expresses/experiences that state. And precisely the sharing of some of the corporeal states between observer and observed allows this direct form of understanding, which we can define as 'empathic.' "[47] The "observed" include virtual persons in stories on screen and on images, including paintings.[48] The system in the brain makes use of

43. Ibid., 147.

44. Lakoff, *Women*; Lakoff and Johnson, *Metaphors*; Lakoff and Turner, *More*; Johnson, *Body*.

45. Gibbs, *Embodiment*, 90.

46. Ibid., 91; also 138–42.

47. Wojciehowski, "Interview," 2.

48. This is the way we experience the persons on the paintings discussed in this book as real. In fact, brain research using fMRI scanner repeatedly shows its test subjects film footages as stimuli, despite of the fact that films are not interactive.

mirror neurons constantly. Mirror neurons—one of the major discoveries of neuroscience over the past decade—are located in the prefrontal cortex of our brains and fire either when we perform an action or when we see the same action performed by someone else.[49] Mirror neurons play a crucial role in learning and understanding, but also in understanding and interpreting art. They are important in feeling empathy with others, including fictive others, like characters in paintings, novels, films, and on television. Mirror neurons are part of circuits in our brain that suggest that when we watch others performing actions we are in a way performing those actions ourselves. This is why people get involved with anguish, pain, and tensions, both in real life and in films. In general the information obtained is not forgotten but checked for usefulness by the brain and then stored as memory. The brain can use the information at any moment rather freely, for instance to run simulations about situations that seem at hand, or to get a grip on complex realities. Economists, meteorologists, or linguists do exactly the same. Sometimes, simulations, fantasizing about events and situations, or dreaming about them, can be useful as exercises related to future behavior and testing the emotions involved.

Seeing others in real life or in images or as statues, we simulate their bodily states and movements because of the mirror mechanism in our brains. Vision, says Gallese, "is always a multimodal enterprise, encompassing the activation of sensory-motor, viscero-motor and affect-related brain circuits."[50] When we see others act or experience emotions and sensations—in reality or virtually— our own neural structures are activated. Although most research has been done on the effect of ongoing actions on what has been coined the mirror-neuron system (MNS), "recent research carried out on the MNS in humans with a variety of techniques has shown that even the observation of static images of actions lead[s] to action simulation in the brain of the observer, through the activation of the same brain regions normally activated by execution of the observed actions. [. . .] In any still image, the 'decisive moment' of the action portrayed [. . .] is captured by an embodied simulation of the contemplator."[51] This is because the MNS underpins a fundamental aspect of social cognition, "that is, the multi-level connectedness and reciprocity among individuals within a social group."[52] The MNS provides the neural basis of the social sharing of situated experiences of action and affect.

49. For example: Iacoboni, *Mirroring*; Rizzolatti and Craighero, "Mirror-Neuron"; Rizzolatti and Sinigaglia, *Mirrors*.

50. Gallese, "Seeing," 62; also Freedberg and Gallese, "Motion," and Gallese, "Mirror."

51. Gallese, "Mirror," 444.

52. Ibid., 447; italics in original. See also Barsalou, "Grounded," 623, 630–31.

To conclude, despite the fact that the schema, its slots, and network are drawn on paper with lines and words, triggering is *not* principally through a lexicon or text nor does it activate only language in the brain. Academics have recorded many findings indeed that demonstrate that cognition blends with bodily states or are effects of them, and have documented the roles of simulation in cognition. This is cognition fed as it were by the senses: first, by vision, but also and at the same time by smell, sound, and touch, or, stated differently, the way we are grounded in the world. Grounded cognition, says Lawrence Barsalou, "reflects the assumption that cognition is typically grounded in multiple ways, including simulations, situated action, and, on occasion, bodily states."[53] Meaning does not come simply by words alone. Some meanings are better expressed visually or musically than verbally.[54]

4

On the stage of the theater of the mind, the actors bring the unconscious thoughts into consciousness. More than often, this involves language and narratives. However, the actor on the stage also stimulates to encode into the network of the audience in the theater of the mind—the Cognitive Unconscious—the narratives that have just passed on the stage. The actors act out what the audience asks them to do, but in their turn they arrange for the audience to respond with an encoding of the actors' acts. This is a kind of loop. In general, stories may serve as models for future behavior. They are *simulations* for future action. Apart from real-life experiences, the mental stock of simulations includes stories we tell each other about real-life experiences of others and fiction. Recent findings from cognitive research into simulation theories postulate and demonstrate that narratives "learned" from fiction could work in human minds as simulations for finding solutions to particular problems. Fiction, says psychologist Keith Oatley, is the mind's flight simulator.[55] This idea is not difficult to grasp. Gaining insights into the human condition requires what literary scientists and cognitive psychologists call mindreading.[56] Mindreading is the ability to interpret behavior of others in terms of their assumed states of mind. The system that invokes our mindreading abil-

53. Barsalou, "Grounded," 619.

54. See the essays and introductions in Ryan, ed., *Narrative*.

55. Oatley, "Mind's." This paragraph and the next are from Ouweneel, *Freudian*, 1–2.

56. Borrowing from psychology, one champion of this argument is literary scholar Lisa Zunshine, who wrote at least three influential titles in only a few years; Zunshine, *Why* (2006), *Strange* (2008), and *Getting* (2012).

ity is active not only in real life but also when reading fiction, watching fiction television or feature films, and even while enjoying sculptures, photographs, and paintings, even when seeing abstract figures. For convenience of comparison, the simulations work with a limited number of variables. Complexities can be made more conveniently arranged this way. Perhaps we should regard all our thinking as simulative, because we seem to run simulations in the split seconds before behavior is set in. For that reason, scholars argue, we build up as much simulation as we can in order to be prepared for "correct" behavior.

As simulations, fictions serve us well because they are not direct copies of reality and condense complex information—regarding interactions between multiple autonomous and intentional agents—without substantial discarding of key elements, while simultaneously revealing the principal underlying chords of the social world. The social reality is ineffably too complicated and too detailed to do it otherwise. Therefore, we need to regard narrative worlds as simulations of social behavior. On the other hand, fiction helps us fit the experiences into a story we understand and preferably also like to hear. Simulations of social worlds through abstraction, simplification, and compression are not only to simulate varieties of behavior but also to prepare us to better understand situations we encounter. This abstraction, psychologists Raymond Mar and Keith Oatley write, "condenses complex information regarding interactions between multiple autonomous and intentional agents without substantial discarding of key elements, while simultaneously revealing the principal underlying chords of the social world."[57] The abstractions serve to disconnect them from specific circumstances or persons. Stories from real life or fiction include a timeline, characters, and a stage. These are the "variables" of our simulations. Fiction is perhaps as important as nonfiction, for, as the title of an article by Mar and Oatley runs: "The Function of Fiction Is the Abstraction and Simulation of Social Experience." This is what brings me to the abstract characters in paintings. Hence, the agency Alfred Gell talks about is a feature of any fictional character. Pictures are scripted.

The advantage for everyone in the theater of the mind is that simulations provide information by offering models when access to real information is too difficult. Simulations serve to prepare for unknown situations. Narrative worlds, or *storyworlds,* says David Herman, "can be defined as the worlds evoked by narratives, and narratives can be defined in turn as blueprints for world-creation."[58] These "blueprints" are simulations encoded in clusters of cognitive schemas, as laid down in the expressive resources of spoken lan-

57. Mar and Oatley, "Function," 187; see also 173.
58. Herman, "Editor's," xviii.

guage, but also the written word and its typographical formats, the disposition of space on the printed page, diagrams, sketches and illustrations, and of course in the relevant colors, smells, feelings, and so forth. Furthermore, they include theatrical scenes, stills like photographs and paintings, and the diegesis of a film. In order to better understand, generalize to other circumstances, and act upon them, a narrative world functions to abstract social and personal information about human behavior. Interlocutors in contexts of face-to-face storytelling, Herman continues, viewers of films and participants in computer-mediated modes of storytelling use a variety of cues to decode what has been offered. They need to construct a timeline for events, a broader temporal and spatial environment in which those events occur, an inventory of the characters involved, and a working model of what it must have been like for these characters to experience these events. The narrative world as a simulation of human behavior and its underlying cognitions and motivations— on specific stages during specific moments and events—achieves a form of learning through experience by facilitating the communication and understanding of social information and making it more compelling. "Although narrative is entertaining, its function is not of mere entertainment."[59] This confirms psychologist Steven Pinker's earlier conclusion from *How the Mind Works* (1997) that the "technology of fiction delivers a simulation of life that an audience can enter in the comfort of their cave, couch, or theater seat."[60] And he continues: "Words can evoke mental images, which can activate the parts of the brain that register the world when we actually perceive it. Other technologies violate the assumptions of our perceptual apparatus and trick us with illusions that partly duplicate the experience of seeing and hearing real events. They include costumes, makeup, sets, sound effects, cinematography, and animation."[61]

In his book *Stumbling on Happiness* (2006), Daniel Gilbert shows that people have problems using their imagination to simulate the future and seem to take the wrong things into account in their simulations. One way to learn to improve, Oatley says, is to talk with others. This we do abundantly—even more so, now that we have portable cell phones. "In its explorations of the what-ifs of social life, fiction offers more experience and more consultations than we could otherwise have."[62] Mar, Oatley, and Maja Djikic tested the idea empirically that reading and watching fiction has psychological and social benefits. For example, they found that children's use of terms for mental states

59. Ibid.
60. Pinker, *How*, 539.
61. Ibid.
62. Oatley, "Mind's."

and their abilities for mindreading were related both to the amount of reading parents did with them and to the number of mental-state terms that parents used. The key was for children to imagine such mental states. As compared with those who read a nonfiction essay about women's rights in Algeria—this is another investigation they referred to—the students reading a chapter from a novel about the life of an Algerian woman reported that they would be less likely to accept current norms for relationships between men and women in the country. The students were studying in a Western country. In yet another study, comparing the effects of a fiction story and a nonfiction journalism piece, they found that the readers of the fiction did better on a test of social reasoning, though not on a test of analytical reading, than those who read the nonfiction. Other researchers found that readers of a fictional (love) story changed their personality in small but measurable ways, and in idiosyncratic directions. These changes were mediated by the changes in emotion that readers experienced in the course of reading. In a further study, student readers who were asked to project themselves mentally into the situation of the story showed decreased tolerance for current norms than readers who were invited to concentrate on the structure of the story.[63]

In short, simulations are designed to use theories about the world. It is the process by which we come to "have a world," forming the basis for our physical, cultural, social, and ethical behavior in the world. It connotes processes of perception and cognition as well as processes of emotions and feelings—continuously on the move. As schema theory predicts, most narrative worlds tend to confirm stored knowledge and only slowly agree to give in to change. Remember what Pinker wrote in 1997: "Television stations get mail from soap-opera viewers with death threats for the evil characters, advice to the lovelorn ones, and booties for the babies. Mexican moviegoers have been known to riddle the screen with bullets. Actors complain that fans confuse them with their roles; Leonard Nimoy wrote a memoir called *I Am Not Spock,* then gave up and wrote another one called *I Am Spock.*"[64] If what you see disturbs your view, attack it or embrace it: "In July 2007 the artist Rindy Sam left the lipstick traces of her kisses on the entirely white surface of a Cy Twombly painting.

63. Oatley, Mar, and Djikic, "Psychology," including the references to these investigations. To have this kind of results, for philosopher Scott Stroud simulations involve three important steps. First, the viewers or readers are confronted with a specific fictional situation on screen or described in a text. Second, they place themselves in this specific fictional situation via simulation. Third, general values and mental schemas are adopted, which they can use in a variety of real situations. See Stroud, "Simulation," especially 24–33. This note also in Ouweneel, *Freudian,* 242n7.

64. Pinker, *How,* 538–39.

In her statement to the press, she declared that she had become so 'overcome with passion for this work of art' that she 'had to kiss it.'"[65]

In giving substance to the psychological lives of characters, museum visitors, moviegoers, literature readers, and so forth must use their own experiences. Also encoded in cognitive schemas, the experiences are used to bridge gaps in narratives, including facts and emotions to bear on them. On the basis of such acquired cognitive schemas and personal temperament, the art consumer uses the space provided by these individual differences to form various interpretations of performances. Because we continually draw inferences and exhibit participatory responses in everyday life, we may look at our reality as constructed as much as any narrative world. Knowledge outside the narrative is often critical to the adequate construction of a narrative world. Whenever we attend a museum, theater, or cinema, or open a novel we are actively supplementing the narrative. I like to recall here what Richard Gerrig wrote: "We are quite willing to infer that Mona Lisa has legs."[66]

Again, embodiment plays a role here. Therefore, based on the literature, Gibbs challenges the use of "simulation" for some situations and moves to replace it with "simulator," because the former gives us the idea that we are looking at something whereas the latter "provides something of the full-bodied experiences that have textures and a felt sense of three-dimensional depth."[67] A simulation could be seen as a *cogito-ergo-sum* situation, whereas a simulator involves a full body engagement. All this supports the idea that imagination and simulation may stimulate directly the willingness *to start doing something*. If people have encoded that specific situations trigger specific solutions, chances are they will act them out as well when the situation is decoded in that direction. In fact, experiencing a storyworld feels already like an activity, like participating. At leaving a museum, a theater, or the cinema, and closing a book, any viewer or reader will recognize the experience of having been transported to the narrative world of the works of art, plays, films, or novels. In general, human beings share openness to the images screened, performed, or described; a readiness to interpret the life of others, even from the past or the future; and the ability to observe, to conjecture, to experience, and to be carried away with emotions. And to act, if necessary. Solving problems involves embodied simulations.

All this would mean that characters in paintings—which are stylized versions of simulations—not only directly interact with our world as we meet them in the museum, in the art gallery, on the internet, in newspapers, maga-

65. Van Eck, "Living," 643.
66. Gerrig, *Experiencing*, 29.
67. Gibbs, *Embodiment*, 135, 136.

zines, or books, or at home, but also that they could plant a simulation script or scenario in our brain which would change our thoughts and the topics they bring up. This includes the encoding and re-encoding of cultural memory schemas. It all confirms the idea that our stereotyping or ethnotyping of "them" and "us" follows the same rules of stylization and abstracting. The ability to recognize the history of works of art by decoding schemas seems to be inborn.[68] The naming process based on the true or imagined history of a drawing, painting, sculpture, or other piece of art work is rooted in the cognitive schema passed down from experience and education. This includes our emotions—after all, no cognitive schema is without emotions—and provides the works of art with the power to overcharge us with emotion. It includes also action and doing because that is what cognitive schemas do.

5

If we look at *Días de Santiago*, we recognize most of these features of the theater of the mind. Set in a popular neighborhood in the outskirts of Lima, the film recounts a few weeks in the life of Santiago Román after his return to his impoverished family and his simple two-room apartment. In a voice-over, we hear him say to himself that life is psychology and that without order, nothing exists. "You have to control yourself, you have to think. There must be an order here, too." That is the "interpreter" indeed, informed by his military schemas, in fact expressing that he should *not* change. But because he also wants to learn, to be educated, and adjust, a clash between schemas—cultures—lies ahead. It does not help that he only faces unemployment, crime, and a less than welcoming family. Santiago Román's brutish father and cowed mother fight constantly. They have already one unemployed son, who lives with them in their squalid house with his trampy wife. The father beats her whenever he comes home drunk and leaves the baby crying on the dirty kitchen floor. Santiago Román's father makes his sister wear tight clothes to impress the men in the neighborhood. His wife, Mari, works at a hospital and lives and is profoundly disappointed about the bleak prospects before them. Santiago Román feels inadequate for not be able to provide for her. After being emasculated by the refrigerator salesman he turns against his wife and hits her in the face. When he returns home later after another adventure in the city, he finds it

68. Bloom, *How*, 143–44; I was drawn to this by Zunshine, *Getting*, 148. However, see also the debate, or "exchange," on mindreading between Brian Boyd and Zunshine in *Philosophy and Literature* 30.2 (2006): 590–600 (Boyd) and 31.1 (2007): 189–96 (Zunshine's reaction), and 196–99 (Boyd's response).

deserted. His wife has left him, obviously terrified by this kind of outburst he cannot control. Eventually, Santiago Román sinks into an incapacitating mood of despair and frustration. What is the point of trying to be a good citizen in a world that treats you so indifferently? Walking the street of downtown Lima, Santiago Román becomes progressively sensitive to the city's hostility. Trusting his active military cognitive schemas, he begins imagining the city as an amorphous "enemy" surrounding him. Lima has become the jungle. Paranoid fantasies about beating innocent people who walk the street next to him begin plaguing him. He walks around as if on guard, his shoulders in motion, and his eyes flickering around. Due to this inability to conform and the crisis of identity, Santiago Román cannot free himself from the schemas that are so out of place in Lima.

Eager for solidarity, Santiago Román calls on his former Navy buddies and meets them in a cemetery, on the beach, and in a deserted clubhouse. Without the necessary job skills designed for Lima, they share the same predicament. The memories of the wars haunt them at night. "I remember everything, every day, and it does not let me sleep," says Santiago Román to one of his comrades. "I want to take it easy now." No more stress, please, for Santiago Román. The others, however, are eager to act. They discuss the possibility of applying their military training to robbing banks. Santiago Román refuses. One day, one of his buddies, who came home crippled, hangs himself in despair. Disturbed, Santiago Román decides to make every effort to adjust to the new life—no way he will end up like his friend—and takes his car to earn money as a taxi driver. He enrolls in a local computer school that holds out the promise of a legitimate career. Although the money he earns from taxi driving will not meet the minimum monthly payment, driving the cab and attending classes introduce him to a cross-section of the Lima jungle. He meets a gaggle of club-going giggling seventeen-year-old girls, who drag him to a forlorn disco and try to invite him for a dance or two and some party drugs. The spectacle of the girls' reckless promiscuity and drug use fuels the seething fantasies of frustrated violence that buzz in his brain. Eventually, he rejects the affection that one of them tries to show him.

This is the first negation of sex in the film. Santiago Román's choice is a self-declared kind of sexual impotence. He must get rid of the stress in his head first. All the time he struggles to impose the order of too-schematic military schemas on his life and those around him. Santiago Román is a bundle of nervous indignation. Unexpectedly, after he finds his sister-in-law lying on his bed, sleeping, when he comes home one day, she offers herself to him. She has been beaten once more and begs him to help her run away. Santiago Román refuses to have sex with her and sends her back home. However, after some

thinking he finally feels useful in protecting her, and after grabbing his gun, he rushes to his parents' house with the intention of taking his sister-in-law away with him. What he finds there is shocking. He opens the door of one of the rooms and discovers his father abusing his teen sister. Deeply distressed, Santiago Román first points his gun at his father—interrupted by his mother, who begs him not to shoot for he will ruin all of them forever—and then leaves. Back in his own house, he stares at the gun, turns it round and round in his hand—caressing and scratching his face with it. We are stuck with the question: Will he pull the trigger to escape in death?

The film ends there. Two things drove him to make this film, writes Méndez in a "director's note." First, he read scrawled on a wall in Lima: "They call wild the river that overflows, but not the fucker who oppresses it."[69] The other thing behind the film, says Méndez, came from a Peruvian Channel Four television report. They were interviewing former combatants. These men said that even if they went to the beach or to the mountains, they continued living as if they were at war. Méndez began interviewing these men as well for a short fiction film but he accumulated so much that a feature film was possible. One of the ex-combatants was Santiago, the real one: a marine infantryman, a member of an elite force, an amphibious commando, and trained to survive on his own in the wild under all circumstances. Today he lives in Lima but he has obviously Andean roots. The real Santiago's predicament was, despite being in military top condition, how to survive in Lima. Not educated for this, he was virtually helpless in urban surroundings—he had no instruments, no "weapons," for this. The real Santiago, like many other ex-combatants, has something that persecutes him: desperation. He wanted to do things, achieve goals. His friends were prepared to do things illegal, but the real Santiago was not. From the events of his life Méndez wrote the first draft of the script. On the basis of his interviews Méndez generated ideas, which he suggested to Santiago, asking him: "Would you react this way or that way?" And he would say: "Oh, I would react this way." Or: "I think something else." These reactions were the building stones of the fictional framework. From this story, the actor Pietro Sibille played the character Santiago Román and added actions that result from this background.

69. Writing the summary above and the paragraphs below, I profited from the "Making of . . . ," on the DVD, which includes interviews with Méndez, Sibille, Durán, and a few others involved in the film, as well as with film critic Ricardo Bedoya; the PressKitt prepared by Chullachaki Producciones (2004), which was included in the DVD; and a series of documents at CinEncuentro, at http://www.cinencuentro.com/dias-de-santiago/ (accessed 6/16). See also: Press book, by Mediendossier trigon-film, on-line at https://www.trigon-film.org/de/movies/Dias_de_Santiago/documents/mediendossier[de].pdf (accessed 3/16).

Días de Santiago communicates very directly because it is rooted in the cognitive schemas of the everyday. Following rehearsals with his actors, and in the presence of the real Santiago, Méndez rewrote the script constantly. Therefore, *Días de Santiago* is the product also of the actors and it reflects their personal experience, which very well could be that of the Limeño audience. Set in an urban jungle, Santiago Román tries to find answers in the actions in his surroundings. He seems to think constantly: How to decode their actions? What to do next? His theory of the world, his theory of Self, and his theory of the next moment—all informed by his cognitive schemas—were deeply confused by the impossibility of adjusting his military experience to Lima. One of the devices Méndez came up with to show this problem on screen was the alternation between scenes in black and white and in color—or even an alternation within scenes, like the one in the taxi with Santiago Román in black and white and his sister next to him filmed in color, or the one with Santiago Román in bed—in his own world, black and white—and his sister-in-law on top of him—in full color trying to kiss him. Changing colors was helpful to showing something of the character's inner complexity, Méndez said: a conflict between the real present in color and his personal past in black and white. The turning point, says Méndez, is the sequence in bed with Santiago's sister-in-law. In shooting her, the coloring changes. After this scene, Santiago's state of mind deteriorates, as he desperately tries to fulfill meaningful actions in the city.

But there is more to the case of Santiago Román, of course. The ex-soldier obviously suffers from a war trauma, articulated perhaps as posttraumatic stress disorder (PTSD). His nightmares are attempts by the brain to clear the mind of stressful memories and prepare for novel situations, but because he experiences the city as a hostile jungle similar to the one of their military experiences, the old cognitive schemas are simply being recoded. He needs explicit conscious action to resist falling back. Santiago Román loses his fight because he tries to do the good thing from his black-and-white mind without a moment's thought about the consequences as experienced in the full-color world.[70] Although the PTSD can be suspected, it is extremely difficult to work with stereotypical models in behavior and memories. Although the way survivors of traumatic experiences remember them differently, it seems that the worse their current symptoms are, the more severe they remember the trauma to have been. Santiago is indeed a heavy case. Over time, he would recall the traumatic events as worse than before, whereas others who might have been present could have been doing much better over time and consequently

70. McNally, *Remembering*, 78–124.

remember things less harrowing in due course. But research has shown that war veterans with the most PTSD symptoms tend to amplify their memories of traumatic events over time. Falling into a deeper crisis, Santiago Román thinks about killing himself, but he might not do so and opens therefore a road to recovery. Therefore, I think, Santiago Román, who desperately tries to avoid disorder, is not a typical PTSD patient. We should realize that actually relatively few people develop PTSD. Epidemiologic studies indicate that large numbers of U.S. citizens have been exposed to stressors like physical assault, accident, or rape, but that only a minority of them had developed PTSD. And if it develops, it seldom is the only disorder to emerge—PTSD comes with depression, alcoholism, and several others. Some people do not develop PTSD even after being exposed to the most horrific stressors, McNally concludes in *Remembering Trauma* (2003), while other develop these symptoms following exposure to seemingly minor stressors.[71]

6

Where the "jungle" of Lima kept Santiago's cognitive schema "afloat"—alive in the theater of the mind—another series of features "in the world" influences thinking about the Amerindian mnemonic community from the outside in and the inside out. There is no doubt that Santiago Román was sent to the Andes by commanders who were motivated by a specific cognitive schema encoded in their brain about the *ignoble* Andean *indígenas*—as they were ethnotyped in Lima and by the National Army—as a dangerous, colonized class of "secondary citizens" who needed to be educated or destroyed. With the revolt by Sendero Luminoso, which indeed tried to take over power, property, and capital from the Euro-Peruvian ruling classes (so-called *blancos* or *whites*), the "secondary citizens" appeared to have been rising against Lima and Peru. However, the real destruction was carried out by the National Army and Sendero Luminoso in a seemingly joint effort. The Andean population was victim of both. The National Army's—and Santiago Román's—resilient stereotyped or ethnotyped cognitive schema I like to call the cognitive noble savage schema, or CNSS.

The CNSS consists of an ethnotype designed about the indigenous people in the West, seen from Europe, long before the Americas had been integrated into the Spanish Empire. Because of endless replications the CNSS in the minds of Europeans, North Americans, urban Latin Americans, and indeed

71. Ibid., esp. 82–84, 87–88, 100.

Native Americans and Amerindians, many people believe that the indigenous or *indígenas* could not be modern city dwellers, even though the Amerindians the Spaniards encountered in the Americas usually *were* city dwellers. The CNSS works with the idea that the indigenous had to be "natural" people, noble savages, who led an uncorrupted, natural way of life close to nature in an egalitarian state. As said, this was *known* in Europe long before Columbus had set sail to the West. As the Dutch philosopher Ton Lemaire wrote in his book *De Indiaan in ons bewustzijn* (1986; The Indian in Our Consciousness) with Columbus, the Europeans had rediscovered the "truth" of the myth of Atlantis and the Golden Age.[72] All their knowledge suggested the existence of a true utopia in the West. This utopia guided the audience in their theater of the mind.

The European lettered shared their knowledge that in the West the remnants of a paradise-like world could be found that had preceded European civilization—a Golden Era without inequality, conflict, or poverty. In short, it was "known" that these Westerners were a highly civilized people, urban but also living closely to nature in a serious egalitarian state. Of course Columbus's landing in the Americas can be seen as a mercantilist desire for gold and wealth by finding the route to the Indies, says Lemaire, but also as the next step of the medieval quest for increased knowledge about the paradise of the Golden Era. No wonder that once Columbus had proved the long-awaited existence of a continent in the West, the British philosopher Thomas More mapped his *Utopia* (1516) in the Americas, as did Francis Bacon his *New Atlantis* (1624 and 1627)—characterizing the new land as ruled by "generosity and enlightenment, dignity and splendour, piety and public spirit."[73] And the stories that came from the newly discovered territories were indeed about gold and silver and people living "innocently" in lushly green gardens. No doubt the CNSS was remodified when the Spaniards took over in the Americas. The new schema was bipolar: *white* ([former] colonizers) versus *nonwhite* ([former] colonized)—and for Spain's enemies it was the brutal versus the innocent, the Colonial Divide.

The CNSS is the crucial schema of a particularly large mnemonic community. The development model behind the CNSS runs from a violent savage warrior to a coerced inhabitant of a "civilized" state. Part of the schema is the self-image of the Western male, which tells us that he has beaten anarchy, wildness, communalism, and nature, thereby escaping some kind of rural effeminate state of being and eventually "maturing" into an urbanite. However,

72. Lemaire, *Indiaan*.
73. Ibid., 18–23.

urban civilization was also felt as alienating from the "true nature" of human-
kind. Run into "natural man" in the Las Indias, the European lenses consti-
tuted by the CNSS told the Spaniards that the *indio* had not escaped that fate
as yet. The ingredients of this model of European history, says Lemaire, were
used to assemble the basic constituents of the contemporary CNSS. Typically
built on the nineteenth-century fashion of seeing the world through dichoto-
mist lenses, it must look like this:[74]

STATE	URBAN	CIVILIZED	REASON	MODERN	PROPERTY	CULTURE	MALE
ANARCHY	RURAL	WILD	MYTH	TRADITION	COMMUNAL	NATURE	FEMALE

Accordingly, Western man regarded himself as civilized, cultured, and full
of reason, while living in an urban state, ruled by property rights. The *indio*
could not be like this. He was—and the *indígena* today—his mirror image.
Incorporated into the CNSS, the cognitive schema denies the Amerindian a
Native American face. He was portrait in the CNSS as a youthful European, a
little childlike, the better side of the European; and it was seen as a European
task, of Western educators, to *not* change the Native American and to prevent
him from "progressing." And to do so, the European kept the prospect of a
return to a natural state as progress *for himself.*

However, the contemporary CNSS constructed the Native Americans
both as noble savage and as base or ignoble savage; "noble" because of their
supposed primitivism, "base" because of the supposed lack of Western civili-
zation. A sixteenth-century religious politician, Bartolomé de Las Casas, pro-
posed that the Spanish Crown keep the noble and dismiss the ignoble savage
by educating the "indigenous" as proper Roman Catholics. As we all know of
course, Las Casas won the Spanish Crown for his cause. Therefore, the New
World did not bring about an epistemological revolution, Lemaire concludes:
"A true knowledge of the Other—making a breach in eurocentrism—presup-
poses a transformation of the Self."[75] Because the latter failed to materialize,
the Europeans had only *confirmed* their traditional cognitive schema (CNSS)
and began projecting it on the Amerindians in their writings and policies.
Next, based on the noble/ignoble savage schema, the colonizers disseminated
their version of the CNSS throughout the Americas. This dissemination finally
influenced the theory of the Self of the colonized *and* their descendants—iden-
tity is a theory of oneself, in this case based on the CNSS.[76] It survives until

74. Ibid., 246; to his list I added a few because they popped up while writing this text.
75. Ibid., 49.
76. Moshman, "Identity."

today. Hence, first, the construction of the "indigenous" as a rural dweller and, second, the idea that "indigenous" struggles still need to focus on the demolition of the European heritage of Latin America because even though Europeans and Africans have been in the Americas for five hundred years, the CNSS still offers the opportunity to treat Europeans as principally alien to the continent. This small detour through Lemaire's insightful book demonstrates that cognitive schemas tend to become increasingly resistant to inconsistent or contradictory information, although, Hazel Markus notes, "they are never totally invulnerable to it."[77] Schema-disconfirming information is in general disregarded or reinterpreted—as if the audience in the theater of the mind defends what they have against unwanted novelties from the outside, as if the audience must be convinced.

7

In Peru, memory is a concern. There is a small yearly commemoration of the victims of the Internal Armed Conflict in the center of Lima, next to the monument sculpted by Dutch artist Lika Mutal, called *El Ojo Que Llora, The Eye That Cries*—a crying eye within a monolith, surrounded by a small labyrinth.[78] The press writes about it; the commemoration and the Internal Armed Conflict itself is regularly an item on Peruvian television. Of course, memory is also kept alive by feature films and documentaries, by novelists, journalists, and artists. And by artists like the Peruvian rock band Los Mojarras. In Los Mojarras's 1992 debut album *Sarita Colonia*, the band fused European rock and Peruvian *chicha* music. Although, in general, *chicha* is a term used for several varieties of fermented beverages derived from maize, in Peru the word is mainly used to indicate popular, "cheap," and transient arrangements, including the *música chicha* or Peruvian cumbia. A *diario chicha* is a daily paper of the Peruvian yellow press. Most of the lyrics in Los Mojarras's songs were about Peru's contemporary problems of youth, poverty, and violence—especially in their home town of El Agustino, one of the oldest twentieth-century former shantytowns of Lima formed by Andean migrants—but the

77. Markus, "Self-Schemata," 64.

78. Followers of former president Fujimori called the monument a "monument to terrorism" and partly destroyed it first in 2007 and in 2017. It was restored and eventually declared national patrimony on August 24, 2013. The destruction in 2017, on February 28, happened while I was revising this chapter. On March 12 a ceremony was held to repair the monument.

song "Cayara" is about the massacre in the eponymous town in the Andes of the Ayacucho Department.[79]

On 13 May 1988, a Sendero Luminoso cell attacked an army convoy near the town of Erusco. The military reacted the next day by violently "investigating" the population of the towns of Erusco, Mayopampa, and Cayara. It seems they found Sendero Luminoso–linked gear in Cayara and subsequently killed about forty inhabitants, tortured at least six survivors, and raped numerous women. In the lyrics of "Cayara," Los Mojarras suggest a connection with the poverty of the Andeans. We hear Hernán "Cachuca" Condori, the writer of these lyrics, singing: "This situation makes me very angry; breaking my back for a few coins, while others live in luxury, chatting about the fatherland. They raise their earnings whenever it suits them, whereas the people are condemned to oblivion. Whatever happened to the promises made during the elections? We heard only pious words. [. . .] Where are the peasants now who once lived in these ghost towns? Where are the slaughterers? Irrational genocide! Power is nice, but it does not last long."

In Peru many perpetrators were convinced that the Andean population consisted of a kind of secondary citizens. In *Hatun Willakuy* (2004), the Comisión de la Verdad y Reconciliación (CVR; Truth and Reconciliation Commission) signals that Sendero Luminoso "reproduced ancient conceptions of superiority over *indígena* towns."[80] Because it tolerated racism against the Andean population openly, the CVR furthermore argued that the Administration of Fernando Belaúnde Terry (in office: 1980–85) bore the responsibility for the violent racial profiling attitude of the National Army.[81] The CVR documented that of every four victims of the Internal Armed Conflict, three were Quechua- or Aymara-speaking Andeans. This anomaly would not have been possible, CVR President Salomón Lerner concludes, without the profound contempt toward the Andeans, woven into every moment of Peruvian everyday life. Lerner had found out that, over and over again, racial insult, the verbal injury toward the Andeans, "like an abominable refrain that precedes the beating, the rape, the kidnapping of a son or daughter, the point blank shot" delivered by some agent of the armed forces, the police, or the insurgents, had cleared the way to the outrageous violence against them.[82]

79. The album is uploaded on YouTube, https://www.youtube.com/watch?v=2JRzwyqlZYo&app=desktop; also see (or listen to) https://www.youtube.com/watch?v=E49hJTc4qYk (both accessed 3/17), uploaded by the band on their YouTube channel "Mojarrasperu" in March 2008, "Cayara—Los Mojarras."

80. CVR, *Hatun*, without pagination.

81. Ibid.

82. Franco, "Alien," 1–3; important is Starn, "Revolt."

In fact, the CVR argues that both armies, Sendero Luminoso's and the Peruvian marines, have attacked the Andean population because they saw them as *indígenas* and therefore as a dehumanized kind of people. In all, some 70,000 lives were lost to President Gonzalo's revolt (PCP-SL). Peru desperately needs to fundamentally adjust its CNSS.

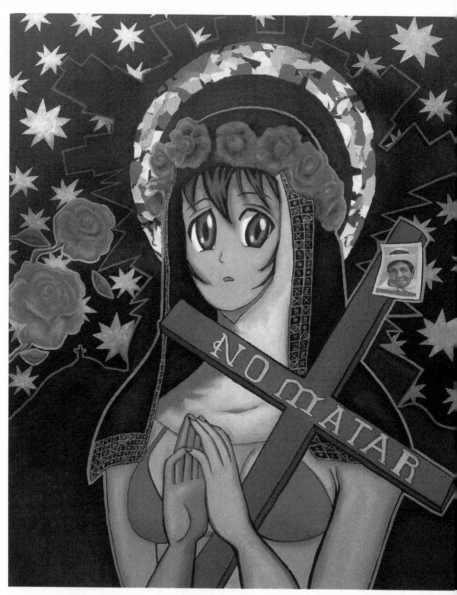

FIGURE 4.1. *Patrona de América 1,* Jorge Miyagui, 2010, oil on canvas, 1.2 × 1 m.

DISCORD

THE INTERVENING AGENT

1

¡No matar! No more killings! Mothers, women, and other family members began marching during the Internal Armed Conflict against the violence, the rapes, the abductions, the disappearances, and the killings in Ayacucho, Peru. Mamá Angélica, "speaker" of Asociación Nacional de Familiares de Secuestrados, Detenidos y Desaparecidos de las Zonas Declaradas en Estado de Emergencia del Perú (ANFASEP; National Association of Kidnapped, Disappeared and Detained Relatives of Zones that were Officially Declared in a State of Emergency), was one of them. In times of war, being a speaker means having incredible courage. To recognize this, Jorge Miyagui painted various pictures of Mamá Angélica tagged to such a cross. One of them shows the "Patrona de América" or "Patroness of America" Saint Rose of Lima carrying a cross (see figure 4.1). Saint Rose of Lima is both the saint of Peru's capital and "European city" and the patroness of the *indígenas* in the Americas. She protects Mamá Angélica and her ANFASEP, who had stood up against the last colonial massacre in the Andes. It turns Mamá Angélica into a kind of co-saint, to be venerated by the people of the Americas with Saint Rose. However, Miyagui's painting is more than just a tribute to Mamá Angélica's important work. As we shall see, the painting also speaks to her power to mobilize her community, and perhaps a much wider audience in Peru.

2

Why do we need a European saint to put this Amerindian speaker into the spotlight? This is the history of the Americas, says anthropologist Gary Gossen, because many "indigenous" movements actually had *white* leaders and *white* saints.[1] They are an integrated part of the Amerindian mnemonic community. This ostensible paradox goes back to Spanish-installed but *amerindianized* Colonial Catholicism: an Amerindian culture worshipping and venerating *white* saints—with the exception of Mexican Our Lady of Guadalupe and Peruvian Saint Martin de Porres, O. P.—next to a *white* Christ and a *white* male God. Amerindianization is domesticating, adopting, and making their own external and new features into their Amerindian cognitive schemas. And we recognize this oddity still in several Mexican rebel leaders, among others in Miguel Hidalgo and his Guadalupe in 1810, and in Subcomandante Marcos of the EZLN or Ejército Zapatista de Liberación Nacional (Zapatista Army of National Liberation) in 1994. The idea is that in calling in brokers from the "other side" of the Colonial Divide, the *indios* or *indígenas* would be taken more seriously. Also, the *white* brokers might know better how to find their way to assist the Amerindians on the "other side."

Miyagui, however, highlights—put into the spotlight of our consciousness—that the Amerindians are very well able to present themselves. He paints Saint Rose as Sailor Moon, a Japanese manga character designed by the female author Naoko Takeuchi (*Bishōjo Senshi Sērāmūn*). Because the link is there, it is interesting to observe that Sailor Moon is the Moon Princess, representing the magical girl genre. By invoking her as the Virgin, blessing Mamá Angélica, the painter lifts the latter into both the Peruvian Heaven of the angels and into a kind of Pantheon of Popular Heroes. The heroes protect social struggle and popular movements in the country. It is an attempt at a decolonizing mode of painting—a de-Europeanization of Catholic saints and Amerindian "speakers" at the same time. Curiously, in this sense the painting functions also like a *butsudán*, or sacred cabinet for deceased loved ones. In Japan, people believe that deceased loved ones live on as tutelary deities.[2] For Miyagui, Mamá Angélica would be one—the old lady died at the age of eighty-eight years in the Summer of 2017.

Mamá Angélica "speaks" for the victim-survivors of the Internal Armed Conflict in Ayacucho, and Miyagui felt inspired as an activist to "speak" in her name and ANFASEP's. Mamá Angélica fights to keep the memory of the

1. Gossen, "Who" and "Maya."
2. Nakamaki, *Japanese.*

Internal Armed Conflict alive. As said, in Peru, memory is a concern. The Comisión de la Verdad y Reconciliación (CVR; Truth and Reconciliation Commission) created a website with information, reports and testimonies,[3] there is an image bank containing some 1,700 photographs that was open to the public, and it selected more than 200 of these, organized in twenty-seven topical rooms, for the photo exhibit *Yuyanapaq: To Remember* on the sixth floor of the National Museum of Lima—styled as a concrete bunker that lords over Avenida Javier Prado Este in San Borja. In late 2016 the Lugar de la Memoria, la Tolerancia y la Inclusión Social (LUM; the Place of Memory, Tolerance, and Social Inclusion), as the national memorial museum near the Pacific coastline of Lima came to be named, was declared open. In Ayacucho a tiny museum had been installed over ten years ago, and handed over to ANFASEP—a museum I found it difficult to find; it should be closer to the city center. In line with the mirror image of the CNSS, it seems that attacking the *indígenas* was of little concern to current rulers.

If someone is the quintessential example of Amerindian *spirit of independence and opposition*, it must be Mamá Angélica. Of course, resistance had always been strong in the Andes, also during the Internal Armed Conflict. President Gonzalo's Shining Path had consisted of people of all ages including women and young children—not a typically *white* army. But next to a few carried guns and machetes, most of them carried only simple weapons such as rocks and sticks. Their "revolutionary taxes" were understood as thievery by the Andeans who had to pay them. During the war, these rural dwellers had struck back. The Andeans were not living in communities out of touch with the rest of Peru. During the Internal Armed Conflict, many highland communities had formed militias called *rondas campesinas* to protect themselves against the attacks of the Sendero Luminoso insurgents and indeed defeated the *Senderistas* before the Peruvian army could.[4] Therefore, Miyagui's *Patroness of the Americas 1* shows us the unbroken spirit of self-defense (figure 4.1). After so much violence during the Internal Armed Conflict, Miyagui believes that to show respect to ANFASEP's resistance a *butsudán* was desperately needed.

Miyagui had indeed painted several *butsudáns* for deceased persons, honoring several Peruvian social activists—including union leaders Pedro Huillca Tecse and Saúl Cantoral Huamaní; both men identified as Amerindian by their surnames. Because Miyagui included similar portrait photos in other paintings, it seems he regards creating *butsudáns* in the form of paintings as a

3. Comisión de la Verdad y Reconciliación, http://www.cverdad.org.pe/ingles/pagina01 .php (accessed 2/17).

4. Franco, "Alien," 6–16, quote on 15; Starn, "Revolt."

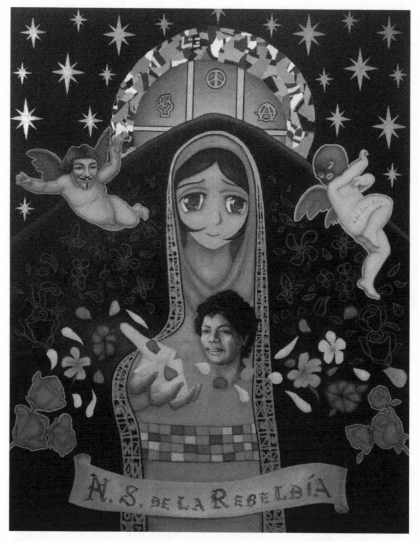

FIGURE 4.2. *Nuestra Señora de la Rebeldía 2*, Jorge Miyagui, 2013, oil on canvas, 1.4 × 1.1 m.

major task for him as an artist. Another one is *Nuestra Señora de la Rebeldía 2* (see figure 4.2). We see María Elena Moyano Delgado between the blessing hands of the Virgin; who, by the way, goes disguised as a generalized form of a Japanese manga girl. In February 1992 Moyano, one of the federation leaders, was killed by a cell of Sendero Luminoso. Moyano had been an Afro-Peruvian community leader of the Federación Popular de Mujeres de Villa El Salva-

dor (FEPOMUVES), the women's federation of Villa El Salvador, then a new neighborhood of southern Lima. She had initiated through FEPOMUVES the establishment of public kitchens, committees for basic education and health, and other community projects. She left the organization in 1990 to be elected deputy mayor of the municipality of Villa El Salvador. In this capacity, she soon had to confront Sendero Luminoso's agitations and organized a march against them. After the assassination, thousands of people were brave enough to attend her funeral. Here, the *butsudán* not only honors the assassinated social hero but also asks her to assist in the daily activism of social movements today in Lima. Miyagui's paintings do not simply keep the activists in our memory. Their active assistance as a deceased but present ancestor is still dearly needed. This truly is not only Okinawan belief but also Amerindian Andean.

According to information obtained from the painter, Miyagui did not consciously design his paintings as *butsudáns*.[5] This confirms my impression that the *butsudán* style came to the canvas while sketching the paintings, from the back of his theater of the mind. He had a series of schemas ready to work with from his cultural background and combined them. Historians Moromisato and Shimabukuro describe Miyagui as an artist committed to the cause of human rights, who through his art supports the search for freedom and emancipation of groups marginalized by the contemporary economic system.[6] This sounds less radical than his own words from a few years earlier. In his May 2007 piece on art, colonialism, and social exclusion,[7] Miyagui shifted his attention to the question of cultural decolonization. Working within the art world, he had come to dislike the institutional system of art trade, which made a strong division between "true" art, made by artists selling their products through the system (galleries, museums, supported by the media), and *artesanía* or "crafts," made by *artesanos* or craftsmen selling their products on the popular and tourist markets. The representatives of the first excluded the latter from the institutional system. This was a result of the Colonial Divide, Miyagui argues, because the first consisted of descendants of the Spanish/European colonizers and the second of descendants of the Andean and African colonized populations. If your slogan reads "Another World Is Possible," then the artist in Peru should work with a kind of "subslogan": "Other Art

5. He did agree though, later on, in a Messenger chat exchange, that the *butsudán* style could explain the design of his paintings.

6. Moromisato Miasato and Shimabukuro Inami, *Okinawa*, 79–80.

7. Jorge Miyagui, "Arte, colonialismo y exclusión social: hacia una nueva institucionalidad artística," signed May 2007 and published at his blog at http://jorgemiyagui.blogspot.nl/2007/07/arte-colonialismo-y-exclusin-social.html (accessed 9/13).

Institutions Are Possible."[8] This means the creation of a new kind of art market, ending the exclusion of "artesanos" and other types created by the official institutions. The result is a series of political comments. In *Colonialidad*, for example, Miyagui is above all the commentator from Lima, but in the *butsudán* paintings he is a participant—his paintings are participatory agents of social movements. In fact, seen from an Amerindian view—if I can imagine this—the butsudanized paintings appeal to the Amerindian theater of the mind, triggering some basic Amerindian cognitive schemas to incite people to act. In this sense, Miyagui's painting serves as an intervening agent.

3

To see how that intervening activity works, we go from Andean Peru to Southern Mexico to tackle the role played by the Zapatistas in 1994. Contrary to what is customary, I do not point primarily to the writings and interviews of Subcomandante Marcos, although he was both the military commander of the Zapatista revolt and the theoretician of the prospects that another world is possible. As speaker, Subcomandante Marcos sits somewhere between the seats taken by Mamá Angélica and Jorge Miyagui because he is an outsider like the latter but also close enough to the Maya population to be an insider as well—a kind of in-law. He (sub-)commanded the soldiers of the EZLN. No group of rebels has fired the imagination of the activists in the world so much over the past twenty years as Subcomandante Marcos and his masked compatriots. The word "Zapatistas" is in use both for the masked soldiers under Subcomandante Marcos's (sub-)command and the civilian population of the Maya communities under EZLN protection in eastern Chiapas. It would be more accurate to recognize the existence of the two groups because the military command structure seems to have been different from the political functioning of the civil communities, and even for most of the Zapatistas themselves they are either warrior/soldier or *comunero*.[9]

Another difference is the Zapatista identity at the moment of the rebellion in January 1994 and the identity during the years following the revolt, or perhaps following the Peace Accord of San Andrés in 1996. The former is

8. Ibid.; Miyagui, "Conversando en 80m2. Institución Artística y Sociedad," August 23, 2006, Galería 80m2, http://jorgemiyagui.blogspot.nl/2007/08/conversando-en-80m2.html; Miyagui, "Interculturalidad," http://jorgemiyagui.blogspot.nl/2007/07/interculturalidad-arte-migracin-y.html (both accessed 9/13).

9. In 1994 I studied the revolt intensively and wrote a book for a Dutch audience, *Alweer die Indianen* (Not Again the Indians), and two articles which were later republished in a blended version in *Psychology*.

expressed in the First Declaration from the Lacandón Jungle of January 6, 1994—the Lacandón is their home ground, a large forest at the southern border of Mexico—the latter eventually resulted in the Sixth Declaration from the Lacandón Jungle of 2005. The First Declaration spoke of a socialist revolution in Mexico (National Liberation!), the aim of taking over power in the national capital. This declaration also expressed: "Today We Say: 'Enough Is Enough,'" ¡Ya basta!, a reaction to exploitation and abuse. The Sixth Declaration, however, was about nonviolently "living in resistance" in Chiapas but also in other areas of the world, including Bolivia, Ecuador, and Cuba. It was a declaration supporting the anti- and alter(native)-globalization movements that had grown after the World Social Forum held in Brazil in 2001. Where the First Declaration explained the EZLN reaction to poverty and exclusion in Mexico, the Sixth offered prospects for an alternative restructuring of the globalizing world. Personally I feel that the Maya population of the Lacandón Jungle had more to do with the First Declaration whereas Subcomandante Marcos and his staff were more involved with the Sixth. No doubt, Subcomandante Marcos had a strong say in both, as perhaps did the speakers of the Maya communities, but the subtle difference should not be overlooked. Although this is a topic for a book in itself, of course, even in the limited space of a chapter I should be able to shed some light on this difference, which is, I believe, important for an honest assessment of the Zapatistas and the role of "the Sub" as a broker and that of the Maya leaders assumingly commanding him as intervening agent.

It all goes back to that tantalizing moment of New Year's dawn 1994 in San Cristóbal de Las Casas, the state of Chiapas's main highland city, when hundreds of ski-masked EZLN rebels took their nation by surprise. In the early hours of the day, the rebels had occupied municipal buildings in a few towns in the state of Chiapas and the one in San Cristóbal. After massive revolts like the Tzeltal revolt in 1712, Cuzcat's revolt of 1868–69, and the Caste War of Yucatán of 1848–1901,[10] this was understood by observers from the academic world as the fourth major Maya revolt in Southern Mexico. What had been going on? "Welcome to the nightmare," Subcomandante Marcos wrote to Mexico's president,[11] Ernesto Zedillo Ponce de León (in office: 1994–2000), just before his inauguration in December 1994. The Maya population of the forests of the Lacandón Jungle knew precisely what he meant. In that part of Chiapas, "chaos" was obviously at hand: hunger, disease (pneumonia, the flu,

10. See the essays in Gosner and Ouweneel, *Indigenous*; also Bricker, *Indian*; Vogt, "Possible."

11. Ouweneel, *Psychology*, 3.

anemias), no education, no good clothing, despair and anger, and a government policy that excluded the poor.

The Lacandón forest once was a huge rainforest in eastern Chiapas, bordering Guatemala. Survival in such difficult surroundings like a subtropical forest with a tendency to overpopulation needs a lot of utopian vision about a better future. The Lacandón is presently divided into some six subregions. Belgian historian Jan de Vos wrote a multivolume history of forest exploitation since the Spanish conquest.[12] Of the six subregions, only one could keep its particular forest character: the Reserva de Montes Azules in the center of the Lacandón. By 1902 the forest was divided into fewer than a dozen possessions, all by owners who wished to produce timber, the Green Gold of the time. The near-slavery labor system here was harsh.[13] The eastern part, near the border with Guatemala, had been a kind of "neutral" territory. In the 1980s the Mexican government turned a blind eye to Guatemalan guerrilla forces that used the area to rest from their fighting; the two players had a tacit agreement not to attack each other. The population that had come to occupy the western part of the Lacandón was not part of this history, but of Central Chiapas. By the end of the eighteenth century, the population of the Central Chiapas highland towns had started to grow, and during the following two centuries it skyrocketed. The Central Chiapas highlands are generally called Los Altos. The Maya towns had been *pueblos de indios* under Spanish rule and then had been governing themselves; their territories had been protected under Spanish law and supervised by the *república de indios*. Without economic adaptation such growth must have strong adverse effects: subdivision of farms, underemployment, unemployment, falling real wages, falling crop yields, deep poverty; a chilling diagnosis of imminent calamity. Even elsewhere in the world there rarely are economies in modern times that can keep up with population growth like this. Many Maya decided to leave their *pueblos* behind; large numbers arrived in the western Lacandón valleys or Las Cañadas and its immediate surroundings, looking for new prospects in agriculture.

The EZLN had launched a "Lacandón Rebellion" and not a "Chiapas Rebellion." Most important for the Zapatista population were the western valleys of Las Cañadas de Ocosingo (populated by Tzeltal and Chol Maya) and Las Cañadas de Las Margaritas (a Tojolabal Maya area). They had begun to clear the fields in a kind of pioneering agricultural communities. It was their Promised Land, the only future that landless migrants from the highlands felt they had. The majority had brought their memory of Maya town life—which

12. De Vos, *No queremos, Viajes, Vivir,* and *Oro verde.*
13. De Vos's *Oro verde*; see also Leyva Solano, "Catequistas," and O'Brien, *Sacrificing,* 67.

had lived on despite the abolition of the *república* constitution after Indepen-
dence in the early 1820s—with them to the new surroundings. Spread out,
dispersed with little cohesion, their newly established communities were fun-
damentally different from the more coherent Los Altos towns. However, due
to ongoing migration and natural expansion, population growth also reached
the Lacandón, and soon the jungle was filled up. Furthermore, the Lacandón
is a tropical rainforest with poor soils. The Maya practice slash-and-burn agri-
culture, which needs a lot of territory. Contrary to the highland soils of Los
Altos, the returns of such tropical soils are usually poor. Bit by bit, slash-and-
burn farming deforested the jungle and degraded its fragile soils further. The
colonists became enmeshed in constant struggles, competing for space with
the timber industry in the Lacandón between the western and eastern areas,
and even with one another. By 1992 the chaos of poverty reigned again. The
Promised Land was no more.

Why the Lacandón and not the Los Altos? The communities of the Lacan-
dón settlers had been the descendants of *pueblos* from the Spanish era in Los
Altos. Since Independence they were ruled according to a system of *usos y
costumbres* or "traditions and customs." These *usos-y-costumbres* were toler-
ated in many former *pueblos* during the nineteenth and twentieth centuries
and became semi-institutionalized after the revolution of 1910. The presi-
dency of General Lázaro Cárdenas (in office: 1928-32) was the period of the
political assimilation and "pacification" of the peasants into the revolution-
ary constellation,[14] usually through the Confederación Nacional Campesina
or CNC (National Peasant Confederation), an institution linked to the rul-
ing Partido Revolucionario Institucional (PRI; Institutional Revolutionary
Party). These state institutions operated through informal networks of local
and regional power. In Chiapas this would involve *cacique* families—in the
traditional Amerindian towns the leaders were called *caciques* or nobles.[15] The
CNC had made itself essential to the allocation of resources between state and
town. Eventually, this meant that state-linked bilingual political brokers took
over the formal and informal offices of the traditional Maya leaders in their
Los Altos towns. These brokers sought to bolster their positions internally by
taking the responsibilities that went with the *cargo system*—as the rotating
system of time-consuming and expensive civil and religious offices among
the town's Maya elite was called. As political scientist Neil Harvey concludes:
"The new brokers could uphold 'community tradition' while at the same time

14. Rus, "Comunidad."

15. Neil Harvey argued that, for example, the CNC functioned within a power structure
that made state-provided goods indispensable for community development, and vice versa; see
Harvey, *Chiapas*, 54–61.

expanding their influence as labor contractors, leaders of agrarian commit-
tees, and representatives of the CNC and the PRI. [. . .] The outcome was the
consolidation of [this] group of bilingual, politically connected indigenous
caciques whose alliances with the PRI and with *ladinos* enabled them to accu-
mulate wealth and land within their communities."[16] The "indigenous" here
were Maya; the "ladinos," the non-Maya. Harvey argued that, for example,
the CNC functioned within a power structure that made state-provided goods
indispensable for community development and vice versa.[17]

Indeed, the mid-revolutionary period of the 1950s and 1960s in Los Altos
was characterized by close control of internal conflict by the village elite. Dur-
ing their period of control and afterwards, internal stratification was repro-
duced. In 1992 the anthropologist Frank Cancian acknowledged that "the new
rich are the sons of the old rich, and the new poor are the sons of the old
poor."[18] Still, the participation or willingness to participate in the cargo sys-
tem was great. For example, the civil officials in the Maya town of Zinacan-
tán served three-year terms and were selected at annual political meetings
attended by the important caciques of the township. However, new offices
were created to address labor and agrarian matters and mostly young men
from the communities began occupying these key positions, especially the
men who had been schoolteachers. They became public officials in the name
of the PRI. They controlled the distribution of communal lands.[19] The offi-
cials collected money for and supervised construction of public works, carried
out a few ritual functions, appointed committees to organize for fiestas, and
settled disputes of any kind. In short, they could profit from their position.
Anthropologist Gary Gossen affirms that these "side benefits of the cacique
system have [in January 1994] created the apparent paradox of some Chi-
apas Indian communities asking the Mexican army for protection from Indian
insurgents."[20]

The *usos-y-costumbres* of the cargo system had been the Maya way of mak-
ing community. Thanks to new opportunities, in most Chiapas communities
agriculture gave way to alternative sources of income like industry and trans-
port. In the 1960s Zinacantecos were corn farmers; they made *milpa*, or corn
fields planted with other products. Only the young and the poor took wages
from others regularly. But in the 1980s many Maya Zinacantecos seeded no
corn at all. Most men were involved in wage work all over the state, as renters

16. Ibid., 57.
17. Ibid., 54–61.
18. Cancian, *Decline*, 193.
19. Vogt, *Tortillas*, 26.
20. Gossen, "Comments," 21.

on lowland cattle and corn estates, in the oil industry, in commerce, in government jobs, and in various other economic activities like trucking. In just two decades cash income and cash expenditures had increased because fewer and fewer men were farming corn. Many became dependent on wage work. A classical conclusion can be drawn: the rich got even more richer while many others stayed poor. And it grew into an authoritarian system reserved for a small elite—as had been the *cabildo* or ruling council of the former *pueblos de indios*—which stands far away from romantic cognitive noble savage schema (CNSS) notions of egalitarian and simple agricultural "indigenous communities"; far away also from the idea of "indigenous communities" cherished by members of the M/C Project. Remember that the CNSS triggers beliefs about the "indigenous" as noble savages, leading uncorrupted, natural ways of life; despite the fact that the actual Amerindians found in the Americas around 1500 usually had been city dwellers. In some places of Chiapas caciques did maintain their traditional position, like San Juan Chamula and Chalchihuitán,[21] though with violence and aggression toward deviant subordinates. This drove many inhabitants to escape cacique power. Or they were sent away, like the members of the evangelical Protestant minorities. In fact, the evangelicals could easily be seen as political activists protesting *caciquismo,* since Colonial Catholicism expressed loyalty to "community" and the traditional cargo system and traditional rituals presided over and sponsored by the caciques.

4

This warrants a first detour. Until the early 2000s the alliance between the ruling PRI and local Amerindian elites has been highly effective. It has enabled a number of municipalities in the highlands to maintain a strong Maya identity and semiautonomy from the national government. In Zinacantán, from the 1940s onward the Maya cacique Mariano Hernández Zárate controlled much of the redistribution of sources in the township, especially land. His influence weakened as he grew old in the 1960s and open trouble began in 1976 when one person was named PRI candidate for mayor against the will of others. Internal splits occurred, tax collection for fiestas broke down, and there were fights, jailing, and continuous disputes over the control of the town hall. The willingness to accept cargoes decreased rapidly. Cancian acknowledged that the events may be seen "as a struggle to fill the power vacuum left by the

21. Ouweneel, *Alweer.*

demise of Mariano Hernández Zárate."[22] Population growth had caused alternative employment possibilities and this, I think, decreased the need to accept cargoes. I suggest that the "subordinates" had formerly accepted to "please" the cacique in exchange for access to the resources—especially the distribution of land that the cacique had controlled in the town for three decades. This was a crisis of traditional community control, a crisis in the basic unit of Amerindian social organization and state control. It was the demise of personal power bonds within the community after the death of the *patrón,* which in itself had little to do with the forces of the world market.

Other parts of Mexico and perhaps regions elsewhere in Amerindian America underwent similar crises. The traditional highly stratified and authoritarian rule of the Amerindian towns, first by *cabildo* and *caciquismo* under Spanish rule and then by *usos-y-costumbres* since the 1820s, is under pressure to democratize. Lynn Stephen, a distinguished anthropologist of the Zapotec-speaking population of Oaxaca, the state bordering Chiapas to the north, defines *usos-y-costumbres* as "indigenous claims to local governance and legal autonomy through customary indigenous law and systems of governance in Mexico [. . .], built around different understandings of rights, justice, punishment, and security than those of the state," and officially recognized by the Congress of the State of Oaxaca in 1994.[23] In 2007 the major consequence of this by-now-antiquarian instrument surfaced in Oaxaca: androcentric power structures. That year, twenty-seven-year-old Eufrosina Cruz Mendoza was elected *alcalde* (mayor) of the Zapotec *usos-y-costumbres* town of Santa María Quiegolani in Southeast Oaxaca State—a town of 1,300 inhabitants. She was not assigned to the post, despite the fact that she was Zapotec. The current Zapotec mayor, Saúl Cruz Vázquez, responded: "Here, women do not exist."[24] He added that "women were created to assist the men, to prepare meals and raise the kids, but not to rule" because women "had no idea about government."[25] The ballots with Cruz's name marked on them were destroyed,

22. Cancian, *Decline,* 128.

23. Stephen, *We Are,* quotes from resp. 30, 278, and 69.

24. This is from Eufrosina Cruz's website "Quiego. AC," at http://blog.quiego.org/search ?updated-min=2007-01-01T00:00:00–08:00&updated-max=2008-01-01T00:00:00–08:00&max -results=1. See also, among many more reports, Francesc Relea, "La rebellion se llama Eufrosina Cruz," *El País* (Madrid) February 10, 2008, also at http://elpais.com/diario/2008/02/10/ internacional/1202598001_850215.html (both accessed 1/14).

This history has been skillfully recorded by Spanish reporter Marta Gómez-Rodulfo and beautifully illustrated with photographs by Antonio Turok. The book—*Alas de maguey: La lucha de Eufrosina Cruz Mendoza* (2012), with a preface by Elena Poniatowska—serves as a manifesto against the male dominance of Zapotec traditions.

25. From "Quiego. AC," at http://blog.quiego.org/search?updated-min=2007-01-01T00:00: 00–08:00&updated-max=2008-01-01T00:00:00–08:00&max-results=1 (accessed 1/14).

and after "women are of no value in politics," Eloy Mendoza Martínez was installed. Eufrosina Cruz claimed her victory, supported by other women and some men—whom the new mayor's group later on addressed as idiots, drunks, and gay. When Eufrosina Cruz appealed to the Congress of Oaxaca she received death threats.

In Quiegolani, Eufrosina Cruz had always been known as a rebel. At the age of eleven she ran away from home because her father had arranged for a marriage with a much older man. In Oaxaca she had learned to speak Spanish and eventually received a proper university education. This was in fact a life much better than that of her older sister, who had been given away "in property" to another Zapotec community member in Quiegolani to breed at least nine children. Within a year, Eufrosina Cruz had become the figurehead of a women's movement in Oaxaca, uniting all social classes and "ethnic" groups, combating reactionary "indigenous" politics. Oddly enough, Eufrosina Cruz found political refuge with the Partido de Acción Nacional (PAN; National Action Party), a conservative party and at the time under the leadership of President Felipe Calderón (in office: 2006–10). Nevertheless, Eufrosina Cruz had laid bare the political tension between "reformist indigenists" like herself and "conservative indigenists" like the power holders in her town. The latter are in general sometimes supported by activists from outside, especially the ones who in a way regard the inhabitants of towns like Quiegolani as a kind of noble savages—indeed, the CNSS again.[26]

Most certainly, the State of Oaxaca is known for many communities applying *usos-y-costumbres*—418 out of 570 municipalities practice this type of government (73 percent). But a chain is no stronger than its weakest link. Eufrosina Cruz's actions through *ab-usos-y-costumbres* or "*abuses* and customs" of women's rights under "indigenous" rule were received by the men in power as an assault on the "indigenous" case in the first instance.[27] Although people like Eufrosina Cruz operate at the "indigenous" side of the Colonial Divide, and her "decolonizing attitude" is directed toward the destruction of sexism, her opponents experience her activities as the destruction of "indigenous" rule in Oaxaca in general. There can be no doubt that the Amerindian societies have always been very dynamic; amerindianizing or "making their own" beliefs, customs, and products from elsewhere on the continent or from Europe or Asia. Any essentialist vision of the "traditional community" encoded in the CNSS does no justice to them. It is nonsense to say that the Amerindians welcomed the Spaniards, colonialism, and the succeeding colo-

26. Gómez-Rodulfo, *Alas.*
27. Eisenstadt, "Introduction"; quote on *abusos y costumbres* from 7.

niality, but although it was governed by imperious Amerindian nobles, the Amerindian Order—*república de indios*—that came with the Colonial Divide proved to be an instrument for recreating their culture within the modernity of their times, as is the "indigenous movement" today. Indeed, given that opposing groups claimed to defend "authentic customs" and faced violent conflicts between "indigenous" municipal factions, one participant in Quiegolani responded with: "What we have doesn't work anymore; what we need are new customs."[28] This is also an appeal to reform the cognitive schemas of what constitutes as "indigenous" in Quiegolani.

My own research taught me that the *república de indios* under Spanish rule gave the *indios* a kind of semiautonomy and semi-self-rule as well as protection from the encroachment on their lands and labor and tribute obligations, again, in spite of their authoritarian governing structure—or perhaps thanks to it. Exploitation, poverty, the abuse of hacendados, and the loss of lands reached their communities mainly in the nineteenth and twentieth centuries, when the Latin American economies became integrated into the age of modern imperialism of the West. More than classical Spanish colonialism, the Amerindians would recognize their entrance into a black era of poverty and discrimination as a consequence of the increasing wealth of Western Europe and the United States. The memory of this situation lives on in modern-day "indigenous movements," using the scripts, scenarios, and stereotypes of the CNSS as a straitjacket of all sorts of characteristics that bound the "indigenous" to a rural lifestyle. Because it leaves the Colonial Divide intact, any designation as "decolonial" in this case escapes me. Despite the attempt to reform sexism, the case of Eufrosina Cruz still indirectly *confirms* the Colonial Divide.

5

Back to eastern Chiapas in 1994. The Lacandón migrants had escaped from the burdens of overpopulation and the obligations of *usos-y-costumbres*. We know that the free-market reforms of the administrations of Miguel de la Madrid (in office: 1982–88) and Carlos Salinas de Gortari (in office: 1988–94) had excluded Maya from Los Altos from markets in and outside Mexico. Mgr. Samuel Ruiz García, Bishop of San Cristóbal de Las Casas, had reported that the miserably poor peasant communities of Los Altos were increasingly frustrated by government neglect of their needs: "We spoke out, but there was no

28. More on Eufrosina Cruz in Juan Martínez, "What," 146–47; quote from 163.

echo."[29] The caciques had ruled the villagers by keeping order with violence, arranging the voting of the townspeople, owning the stores where they shop, and buying their corn for prices much too low. Cattle ranchers to the north and east of Los Altos—*ganaderos*—had taken over high jungle land that was promised for *ejidos*—collective agricultural communities, fruits of the reforms of the 1930s and 1940s, which followed the 1910 revolution—and existing *ejidos* became concentrated in the hands of an ever smaller portion of their members.[30] We know, finally, about the agricultural industry with its large landowners, who wield quite a bit of power in the state. Land-hungry peasants had invaded hundreds of hectares of agricultural land in the state, while the cattle ranchers whose land was threatened muttered about their willingness to take up arms themselves. But the inhabitants of Los Altos de Chiapas did *not* take the radical solution of going to war in 1994. The Maya of Los Altos had tried to opt for the most legal way: court cases, elections, political protests, and marches. Some communities in Los Altos had arms, but left them mostly unused. Even the occupation of town councils endured without open warfare.

The decision to go to war was made in the Promised Land of the Lacandón, some 150 kilometers to the east of Los Altos. One reason was deep frustration after two government decrees cut off the future entrance to new lands. One of these was issued to protect the Lacandón from further exploitation and destruction. The other one consisted of the much-debated revision of Article 27 of the Mexican Constitution in early 1992. Both decrees were issued by the presidency of Salinas de Gortari. The first was intended to create an ecological haven for rainforest flora and fauna. It obstructed the younger peasants in the jungle—children of the first colonists—from finding new opportunities for agriculture near their parents' homes. The possibilities for geographical expansion in eastern and southern directions were over. Because Article 27 had encompassed the possibility of a fruitful claim on hacienda lands for redistribution among peasants, its modification cut off peasant expansion to the areas bordering the Lacandón in the western and northern directions, where a considerable number of the large estates in Chiapas could be found. "This slammed the door shut for indigenous people to survive in a legal and peaceful manner," Subcomandante Marcos later declared.[31] The second decree aimed to "modernize" Mexican agriculture and abolish the *ejido* system of collective agriculture. In the eyes of Salinas de Gortari's technocrats, by the end of the twentieth century the *ejido* was considered an anachronism, impeding

29. Fazio, *Samuel Ruiz*; MacEóin, *People's Church*.

30. But note: contrary to the history of the word, the *ejido* was *not* similar to the English commons. Most of the lands were distributed and eventually sold on a private basis.

31. Stephen, "Zapatista Opening," 15.

economic progress in the countryside. This formed part of the North American Free Trade Agreement, or NAFTA, with the United States and Canada in January 1994. The withdrawal of credits was a deliberate choice of the Salinas de Gortari administration. We can label this the collapse of economic support for the peasants. Also important was the deterioration of maize yields after decades of uncontrolled expansion into the jungle. This resulted in the reduction in slash-and-burn farming cycles from thirty to two years.[32]

The landless peasants found themselves without much future. Some villagers from the jungle area had pressed their demand for expansion of their *ejido* for more than a decade without any quick solution.[33] One villager said: "But they always lied to us. They would tell us to go home and get a certificate of this or that and then come back on such-and-such a date. So we would go back on the appointed date, and they would say, 'Oh, no, El Señor isn't here, he had to leave, come back another day.' And we would come home again, thinking, well, it couldn't be, and now we've spent our compañeros' money on the trip. And then the government changed Article 27, and now we can't file a claim on that land anymore, and we'll never be able to take out a loan, because the interest rates are very high, and if we don't pay our debts on time the bank can take the land we have away from us. The end of Article 27 was what made us decide we'd had enough."[34] Salinas closed a door that always had stood open. In January 1994 the Zapatistas would demand the reparation of Article 27. They attacked the cattle producers' offices and occupied the town of Ocosingo in the center of the latifundista area. It was their hope to reopen the entrance to this last resort for the landless.

The need for a solution to the problem could not have been more acute. Misery all over Chiapas had intensified. Within the Mexican state, Chiapas led in infant mortality, illiteracy, no running water or electricity. "The river-rich state provides one fifth of the country's electricity and a third of its coffee production, but none of this wealth trickles down to the various Maya peoples," well-informed U.S.-Mexican journalist Alma Guillermoprieto wrote at the time.[35] About one million persons occupied a little over three million hectares of land, of which only about 40 percent was classified as good for agricultural use.[36] Though some intensification took place, only one new profitable cash

32. Hernández Navarro, "Chiapas," 51; Aubry, "'Lenta.'"

33. Hernández Navarro, "Chiapas."

34. Guillermoprieto, "Letter," 54. Also Benjamin, *Rich*, 95–143, 223–43. Collier, "Reforms," 119, saw the revisions of Article 27 as a modernization of the agrarian code to conform to realities already in place, and not so much as a change.

35. Guillermoprieto, "Shadow," 34.

36. Harvey, *Rebellion*, 7.

crop could root: coffee. Soon, some seventy thousands of the 190 thousand coffee growers in the country lived in Chiapas; seventeen thousand alone in the Lacandón Jungle. During the 1980s in the tropical lowlands around Los Altos bordering the Lacandón, private capital developed commercial enterprises to produce soybeans, peanuts, sorghum, tobacco, bananas, cacao, and sugar in greater amounts than before. The production of meat quadrupled in just a decade, but the market for coffee collapsed. In June 1989 the International Coffee Organization failed to agree on production quotas and the world price fell by 50 percent. In the end both productivity and total output in the sector fell strongly between 1989 and 1993. Small producers suffered a 70 percent drop in income without much possibility of climbing out of their debts and poverty.

Next to Article 27 and the coffee crisis, a third factor influenced radicalization in the Lacandón. The creation of the Reserva de Montes Azules in the center of the Lacandón cut off a very large area. Although by official decrees issued in 1957 and 1961 the jungle was declared open for colonization, now a fence was built. Although in 1972, in an attempt to stop the colonists from penetrating too far into the limber areas, the government had issued a decree declaring a part of the forest free from colonization, landless peasants from Chiapas, Oaxaca, and Veracruz had settled there. The creation of the Montes Azules National Park was followed by the foundation of the Comunidad Lacandona, supposedly owned by sixty-six families of Maya Lacandones. Almost ten thousand colonists had to move to other parts of the forests. According to writer Carlos Montemayor, the displaced of Las Cañadas recall this procedure as the germination of resistance.[37]

In short, the Zapatista Lacandón Rebellion of 1994 had been a revolt like many others: against exclusion and neglect, against exploitation and abuse of power, and nothing to lose. Crucial for the argument of the Unconscious and *Colonialidad* under modernity is that the Maya communities in the Lacandón cannot be interpreted using the CNSS. The new Lacandón settlers had developed a different political and social structure. The "new communities" in Chiapas built a "mixed" Maya culture of the different migrant communities, blending series of cognitive schemas of how to do things in life. The caciques system was no part of this. As time has gone on, anthropologist Jan Rus affirmed, a pan-Maya culture seems to have been adopted, as the basis of higher levels of organization and *opposition* to the highland *usos-y-costumbres*. After a few decades every highland community had former members living

37. Carlos Montemayor, "El agrarismo y la Selva Lacandona," *Proceso* 2137 (26 September 1998): 41.

in "new communities" in the Lacandón, with the result that there is probably not a family in the highlands that does not have relatives participating in "new" organizations. Most of these people were in contact with each other, exchanging information and ideas. In fact, because most *usos-y-costumbres* communities were conflict ridden—fraught with factionalism in which parties contend for the power to designate who belonged to the community and what were its traditions and customs—the political prospects before the "new" communities" sounded more promising.[38] Furthermore, Gossen believes that the grassroots support for the Zapatistas derives, in part, from the great concentration of displaced individuals: "Many of them have nothing to lose, and perhaps something to gain, through political activism."[39]

The "new communities" were built not on traditional Amerindian foundations of hierarchized governing elites but on the teachings of Western-schooled intellectuals. In Las Cañadas, three outsider groups had constituted the character of the "new" Maya colonists. First, Roman Catholic liberation lay deacons and fieldworkers had entered the lowland jungle on the initiative of Bishop Samuel Ruiz García of San Cristóbal. From the late 1960s onwards the bishop was one of the principle liberation theologians of Mexico, indeed of Latin America. In fact, in putting the tenets of the Medellín Conference of 1968 to work, he was one of their leaders from the beginning. His work was characterized by preaching a radical gospel in favor of the Amerindian poor. Like the Maya colonists, the bishop saw the Lacandón forests as their Promised Land. He commissioned a translation of the *Book of Exodus* into Tzeltal. In October 1974 he had organized an Indigenous Congress in San Cristóbal to commemorate the 500th anniversary of the birth of Fray Bartolomé de Las Casas. Since then, a network of lay preachers worked among the pioneers in the Lacandón to work out Catholic liberation and support the poor. The message was that only radical egalitarianism could lead to "salvation." The lay deacons hoped to create a society free of what they call the *social sin* of Mexico's unequal, inegalitarian capitalist society. Important was that in preparation for the Congress, the diocese had set up an educational program in the villages, including courses in agrarian law, history, and economics. These courses offered the first political schooling to community leaders in the twentieth century. Later, the lay preachers became more radical and went even beyond the bishop's policies to revolutionize the peasants' ideology. Nevertheless, the Church remained the protective umbrella for Maya groups, giving legitimacy to their demands for land and for the protection of human

38. Rus, "*Jelavem*," 18; Guillermoprieto, "Letter," 54.
39. Gossen, "Comments," 21.

rights. The bishop had set up a human rights office that had performed an essential task in defending the Maya population. The cognitive schema that co-influenced the bishop's policies was of course the CNSS, and the current Zapatista egalitarian discourse finds its root here.

Second came the Maoists of Política Popular (People's Politics), on the initiative of Mexico City University professor of economics Adolfo Orive Berlinguer but invited, in a way, by Bishop Samuel Ruiz, who had met the activists in Torreón (Coahuila, Northern Mexico) in 1976.[40] Although it should be stressed that from the mid-1970s onwards the Mexican Maoists no longer promoted armed struggle,[41] these men and women had also worked in Mexico City, and some had even been invited to go to North Korea for guerrilla-warfare training.[42] The political fieldworkers spend the stretch to 1984 organizing the colonists' communities to win bureaucratic battles for land, press for agricultural credits, subsidies, and education. In vain, the Lacandón became overpopulated, without much relief from poverty. Some communities sent the Maoists away during the mid-1980s (although they returned within a few years) because they had felt that a part of the Maoist-bred leadership in their own ranks had become too close to the Mexican bureaucracy, even negotiating behind their backs or "selling them out." By the mid-1980s the Maoists had succeeded in reorganizing local decision-making. They also had set up a system for egalitarian decision-making (CNSS!) that included every voice of the community, including that of children. This is what is meant by "democracy" in the Zapatista declarations. However, small assemblies—*asambleas chicas*—consisting of some five to ten leaders from the Maoist vanguard worked out proposals and became crucial in setting the agenda. Many of these small assemblies were guarded by non-Maya community workers.

By the end of the 1980s a third group had done its work in strengthening or constituting the utopian character of the communities. This group consisted of Euro-Mexican (*white*) or *mestizo* guerrilla fighters that formed the leadership of the EZLN. Some most likely were veterans of the 1970s guerrilla rebellion in the state of Guerrero, or had worked in the slums of northern cities. Among them was Subcomandante Marcos, its eventual leader, who is thought to have worked several years in Nicaragua as well.[43] They were and remained independent of the unions and included a small group of twelve

40. Curiously, Orive later served the Salinas Administration as the Coordinator of Advisers on Social and Rural Policies, and later on the Zedillo Administration.

41. Romero Jacobo, *Altos*, 75–89; Melgar Bao, "Utopías."

42. Interviews with Zapatista leaders in *La Jornada*; see my *Alweer*, 208.

43. Other names frequently heard are those of Fernando Yáñez, Jorge Elloreaga Berdegue, Jorge Santiago, Silvia Fernández Hernández, and María Gloria Benavides.

political activists from the Central Mexican highlands—or five, as Subcomandante Marcos repeatedly stated. Initially, the EZLN had been quite traditionally Marxist in origin. From 1983 on, they sought a newly armed revolution and thought that the Promised Land of the Lacandón colonists was the perfect place to begin. The bureaucratic battles led by Orive's men had not brought many victories, and the new radicals convinced the peasants that they never would: "More than anything, it's like an aspirin; when your head aches, it doesn't cure the illness, but only relieves the pain for a little while."[44] They offered to train the peasants in armed struggle and waited in the Lacandón Mountains near the Guatemalan border until they presented themselves. After nine years, in 1992, many youngsters did. To connect to the Maya population, the EZLN changed its conception, appropriating specific Maya schemas, starting to obey a Maya Council. The Zapatista guerrillas had not been identical to the Lacandón settlers but adapted themselves to their worldview—which rang a bell, because it had some crucial Western roots after all (CNSS)—and attracted hundreds of young Lacandón settlers or older settlers' children.

In the end Subcomandante Marcos highlighted the Maya unity whenever he could. He stated several times that the ideas of the non-Indian guerrillas were turned over by the Maya conceptuality. He said: "We are the product of a hybrid, of a confrontation, of a collision in which, luckily I believe, we lost."[45] However, this setback facilitated growth, from eighty to thirteen hundred members in 1989 alone; and after 1992, after the 500 Years of Struggle Movement—in the wake of the Columbus Memorials and the reforms of the Salinas administration—a mass of youngsters joined the guerrillas.[46] Subcomandante Marcos convinced everyone that the Zapatistas had a true collective leadership, the Comité Clandestino Revolucionario Indígena (CCRI; Clandestine Indigenous Revolutionary Committee)—a self-proclaimed council of corporate Maya leadership "in resistance."[47] For sure, the EZLN had other commanders, including the *comandantes* David, Javier, Daniel, Gerónimo, Guillermo, and Rafael. At the time, apparently no women were included, but as reporter John Ross found out, the CCRI was composed of delegates from various jungle committees and was responsible to the committees, which are in turn responsible to the local communities in the Selva Lacandona.[48]

44. See "An Interview with Subcomandante Marcos," by Michael McCaughan, in *NACLA: Report on the Americas* 28.1 (1994): 35–37, quote on 37.

45. Harvey, *Chiapas,* 167.

46. Ibid., 166–67.

47. Ross, *Rebellion*; also http://www.ezln.org/archive/ezln000510.htm (accessed 5/2000).

48. Ross, *Rebellion*. During the latter years of the movement, indeed more "anonymous" *comandantes* acquired the status of the factual and personalized Zapatista leaders, including Comandante Tacho and Comandante Moisés; see http://www.ezln.org/Guadalupe_dibujos/

6

Despite all the influences and practices of outsiders, when the Clandestine Indigenous Revolutionary Committee (CCRI) spoke out on February 27, 1994, it echoed ancient Maya beliefs. The poetic CCRI communiqué was issued officially on the last day of 1993 but arrived in a series of selected offices around the world by fax during the first days of 1994:

> When the EZLN was only a shadow, creeping through the mist and darkness of the jungle, when the words "justice," "liberty" and "democracy" were only that: words; barely a dream that the elders of our communities, true guardians of the words of our dead ancestors, had given us in the moment when day gives way to night, when hatred and fear began to grow in our hearts, when there was nothing but desperation; when the times repeated themselves, with no way out, with no door, no tomorrow, when all was injustice, as it was, the true men spoke, the faceless ones, the ones who go by night, the ones who are jungle [. . .]. The world is another world, reason no longer governs and we true men and women are few and forgotten and death walks upon us, we are despised, we are small, our word is muffled, silence has inhabited our houses for a long time, the time has come to speak for our hearts, for the hearts of others, from the night and from the earth our dead should come, the faceless ones, those who are jungle, who dress with war so their voice will be heard, that their word later falls silent and they return once again to the night and to the earth, that other men and women may speak, who walk other lands, whose words carry the truth, who do not become lost in lies.[49]

Returning to the night could mean being killed—a sacrifice anyway.

The Communiqué reads as an autobiography of an intervening agent, who comes to respond to abuse or chaos, intervenes to end it, and leaves again, perhaps sacrificed. The leadership of the Lacandón settlers described

(accessed 5/2000). According to a communiqué of May 10, 2000, by then Comandante Moisés had become the second in row after Subcomandante Marcos. Although the stream of communications published by Subcomandante Marcos from 1994 onwards are all except a few "in name of" the EZLN's collective leadership, the texts themselves give the impression that the subcomandante was nevertheless more or less free to issue whatever he liked, above all on no-military, political issues. In short, these *in-name-ofs* seem ritualized additions to private documents of the subcomandante.

49. "Communiqué from the Clandestine Indigenous Revolutionary Committee High Command of the Zapatista National Liberation Army (CCRI-CG del EZLN)," made public by telefax, e-mail, and on paper on February 27, 1994. Also published by *Cultural Survival Quarterly* 18:1 (1994): 12.

the EZLN soldiers as "faceless ones": Faceless Warriors. They were an anonymous force who were "jungle" and who "dressed with war so their voice would be heard." The Faceless Warriors came from the Mountain, as the Lacandón was described, containing the immemorial power of the trees and the forests. The Mountain was a reference to the Face of the Earth where the ancestors ruled. Although they had modernized economically and above all politically, they still shared this ancient Maya belief about the world and the ancestors as, for example, sculptor Diego Chávez Petzey from Santiago Atitlán, whom we met at the end of chapter 2. And like the *pueblos* under Spanish rule, they were able to integrate and adopt non-Amerindian artifacts, customs, and ideas into their own culture through amerindianization. After the Faceless Warriors' intervention, their word would fall silent and they would return once again to "the night and to the earth" in order that other men and women would be offered space to speak and to walk other lands; endowed with words that would carry the truth and who would not become lost in lies. In short, the Faceless Warriors and their lives on the Mountain as embodied ancestors were only passing.

The February 27 Communiqué of 1994 was a critique on the failed reciprocity between the pairs who stand at the core of the Colonial Divide: the rulers of the nation did not bring the community of the nation into salutary movement. In the First Declaration of the Lacandón Jungle, the Zapatista Lacandón leadership had expressed this prospect as follows: "Here we are; the dead of all times, dying once again, but now with the objective of living." It looks as if Mexico as a country favoring a peasant's life was finished and as if, in response, something entirely new, and yet very old, seemed to have manifested itself: to be endowed with new life for their own form of organization. As if mere instruments of time, the CCRI presented the ski-masked or Faceless Warriors in its specific statements of February 1994, as a sign of the end of chaos. This was the face of the "First Phase Zapatistas." If there was a "voice from the jungle," a sound that represented these first formative years in the Lacandón, this was it. The interesting thing here is of course that the youngsters went to participate in the EZLN as "the dead of all times" in the moment of utter chaos. It looks as if they were indeed searching for the intervening agent, found him in Marcos and his small group, and turned themselves into their instrument of total turnover under the leadership of the CCRI.

The "voice from the jungle" was a voice coming from the Maya "Unconscious," from the encoded networks of cognitive schemas in the Maya theater of the mind. The voice connected to a series of other schemas. First, there was the Amerindian cyclical time schema. Unlike our Western version, Amerindian revelation is cyclical. This means that everything that *is* today, once

was, and will also *reappear* sometime. Looking at the past, one may know the future. Therefore, Amerindians poetically see the past in front of them. The past delivers the prophecies of the future. Time would repeat itself periodically according to fixed cycles, and people could anticipate the next cycle long before it actually came, and could accordingly try to force—also without being conscious of it—the fulfillment of its prophecies. What has happened will happen again. This threat that time poses in the scripts that rule Amerindian peoples' being-in-the-world is understood as a tyranny connected to their chronotopes. Cycles would repeat themselves in 260 days, 52 years, 260 years, and much more. This chronovision was not a deification of time, says Gossen, "but an acknowledgment that all things, human and natural, were programmed with shifting valences of cause and effect dictated by divine cycles located outside the body."[50] Variants of the ancient beliefs, Gossen continues, persist today, and humans have no choice but to adjust their behavior accordingly.

As an agent of time the old hero of the Mexican Revolution (1910–20), Emiliano Zapata, is very present in one of the official statements of the CCRI, the one issued on April 10, 1994. In the document, Zapata appears as a major deified warrior of the EZLN. In fact, he has materialized as the source of life itself: "Votán Zapata, light from afar, came and was born here in our land. Votán Zapata, always among our people, timid fire who lived 501 years in our death. Faceless Man, tender light that gives us shelter. Name without name, Votán Zapata watched in Miguel, walked in José María, was Vincente, was named Benito, flew in bird, mounted in Emiliano, shouted in Francisco, visited Pedro. He is and is not all in us. He is one and many. None and all. Living, he comes. Without name he is named, face without face, all and none, one and many, living dead. Tapacamino bird, always in front of us. Votán, guardian and heart of the people. He is the sky in the mountains."[51] This Votán Zapata came to "our mountain" to be reborn. He took the face of those without faces. Because of his presence, the CCRI explained, unjust peace was *transformed* into a just war: death that is born. This is order reborn out of chaos, a classic theme of Mesoamerican culture indeed.[52]

50. Gossen, *Telling,* 254.

51. *La Jornada,* April 11, 1994. The names appear of Miguel Hidalgo, José María Morelos, and Vicente Guerrero, heroes of the independence movement of 1810–21. Also mentioned is Benito Juárez of the Reform Movement in the 1870s, the great hero of the Mexican nation, and Emiliano Zapata and Francisco Villa.

52. To me, the name of Votán is known from the work of Fray Ramón de Ordoñez y Aguilar. In 1773 this canon of the cathedral town of Ciudad Real in Chiapas (San Cristóbal) went to visit Palenque. The ruins had so much impact on him that he decided to write a book on the place and its history. He claimed to have received the material from a book, written by

Second, there is the face. Anthropologist Munro Edmonson, known for his editions of two of the most important documents on the Mayan faith—the *Popol Vuh* and the *Book of Chilam Balam of Chumayel*—writes that the Maya see the face as one's visible self.[53] It is the most important projection of one's ego and must be carefully protected from insult, criticism, and ridicule. To destroy the enemy is to destroy his face. Classical Maya art is known for its destroyed faces, the literal defacement of the portraits of deified rulers at the ending of a dynasty. Because also speech is an external manifestation of the soul, the face is strongly linked to the mouth. The prominence of masks and disguises in Mayan ritual and the rigid formalization of speech militate against the easy assumption that things are what they seem, Edmonson continues. Faceless and masked men are not only shielded against insult and ridicule or, indeed, against violent assaults, by their masks, they can also act as men ritually transformed into sacrosanct warriors. Then, these warriors are men sacrificed to God and the saints; the spiritual powers who command over life and death, the very existence of human families and the rebirth of society. The sacrifice of the warriors is at the very center of Maya belief. In ancient Maya language, sacrifice is not summed up in a unitary word, Edmonson concludes, because it is the point of nothingness, the point at which the 0 of death equals the 1 of life.

Combining the first two Amerindian schemas mentioned here means that the sheer consequence of cyclical thinking is an attitude of *non-defeat*. A good source to demonstrate this is the "Battle Mural" of the eighth-century palace of Cacaxtla, in Tlaxcala, from about the year 700. In late pre-Hispanic Mexico, Eagle Knights and Jaguar Knights had fought with the Aztec emperor, sometimes during the Wars of the Flowers—ritual warfare—with the Central Mexican lordship of Tlaxcala. The mural shows us a battle, a bloody scene, with Jaguar Knights slaughtering Eagle Knights. It is a sacrifice or ritual combat. The theme is clearly one of predator versus prey in which the executioners wear jaguar skin capes and their unarmed victims are dressed as quetzal birds and parrots. Interesting is a suggestion made by Mexican ethnologist Sonia Lombardo after she read in a sixteenth-century document that the kings of nearby Cholula were later called Aquiach or Upper-King and Tlalchiach

Votán himself in K'iché. Votán was said to have traveled from the land of Chivim, Ordoñez thought, somewhere in the Near East, to the Americas and to have settled in Palenque. He is said to have submitted the Amerindians and founded the cities of which the present ruins are its remnants. According to Ordoñez, Chivim must have been the city of Tripoli in Phoenicia. Curiously, Votán's name stuck to the Amerindians of the area; or must indeed have been known there before and inspired Ordoñez to write this peculiar narrative. See Ouweneel, *Alweer*.

53. Edmonson, "Mayan," 71.

or Lower-King. The Upper-King reigned during the rainy period, supervised sowing, and arranged for the administration in the city itself; the Lower-King reigned during the dry period, supervised the harvest, and arranged for relations with outsiders. In short, the Upper-King stood at the beginning of the yearly cycle, the Lower-King at the end. It seems that a blood sacrifice during a play, a dance, a ritual battle or a true battle included a bird hunted and caught by a jaguar or any other large animal on four legs. The goal was blood sacrifice, not victory. The blood was sacrificed for a new dawn, some new cycle to begin, to have the land fertilized, and the like. The captured bird was not defeated but sacrificed to feed the divine powers. This means that the "sacrificed" could expect to be fed by them.[54] The victor would be caretaker, the defeated the one who is taken care of. If this picture is accurate, and if it can be used to interpret the Spanish invasion of the early 1500s, then the Amerindians did not felt defeated in our sense of the word either. And the colonized would have the idea that they needed to be taken care of by the colonizers. If the latter would not fulfill this promise, the colonized have the right to remove the colonizers from power.

Another curiosity is the confirmation of Amerindian schemas by the colonists. Louise Burkhart's *The Slippery Earth*'s (1989) discussion of Nahua-Christian moral dialogue in sixteenth-century Mexico demonstrates that using Native American terminology could lead to the opposite of their wishes, in fact to a confirmation of Amerindian religious motifs and beliefs instead of introducing a new religion. Take the Roman Catholic concept of sin, in Spanish *pecado*. The Nahuas of Central Mexico used the concept of *tlatlacolli*. This meant something damage, spoiled, harmed, polluted, corrupted. As Burkhart argued, "Any sort of error or misdeed could be labeled a *tlatlacolli*, from conscious moral transgressions to judicially defined crimes to accidental or unintentional damage."[55] Afterwards, the order or the world ran into danger. This could take some time, in an accumulating annoyance of the deities. But it had not at all the terrifying consequences of Roman Catholic *pecado* in the afterlife of purgatory or hell. By insisting on the word *tlatlacolli*, the Nahuas recognized their own concepts that made it easier to continue the practices of their own religion in the churches of the missionaries instead of being "truly" converted.[56] Later, however, the Spanish missionaries would eventually realize that they unwittingly confirmed Amerindian cognitive schemas and that they had to describe the mysteries of Christianity in Native American concepts.

54. Lombardo, "Pinturas."

55. Burkhart, *Slippery*, 28; italics in original. For a similar case, see her *Holy Wednesday*.

56. Ibid., 28–29. As anyone in Europe will agree: this is quite similar to the history of Christianity in Europe; see Bossy, *Christianity*.

On the other hand, for Subcomandante Marcos the word "faceless" meant something completely different than for the Maya. He had appeared ski-masked in the town hall San Cristóbal de Las Casas on the day of the uprising and has not left the stage without his mask since then. Shortly after the taking of the Municipal Presidential Palace of San Cristóbal de Las Casas in January 1994, he spoke with several journalists. The journalist of the *La Jornada* daily reported to the newspaper on January 19, asking Subcomandante Marcos why the Zapatistas wear ski masks. Subcomandante Marcos answered that he wished to be careful that nobody would try to be the main leader or that others—the newspapers, for example—would pick one: "The masks are meant to prevent this from happening. It is about being anonymous, not because we fear ourselves, but rather to avoid being corrupted. Nobody can then appear all the time and demand attention. Our leadership is a collective leadership and we must respect that. Even though you are listening to me now, elsewhere there are others who are masked and are also talking. So, the masked person here today is called 'Marcos' and tomorrow it might be 'Pedro' in Las Margaritas, or 'Josué' in Ocosingo, or 'Alfredo' in Altamirano, or whatever he is called. [. . .] The only image that you will have is that those who have made this rebellion wear ski masks. And the time will come when the people will realize that it is enough to have dignity and put on a mask and say that they too can do this."[57]

7

This brings us to the intervening agent script, or IAS, as a schema for intervention. Being recreated at every instant it was used, it has survived the passing of time. There are some general characteristics that are easily recognizable. Usually the intervening agent's activities last a short time, sometimes even almost like a thunderbolt. More than often, the intervening agent is female as a character or as a force. In classical Mexican narrative, the character is called the Woman of Discord. In Nahua (Aztec) belief she replicates the earth-mother deity, and it may be that shortly after the Spanish conquest her role was also connected to the New Sun of Christ. Typically, as a power in between cycles the Woman of Discord endows males, or male forces, with powers to take over the new cycle and is then sometimes sacrificed. The Woman of Discord creates life and then dies—literally or figuratively. As part of a narrative, we may imagine the experiences of the protagonist going downhill step by

57. (Autonomedia), *¡Zapatistas!*, 62–63.

step until reaching a nadir. At that moment the intervening agent terminates the pandemonium of the protagonist's experiences and life for the protagonist improves, again step by step, until a kind of order has been reached again. The intervening agent's position has now become superfluous and she leaves the narrative—sometimes violently by death, as if sacrificed. Interestingly, as we shall see in some narratives, the intervening agent had herself an *improving* set of experiences in a row, reaching a peak at the moment she intervenes in the protagonist's sequence—going through a reverse cycle as the narrative's protagonist.[58] Listening to centuries-old stories and looking at a feature film built on the crucial role of an intervening agent encodes that role of that agent for the specific situations of distress presented in the stories and by the films. If these listeners and viewers then experience distress, they trigger the intervening agent schema—or, better: the intervening agent script, for it is a schema for an event—as a simulation (in their minds) and as a simulator (in their entire body) that brings to act.

The Woman of Discord is the topic of four out of seven chapters of Susan Gillespie's celebrated study on the construction of rulership in Mexica history, *The Aztec Kings* (1989).[59] Two features stand out. First, in ancient American history a historical cycle follows a pattern without being a true replica of any previous cycle. Because also dynasties, political systems, and governments go through the cycles of sprouting, developing, flowering order, decaying disorder, and total disarray, a Woman of Discord may appear at the beginning and end of dynasties. She embodies mother, wife, and daughter in one—*past-present-future-in-one*, as with the Virgin Mary—to some male ruler. The Virgin Mary was the mother of Jesus and thus the spouse of God, but as any human she was also the daughter of God: *mother-wife-daughter-in-one*. In Mexico, on a more abstract level, her role is played by Our Lady of Guadalupe. She ennobles the new ruler; without her there is no new ennobled ruler. This type of cognitive schemas invokes a conditioned agency that restrains individual action with the bonds of tradition. Origins and outcomes of actions may be beyond people's control, but the narrative framework allows them to explain their perception of events and to shape their responses according to the cultural schema. People appear to move through a series of almost premeditated actions with largely predictable consequences by which the motifs of traditional narrative or myth appear to work themselves out in real life.[60]

In Nahua history, Quetzalcóatl, the Feathered Serpent, was invented to explain the Spanish invasion. Quetzalcóatl was a man-god returned—in

58. Gillespie, *Aztec*.
59. Ibid., 3–120.
60. Seal, "Robin," 79–81.

the body of Hernán Cortés, perhaps. For a new cycle, the Woman of Discord needs to bear the fruit of the last male on the throne—the King of Chaos, the Motecuhzoma. In Mexica history written under Spanish rule, two kings received the title of Motecuhzoma: the fifth king, Ilhuicamina or Motecuhzoma I, and the ninth king, Xocoyotzin or Motecuhzoma II. We now regard them as the first and the last true—not mythical—rulers of the Mexica kingdom. Both rulers had a daughter who married the ruler of a new dynasty. We know Xocoyotzin's daughter as Malintzin, the lover of Cortés, the lover of the "Returned Quetzalcóatl." For this role, Malintzin is seen as intervening agent, the Woman of Discord of the fall of Tenochtitlán in late 1521. She embodied the end of the previous cycle and gave birth to the new one—in her case, her son Martín Cortés, born in 1522. The Woman of Discord as the embodiment of *past-present-future-in-one* is needed to break into the home of the New Times, to impregnate herself there with the new fruit, and thereby start the new cycle. History begins in disarray and chaos; this is its fruit, in fact, thanks to the key role of the Woman of Discord. She terminates incompetence, corruption, darkness, and disorder. This was precisely the role played by the Faceless Warriors in Chiapas in 1994—although also Eufrosina Cruz's actions in Quiegolani could also be interpreted with this schema and explain in part male resistance in the town. The Faceless Warriors and their "return into the night" had announced their sacrifice; and in a way, against her will, this was also the lot that fell to Eufrosina Cruz.

8

Whereas the Faceless Warriors' ski-masked performance can be understood as intervening agent, Subcomandante Marcos had begun using a different language. After the Zapatistas declared having laid down their arms, he changed his role from that of military commander into that of theoretical author and spokesman. It seems that for the Maya population in the Lacandón he had become their speaker. More than before, he began explaining and defending the Zapatista lifestyle, thereby cleverly going with the flow of international activism. More than before, his argument moved into the support of antineoliberalism and the underpinning of the idea that "another world is possible," the credo of many contemporary social movements worldwide. And although it will be silly to argue that Subcomandante Marcos and the CCRI Maya leadership were presenting two different projects, they addressed the audience from different schemas. For sure, the Euro-Mexican military commanders who had come from Central and North Mexico to Chiapas had been the ones

to adjust to Maya schemas, not the other way around. But scholars did recognize the two voices of the Zapatistas. Subcomandante Marcos's own obvious distancing probably was a personal intuition. As a non-Maya from Central Mexico, he may be supposed to have voiced a different Zapatista narrative than his Maya followers. Soon after the "war" was over—in 1995 the Mexican army invaded Zapatista territory and destroyed much of their settlements and livelihood, forcing the Zapatista to retreat further into the jungle—Subcomandante Marcos and his team set out to reinforce their nonviolent strategy by communicating through the new media, organizing solidarity events, and inviting international sympathizers to participate.

As Subcomandante Marcos became more actively involved, and his brilliant theoretical writings were issued and published worldwide in a host of journals, magazines, and websites, he became the face of the "Second Phase Zapatistas," the ones described in their Sixth Declaration and between 1996 and 2014 basically guided by Subcomandante Marcos. There was life after the intervening agents' active period. Despite the repression by the Mexican National Army since 1995, the Zapatistas have become one of the most successful Amerindian movements ever.[61] The regional forces that were proposing social, economic, and political rehabilitation throughout the Mexican republic were no longer based in the cities only—as was previously thought—but include the Maya CCRI of the Lacandón jungle and the peasant and popular organizations with their own bases of development elsewhere in Mexico. A wave of national joy and solidarity at their appearance has given the Zapatistas one of their primary positions. Success was also local, but not perhaps as impressive as it is sometimes suggested. True, as Lynn Stephen reminds us, in the fall of 1994, almost half of the municipalities of Chiapas declared themselves to be part of pluri-ethnic autonomous regions.[62] And a few months later, the first national meeting of the National Indigenous Convention was held. Its purpose was, among others, to launch a nationwide campaign for such pluri-ethnic autonomous regions across the country.

Although many communities in eastern Chiapas also resisted the Zapatistas and continue to be governed through *usos-y-costumbres,* the Zapatista Amerindian social identity and political stance has shifted from the prior localist perspective to a new national and sometimes pan-Amerindian identity or pan-Maya cultural perspective, forged from the mixing of the Amerindian. The wider national impact is illustrated by a testimony of an Amerindian scribe, a member of the Amerindian elite of the township of Chilchota in

61. See on this, among others, J. Elguea, "El sangriente camino hacia la utopía: la violencia y el desarrollo en América Latina," *Perfil de La Jornada,* February 19, 1994.

62. Stephen, "Zapatista Opening," 5–6.

Michoacán, Western Mexico, who stated, somewhat crestfallen, that before the events in Chiapas the commoners of his town resigned themselves to the rule of the caciques. After the revolt everything was changed. They wished to change the fate of their poor life and they wanted this fast. "And now we [the ruling elite] are really concerned, because they stand firm to reach their goal anyhow."[63] Another illustration comes from Xun Mesa, a Maya from Tenejapa in Los Altos de Chiapas. Mesa, president of one of the numerous new Maya organizations in Chiapas, gave a lecture in Austin, Texas, in early 1994 and answered a question about the EZLN identity: "No, we do not know who they are. They came, made their list of demands and then they left. But we are with them because those demands are ours too. It is why I am here now. Without them, we would not have a voice."[64]

From the very start of the revolt, the EZLN survived because Subcomandante Marcos mobilized national and international solidarity. An impressive stream of information can be found on the Internet.[65] These postings included news reports, communiqués, interviews, and stories that created sustained international pressure on the Mexican government to withdraw weapons by an increasingly well-informed audience all over the world. Sociologist David Ronfeldt and his collaborators have discussed the future of "netwar" as a strategically influential means of "combat" that came out of this Zapatista development.[66] They show how the Zapatistas and their followers used the Internet to achieve many of their goals. In 1994 the pressure through the media indeed influenced the Mexican president not to crush the EZLN within a few weeks. One general of the Mexican National Army declared that the survival of the Zapatistas had a political, not a military, background. The Internet had become a successful weapon in the Zapatista revolt. Newspaper reporters were labeled the "third army" in the conflict, both because they occupied the city of San Cristóbal, a few key towns in the lowlands, as well as main areas of the Lacandón itself, and because they supported the revolt with images and words, many words. The coverage was favorable for many reasons—sympathy with the Maya peoples, exploited for so many centuries and still extremely poor, restoration of their dignity—but among them not at least because the Zapatistas provided the reporters with information, while the government kept silent. The EZLN was more interested in getting out messages than overpowering an enemy by force. This is a technique that had numerous consequences for future actions both in Mexico and elsewhere around the globe.

63. Testimony published in *Ojarasca*, March 1994.

64. Earle, "Indigenous," 26; see also 27.

65. On this topic, see for instance Brysk, *Tribal*, 160–62.

66. Ronfeldt et al., *Zapatista*.

Curiously, even the PRI-dominated television contributed to the Zapatista success. Anthropologist June Nash writes that despite the discrediting messages, "the mere appearance of indigenous people in the media [. . .] was recognition that they were making their own history."[67] Where the government officials could block telephones, prevent the distribution of newspapers, hinder reporters from doing their work, and even send them away, especially the foreigners, the Internet grew in messages, images, stories, interviews, comments et cetera from all over the world as killing bullets to the repressive apparatus of the Mexican state. In effect, the Zapatista e-mail messages, which bypassed local censoring agents, were crucial but not central. It was international communication and information exchange that made the 1994 uprising one of the first great Internet successes. To this came a great number of videos, taped mainly by sympathizers that circulated internationally. It all turned Zapatismo into an uncontrolled phenomenon. The Zapatistas broke so many barriers that the Mexican power structure had to be reformulated in order to recuperate national and global control to plug up the opening. One Mexican reporter suggested, says Nash, that "the army forget about disarming the Zapatistas and just take away Subcomandante Marcos' typewriter."[68]

Over the past decade, the Zapatista leadership keeps the fire of national and international solidarity alive by inviting and permitting "students" from all over the world—mostly social movement activists—to follow "courses" once or twice a year in the Zapatista Escuelita or Little School. The Zapatistas demonstrate that a new society based on communal lands, local culture, gender equality, cooperative self-defense, resources for all, and above all dignity is possible. The "students" learn about harsh life "in resistance," built on the teachings of Bishop Ruiz García's lay preachers, Orive's Maoists, and Zapatista experiences. For what I can see, they are taught exactly what their CNSS made them expect to see: a poor and rural "indigenous" culture, exploited by society. Nevertheless, it reinforces the motivation of the "students" to promote the Zapatista attitude worldwide. Indeed, the Escuelita demonstrates that the Zapatistas have switched from simulated armed rebellion in order to take over the state—as intervening agents—to an alternative struggle by promoting their participatory lifestyle. Shannan Mattiace argued in her 1997 overview that they "have provided a dramatic boost for the Indian movement by linking the struggles of Mexico's indigenous population to broader ones for democracy and citizenship, effectively opening political spaces that indigenous organizations have used."[69]

67. Nash, "Press," 49–56.
68. Ibid., 44, 53, and 55; also 49–56.
69. Mattiace, "Zapata," 34.

9

Without much trouble we can find the intervening agent in the film studios; for example, the Mexican feature *Y tu mamá también* (2001; Your Mother As Well), written by Carlos and Alfonso Cuarón in the early 1990s and directed by the latter. The film suggests that the role of the female protagonist was very much in line with the typical Mexican character of Malintzin.[70] This character, Luisa Cortés (played by Maribel Verdú), is Spanish but she clearly functions like an intervening agent, including her sacrifice at the end. To illustrate her role, we begin on a beach near Puerto Escondido, State of Oaxaca. As we shall see, the scene is the first after the film's turning point, its nadir. The narrative has gone downhill until that moment, led step by step toward this situation. We see two boys taking down their tent, although they had awakened that morning, naked, in a peasant hut nearby. Both are seriously shaken—sick about what they have done. At that moment, the soundtrack is interrupted and we hear the narrator:[71] "At one o'clock that day Julio and Tenoch started their trip back home. It was a silent trip with no events. Their parents never knew they had gone to the sea with Luisa. Luisa stayed exploring the bays around." We see Luisa walking into the sea for a swim. "Parting from Tenoch and Julio, Luisa told them: life is like the foam of the sea. You must dive into it." Much later, when the boys meet again in Mexico City, they learn that Luisa had died in San Bernabé, about a month after their departure. Tenoch tells Julio that she had cancer all over her body. When they met her, she already knew she had to die, but she did not want to tell anyone. "Luisa spent her last four days in the local Hospital of Santa Maria Colotepec," the narrator adds, taking over again, leaving the two boys with their memories. It is the final scene of the film. A moment earlier, the boys had met by coincidence at a crossroads in Mexico City. After a quite superficial conversation about their studies, the boys in a way take leave of each other. The narrator has the last word: "Tenoch apologized. His girlfriend was waiting for him at the cinema. Julio insisted to pay the bill. They never met again." Julio remains behind, sad. "The next summer, the PRI lost the elections for the first time in 71 years."

Based on a cyclical format, *Y tu mamá también* goes through half a cycle to witness these final scenes. The encounter with Luisa, which dominates the film in the preceding hour, ruins the friendship of Tenoch Iturbide (Diego Luna) and Julio Zapata (Gael García Bernal), two recent high school gradu-

70. Acevedo-Muñoz, "Sex."

71. The narrator was an idea borrowed from *Masculin, féminin* (1966), a film by Jean-Luc Godard (an intertitle of that film reads: "This film could be called *The Children of Marx and Coca-Cola.*")

ates. Perhaps "ruined" is not the right word here. Luisa reveals the hidden tensions between the two boys. And because these two characters are metaphors for the two strata of the Mexican elite around the year 2000, Luisa has revealed a tension that ran and perhaps still runs through the elite in general. The narrator informs the viewer for a reason that the "next summer, the PRI lost the elections for the first time in 71 years." The narrator also provides the viewer information about the characters, events, or settings that the viewer notes in the diegesis. Much of what goes on in the film is not on the surface but hidden from each of the characters, and the narrator reveals them to the viewer. For example, at one point, the narrator, by explaining how ten years earlier a chicken farmer and his child died in a car crash at that spot, offers an understanding of the highway the boys are traveling, its uses, and its dangers. These comments record the step-by-step descent of a seemingly harmonious union to aged open fractures.

The two allegorical characters of Mexican politics are set at the threshold of adulthood, both seventeen. Upperclass Tenoch Iturbide belongs to the Great Revolutionary Families—heirs to the colonial "primary elite," as historian John Tutino calls them.[72] As in the Spanish era, the postrevolutionary Great Families distinguished themselves through an aristocratic lifestyle. They owned companies and large tracks of land and divided the better political positions among themselves. The Great Families' base was Mexico City. The narrator explains that Tenoch Iturbide is the second of three sons of a Harvard economist who became subsecretary of state. His mother is a housewife attending esoteric courses and activities. They decided to name their son Hernán, after the conqueror of Mexico, but then his father accepted a job for the government and, hit by nationalism, named his son Tenoch, after the former Aztec capital. He is born into the life of the privileged, most assuredly bought and paid for by corruption—and as the final scene reveals: he accepts his fate and enrolls in that world through studies. The mother of Tenoch's girlfriend Ana is a divorced French woman, a teacher at the Foreigners Institute, who does not object to Tenoch sleeping with her daughter. Ana's father is a journalist, recently converted to politics and now the director of the Institute of Culture in Mexico City. He has a liking for Tenoch but with his Party mates, and never in front of Ana, he calls him "the young lad." Tenoch takes Julio with him into an exclusive country club where underlying rifts come to the fore.

Julio Zapata, however, belongs to the Revolutionary Families—without the "Great"—or, as Tutino would have seen them: heirs to the colonial "secondary

72. Tutino, "Creole," 1–43, 193–221, 237–53.

elite." They were in the service of the Great Families as politicians, military, corporate managers, et cetera. They were certainly wealthy but depending on the Great Families for their political and economic positions. Included in the secondary elite were the provincial elites. In Tenoch's company, Julio Zapata is insecure because of his "secondary" position. Julio lives with his mother— a secretary in a corporation—and sister, Manuela, known as "Boinas," who studies political sciences at the National University and sympathizes with the EZLN. Julio has not seen his father since he was five. Furthermore, Julio stays with his girlfriend, Cecilia, until dinner, and has to come back the next morning. "It was not noticeable," the narrator tells us, "but Cecilia's father, an allergy specialist, feared that her relationship with Julio went too far beyond. Her mother, a psychologist, saw it positively, as an innocent thing." For the outside world, both strata formed the country's oligarchic elite, but for the insiders, the differences were all too clear.

Following a cyclical narrative, *Y tu mamá también* sets scenes in a step-by-step slow downhill sequence. First, the boy's girlfriends are leaving for a trip to Italy. This will leave them without sex and female company. However, they try to interpret it as an improvement: they are now free to have sex with others. On the way home through the city they get stuck in a traffic jam. The narrator informs us how bad a shape the city was in: "That day, three demonstrations took place. The traffic jam had been caused by a pedestrian having been struck; Marcelino Escutia, an immigrant carpenter from Michoacán. Marcelino was hit by a truck at high speed. He never used the pedestrian bridge because it forced him to walk two more kilometers to get to the building yard. His unidentified body was recovered and brought to the mortuary. It was claimed four days later." Then a pleasant surprise: the two boys meet the Spanish wife of Tenoch's cousin Jano at a wedding. This is a Great Family occasion, with the president of the nation, his wife, and his bodyguards in attendance. The gorgeous twenty-eight-year-old Luisa Cortés becomes the subject of the boys' attention. They flirt with her and invite her to join them for a weekend trip to the imaginative magical beach of Boca del Cielo, Heaven's Mouth—it should be heaven for the two boys, who hope to sleep with the attractive Luisa. Within a few days, after Jano had confessed he cheated on Luisa, she accepts the invitation. The boys arrange for a car and begin their journey south. The car has a metaphoric role as well. It keeps the three together but also isolated from the world outside. They are with each other, but not with Mexico. Luisa, however, does notice the country around them. In short, the Mexican elite is occupied with its own desires—the boys only talk about sex—and does not show any interest in the population of the country.

On their way to their nonexistent heavenly resort, Tenoch and Julio boast about their sexual conquests, while Luisa speaks in more measured terms about her relationship with Jano and a previous lover, who died in a road accident. Along the way, Tenoch and Julio tell Luisa they had seen themselves as Charolastras or Space Cowboys—a metaphor of the front men of the Mexican revolution—and boasting about their ideas and experiences they tried to prove, as the narrator expresses, "the strong ties that joined them, they were like one. The stories, although enriched with personal mythology, were true, but like it always happens, they were incomplete truths. Julio did not say that he used to light matches to cover the smell in the toilet in Tenoch's house, nor did Tenoch reveal that he used to lift the toilet cover with his foot at Julio's. There was no need to know those details." At night the trio arrive in a provincial town. The camera shows us attractive classical Mexican urban scenery. In the hotel, Luisa phones Jano's answering machine, crying, leaving a kind of goodbye note. That night, the boys notice her crying.

The next morning, on the road again, they pass another small town. The narrator informs us: "Tenoch did not know that Tepelmeme was the birthplace of Leodegaria Victoria, Leo, his nanny. At thirteen she had moved to Mexico City. Leo had found a job at Iturbide's house, and took care of Tenoch since his birth. Until he was four years old, he called her 'mom.'" While the boys and Luisa are discussing the use of a condom, they cross a barricade set up by townspeople collecting money for their yearly fiesta. A little further down the road, they pass a military patrol controlling taxis and a herd of cattle blocking the road. In the provinces—*Y tu mamá también* was filmed in the State of Oaxaca in the late 1990—Mexico was still a rural country. Suddenly, the portable tape player runs down, forcing them to leave their rock music aside and listen to more "local" Mexican music, which Luisa likes very much. Then, the car breaks down and a tractor drags them to a mechanic. Luisa loves the stop; she enjoys buying some coconut milk. Julio talks with an old man with a poncho who gives him his hat. Bit by bit, problems pile up for the two boys, but Luisa's mind improves slowly.

The three travelers stay in a hotel nearby. Luisa phones Jano once more with some instructions for how to live on his life in their Mexico City apartment. That afternoon, she sits again crying in her room, but when Tenoch enters, she seduces him and they have sex. Unwillingly, Julio is a jealous bystander looking through an open doorway. The scene shows the first symptoms of a break: Tenoch takes it all, simply because of his descent. The narrator knows: "Julio didn't know what he felt. He only knew it wasn't anger. He was eight years old the last time he had felt a similar knot in his stomach. One night he had woken up thirsty and had found his mother in his godfather's

arms. Julio had retired in silence and never told anyone about it." Shortly afterwards, in their bedroom, Tenoch starts boasting about this catch. Julio, jealous, admits that he had sex with Tenoch's girlfriend, an insult that opens the wounds between the two boys. The narrator: "The last time Tenoch had felt like that he was eleven. He had noticed his father's picture on a newspaper accusing him of a fraud in the import of spoiled corn for the poor. Tenoch and his parents moved to Vancouver for eight months. Tenoch never asked the reason." Luisa did not know about Julio's confession, the narrator continues. "During dinner, though, she felt the tension between the two friends. She sensed the broken equilibrium that she had to reestablish."

To even the score, Luisa also seduces Julio at the side of the road, with Tenoch in full awareness of the situation. But it is too late. This brings Tenoch to admit, in the car, that in his turn he had sex with Julio's girlfriend. The boys begin to fight until Luisa threatens to leave them: "Who cares if you screw each other's women, if you come immediately? Who made me do this? I am here changing diapers." The Charolastras now realize that their awareness of each other's social status had come out. Tenoch calls Julio a *naco* or *white* trash; Julio counters by calling Tenoch's father a thief. In the meantime, we have seen scenes about an abandoned cemetery and heard the car radio playing Brian Eno's desperately sad "By This River" ("Ever falling, down, down, down . . . ," 1977). And the threesome had passed by a funeral of a child. Despite these tensions, they arrive at the seashore and set up a camp near a small restaurant. The narrator informs us: "Jesús Carranza, known as Chuy, and his wife Mabel, the fourth generation of a fishermen family. They lived there, close to San Bernabé. Chuy offered himself to escort them to the beaches the next day. He asked them 350 pesos, including lunch." Stimulated by the narrator, the camera is allowed space to offer its own comments by showing the details of ordinary life in Mexico. For example, the camera moves into Chuy's kitchen, where his entire family is working hard preparing the food to make ends meet. The camera is mostly set at a distance, showing the diegesis as being somewhat posed. We learn from the narrator that Chuy will later lose his profession because of the construction of a luxury hotel in the area. The film suggests that Chuy's family has lived in this unspoiled paradise for four generations. Soon, Chuy has to go to the city in search of a job, fails, and returns to take a job as a janitor. They share a meal and lots of drinks there. This brings them to continue their sexual boasting, confirming that they had sex with the same girls frequently, including each other's girlfriends, and Julio says to Tenoch: "And your mother as well."

That night Luisa seduces both boys for a threesome but retires in due course, leaving the two to make love to each other. Tenoch and Julio grasp and

kiss each other passionately—which would make them literally sick the next morning. Tenoch, this heir of conservative General Agustín de Iturbide, who led the War of Independence in 1821 against Spain, and Julio, the heir of Emiliano Zapata, had screwed each other, screwed each other's classes, screwed their nation, screwed a democratic future and the new Mexico. All the time, Luisa had been preparing this intervention. She is Death. In cyclical Mexican and Maya cognitive schemas, Death is said to be the sprouting of new life, endowing a new future. *Y tu mamá también* may be understood as a metaphor for moral and political corruption in Mexico that is at its end, giving birth to new life—this was a decade before Mexico fell into a brutal war on drugs. Ostensibly looking for a new Mexico, the Cuaróns were killing off the intense, dangerous, selfish, and otherworldly bond between the primary and secondary elites of the Revolutionary Families. The narrator was a mere opportunity for the Cuarón brothers to comment on their country's daily struggles with life and death. Following naturally from this comes the conceptualization of a more severe critique of Mexico's arrogant ruling class. Alfonso Cuarón uses narrator and camera to reclaim Mexico, to rediscover his native country after ten years working in the United States. The film suggests that his country still passes through a teenage and male phase, trying to find its identity as an adult nation. But even at that time Cuarón shows us images of government officials busting people, drug busts and traffic accidents, shanty towns, and roadblocks with villagers asking for a donation for their festival. He needs Luisa's eyes, not the camera, to see that despite the fact that the Mexican classes are lost, the country still looks like Eden. "You have the luck of living in a country like Mexico," she says to the boys. "You can breathe life everywhere here."

The Woman of Discord is part of a cyclical worldview and is called upon when, between cycles, moments of disarray and chaos are in need of a solution. As a female figure, embodying past-present-future, sometimes in one, with a sacred role and sometimes sacred powers, the Woman of Discord appears at the beginnings and at the ends of dynasties. In the role of the intervening agent, the Woman of Discord breaks into the home of the New Times, to impregnate herself there with the new fruit, and thereby begin the new cycle. In *Y tu mamá también*, Luisa takes on the role of terminating incompetence, corruption, darkness, and disorder. Thus, Tenoch and Julio are Old Men. The cultural script of the Woman of Discord describes also the need to open up a new cycle, before retreating from the stage. Luisa is constantly looking around, out of the car, to the "true" Mexican culture, signaling to the viewer that we must look for ourselves for the New Times there: "You can breathe life everywhere here." The viewer leaves the cinema with this in mind. Keeping the turnover of time in mind of Iturbide and the 1820s and

Zapata and the 1910s, with the PRI voted out in 2000, the new millennium had begun with similar prospects. Therefore, what the Cuadróns actually did with *Y tu mamá también* is to congratulate the Mexicans on the removal of the perverted ruling classes from power and to invited Mexicans to look at their country for this new Mexico.[73]

10

For a few years in a row, teaching cognitive cultural analysis at the Center for Latin American Studies and Documentation in Amsterdam, I invited students to classify Latin American films as either cyclical or linear. We were surprised to find a relatively high number of films that not only passed from a kind of order to their nadir and back again but that also starred intervening agents. This type of character from the deeps of history seems typical for countries with a rich Amerindian tradition like Mexico, Peru, and Bolivia. They may have a larger library of ancient narratives built on typical Latin American archetypes than countries like Argentina, Brazil, or Chile.

But we also found them in films from Chile, Colombia, and Brazil. An amusing Mexican example is *Temporada de patos* (2004; Duck Season), written and directed by Fernando Eimbcke and co-written with Paula Markovitch. The film shows us two boys playing television games in a high-rise tenement apartment in Tlatelolco, a well-known residential zone in a Mexico City for middle-class families. Like *Y tu mamá también*, *Temporada de patos* shows us an intervening agent that unexpectedly comes into the protagonists' lives. The scenery seems important. It is a place that may be called a site of memory, directly pointing to specific and conscious schemas. Tlatelolco is constructed in 1958 near the remains of an archeological zone—in Mexico an important sign of the presence of the pre-Hispanic past. In October 1968 the zone witnessed a student massacre when government troops opened fire. In 1985 two massive earthquakes destroyed an important number of its structures, taking the lives of several hundred residents. These are watershed moments in Mexican history. Moreover, this particular flat is called *Niños Heroes*, after nineteenth-century Mexican-American War martyrs. This suggests that, like *Y tu mamá también*, *Temporada de patos* documents the atmosphere and the end of the PRI epoch. Cuarón's car is replaced by the apartment, the Mexico that

73. Interview, Philip Williams, "From Mexico to Hollywood and Back," *MovieMaker Directing* (2007), http://www.moviemaker.com/directing/article/from_mexico_to_hollywood _and_back_2792/; and the *Looking Closer* blog, http://lookingcloser.org/2007/09/y-tu-mama -tambien-2001/ (both accessed 10/09).

Luisa sees through the car's windows is replaced by the historical signs sur-
rounding the high-rise building, and Cuarón's two metaphorical boys are here
reborn in the fourteen-year-old friends Flama (played by Daniel Miranda)
and Moko (Diego Cataño). Eimbcke's Luisa is called Rita (Danny Perea), a
sensual sixteen-year-old girl from next door.

Flama and Moko are left home alone on a boring Sunday afternoon after
Flama's mother has left the flat. Celebrating her absence, the two boys install
themselves on the couch to play video games using the Xbox. They arranged
for a fridge full of Coke. Unexpectedly, Rita rings the bell to ask for the use
of the oven to bake a cake for herself to celebrate her sixteenth birthday. Like
Luisa, Rita is world-weary. But unlike Luisa, she is not very welcome. The boys,
interrupted in their gaming, grant her fifteen minutes, "no more." They ignore
her to concentrate on their game of *Halo* ("Bush vs. Bin Laden"). Apparently,
it takes more than fifteen minutes; Rita stays for the rest of the day. After a
while, the power goes out in the building. This ruins the boys' gaming fun,
and they are forced to sit still with nothing to do. But boredom is a bad coun-
selor. First, Flama decides to order a pizza. They try to get it for free, which
might happen if the delivery does not arrive in half an hour. Pizza man Ulises
(Enrique Arreola) is on time at the building but because of the dead elevator
he arrives too late upstairs—by eleven seconds, the boys say. However, Ulises
disagrees and refuses to leave. In the end, the boys and the pizza man come to
an agreement: they will play computer football against one another when the
power is (briefly) restored, and if Ulises wins, he will be paid in full.

Step by step, Rita begins intervening. First she flirts with Moko and kisses
him. Next, to stir up things a bit further, she stuffs her brownies with Flama's
mother's marijuana. Soon, the animosity between the boys and pizza man
cools, and the boys and the girl begin playing silly games and telling each
other about their dreams, broken or not. Under the influence of the pan of
pot brownies, the characters realize that their lives are induced from the out-
side and begin to rebel against this dominant power. One moment they notice
the painting on the wall behind the television screen. It is a landscape with
ducks, entitled "Duck Season." The pizza man tells the others the significance
of geese and ducks flying in a V-formation. He tells them that the ducks help
each other out on long journeys. Moreover, we learn that Flama's parents are
divorcing and that the boy has to choose with whom he is going to live. He
also wonders whether he is really the offspring of his parents since no one
in the family has red hair. Moko is contemplating the attraction he feels for
his friend. At the end of the afternoon, everyone has discovered much about
not only the intricacies of friendship and family but also about the possible
positive outcome of joining hands. Although the everyday boredom is not,

as yet, transferred into a new future, thanks to Rita's action a cycle of world-weariness might nevertheless have terminated. A new cycle of profiting from opportunities could have set in. "The issue is who fucks over whom," says Flama, gazing into a painting behind the television. Thanks to Rita's intervention, Flama and Moko have felt their friendship growing, and Ulises has taken his life back into his own hands. This is the turning point, and it is where the film ends.

Rita enchants the men with her magical bakery, but also with her presence. She is the dangerous one in that apartment, that afternoon—a *Belle Dame sans Merci*. For a conservative, authoritarian Mexican, Rita might be the devil incarnate, shocking traditional values. *Temporada de patos* turns against the politics of androcentrism. Perhaps the "othering" of the female has been typical for Western culture since the later Middle Ages. It works through gender polarization and biological essentialism. Gender polarizations do not just mean that women and men are different from one another but that a male/female divide is superimposed on "so many aspects of the social world that a cultural connection is thereby forged between sex and virtually every other aspect of human experience,"[74] says psychologist Sandra L. Bem, like social roles, dress, sexual desire, or the expression of emotion. Through biological essentialism, Western Christian, Jewish, and Islamic peoples from the Middle East, or any other male-dominated society, categorize androcentrism and gender polarization as *natural* and therefore as inevitable consequences of the intrinsic biological natures of the female and the male—which makes crossovers, mixtures, or undefined sexes unquestionably impossible. In our Western androcentric culture, as the child learns the language, it absorbs the patriarchal androcentric concepts that constitute it. After decades of feminist research we know that androcentric language privileges the male gender by speaking of *man*-kind, of a paternal God, by commonly using "he" as a generic pronoun. It is the language of the deeds of men, of kings and presidents, warriors and scientists, priests and poets and philosophers. We are all familiar with French author and philosopher Simone de Beauvoir's work on the role of women as the "second sex," as minor player and spectators "in a human drama whose leading characters are almost always men and whose script is written in a masculine tongue."[75]

We find another intervening agent in Chile, one that also forces herself upon the protagonist but perhaps is also being recognized and invited by her.

74. Bem, *Lenses*, 2–3.

75. Solomon, *Signs,* 203. Solomon refers to de Beauvoir's famous book *Le Deuxième Sexe* (Paris, 1949; trans. *The Second Sex*; New York, 1973).

This intervening agent is closer to an angel than a devil, performing in Sebastián Silva's successful feature *La nana* (2009; The Maid). *La nana* presents us with the difficult and overworked order of maid Raquel (Catalina Saavedra) in a middle-class neighborhood, perhaps of Santiago de Chile. Plagued by migraines and dizziness, Raquel nevertheless devotes herself to her domestic responsibilities and to a complex series of relationships with the individual family members she serves. After twenty-three years of faithful service, her employer notes the growing problems for her maid and tries to help out by hiring extra hands. This is again a history of a step-by-step deterioration. Raquel realizes this. She fears losing her position in the house, and one by one pushes the girls and women out of the house. Every success, however, is a step backward. Her situation in the house goes from bad to worse. Until Lucy (Mariana Loyola) appears. As a true Woman of Discord, Lucy comes, wins her way into Raquel's heart, and helps her reconquer order in the house. Lucy even invites her to a family reunion in southern Chile. And also as a true intervening agent, she disappears again as sudden as she came. Order is restored but a little different than before—as is usually the case in cyclical narratives. Lucy is, like Luisa and Rita, an archetypical character that comes with cyclical narratives. Because her main goal in the narrative is to be the instrument of restoring order only, she does not operate by "unearthing" internal contradictions, as Luisa did in the Mexican ruling class. But like the two other intervening agents, Lucy builds on a type of Amerindian archetypal narrative told and retold among Latin Americans generation after generation.

These narratives were also told in Colombia. It must be, because the Colombian feature *Karen Llora en un bus* (2011; Karen Cries on the Bus) is not only cyclical but uses an intervening agent as well. Filmmaker Gabriel Rojas Vera could have been well informed, but I have not found an explanation of his narrative form in this sense as yet. Therefore, I suppose, the format had been encoded in his theater of the mind by his listening to stories, looking at them on screens, or experiencing them in real life. In that case, the format was *intuitively* set in motion—and intuition comes from the Cognitive Unconscious.[76] Interestingly, this time the intervening agent was searched for by the protagonist to turn her life from chaos into order again. After ten years of marriage, Karen (Ángela Carrizosa) realizes her life with entrepreneur Mario (Edgar Alexen) in Bogotá has been boring, unrewarding, and empty. In her mid-thirties, serving as a kind of personal housemaid—"Can you get me my jacket, please?" Mario says one moment—Karen sees herself as old, unattractive, and useless and decides to take her life into her own hands. Cry-

76. Dijksterhuis, *Slimme*, 139–211.

ing in the metropolitan bus line of Bogotá, she leaves her home in a luxury outskirts of the city to find a room to rent in the old and impoverished center of the city. Instead of an improvement, standing on her own feet proves to be a disaster. She uses her savings to pay for three months in advance and next needs to find a job. But in the boardinghouse, the room is dirty, the bathroom filthy, the water in the shower cold, and the landlady far from nice. At night she reads Henrik Ibsen's three-act play *A Doll House* (1879), about a woman leaving her husband and children because she wants to discover herself. For Karen, each day gets worse. Karen cannot find a job—although she hands in a free application at a well-known bookstore—and eventually needs to beg for money at the bus stop with the excuse of having been robbed and steals things from the supermarket.

More pessimistic and gloomy by the day, Karen meets twenty-four-year-old hairdresser Patricia (María Angélica Sánchez), who also lives in the boarding house. Her life is as miserable as Karen's but seems to improve a bit, during this period. Talking to her, Patricia maps Karen's miserable life: "It's funny. I knew that you would be like that. [. . .] Because of your haircut." Nevertheless, the two go out, and thanks to Patricia, Karen gets to know a few men. The one who is nice to her, teacher and playwright Eduardo (Juan Manuel Diaz), enters her life. She meets him at his office and they have dinners together. A bit later—we are two-thirds into the film—Karen finally lets Patricia restyle her hair and transform herself into her new more independent persona (see figure 4.3). Although the two women barely speak in that scene, this is the turning point of the film. Karen had invited Patricia to do her work as a makeover, but it is a makeover with huge consequences that can only be recognized as the work of an intervening agent. Therefore, Karen walks out of the hair salon with a smile on her face. From that moment on she is assertive and enterprising. The first thing she does is intensify her contact with Eduardo to have sex with him.

So, Patricia is the intervening agent here, and, as expected, soon things turn bad for her. Patricia's lover has left her and she loses contact with another man who had sponsored bits of her life as well. Karen finds her in her room after she had just cut her wrists. They meet again in the hospital. Patricia appears to have a disabled daughter. It makes no difference for Karen; they remain friends. Karen has a reconciliatory talk with Mario, but without returning to her marriage. "Well, when will I see you again?" he asks her. "I don't know Mario. I'll call you sometime, okay?" Next, Karen is offered a job at the famous bookstore. "I'm so happy. It's like everything is beginning to fall into place." Around that moment, Eduardo invites her to join him to live for a while in Buenos Aires, where he is offered a job. However, after he also makes

FIGURE 4.3. Patricia and Karen. Still from *Karen llora en un bus,* feature by Gabriel Rojas Vera, Colombia, 2011.

the androcentric remark—"Can you pass me my jacket, please?"—Karen decides to build a life in Bogotá on her own. At the end of the film, Karen is back on the bus and notices another woman entering, crying.

11

Many, many cognitive schemas can be identified as steering Amerindian life from the Cognitive Unconscious. In this chapter, one of them has been discussed: the intervening agent as endowing new powers, new life at the nadir of a narrative sequence. The Faceless Warriors had presented themselves as an intervening agent for Mexico's poor peasants, especially the ones in Southern Chiapas. After the San Andrés Peace Accords of 1996, they worked with Subcomandante Marcos and their leaders in a quest for autonomy that looks very similar to the *pueblos de indios* from the Spanish era. This was to be their project for life after the nadir of the early 1990s. However, outside of the original Zapatista zone the idea of political and administrative autonomy had only limited results because many communities in eastern Chiapas rejected the isolation that came with it.[77] By December 1994 more than forty Maya communities, most of them outside the EZLN zone, had responded with the formation of four autonomous regions. For the Maya the restoration of traditional *pueb-*

77. Van der Haar, *Gaining.*

los de indios would mean a return of *order* and the defeat of chaos. Order means self-governing institutions, a "just" distribution of land, and modern health care and good education, but also the establishment of commercial centers for the benefit of the peasants to buy and sell at a "just price" as well as amusement centers for a "dignified" rest without *cantinas* or brothels. One of the CCRI members declared to *La Jornada* in February 1994 that there is "no need to hold our hand. We believe that our people are capable of governing themselves because our people are aware. That is why we do not need a government that only wants to manipulate us, to have us under its feet. As *indígenas,* we need our own autonomy; we need that identity, that dignity."[78] The *pueblo* is autonomy, identity, and dignity; it means social order.

For Subcomandante Marcos the revolt had not been about an intervening agent. It had been rewarding to raise their voices, he thought: "It fell to the lowest citizens of this country to raise their heads, with dignity. [. . .] And this should be a lesson for all. We cannot let ourselves be treated this way, and we have to try and construct a better world, a world truly for everyone, and not only a few, as the current regime does. This is what we want. We do not want to monopolize the vanguard or say that we are the light, the only alternative, or stingily claim the qualification of revolutionary for one or another current. We say, look at what happened. That is what we had to do."[79] And he ended with: "We have dignity, patriotism and we are demonstrating it. You should do the same, within your ideology, within your means, within your beliefs, and make your human condition count."[80] Words like these struck a chord both internationally and nationally with the more leftist groups. This was about politics and the right of the poor and the economically subaltern to raise their voices and eventually to rise against tyranny. Although the voice for dignity and the wish to create a better world for everyone and "not only for a few" is still relevant today, in practice life in eastern Chiapas was harsh and extremely difficult. Despite the inspiring words of Subcomandante Marcos and the international activist support for his vision, a lesson in dignity does not bring economic welfare or a better life in relative prosperity.

The intervening agent is a branch of the cargo system. Within the cargo system all villagers or the wealthy villagers or a specific political elite discharge their duties by rotating the performance of local government offices. An intervening agent performs more in an ad-hoc way and rather unexpectedly, especially when the system is failing. But the basic principle is the same: to bring the community in movement in order to go forward and improve life

78. Published February 4, 1994.

79. Hayden, ed., *Zapatista,* 211–12.

80. Ibid.

for all. The workings of the cargo system in a modernized Amerindian town have been researched by anthropologist Roger Magazine and his students of the Universidad Iberoaméricana in Mexico City. His book *The Village Is Like a Wheel* (2012) is based on years of fieldwork in the Texcoco area to the east of Mexico City, researching the former *pueblo de indios* of Tepetlaoxtoc. Despite the rural occupation of cattle fattening, the villagers are occupied with typical urban capitalist activities like wage labor in construction work, salaried employment in the city, the *maquila* or assembly of clothing, and rendering other paid services that position them on the continuum near or among the city people of adjacent Mexico City. They also consume in an almost urban way, buying machines and urban pieces of furniture, including television and computer gear. The designations "Nahua" and "*indígena*" gradually disappear from the Texcoco area.[81] Some parts of the towns in the area still speak the old language, but in general Spanish got time on its side; as is the case in, for example, the Mapuche region of southern Chile. The dichotomous approach of "indigenous"/"nonindigenous" is hard to verify, which convinced Magazine to refuse to speak of "indigenous."

Is Tepetlaoxtoc a *mestizo* town? No, it is not. The population enthusiastically cherishes a communal way of living, which Magazine describes as "motivating others to act," and that as "communal ways of living" would certainly qualify elsewhere in Latin America as "indigenous"; as it does for example for the Mapuche in Chile. The so-called collective action finds its quintessential purpose in making other community members *do* things. Indeed, "community" is a *doing*. The family functions not simply for biological reproduction but for a kind of cultural reproduction as the site for reproducing this *doing*. Helping and assisting family members is not an end in itself; it is the means to creating active subjectivity in each family member. The same with the local fiesta system: the fiestas are not an end in themselves but a means to activate the community members by coaxing them to work together, or, better perhaps, to perform the community. Discussing a wealth of information, full of ethnographic observations and anecdotes appealing to our imagination, *The Village Is Like a Wheel* demonstrates that the community does not collectively produce artifacts like fiestas and family networks, but that through these artifacts produces *itself* as active subjectivities in its constituting members. Community members, who do not participate this way, fall out; outsiders actively participating are welcomed "in."

These activities have ancient roots but are not recognized by the people themselves as something "indigenous." This is because the usual mode iden-

81. Magazine, *Village*.

tifies the "indigenous" by its produced artifacts as identity markers—such as traditions, social structures, rituals, myths, and so forth. *The Village Is Like a Wheel* is built on the idea that the "indigenous" "had never defined themselves in terms of things [. . .] that they had produced and possessed, and so such a definition had to be invented for the sake of government agencies or other actors that do recognize an other though its culture."[82] They cannot identify when something *is* "indigenous" or not. Magazine found in the Texcoco towns that identity markers have little meaning for people "who do not share our [Global Northern] notions of culture, self, and otherness."[83] Perhaps as any other "indigenous" people, the people of Tepetlaoxtoc see no relevance in terms like "culture," "ethnicity," or "modernization" to describe their activities. For them, these products are conduits or by-products of "actions directed toward the production of active subjects,"[84] of a *doing* that would involve the individuals together. In short, following *The Village Is Like a Wheel*, the community's cognitive schemas are about blending a very heterogeneous series of activities. This does more justice to Latin America's "indigenous" heritage than its bipolar counterpart—the CNSS—directed to political and cultural struggle only. The characteristics of their cognitive schemas are not only much more difficult to understand, they are also politically challenging because they consciously avoid the formulation of a utopian discursive idealist view of the "indigenous." For that reason, perhaps, these are not seen as "indigenous" by the CNSS-sharing outsiders and classified as whitened, nonindigenous, *mestizos*. Reading Magazine's wonderful book, arguing cogently that something like an "indigenous culture" has never existed as such at all, we cannot help concluding that the "indigenous" and "indigeneity" have always been scholastic concepts with little practical local significance. Also, that the people of towns like Tepetlaoxtoc can be conceptualized as belonging to "modernity"— the M/C Project's major effort—is of no relevance to them.

No wonder that the two manifestations of Zapatismo—the intervening agent and modernizing political identity—are present in the behavior and discourses of the Zapatistas, including Subcomandante Marcos's, and also in fiction films like *Y tu mamá también* and *Temporada de patos*. Nevertheless, the Chilean film *La nana* and Colombian feature *Karen llora en un Bus* do not share the latter's political message. Some of the films and Subcomandante Marcos's and the Zapatistas' writings and performances either confirm or build cognitive schemas of the intervening agent in the audience's minds, or confirm or build their discursive visions in the encoding of new schemas.

82. Ibid., 105.
83. Ibid.
84. Ibid.

With his paintings, Jorge Miyagui serves both. He is inspired to design *but-sudáns* for the victims of violence as well as for movement and community leaders in trying to keep the memory alive of what happened in the 1980s and 1990s in Peru. Miyagui's initiative is, like many others, very important. The situation of the "victim-survivors," as sociologist Mijke de Waardt calls them,[85] is in Peru still much worse compared with the widely recognized Mothers and Grandmothers in Argentina. The members of ANFASEP are, like Mamá Angélica, mostly Quechua-speaking mothers, wives, and children of those still missing, and they continue to peacefully pursue the building of a Sanctuary of Memory. They provide witness reports of what has happened, they organize themselves as political lobby groups to keep their position on the political agenda, there is of course the ANFASEP memory museum in Ayacucho, and they demand reparation and compensation. They lead the way in the struggle against racism, which had been so decisive in the massacres of the Internal Armed Conflict.

12

In short, what we have witnessed in this chapter are examples of the cognitive impact of experience—as encoded in cognitive schemas, entering deeply into the Amerindian memory—from the world of action to the mind and back into action again. The example of the intervening agent demonstrates how cognitive schemas can be embodied guiding emotions like fear, frustration, anger, and then hope and perhaps joy. The Maya population in the Lacandón forests had seen its economic and social situation deteriorating step by step, almost day by day. In the fiction films *Karen llora en el bus* and *La nana* the protagonist recognizes that same pattern, as do the boys in the two Mexican films *Temporada de patos* and *Y tú mama también,* but perhaps not as consciously aware of it as Karen in Bogotá and the Nanny in Santiago de Chile. All these protagonists, as well as the population of the Lacandón in the early 1990s and no doubt the court surrounding the Motecuhzoma in both early fifteenth-century and early sixteenth-century Aztec Mexico, must have been awaiting the intervening agent, to turn their life around, delete the negative characteristics, and begin living positively again. Interesting is that if the intervening agent is not putting herself forward in expected moments of despair, representatives of the victims may act. The intervening agent in the Lacandón were the children of the desperate Maya colonists of the forest; Karen decided by herself to see

85. De Waardt, "Name."

the hairdresser. The audience watching the fiction films, but also the observers of the Zapatista revolt, recognized—decoded—the pattern and made it their own. The intervening agent script would be encoded or re-encoded, ready for use by this audience—consciously or not—somewhere in the future. The *idea of non-defeat* would be encoded in the IAS, which means that combatants fight until a blood sacrifice, and also that the "victims," the "sacrificed," or the "captives" have to be taken care of, "be fed," by the "winner," the one with the upper hand, who by taking the upper hand accepts the role of caretaker. In this construction, the *indios* under Spanish rule would have accepted being taken care of by the Spanish King, El Rey Padre or the King the Father, who "granted" them the *república de indios* as his major instrument. Learned or experienced cognitive schemas like this shape actions, reactions, and discursive interpretations now or in the future.

FIGURE 5.1. *Plebeya 3,* Claudia Coca, 2007, oil on canvas, 1.7 × 1.4 m.

CHAPTER 5

DIVISION

A COLONIAL HANGOVER

1

"Our blood is not different, Lord. Neither is our heart, Lord. So why are we humans not all of equal value?" This short stanza comes from the waltz "El plebeyo," first performed in 1930 by Alcides Carreño in a theater in Callao, near Lima. The waltz was written by Felipe Pinglo Alva and is generally seen as one of the most popular songs of its kind.[1] Peruvian painter Claudia Coca (1970) took it as the motto of her painting *Plebeya 3* (2007; see figure 5.1). This painting is third in a series on racial discrimination in Lima. Coca's painting was part of her exposition "Globo Pop," held in 2007. Both Pinglo's waltz and Coca's painting express sadness about the incomprehensible and iniquitous consequences of the supposed supremacy of the *white race*. Through the Plebeya paintings Coca declares her solidarity with the population of Andean descent. As a self-declared *mestiza* (*chola*) she is a member of the Amerindian mnemonic community. This solidarity was soon recognized by international art watchers. In the documentary *Pintura contemporánea latinoamericana* (Contemporary Latin American Painting), for example, Chilean art historian Edward Shaw stated (2010):[2] "Claudia Coca uses herself as a character in order

1. See http://rinconperuano.com/musica-criolla/10-mejores-vals-peruanos (accessed 10/13).

2. *Pintura Contemporánea Latinoamericana*, Santiago de Chile: Celfin Capital, Cazuela Films, 2011; book: Shaw, *Pintura*.

to fight for human rights in her country, for gender rights, and indigenous rights—all against the discrimination that prevails in Peru. Her fictive character fights for a space in Peru. [. . .] In Peru, one can feel vibrations and energy that I could not find among the younger generations in the other countries—who were more intellectual in their way of painting." The documentary is about painting in Argentina, Brazil, Chile, Colombia, Peru, and Uruguay; Shaw's words are therefore quite a compliment to Peruvian art. This comment warrants singling out cases from Peru to study the Amerindian Cognitive Unconscious.

2

As a foundational member of the Colectivo Sociedad Civil (Civil Society Collective), Coca participated in the "Lava la bandera" ("Wash the Flag") performance of May 20, 21, and 24, 2000, protesting against the corruption and antidemocratic regime of Alberto Fujimori and his chief adviser Vladimiro Montesinos, the long-standing head of Peru's intelligence service. For Coca and her friends it was time for action when Montesinos was exposed on television bribing politicians. The idea of the Colectivo Sociedad Civil was to "wipe the corruption off the face of Peru" symbolically by cleaning the flag.[3] From the 24th, adopted by a wider group of militants, the action was repeated several Fridays in a row at Lima's Central Plaza, in front of the presidential palace, and widely covered by current affairs programs on television. Shortly after the fraud of the April elections, it was a time when any oppositional public action could be interpreted as terrorism. For Coca the performance demonstrated that art could be influential. During that time, also perhaps as a cheeky homage to Joseph Bueys, she had chosen to follow the dictum *art = politics = life*. Although her *chola* background would have made her already sympathetic to an antiracist attitude, her training at the Escuela Nacional Superior Autónoma de Bellas Artes del Perú (ENSABAP; National Art Academy, graduation 2008) in Lima had brought her into contact with students from the interior provinces, who confide their experiences in discriminating Lima with her. There she came to the startling realization that she actually had to call herself *chola*. "We have implanted a chip to frighten us for recognizing ourselves as Andeans," she said.[4] The *cholos* are difficult to define, but they are mostly seen as the Amerindians of Peru who are not defined straightforward as *indígenas*.

3. Vich, "Desobediencia," 66–69.

4. For all this, see the interview with María Isabel Gonzáles, "Trabajo con las cosas que me agarran las entrañas," *La República*, May 22, 2011, Domingo, 26.

Indeed, the migrants of Andean origins who arrived in Lima since the 1970s self-identified increasingly as *cholos*. The *cholos* are modern, new, and progressive—children of a New Peru.[5]

Coca also works as an art instructor. She has exhibited several times in well-known Peruvian art galleries, including "Mejoranda la Raza" (2000; "Improving the Race"), "¿Que tal Raza?" (2002; "What about Race?" or: "What a Cheek!" Galería Forum Lima), "Peruvian Beauty: Centro de Estética" (2004; "Peruvian beauty: Center of Aesthetics," Galería Luis Miroquesada Garland Lima Miraflores, with Susana Torres), "Globo Pop" (2007; Galería Vertice Lima), "Revelada e indeleble" (2011; "Educated and Indelible," Museo de Arte de San Marcos) , and the retrospective "Mestiza, 2000–2014" in Lima's major art museum, the Museo de Arte Contemporáneo (MAC, 2014). In 2010 her work had already been included in the Contemporary Art Collection of the Art Museum of the San Marcos University in Lima, a collection created to celebrate its fortieth anniversary. Her message about unequal gender relations and the problem of race is being heard from inside institutions. In 2011 she was appointed Academic Director of the art school Escuela de Arte Corriente Alterna in Lima.

After a few years, and by chance, Coca began using the self-portrait as her main instrument. The technique enabled her to voice her thoughts through them, illustrated by words and sentences from popular culture. Since then, in most of her paintings she posits herself, sometimes only with her face, as the gender and racially subordinate Peruvian woman of Andean descent. In another painting she appears as a pop art superhero, a female warrior as in modern kick-ass movies like *Colombiana* (2000), to demonstrate the ongoing empowerment of her gender and class.[6] Simply and solely her presence as a female painter in the institutionalized art world speaks to this empowerment. She paints artifacts taken directly from society, like newspaper photographs of the Peruvian Congress that acted on Montesinos's orders only. However, because she works "with things that seize [her] throat," Coca needed more than just figurative drawing and colors. Hence the choice of pop art. Nevertheless, the message should not be too literal, and therefore she attaches the image and text to the symbolic. People could identify with her: "She has the

5. The term *cholo* is also known in the United States and Mexico, where it has connotation with being a gang member or being "filth." In Mexico, a *xolo* is a dog; "xoloitzcuintli" is a dog with no hair. Also, Nugent, *Laberinto*, 34.

6. See Enrique Planas, "Los superpoderes del arte pop," *El Comercio,* June 27, 2007, at http://elcomercio.pe/EdicionImpresa/Html/2007-06-27/ImEcLuces0745583.html (accessed 10/13). *Colombiana* (2000); written by Luc Besson and Robert Mark Kamen, directed by Olivier Megaton.

same experience as me," Coca heard viewers say.[7] The family name of Coca and her obvious and careful cherished Andean looks do the rest.

The viewers should realize that Coca's pop art style and her reference to the dramatic history behind Pinglo's song about "his blood being also red, despite being plebeian, and his heart being not different from that of his beloved one," connects politically informed art with a historical period full of turmoil so that both are formative for Coca's position today. Popular history wants that Pinglo wrote his desperate song because he was not allowed to be intimate with the daughter of an Italian entrepreneur in Lima. This is the articulation which connects contemporary Lima with the still predominantly European city of the 1920s. The country had just gone through a period of relative prosperity, the Aristocratic Republic (1895–1919). As indicated before, the nineteenth century had come with neocolonial and internal colonial relationships between the Latin America elites and foreign investors—supervised by the United States in a way—and these elites and the subordinate classes, especially in the countryside. Because it is not difficult to look for the roots of the discrimination against Andean peoples and their descendants in this internal or neocolonial society, Coca's Pinglo-Lichtenstein Nexus is well founded.

3

For Claudia Coca as for Jorge Miyagui, racism in Peru is an issue. Identities, theories of Self, are cultural and psychological—cognitive schemas. One key aspect of the identity/theory of Self of the members of the Amerindian mnemonic community is the experience of exclusion and discrimination. Looking at Coca's oeuvre thus far, we may perceive her as one of the champions of antidiscrimination in Peru. Her 2014 retrospective in the Lima MAC was to serve as a consciousness-raising of her audience. If there is a situation that demands an intervening agent it is discrimination. Is Coca trying to act like an intervening agent? No, I do not think that is her role. Her position is much closer to Jorge Miyagui's *Colonialidad* than to his *Patrona de América 1*. She likes to convince an audience—the people who are interested in the plastic arts: the middle and upper-middle classes in Lima—that at the "colonized" side of the Colonial Divide chaos rules and that discrimination has been and continues to be one of the causes of chaos. She acts like a mediator. By raising consciousness, however, Coca does ask for intervention. Consciousness-

7. Interview with María Isabel Gonzáles, "Trabajo con las cosas que me agarran las entrañas," 26.

raising is a cognitive activity based on learning and experience that changes relevant cognitive schemas. It involves the changing of perceptions and the encoding of adapted or new schemas which we understand as the creation of knowledge. A painting can be instrumental as an agent that sets the viewer thinking. In Coca's case, consciousness-raising is basically about the errors of thinking in races.

In general, racism is the hatred or intolerance of another race or other races, based on the belief or doctrine that inherent differences among the various human groups have racial origins and determine cultural or individual achievement. Racists usually believe that their own "race" is superior and has the right to dominate others or, at least, think that a particular "racial group" is inferior to the others. There is almost no need to repeat that races do not exist. It is not biology that determines identities. True, the human genome can be used to trace origins based on explicit genes for blood group, skin, hair types, eye color, and so on, but these are varieties only of its single origins in Africa. These varieties can be used, for example, to help unravel the roots of disease and develop medications. "Such genetic differences," says the philosopher Kenan Malik, "are not the same as racial differences."[8] This confusion has its origins in the biological language inherited from the nineteenth century. In my view Malik's work provides the best introduction to the problem of discrimination based on "race" currently available. Trained in neurobiology and the history of science, he is an Indian-born English writer, radio presenter, and documentary filmmaker. Working from the philosophy of biology, he criticizes fashionable theories of race, multiculturalism, and pluralism. His major work is *The Meaning of Race* (1996), but he brought his visions up to date in *Strange Fruit* (2008), followed by a short version, *Multiculturalism and Its Discontents* (2013). The titles indicate where he stands: the celebration of difference and the avowal of identity politics that came with romantic currents in the academic world, like poststructuralism, have preserved racial ideas and worked against diversity. Talking about "racism" confirms the relevance of the concept of "race." It stimulates racial profiling.

Today, this sounds radical. As we have seen, even the Zapatistas wanted arrangements of "indigenous autonomy" to preserve cultural difference. However, by triggering the ancient encoded schemas of the *república de indios*, including its legal separation of the "indigenous," the Colonial Divide was confirmed once again. Also in other countries with a large Amerindian population, like Bolivia, Ecuador, and Colombia, this type of legislation was brought into force under the header of multiculturalism. Repeatedly, Malik

8. Malik, *Strange*, 3.

declares himself openly against multiculturalism, not because he fears immigration, despises Muslims in Europe—he lives in England—or wants to preserve a kind of traditional unity of the English but, "on the contrary, because I favour immigration, oppose the growing hatred of Muslims and welcome diversity."[9] Indeed: "The experience of living in a society that is less insular, move vibrant and more cosmopolitan is something to welcome and celebrate. It is a case for cultural diversity, mass immigration, open borders and open minds."[10] Malik cannot identify this with the identity politics of multicultural differences, which "describes a set of policies, the aim of which is to manage and institutionalize diversity by putting people into ethnic and cultural boxes, defining individual needs and rights by virtue of the boxes into which people are put, and using those boxes to shape public policy."[11] Multicultural identity politics closes borders and minds, builds fences between people, and instigates social pressures for the people within the boxes to fulfill with the "ethnicity's" core cultural markers. That is a case "for the policing of borders, whether physical, cultural or imaginative,"[12] and favors the role, and power, of conservative leaders.

Many countries in Latin America, especially the ones with Amerindian and Afro-American populations, are still dealing with this as well. Racialized terms are not neutral. Polish researcher Joanna Drzewieniecki conducted fieldwork among Peruvian youth. She interviewed students at four high schools and four universities in Lima; one high school stood in poor San Juan de Lurigancho in the metropolitan area of Lima. Of the classifications used, *mestizo* was regarded the most neutral. Asked about their ancestry, 64.1 percent of the students chose only one; they do not consider themselves to be of "mixed blood." Nevertheless, of the students from the popular sectors, half saw themselves as being *mestizo*, 13.5 percent as *cholo*, 9.5 percent as *andino*, and some 12 percent as *white*. The data indicate, says Drzewieniecki, that the Peruvians have accepted the *cholo* category as separate. Of the elite students, also half self-identified as *mestizo*, and almost 30 percent as *white*. Curiously, of the 64 percent mentioning being from one single ancestry, many nevertheless chose a self-identity that is usually labeled as *cholo* or *mestizo*. Even more intriguing is the self-identification of the students who mentioned being of

9. Malik, *Multiculturalism*, 6–7.
10. Ibid., 8.
11. Ibid.
12. Ibid.

white ancestry: 21 percent saw themselves as *mestizo*. In short, these results are evidence of the lack of biology in the "racial" terminology.[13]

A similar study was conducted by Martiza Paredes of the Oxford-based Centre for Research on Inequality, Human Security and Ethnicity (CRISE, 2007) in Bambamarca in the Northern Highlands of Peru, in Huanta in Ayacucho, and in Lurigancho in Lima. Huanta had experienced a high level of Sendero Luminoso violence, Bambamarca managed to remain almost outside of the Internal Armed Conflict, and Lurigancho is one of Lima's migrant settlements, where entire wards were formed by migrants from the same towns in the Andes, in this case from Huanta. In popular parlance, the Cajamarca districts are known for their relatively "light-skinned" people across all income and class levels. The Quechua language has to a large extent disappeared from the region. In Huanta, however, the population is generally Quechua-speaking, and most wear traditional dress. Although many migrants in Lurigancho come from the Huanta area, the research settlement was rather heterogeneous. In these three locations, about half the respondents identified themselves as *mestizo* (54 percent). Less than the other half saw themselves as *andino/indígena* (18 percent), *cholo* (18 percent), or *white* (9 percent). Interestingly, the proxy *language* had little to do with this. Half the respondents spoke Quechua more than regularly—30 percent learned it as a maternal language, 17 percent speaking it as an additional language in the family. Quechua was not spoken in Bambamarca, but it was in Huanta by almost everyone, including the people who self-defined as *white* or *mestizo,* as in Lurigancho, also by some 25 percent of the *whites* there and some 28 percent of the *mestizos*.[14]

Paredes's research shows that we cannot automatically equate Quechua speakers with the category of *indígenas*. For example, someone who speaks Quechua in Lima's Lurigancho would most certainly identify as *cholo* or *indígena*—71 percent of Paredes' respondents did. In Huanta this was only 41 percent. Thus, Quechua might be used as an identity marker in Lima but remarkably *not* in Huanta. A second proxy, next to language, was the Coast/Mountain origins. The researchers expected a clear demarcation between "indigenous" roots and "nonindigenous" roots, based on the traditional geographical divide. Almost every one of the CRISE respondents (95 percent) was born in areas that would be seen as *indígena* by anthropologists. However, only a small group of the respondents self-identified as such. Another

13. Drzewieniecki, "Peruvian." For Drzewieniecki, the willingness to identify themselves as *cholo* and, to a lesser extent, *andino,* a category that used to be mainly academic, was an important finding.

14. Paredes, "Fluid." See also: M. E. García, "Introduction," 217; and Matos Mar, *Desborde,* 121; this book contains the 1984 version as well as a new essay and comments.

example offers the self-perception of skin color. On average, based on a scale from 1-*indígena* to 7-*white*, self-identified *whites* (an average of 5.4) of course saw themselves lighter compared with *mestizos* (3.7), *cholos* (3.6), and *indígena* (2.6). The relatively low average of 5.4 out of 7 of the *whites* is the result of the fact that *white serrano* immigrants in Lima do feel themselves less *white*. The *cholo* and *indígena* minorities in Huanta feel darker than the *cholos* and *indígena* minorities in Lima. *Mestizos* score overall the same figure. In short, moving to an urban-core area like Lima raises different self-identification awareness than in the hometown. People in Lima classified themselves as lighter because they think they have moved up the social scale—except for the *serrano whites*, then.[15] The CRISE research demonstrates that it will be difficult to use generally accepted so-called ethnic markers beyond the local time-space arena. In all, provenance is the main marker of ethnotyping in Peru; not language, not skin color, not ancient origins.

Ethnotyping involves the stereotyping of people according to a series of somatic features. Imagologists like Joep Leerssen look at the dynamics between the images that ethnotype the Others or "Them," called hetero-images, and those that characterize the Self or "Us," called auto-images. The imagologist is not a social scientist but a humanities scholar looking at meaning in images and discourses. "Literary works unambiguously demonstrate that national characterizations are commonplace and hearsay rather than empirical observation or statement of facts."[16] This means that the imagologist does not find it relevant enough to look for the "real" person behind the ethnotype but focuses, on the contrary, of the use of ethnotypes by artists or the public. "Our sources are subjective and rhetorically schematized," write Manfred Beller and Leerssen in their encyclopedic *Imagology* (2007).[17] "Their subjectivity, rhetoric and schematic nature must not be ignored, explained away or filtered out, but taken into account in the analysis. [. . .] Ethnotypes (i.e., stereotypical characterizations attributed to ethnicities or nationalities, national images and commonplaces) take shape in a discursive and rhetorical environment; they are representative of literary and discursive conventions, not of social realities."[18] The imagologist works with characterizations and attributes that "lie outside the area of testable reports or statements of fact," and they call them "*imagined*."[19] Finally: "imagined discourse (a) singles out a nation from the rest of humanity as being somehow different or 'typical,'

15. Paredes, "Fluid."
16. Beller and Leerssen, *Imagology*, xiii.
17. Ibid.
18. Ibid., xiii–xiv.
19. Ibid., xiv; italics in original.

and (b) articulates or suggests a moral, characterological, collective-psycho-logical motivation for given social or national features. Imaginated discourse offers characterological explanations of cultural difference."[20] This is precisely how the "ethnicities" in Latin America work.

Within the Amerindian mnemonic community, the ethnotyped *cholo* cat-egory is becoming a strong identity marker based on shared migration experi-ences, more often than not associated with the Internal Armed Conflict, and with shared social and economic developments in the urban world. A Lima census of 1938 gives a population of 407,662, with a majority of *white-mesti-zos* of 91 percent.[21] Marketing experts Rolando Arellano and David Burgos classify the descendants of these people as the *Limeños clásicos*. Today, how-ever, they make up only 13 percent of the eight million inhabitants (2010).[22] A small group of nearly 8 percent have parents born in Lima but grandparents born in the provinces. Everybody else, 79 percent, has parents and grand-parents born in the provinces. A little over 43 percent of these Limeños are born in Lima; some 36 percent, however, are born in the provinces. Also, the population's DNA has been investigated to establish its origins. Interestingly, the category "Peruvians from Lima" is predominantly Native American (68 percent); next is European (15 percent Mediterranean, 10 percent Northern), followed by 3 percent Southwest Asian and 2 percent Sub-Saharan African.[23] Note: the migrants in Lima are basically Native American in origin and share these roots with the population of the Andes, who are "predominantly Native American (95 percent) with a small amount of more recent admixture with European populations (2 percent Mediterranean, 2 percent Northern Euro-pean) in the past 500 years."[24]

These data require some extra discussion. Readers might think that there are some grounds for "bloodlines" after all. Defining people on biological grounds can be dangerous, as we all know. Denominators as Native Ameri-can point at shared genetic roots, not at "races." The data are published by the Genographic Project of the National Geographic Society (NGS) in Washing-ton, DC, in the United States. By inviting people all around the world to send them their DNA, the NGS is able to design a chart of human relatedness.

20. Ibid.

21. Arellano and Burgos, *Ciudad*, 34, Cuadro 1.

22. Ibid., 77, Cuadro 8.

23. Genographic Project of the National Geographic Society (NGS) in Washing-ton, DC, United States. See the 3rd ("Amerindian [Mexico]"), 16th ("Highland Peruvian"), and 33rd ("Peruvians from Lima") populations listed on the website, at https://genographic .nationalgeographic.com/overview-of-regions-and-closest-populations/reference-populations/ (accessed 5/14).

24. Ibid.

The current data have been processed since 2005 by a team led by Spencer Wells. The team works with the Y chromosomes. All men's Y chromosomes stem from an ancient ancestor in Africa more than one hundred thousand years ago. His descendants have settled around the world and, during their journeys, accumulated mutations in their DNA. These mutations make them unique and typical for certain areas and communities. The NGS team gathers and analyzes data in collaboration with "indigenous and traditional" peoples around the world, which means that everyone participating is confident that the data could support "indigenous" claims. "When DNA is passed from one generation to the next, most of it is recombined by the processes that give each of us our individuality," the website reads.[25] "But some parts of the DNA chain remain largely intact through the generations, altered only occasionally by mutations, which become 'genetic markers.'"[26] The NGS team seems to be mostly interested in these markers because they can be used to reconstruct migration history, but for the "indigenous" participants the link with a region, their habitat, has more significance. In our case, this is the Native American blend of a collection of nine ancestral regions that combine to make up everyone's genome. It is dangerous to use the word "pure," but many "indigenous" populations would like to see themselves as such.[27]

The data based on samples from regions in Central Mexico point also to a predominantly Native American background of 83 percent—this is the area of Mexico City, including Texcoco (and Tepetlaoxtoc)—and no child of Spaniard and Amerindian at all. Today, Central Mexico is seen as a *mestizo* region. To this figure can be added some 4 percent from Northeast Asian ancestry, which traveled to the Americas over 20,000 years ago. After 1500, the DNA contributed to this population with 7 percent from the Mediterranean, 3 percent from Southwest Asia, and 5 percent from Northern Europe. A few years ago *Nature* reported on a paper published in *Science* that demonstrated the "close biological connections between Mexico's two traditional cultural groups: indigenous Native Americans and 'mestizos'—people with mixed Native American and European ancestry." The article quotes geneticist Andrés Moreno-Estrada at Stanford University in California, one of two lead authors of the *Science* paper: "As academics, we have been separating them

25. General portal: https://genographic.nationalgeographic.com/; quote about the genetic markers from: https://genographic.nationalgeographic.com/science-behind/. For the "indigenous" populations, see "Who Am I: Reference Populations Overview"; see the discussion of particular blends of nine regional affiliations at https://genographic.nationalgeographic.com/overview-of-regions-and-closest-populations/reference-populations/ (all accessed 5/14).

26. Quote about the genetic markers from https://genographic.nationalgeographic.com/science-behind/.

27. General portal: https://genographic.nationalgeographic.com/.

into two groups—indigenous and cosmopolitan. Genetically, we see that, in fact, there is very little difference between these two. We see that there is very little difference between a cosmopolitan person from the city of Oaxaca and a Zapotec from the highlands of Oaxaca, and I hope this breaks down those barriers. This separation in social terms that we have been accepting for years doesn't have a biological basis."[28] The *mestizo* Mexicans in the study, although economically and socially distinct from *indígenas*, are genetically quite similar to them. Any statement of a "mixed" descent based on biological grounds lacks evidence. As said, the Native American features of the DNA in Highland Peru are even stronger: 95 percent. Only the Yoruban population in West Africa (97 percent) is more "pure" in this regard; the Papuan population of Papua New Guinea scores 91 percent. In short, at least in Central Mexico, the Peruvian Andes, and Lima, the *indígena*, *mestizo*, and *cholo* ethnotypes share the same biological origins: Native American—or Amerindian, according to the category defended in this book.

4

Auto- and hetero-ethnotyping forms a typical part of the Amerindian mnemonic community in Latin America. The available cultural information about this demonstrates that we mostly work with ethnic terminology in our daily lives as if they really are mirrors of reality. Therefore, in appreciating Coca's effort it will help to answer some basic questions. For example: What is identity? There is one classical definition, by the psychologist David Moshman: "An identity is an explicit theory of oneself as a person."[29] Hence, this involves the Self, and therefore, following cognitive schema theory, a whole series of interacting self-schemas, demonstrating that the Self's "identity" depends on the situation and the social context. The theory of Self—"identity"—works to initiate acting on a certain place—stage, in the company of a group—at a certain moment. In our times, a person like Claudia Coca would be identified or self-identifies as Peruvian, Limeña, *chola*, upper middle class, professional artist, teacher, mother. Identity works through reification, a process by which we attribute reality to mental constructions. "The self is such a reification,"

28. Erika Check Hayden, "Sweeping Diversity Seen in Mexican Genomes: Genetic Differences among Mexicans Also Have Health Implications, Study Finds," *Nature*, June 12, 2014, http://www.nature.com/news/sweeping-diversity-seen-in-mexican-genomes-1.15403 (accessed 9/16).

29. Moshman, "Identity," 1.

Mihaly Csikszentmihalhy said in his book *The Evolving Self* (1993),[30] "a fig-
ment of the imagination, something we create to account for the multiplic-
ity of impressions, emotions, thoughts, and feelings that the brain records in
consciousness." And as we know by now, much of it is translated in hindsight
into interpreted and reflective texts by the left hemisphere interpreter. The
interpreter is in direct contact with the "brain's awareness of its own form of
organizing information."[31] "Just as we apprehend the millions of water mol-
ecules as a single ocean, we experience the coming together of information in
consciousness as the self."[32] The conscious self is the actor on the stage in the
theater of the mind, and it includes basically everything that passes in con-
sciousness, including all our memories. Information stored in the brain binds
together to form memory and to form codes about how to perform in a cer-
tain location, influenced by tradition—thus, time—and numbers, like majority
versus minority. Self-schemas sometimes collide because if people move from
one place to another or change group belonging, their identity changes. They
plug in to a new identity, so to speak. In addition, they run the risk of forget-
ting their roots.

For most philosophers and theorists from the nineteenth and early twen-
tieth centuries, including psychoanalysts, the question of identity involved a
personality theory. Recent psychological research has demonstrated that it
does not. Personality theories have tried to describe the similarities and dif-
ferences that people share or do not share in their personalities. Because none
of the personality theories has been truly successful in reaching its goals—
describing integrated personalities of humankind—there are still many differ-
ent ones. Theorists confirmed Gordon Allport's conclusion that personality "is
something real within an individual that leads to characteristic behavior and
thought."[33] Carl Rogers spoke of a "consistent pattern of perception of the 'I'
or 'me' that lies at the heart of an individual's experiences," while Freud argued
that "personality is largely unconscious, hidden, and unknown."[34] The first
two short characteristics cover the idea very well: we think that something
real lives inside us, which we regard as "I" or "me." Even after the cognitive
revolution, much of this is still alive. In their textbook *Personality Psychology*
(2008; 3rd ed.), Randy Larsen and David Buss define "personality" as "the set
of psychological traits and mechanisms within the individual that are orga-

30. Csikszentmihalhy, *Evolving*, 216.
31. Ibid., 217.
32. Ibid.
33. Engler, *Personality*, 2.
34. Ibid.

nized and relatively enduring and that influence his or her interactions with, and adaptations to, the intrapsychic, physical, and social environments."[35]

Most personality theories are relatively old because in our cognitive times the very idea of a "personality" is seriously waning. Scholars tend to share the conclusion that there are no masks; there is no "central me," there are only multiple "me's," depending of the situation. The management of different "identities" or different "personalities" in diverse situations and on specific moments is our normal state—even between home and the street. Every situation requires its own theory of Self, its own time-space limited identity, and we may refer this to our personalities. Studying the works of development psychologists, Judith R. Harris writes in *No Two Alike* (2006) that they have showed that the context-specific socialization of the child takes place basically outside the parental home, in peer groups of childhood and adolescence. Here, there are at least two personalities involved: one suited for "home" and one suited for "friends." She also refers to a long review of socialization research published in 1983—socialization is the influence of parents on the personality of their children—concluding that there is "very little impact of the physical environment that parents provide for children at home and very little impact of parental characteristics that must be essentially the same for all children in a family," like education.[36] In fact, siblings raised in the same family seem to be hardly more similar than children chosen at random from the population.[37]

In her *Nurture Assumption* (1998), Harris gives many more examples. Personally, I like the following, based on the work of development psychologist Carolyn Rovee-Collier. With her colleagues, Rovee-Collier had done a series of experiments on the learning ability of young babies. These babies lie in a crib, looking up at a mobile hanging above them. A ribbon is tied to one of their ankles in such a way that when they kick that foot, the mobile jiggles. Six-month-old babies catch on to this very quickly: they are obviously delighted to discover that they can control the mobile's movements by kicking their feet. Moreover, they will still remember the trick two weeks later. But this is not the case if any detail of the experimental setup is changed. If a couple of the doodads hanging from the mobile are replaced with different doodads, or if the liner surrounding the crib is changed to one of a different pattern,

35. Larsen and Buss, *Personality,* 4.

36. Harris, *Nurture,* 38–40, 45–49.

37. A large list of published parent–child socialization research, studies on sibling differences, birth order, adoption, language acquisition, and child-rearing practices across time and culture does indeed point to a *limited*—that is: not absent—influence of the parents on the development of their children's personalities; Harris, *Nurture,* 42–44, 50–51. Also E. Herman, "How," 308; Plomin and Daniels, "Why."

or if the crib itself is placed in a different room, the babies will gaze up at the mobile clueless, as though they had never seen such a thing in their lives. Harris concludes that, evidently, babies are equipped with a learning mechanism that comes with a warning label: what you learn in one context will not necessarily work in another. She asks her readers to imagine a child who goes outside her home for the first time at the age of four and discovers that out there everyone is speaking a language she cannot understand and that no one can understand her language. Will the child be surprised? Knowing about the babies and the mobile, the answer must be: probably not. Change the liner surrounding the crib and they think they are in a different world, a new world with different rules, yet to be learned: language learned at home may prove to be of no use whatsoever outside the home. Immigrant children know this all too well. "You would think a picky eater in one setting would be a picky eater in another, wouldn't you?" Harris asks her readers. "Yes, it has been studied, and no that's not what the researchers found."[38] One-third of the children in a Swedish sample were picky eaters *either* at home or in school, but very few were picky eaters in *both* places. The latter figure, no doubt, is due to genetic effects like food allergies or a delicate digestive system.

In 2003 anthropologist Ana Mariella Bacigalupo described a series of different identities when she stayed with the Mapuche in Chile. She called it a "context-specific nature of self-defined and imposed representations of self and Other."[39] In her community, due to her genetic origins, seventy-nine-year-old Mapuche machi Pamela was classified as *champurrea* or *mestizo*, whereas Bacigalupo self-classified as having an Anglo-Argentine/Quechua/Italo/Peruvian/Chilean background. A machi is a religious healer or shaman. Bacigalupo moved in 1978 to Chile, a country that has become the place she identifies as home. Because she has no Chilean or Mapuche ancestors, machi Pamela initially classified her as *gringa*—a category reserved for people from the United States or those who speak English—or Argentinian, the generalized stranger. Others thought Bacigalupo was Chilean. Among the Mapuche, the category of *gringa* has a less negative connotation than *winka* (European or non-Mapuche in general). Since there is a large German population in southern Chile, a blonde European could also be classified as *alemán* or German. Visiting Canadian Native Americans were classified as *gringo indígenas*.[40] When the head of Bacigalupo's host family began to claim her as his niece from the city, and people became aware that she was of "mixed descent," machi Pamela changed to call her *champurrea*. In the community, machi Pamela catego-

38. Harris, *Nurture*, 57–58, 60, 62, 64; Rovee-Collier, "Capacity."
39. Bacigalupo, "Rethinking," 40–41.
40. Ibid.

rized herself as a wise, traditional authentic and indigenous Mapuche. Some people in the community agreed with this role, while others categorized her as Other and outsider, a witch, a *champurrea* who knew *winka* witchcraft. Machi Pamela sometimes exploited this script of a powerful witch, an outsider with unknown powers, to keep people and their animals off her land. In talking to Mapuche, machi Pamela often privileged a return to traditional Mapuche lifestyle, living in harmony with spirit beings, while when talking to her *winka* friends she complained about the Mapuche always being envious of each other and doing each other harm.[41]

When Bacigalupo and machi Pamela went into town in Bacigalupo's car, machi Pamela acknowledged her role as a poor Mapuche woman farmer. She would deny being a machi because the machi practice was considered illegal medicine in Chile. In the office where machi Pamela collected her monthly pension, she once feigned ignorance and asked the secretary about a medicinal plant on the desk, one that she used often in her own curing, and thanked the woman for "teaching" her. This attitude was part of the play of ignorance which she thought necessary to avoid conflict in the city. In that context, machi Pamela was *native*, while Bacigalupo was still the *gringa* or *winka*, who possessed the car-driving, place-finding, literate knowledge and language she needed for petitions and office work. When in town, most Mapuche either categorized themselves as *indígena* and feign ignorance, or assume the role of *mestizo champurreas* or *winkas* by speaking Spanish and wearing Western clothing to avoid discrimination. However, in the Mapuche community the roles played were reversed. On that stage, machi Pamela was the one with power and knowledge, a wise woman who had the ability to see spirits and to distinguish between herbal remedies. There, Bacigalupo was inadequate and ignorant, acting as cook, helper, or servant. When Bacigalupo incorporated learned Mapuche knowledge and practice into the way she related to people, machi Pamela called her *champurrea* again, but when she made mistakes or acted inadequately she was called a *gringa* who could not learn everything. One day, driving her truck along a dirt road with machi Pamela beside her in the front, Bacigalupo was stopped by the police. The two women had passengers in the back of the truck, which was forbidden. Bacigalupo put on a heavy American accent, flashed her U.S. university ID card and said to the policeman that all the people worked for her. The policeman nodded, did not fine them, did not make the passengers in the back get out, and let them go. By this act of "resistance," Bacigalupo had become a true Mapuche.[42]

41. Ibid.
42. Ibid.

In his *Principles of Psychology, Vol. 1* (1890), William James, the father of American psychology, wrote that "*a man has as many social selves as there are individuals who recognize him* and carry an image of him in their mind."[43] Perhaps this view is even older than James. Eighteenth-century Scottish philosopher David Hume wrote in his *Treatise of Human Nature* (1738) that the Self was "nothing but a bundle or collection of different perceptions, which succeed each other with an inconceivable rapidity, and are in a perpetual flux and movement."[44] Judith Harris adds: "But as the individuals who carry the images fall naturally into classes, we may practically say that he has as many different social selves as there are distinct *groups* of persons about whose opinion he cares. He generally shows a different side of himself to each of these different groups. Many a youth who is demure enough before his parents and teachers, swears and swaggers like a pirate among his 'tough' young friends. We do not show ourselves to our children as to our club-companions, to our customers as to the laborers we employ, to our own masters and employers as to our intimate friends. From this there results what practically is a division of the man into several selves; and this may be a discordant splitting, as where one is afraid to let one set of his acquaintances know him as he is elsewhere; or it may be a perfectly harmonious division of labor, as where one tender to his children is stern to the soldiers or prisoners under his command."[45] In other words, Harris concludes, "people behave differently in different social contexts." This means that an *indígena, mestizo, cholo, white* (Euro-Peruvian) identity can only be contextual; a specific personality active in specific places in particular moments. The same person will have many more personalities— *cholo* in one situation, *indígena* in another one, "urban" in yet a third situation, and so on.

More than a decade ago, in his *How Our Lives Become Stories* (1999), literary scholar Paul John Eakin followed the lead of developmental psychologists and traced the origins of autobiographical discourse to the young child's initiation into "memory talk," the homely little stories that parents and caregivers coach us to tell about ourselves. Eakin concluded that by doing the talking, as it were, we learn as children what it means to say "I" in the cultures we inhabit. At a young age the Self gets access to language and starts giving a voice to itself by actively voicing itself. This training proves to be crucial to the success of our lives as adults. Our recognition by others as normal individuals

43. James, *Principles,* 1:294; italics in original.

44. Hume, *Treatise,* 252. Perhaps Hume came to this insight after reading the work of his French forerunner Pierre Bayle; see Ginzburg, *No Island,* 65–66: P. Bayle, *Oevres diverses,* The Hague 1727–31, or *Dictionaire historique et critique,* Amsterdam, 1740.

45. Harris, *Nurture,* 56, italics in original; James, *Principles,* 294.

depends on our ability to perform the work of self-narration. Thus, autobio-graphical discourse plays a decisive part in the regime of social accountability that governs our lives, and in this sense human identities could be said to be socially construed and regulated.[46] In recent years Eakin added to this the insights of Antonio Damasio, who stated that bodies have stories. Because we move in time, anything in the body itself moves in time; there is always a past, present, and future—the "imagetic representation of sequences of brain events," says Damasio, or prelinguistic "wordless stories about what happens to an organism immersed in an environment."[47] The body's story—more often a nondiscursive experience—is focused on homeostasis. This is the ensemble of regulations and the resulting state of regulated life in the human organism as nearly constant.

From Damasio's neurobiological perspective, the body emerges as a "homeostasis machine," and the body's homeostatic regulatory activities range from metabolism, basic reflexes, and the immune system at the lowest level, to pain and pleasure behaviors, drives and motivations, and finally to emotions and conscious feelings; feelings precisely that all these activities are taking place. The adaptive goal of all this manifold activity of homeostatic regulation, a great deal of it unconscious, is the well-being of the organism as it moves forward into the future. For Damasio the continuous attempt at achieving a state of a nearly constant and positively regulated life is a deep and defining part of our existence; one of our "drives." Eakin would extend this view of the human organism's homeostatic regulatory activity to include our endless fashioning of identity narratives, our performance of the autobiographical act. Also activities such as science, technology, and the arts assist the mechanisms of "social homeostasis": "Our life must be regulated not only by our own desires and feelings but also by our *concern* for the desires and feelings of oth-ers expressed as social conventions and rules of ethical behavior. Those con-ventions and rules and the institutions that enforce them—religion, justice, and sociopolitical organizations—become mechanisms for exerting homeo-stasis at the level of the social group."[48] In short, Eakin agrees with Damasio that we could say that autobiography's tracking of identity states across time serves a homeostatic goal; the "I" as constant, for example. In this sense, the adaptive purpose of self-narrative, whether neurobiological or literary, would be the maintenance of stability in the human individual through the creation

46. Eakin, "Living."

47. Ibid., 2–3; quotes from Damasio, *Feeling,* 189, and *Looking,* 30–31, 36.

48. Damasio, *Looking,* 166; italics in original.

of a sense of identity. Precisely this is the function of some "collective story-telling," social homeostasis, that is involved in filming or painting.[49]

According to Monisha Pasupathi autobiographies are co-constructed with partners and then gradually become encoded in self-schemas. She believes that this is why we live our lives "immersed in talk, providing others with stories of what happens to us and ideas what we think our experiences mean."[50] This talking includes dreams and talking to ourselves. It is a *doing*. Talking about experiences, the storyteller reconstructs the experience or event during the conversation itself. In general, people tell listeners about events in ways which, they hope, will gain and hold attention. They concentrate on norms, values, goals, and emotions that are accepted by their audience. Some details or perhaps the entire story might be recounted as being more exciting, sadder, or drearier than it actually was. In short, the account conforms to the community's cultural expectations. The listeners contribute to the storytelling by presenting their own insights, and reactions to it, be they positive, negative, or neutral. These reactions influence which events are talked about and what sorts of interpretive statements, details, and emotions are connected with the event as it is discussed. The storyteller then encodes the effects of the conversation about the experience together with his or her memories of the original experience. A new cognitive schema is formed and applied, also as an instrument to reconstruct memory in the light of the conversation. This reconstruction of past experience is consistent with notions of development and cultural values present in other cognitive schemas.[51]

Also "ethnicities" are socially constructed group identities that change at their own discretion. This is well-established knowledge. In *Stigma* (1963), the sociologist Erving Goffman speaks of in-group alignments and out-group alignments.[52] It is a social identity theory, indicating that people's theories of Self are based on their real or imagined group membership. Since Henry Tajfel's successful compilation *Social Identity and Intergroup Relations* (1982), social identity theory has expanded enormously. Research into Tajfel's proposition that the groups to which people belonged (e.g., social class, family, football team, gangs) has confirmed that these groups are indeed an important source of pride and self-esteem as a sense of belonging to the social world. We also know that to improve their self-image, group members enhance the status of their group. After creating "in-groups" or "us" and "out-groups" or "them,"

49. Eakin, "Living," 3–4.
50. Pasupathi, "Social," 651; this paragraph also in Ouweneel, *Freudian,* 220–21.
51. Pasupathi, "Social," 652.
52. Goffman, *Stigma,* 137–49.

Tajfel believed, the former would discriminate against the latter, finding negative aspects of the out-groups to enhance their self-image.[53]

As said, an ethnotype is conceptualized in terms both of the "real" and of the "stereotyped" Self and other. It concentrates strongly on stereotyped biographies of "them" and "us"—in that order, because contrary to regular identity theorizing, ethnotyping is more than often about "them." As a cognitive schema, ethnotyping incites action, drives people to stereotype by doing, including talking. The "ethno-" prefix points at nations. Deducing from theoretical work recently done on European ethnotyping, among others by Dutch cultural historian Joep Leerssen and his research group in Amsterdam, we may regard the Amerindian populations in Latin America as "minority nations" within or even across national borders—indeed, some are even legally recognized. Perhaps the definition of "nation" along cultural, linguistic, and ethnic lines can also be easily recognized in a wider sense at the Latin American Colonial Divide as a consequence of *colonialidad*. In his book *National Thought in Europe* (2006), Leerssen demythologized the discourse of national identity in Europe by arguing that nationalism has been the political instrumentalization of ethnotypes.[54] He demonstrates that demythologizing cultural ethnotyping is a means of consciousness-raising.

Coca believes with many Peruvians that ethnotyping in her country is part of a deeply racist culture—with very real consequences. "It's the fear and rejection of the other," she said in an interview.[55] "Many times we are racists out of innocence, out of ignorance, because of our education; of what we learn from textbooks of Peruvian history; of what we saw the way our grandparents have been treated. All of Peru has been built with this sense of shame, above all with this blot of having Andean ancestors."[56] What plays a part here is that in popular parlance—and also in general academic—language the word *mestizo* refers to a loss, to a negation. People ethnotyped as *mestizos* are no longer *indígena*; they have lost the right to be included in the cognitive noble savage schema (CNSS). Only true *indígenas* have the right to be called indigenous. Coca refuses to look at the ethnotyped categories of *mestizo* and *cholo* as loss: "My work serves to demonstrate that mestizaje is enrichment."[57] Therefore,

53. Tajfel, ed., *Social*. For more recent work: Feliciano, Lee, and Robnett, "Racial"; McLean, "Space"; Owens, Robinson, and Smith-Lovin, "Three"; Staerklé et al., "Ethnic"; H. White, *Identity*.

54. Leerssen, *National*.

55. Alonso Almenara, "Mi trabajo es mostrar que el mestizaje es un enriquecimiento," *LaMula.pe*, July 20, 2014, https://redaccion.lamula.pe/2014/07/30/mi-trabajo-es-mostrar-que-el-mestizaje-es-un-enriquecimiento/alonsoalmenara/ (accessed 10/14).

56. Ibid.

57. Ibid.

like Miyagui's, her art is not art for art's sake. Perhaps the appropriation of a negative hetero-image as proud auto-image will help: an idealization of what is seen as the *mestizo* body. In truth, she said, this is urgently required because the ethnotyped *mestizos* have a problem in distinguishing their own "race" ("reconocerse en su propia raza").[58] In fact, Coca paints to support *mestizo* empowerment: "It's my task to show that we are not dealing with stains, and that mestizaje is enrichment."[59] The construction of *mestizo* empowerment could help shape "a *mestizo* who could look into the mirror without inferiority complexes."[60] Personally, Coca only felt discriminated against in the personal sphere, she said. The mother of one of her boyfriends, for example, had said to her son that she did not like her much "because of the way she was," *chola*. She also remembers that as a child she looked in the mirror, thinking: "If I'm so pretty, why don't they gaze after me?"[61]

5

The urgency of Coca's stance can be underscored by looking at a small series of stirrings caused by ethnotyping in Peru at the time *Plebeya 3* was conceptualized and painted. First, there was the Designer affair, developed after the boys of cumbia band Grupo 5 were photographed in upmarket costumes and interviewed by the Lima glossy magazine *Cosas* in April 2008.[62] Grupo 5 is based in the northern city of Chiclayo, which means that they are *provincianos*, "country boys." Over the past few years, cumbia music, including the popular chicha version, has become increasingly popular among the higher classes of Lima. By now, very few fiestas can do without it. Certainly not chicha were the Italian designer costumes for the *Cosas* photo shoot (*Cosas* 391, 2008). These were borrowed from the exclusive clothingstore Designer in the upperclass San Isidro district of Lima. Designer is the Lima agent for Italian

58. See the interview: "Claudia Coca y el laberinto de la choledad," in *Peru21,* July 20, 2014; also at http://peru21.pe/espectaculos/claudia-coca-choledad-racismo-muestra-discriminacion -2192697 (accessed 12/14).

59. Almenara, "Mi trabajo" (link in note 54, this chapter).

60. Ibid.

61. G. Wiener. "Si soy bonita, ¿por qué no me miran?" *La República,* August 17, 2014; also published online at http://www.larepublica.pe/17-08-2014/si-soy-bonita-por-que-no-me-miran (accessed 10/14).

62. See, for example, Wilfredo Ardito Vega's letter in the *El Comercio* daily, May 19, 2008, at http://elcomercio.pe/edicionimpresa/html/2008-05-19/diganos-lo-que-piensa.html, and the text on his blog "Reflexiones Peruanas" 199 of May 19, 2008, at http://reflexionesperuanas .blogspot.nl/2008/05/reflexiones-peruanas-199-motor-y-motivo.html (both accessed 6/08). The cumbia, of course, is a style of tropical dance music imported from Colombia.

brands like Ermenegildo Zegna, Ferré Milano, Prada, Trussardi, and Valentino. A later edition of the *Cosas* glossy, by the way, also included actress Magaly Solier, proving that the Grupo 5 article was no exception. Solier was born in a village near the city of Ayacucho (1986), and speaks Quechua at home.

Grupo 5 appeared in the popular gossip and talk show *Enemigos íntimos* on May 7, 2008, aired by the Frecuencia Latina network, from Monday through Friday live, at 11:00 pm, and at the time hosted by television personalities, actors, and writers Beto Ortiz and Aldo Miyashiro. The hosts had invited the group to congratulate them on this "revolutionary event": a clearly urban and elitist glossy—made for and read by people of "Blue Blood" (*sangre azul*)—had expanded its attention to successful non-European musicians, artists, entrepreneurs, and politicians. The *Enemigos íntimos* reporter Mabel Huertas showed that the clothing store's representative Vanessa Delacroix had problems seeing photographs of a cumbia band in her clothing. She said to Huertas on the phone that her clientele—classified as A+ or Lima-high-class; E is at the bottom—had commented negatively. This clothing was for "serious" people like politicians and serious artists, implying that the cumbia—Peru's favorite music—was not. Would this not be a racist attitude, Huertas asked her? Certainly not; this was a question of imagery. The clothing shop sold frequently also to a dark-skinned clientele. Delacroix used the word *oscuritos*, a diminutive typical of, indeed, a discriminatory attitude. Asked whether Beto and Aldo could be dressed by Designer, Delacroix answered that she needed to have a form filled out by them, addressing some questions and a photograph. She would then send the form to Italy for advice.

In their May 7, 2008, show, Beto and Aldo told the Grupo 5 members after much laughter that in fact the situation had to be the reverse: Designer should have paid Grupo 5 for wearing their dress. The two ended their scoop by stating that "this kind of stupidity" must be confronted anytime it occurs, until the moment comes that people no longer notice "race differences" in fashion catalogs and glossy magazines. The members of Grupo 5 agreed: "They may not treat us like this, or any other cumbia musician. The *Cosas* staff treated us very good, but after what I heard saying the clothing shop's representative, I prefer to put on a sweater knit by my grandmother." Wilfredo Ardito Vega, a human rights advocate specializing in cases against discrimination and the key executive of the Asociación Pro Derechos Humanos (APRODEH; Peruvian Association for Human Rights), wholeheartedly agreed. He was present that weekend at a kind of street row in front of the clothing shop's door, when many of the writing and broadcasting press tried to interview Delacroix—in vain, of course; Designer's management chose not to comment. In addition, this occasion was filmed by *Enemigos íntimos* and aired a few days later. This

time, Beto and Aldo showed that in front of their cameras one of their clearly *oscurito* chauffeurs was allowed in to buy an expensive Designer coat and was treated in a very friendly way indeed by the clothing shop's personnel.[63]

Around that time, Tula Rodríguez was also negatively ethnotyped after having caused a public stir.[64] She hosted the program *El escuadrón* on the Peruvian Frecuencia Latina network. It was almost a week before Mother's Day, when the thirty-year-old actress and television personality announced on her program that she was pregnant. She would leave the program to enjoy her rest, because the pregnancy was becoming difficult. Informed by the yellow press, viewers realized that the father was Javier Carmona, the network's manager. At that very moment, Carmona was getting a divorce from another television host, Gisela Valcárcel. Within days, Tula's *autoampay* or self-disclosure was widely discussed as a *mensaje a la nación*, a message to the nation. Several other networks programmed reports, and talk shows discussed the marriage. Tula was a *chola*, her *white* lover from Lima. One of the reports, made by Fernando Díaz and aired by the *Día D* Program of ATV Peru on May 11, presented Tula as a kind of Cinderella called Tulicienta (a contraction of the actress's name and the Spanish name of Cinderella, Cenicienta).[65] Based on positive ethnotyping—"the Andeans can make a career and are like us"—the report was sympathetic to Tula.

However, a more villainous sketch was included in the prime-time *Especial de humor* (Humorous Special), broadcast by the Frecuencia Latina network on May 17, 2008, made by Carlos Álvarez and Jorge Benavides. The show has been on the air since 2004, on Saturday nights between 9:00 and 11:30 p.m. Based on negative ethnotyping, the comedians depicted Tulicienta as a "poor" girl in cinders, looking for an opportunity to marry a rich European prince,

63. See, for example, "La tienda Designers no responde sobre discriminación Grupo 5," uploaded June 15, 2008, by Henry Spencer, at http://www.youtube.com/watch?v=r9lKNZU1meg; or the daily *La Primera*, 2008, http://www.laprimeraperu.pe/online/espectaculos/discriminan -a-grupo-5_15777.html; or the news site (2008) http://www.terra.com.pe/entretenimiento/ noticias/oci307231/grupo-5-es-discriminado-por-boutique-san-isidro.html; and another blog, written by Carlo Magno Salcedo Cuadros, published at http://blog.pucp.edu.pe/item/23154/ grupo-5-vs-designers-cronica-de-una-discriminacion-anunciada (all accessed 6/08).

64. See, for example, "Tula Rodríguez embarazada de Javier Carmona," uploaded May 6, 2008, by Gloria Medina at http://www.youtube.com/watch?v=x_wapdd8W6A; or in "Buenos Días Peru," Panamericana Televisión, at http://www.youtube.com/watch?v=HGl15r_2Zmo (both accessed 6/08); or, indeed, "Tula anuncia en vivo su embarazo," uploaded September 19, 2008, by VideosZona at http://www.youtube.com/watch?v=MtVmfKz2Fzw (accessed 9/08).

65. The first part of Díaz's report, "Chollywood: La Tulicienta (I Parte)," can still be found at http://www.youtube.com/watch?v=ahGj2yaNADA, uploaded May 15, 2008, by TV Peruana y la Gentita en JP; the second part "Chollywood: La Tulicienta (II Parte)," at http://www.youtube .com/watch?v=EUVlESTXuSk (both accessed 6/08); and the third part "Chollywood: Tulicienta (III Parte)," at http://www.youtube.com/watch?v=f8kiDWnBta4 (accessed 6/09).

called Marcona the Blue Prince.[66] The *chola* was a treacherous opportunist. As a migrant from the Andes, Tulicienta told the viewers she was constantly discriminated against because of her looks—her "race"—and needed to find a way out. A pretext of course! Marrying the Blue Prince was the obvious solution and had been Tulicienta's goal from day one. The reaction to the sketch in the press was largely negative. Look who's talking, the reporters asked, Álvarez, Alberto Fujimori's court jester! Depicting Tula like this was understood as a scolding of Tula's social climbing. There is no place for a Tulicienta in the castle of the Prince. Tula had been out of joint. Subsequently, Álvarez cancelled all sequences of "Tulicienta."

The show had been known for its hetero-image ethnotyping. In his contribution to the *Coloquio Lo Cholo en El Perú,* the two publications of the Biblioteca Nacional del Perú in Lima coordinated by Susana Bedoya (2009), anthropologist Raúl Rosales discusses a sketch by Álvarez and Benavides on their comedy show. The sketch Rosales reviewed was called "Las tías pitucas de la Molina," or "The White Aunties of La Molina" (2005). The word *pitucas* is an ethnotyping of wealthier, traditional Limeños—the *whites* of Lima Central. The sketch was remarkably long and had several sequences on the show. It was modeled after a real situation. In 2005 the inhabitants of the neighborhood of La Molina had raised a fence along the border with the neighborhood of Ate. For an outsider, La Molina is known as upper-middle-class and considers itself more "residential." The inhabitants look at Ate as more "popular." In the scene, the two comics play two women of La Molina, humiliating a few persons from Ate. The two comics play with the self-identification of La Molina as more classy, whereas the actors performing the inhabitants of Ate play with their supposed poverty. In their usual style, Álvarez and Benavides perform like drag queens with funny voices, the former making fun of well-known Peruvian transsexual Fiorella Cava, the latter of politician Gloria Helfer. One figure is dressed up like a chicken, working for Pio's Chicken, a popular restaurant in Ate. The chicken sides with La Molina and is severely punished by those from Ate because of his treason. The show seems to screen a mutual *choleo* or talking-down between the two neighborhoods, but the real *choleados* here are gay people in general and the poor of Ate.[67]

66. *El especial del humor,* "Tulicienta," at http://www.youtube.com/watch?v=IcqRfITiGyE, first part, and second part at http://www.youtube.com/watch?v=8vdJ5NdWVUU (both accessed 6/08).

67. Rosales, "Lo Cholo," 77–78; the scenes of "El Especial del Humor—Las Viejas de La Molina" can still be found on YouTube, for example at https://www.youtube.com/watch?v=SFMTl2ufiRo (accessed 4/15).

Negative hetero-image ethnotyping of the Andean population has been infecting not only political, cultural, and social communication in Peru but also language. Think for example of *amor serrano*. This expression reads something like "mountain love" or "love in the way the *serranos* do." It means: "the more you hit me, the more I love you" ("más me pegas, más te quiero"). In *Enemigos íntimos* of May 29, 2009, a report about the public rows between folkloric singers and lovers Alicia Delgado and Abencia Meza was labeled "woman contra woman." However, the next day, images of the program found their way into other programs precisely under the heading of "*amor serrano: más me pegas, más te quiero.*"[68] The point is that both singers were of Andean origins, their music obviously as well, and the-more-you-hit-me-the-more-I-love-you love affair was indeed full of mentally and physically violent moments. That it was a lesbian relationship lasting nine years was allegedly of less importance than the way the viewers were supposed to "enjoy" the tiffs and wrangles themselves. It ended rather horribly, by the way; within a few weeks of the ethnotyped stir, Alicia Delgado was found assassinated in her flat. Several months later her lover was considered to have commissioned the murder and was sent to prison for thirty years. Beyond a doubt, the *amor serrano* classification was to be ethnotyped as typical for "this kind of Andean people." In this period, full of media discussions on racist attitudes, no one bothered about the classification—with the exception of *Enemigos íntimos*.

Another interesting case of negative ethnotyping is the Chuño Affair—as it was baptized by the popular Cinencuentro.com website that follows the media.[69] It developed following the *Mesa de noche* (Midnight Table) television show, late night on Thursday May 21, 2009, aired by Plus TV on Channel 6, and hosted by Denisse Arregui and actors Jimena Lindo and Renzo Schuller. Note that these actors are of Euro-Peruvian background. In their program, they present and discuss all kinds of new events in Lima, like upcoming theatrical premiers and new films in the cinemas—usually for the city's Western upper classes. On one moment, the 2009 film festival at Cannes, France, came up. The dialogue began when Jimena Lindo said: "Do you know who are also in Cannes?" The two others responded: "Who?" Jimena Lindo: "Normita Martínez and Magaly Solier." Denisse Arregui reacted: "What are they doing there?" Renzo Schuller knew: "Selling sweaters" [*chompas*]. All laugh. Jimena Lindo continues, laughing: "They are selling potatoes [*chuño*]" [or,

68. The report of *Enemigos íntimos* at http://www.youtube.com/watch?v=mGBJVeTso_A, or at http://www.youtube.com/watch?v=MuqJuTDcW8s; also http://www.youtube.com/user/somoscanalperuvision (both accessed 6/09).

69. See http://www.cinencuentro.com/tag/mesa-de-noche/ (accessed 6/09).

alternatively: "They are selling caps" [*chullo*]."[70] Within days, all major gossip and talk shows had shown the video and commented on it as well. The ethnotyping was covered by the national press, including by the "serious" dailies. The major tone was that Schuller and Lindo would have been jealous. After playing the lead part in Claudia Llosa Bueno's first feature, *Madeinusa* (2006), and a supporting part in Josué Ménez's second feature, *Dioses* (2008), Andean actress Magaly Solier was much more successful than Schuller and Lindo were. Other leading roles include *La teta asustada* (2009), again by Claudia Llosa Bueno, the Belgian feature *Altiplano* (2009), by Peter Brosens and Jessica Woodworth—Solier was in Cannes to promote this film—and later the Spanish film *Amador* (2010), by Fernando León de Aranoa, as well as a supporting role in the Spanish film *Blackthorn* (2011), by Mateo Gil. Solier had stepped up to an international career, something quite rare for a Peruvian actress of twenty-seven, even more so for someone born in the Andes. No wonder, then, that the media are interested in her whereabouts. Soon, surrounded by rolling cameras and microphones under his nose, Schuller must have realized the magnitude of the situation. He eagerly made his apologies to Magaly Solier—not to Martínez, who is Euro-Peruvian and a good friend of his—and said that he had never had any intentions of making a racist joke. Lindo, however, reacted angrily. She said that she had never used the word *chuño*. A *chuño* is the Peruvian dry potato and a typical attribute for negative ethnotyping. As a typical Andean dish it stands for anything traditional Amerindian. Others on the Internet said that Lindo used the word *chullo*, a traditional Peruvian cap. Anyhow, the coordinator of CNDDHH or Coordinadora Nacional de Derechos Humanas (the Peruvian National Coordinator of Human Rights), Mar Pérez, commented that the joke certainly had been at least "unfortunate."[71]

Curiously, Solier seems to be particularly loved by the hetero-imaging ethnotypers—racists, they are regularly called. On October 1, 2013, the Lima-based daily *Perú21* published an interview with her both in print and online. The occasion was Solier's performance in the play *Cao(s), visions de la Dama*

70. To be found at different sites, as well as on various *YouTube* postings. See for example: "¿Discriminaron o no a Magaly Solier en el programa Mesa de Noche?," at http://www.periodismoenlinea.org/; Jimena Lindo: "¿Saben quién está en Cannes también?" The two others: "¿Quién?" Jimena Lindo: "Normita Martínez y Magaly Solier." Denisse Arregui: "¿Qué hacen por allá?" Renzo Schuller: "Están vendiendo chompas [risas]." Jimena Lindo: [risas] "Están vendiendo chuño." [Or, alternatively: Jimena Lindo: [risas] "Están vendiendo chullo."]

71. I have seen it develop on Peruvian television, but there are postings on the Internet; see for example: http://www.peru.com/noticias/portada20090526/36083/Polemica-por-supuesta-discriminacion-contra-la-actriz-Magaly-Solier; or http://criticayevolucion.blogspot.nl/2009/05/magaly-solier-niega-intencion-de.html (all accessed 6/09).

Moche ("Chaos: Visions of the Moche noblewoman"), written by Rebeca Raez.
The play is about an ancient Moche queen. Asked about future film perfor-
mances, Solier told the interviewer that she would not do nude scenes, unless
very well paid and appropriate. "Anyway, there is nothing to show—no tits,
no ass—only talent." The online version received a torrent of abusive racist
comments about the nudity of Andean women. Three days later, the weekly
Hildebrandt en sus trece published a lengthy complaint against *Perú21*, both
in print and online. October 5, way too late, *Perú21* published an apology.
The next day, Solier expressed her gratitude to journalist César Hildebrandt
in a note of thanks on her Facebook page. But she added: "Today I feel disil-
lusioned because I realize that the contempt for Andean women is worse than
I thought." In the *La República* newspaper of October 7, commentator Jorge
Bruce wrote a strong article against discrimination of Andeans in Peru, warn-
ing that this kind of abuse should not be taken lightly. He concludes that it
unveils a strong sense of hatred against the Andean immigrants in Lima—a
hatred rooted in fear: "To accept that this Quechua speaking woman could be
more attractive and, worse, be more successful than they are because of her
talent and personal virtue sparks off feelings of insecurity and panic vis-à-vis
the prospect of Magaly's naked body." The error of not removing the violent
reactions from the *Perú21* website is, Bruce thinks, not only simply irrespon-
sible but perhaps proof of sexism and racism as well.[72]

6

Next to Coca's *Plebeya 3, Mejorando a Sarita* (2002; Improving Sarita, info-
graphics on paper) is a good example of her antiethnotyping attitude (see fig-
ure 5.2). The work was included in her 2002 exhibition "¡Qué tal raza!" One
of the works in the collection was this series of four smaller ones: portraits of
Sarita Colonia. Sarita Colonia Zambrano is known as the popular patron saint
of the poor, a lay saint from Callao, venerated by the migrants from the Sierra

72. "No haría desnudos a menos que paguen bien," *Perú21*, http://peru21.pe/espectaculos/
magaly-solier-no-haria-desnudos-menos-que-paguen-bien-2151519, printed version of October
1, 2013, p. 28; For *Hildebrandt en Sus Trece,* see http://colectivodignidad.wordpress.com/2013/
10/05/ya-se-van-notando-los-estragos-de-la-concentracion-de-medios/; Magaly Solier Ofi-
cial, Facebook page at https://www.facebook.com/pages/Magaly-Solier-Oficial/115535855078;
Jorge Bruce, "Racismo íntimo," *La República,* October 7, 2013, also published online at
http://www.larepublica.pe/columnistas/el-factor-humano/racismo-intimo-07-10-2013 (all
accessed 10/13).

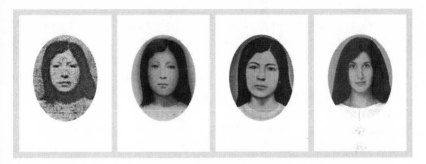

FIGURE 5.2. *Mejorando a Sarita*, Claudia Coca, 2002–13, infographics on paper, 4 times 0.29 × 0.42 m.

who went to Lima.[73] Sarita was from Huaráz in the Central Andes and went to Lima with her family in the 1930s. After her mother had died, Sarita took over motherly care for the other children. Later, Sarita was employed as a servant in a middle-class family. Her story became a popular myth after she was the victim of a rape. There are contradictory versions of this event, and it is not very clear whether the rape occurred or not. However, whether or not she was an "innocent victim" is not important for the pilgrims; rather, it is precisely because of this ambiguity that she currently represents the most important popular religious icon in Peru. Sarita Colonia is said to have instigated several miracles. She will probably never be canonized by the official Roman Catholic Church because the circumstances of her life raise suspicions about her "sexual decency." She died on December 1, 1940, at the age of twenty-six, and her family had to bury her in a mass grave for the poor.

To the left of the four infographics Coca made of Sarita, we see one of her earlier photo portraits (figure 5.2). She documents Sarita's process of whitewashing in the hands of television producers Michel Gómez and Michelle Alexander of Del Barrio Producciones. Coca illustrates the well-known expression "mejorando la raza," or "improving the race by whitening." In fact, even the photograph of the actress seems to have been whitened artificially. Note to the right in the infographics, the portrait of actress Urpi Gibbons, who played Sarita in the 2001–2 eleven-hour television miniseries *Sarita Colonia*. In all, this suggests that the poor, the excluded, and the Andean migrants in Lima had celebrated a *white* saint after all. Because Sarita Colonia was one of the first miniseries from these producers to address a popular theme, the

73. Ernesto Vásquez, "Sarita Colonia: Popular Resistance in the Everyday Life of Transnational Migrants," at http://www.interculturalidad.org/numero003/5_023.htm (accessed 6/08); Graziano, "Sarita Colonia," chapter in his *Cultures*, 141–66.

whitewashing of Sarita would have been done to seduce their traditional audience, which was at that time still thought to be the middle-class segments of society. Therefore, to make the series a success the protagonist had to be at least partially "one of them," as is generally theorized. Instead of propagate diversity, actress Urpi Gibbons, who apparently fulfilled these requirements, was mapped within the Euro-Peruvian fences of Lima. *¡Qué tal raza!* indeed. A missed opportunity.

In Peru, ethnotyping has its own verb: *cholear*. In the summer of 2008, one of the most popular books in Lima bookstores was Jorge Bruce's *Nos habíamos choleado tanto . . . psicoanálisis y racismo* (2007; We All Cholified Each Other So Much . . . Psychoanalysis and Racism). Bruce confirms this popular idea, by stating that in Peru racism is learned naturally at home, fed on a daily basis by the unconscious registration of behavior and speech, led by media exposure and publicity. If two Peruvians meet each other, he notes, they scan the other's physical and cultural features to map the other and the Self according to a racist geography, even without speaking to each other. More than often, the one judged to be "lower" in this mapped hierarchy is seen as *cholo*. Bruce also believes that "liberating" the "repressed" sources of racism in Peru by criticizing public racist behavior, racist media exposure, and racist commercial publicity would educate the kids of Peru to adopt a critical attitude.[74] Bruce's book is a follow-up to a widely read article by the Peruvian psychologist Walter Twanama, director of the International Youth Foundation in Peru, published in the magazine *Márgenes* in 1992. Twanama defined *cholear* as judging yourself superior to the other. By a *choleo* of the other, the speakers—the *choleando*—allow themselves to behave accordingly and confirm existing prejudices.[75] In the digital age, Twanama's article resurged on several blogs during the early 2000s, inspiring him to publish an update in 2008 in the magazine *Revista Quehacer*, which is mostly read online.[76]

The *choleando* behavior, Twanama says, creates *choleo* hierarchies of superior versus inferior at specific moments and at specific places between people in more-or-less direct contact. He agrees that whenever two Peruvians meet, they *choleo* each other immediately and are "*choleo*-ed" constantly at all levels of society. "We Peruvians are very quick in reading the relevant details or make a rapid scan." The *choleo* goes on even between people living in towns in the Andean Sierra. This means that one need not self-classify (auto-ethno-

74. Bruce, *Nos habíamos.*
75. Twanama, "Cholear."
76. Twanama, "Racismo peruano, ni calco ni copia," *Revista Quehacer* 170 (2008), consulted online at http://takillakta.org/rcpal/article/591/racismo-peruano-ni-calco-ni-copia-revista-que-hacer (accessed 10/08).

type) as *cholo* to be *choleoed* or to *choleo* the other. Twanama stresses that the *choleo* must be seen as the basic form of discrimination in Peru. Accordingly, discrimination in Peru is not racist as was experienced in South Africa by apartheid, for example, or in the United States by African Americans. It is *choleo*. By the sight of recent publications, both in print as on the Internet, many Peruvian scholars, writers, and journalists concur. They have established their country as the arena of the *choleo*, where one group tries to gain the upper hand by *cholear* the other. I miss in this discussion the mechanism of *hanan* versus *hurin*, discussed in chapter 2: Upper World/Lower Worlds, superior/ inferior, latter/former, majority/minority, present/past, light/dark, sunrise/ sunset, outside/inside, on top/underlying, and thus *cholear* the other from a supposed *hanan* position. This may be called the *choleo* upper–lower schema. Sometimes it works out positively, sometimes realistically, and sometimes negatively. *Cholear* is the negative form. What can be done about the *choleo*? Twanama answers: break the bond between poverty and provenance.[77] This, we may recognize, is the traditional appeal of class struggle.

Bruce demonstrates that the Peruvian *whites* are included. Once, at university, a student had made a drawing of Bruce's face. When Bruce saw the drawing, he was very surprised to note all kinds of Andean features in his face, especially his chin, nose, and cheekbones. Looking in the mirror, Bruce had never discovered such Andean features. His ancestors form a combination of the Peruvian coastal area, the Sierra, and Constantinople. Later on, another student offered him an explanation: "You are *white* but you have the hair of a *cholo*." Obviously, the draftsman went from the hair to ethnotype the face. This is a harmless *choleo*, but one nevertheless. In another anecdote, Bruce introduces a man of about forty years old, a professional working for a bank. The man was born in a city in the Sierra—which he called his "pueblo." He entered into therapy because of marriage problems.[78] Narrating his background, the patient stated that in his Sierra town, he was considered *white*. His father had been a bank administrator. He went to the best school in town. After graduation, he left for Lima. There, for his fellow students at a private university, he was not *white* but *serrano*. "I have always known that they were talking about me at my back. They did at the university and they did, I believe, in my hometown. At the university they said I walk like a *serrano*, talk like one, and even wear *serrano*-like clothing. And in my hometown they said: 'He thinks he is *white*, like his father, because his father works at a bank.' I was a boaster."[79]

77. Twanama, "Cholear," and "Racismo peruano, ni calco ni copia" (link in note 76, this chapter).

78. Bruce, *Nos habíamos*, 88.

79. Ibid., 90–93, 97–98.

The visual, auditory, and communicative cues that Peruvians use to situate others within everyday hierarchies, says anthropologist Jessaca Leinaweaver in *The Circulation of Children* (2008), including the difficult-to-interpret phenotypical markers like facial features, hair texture, and skin color, are locally defined, relational, evaluated contextually, and changeable over time. They are all part of the *choleo* upper–lower schema, and they can have political implications. Leinaweaver gives the example of the *huamanguinos* or auto-ethnotyped *mestizo* elite of the city of Ayacucho, who may appear based solely on phenotypical cues to be *indígena* yet are not locally evaluated as such. Leinaweaver seems to privilege class markers. The *indígena* is poor and of the lower class in Ayacucho. The urban *mestizos*, her interlocutors in Ayacucho, primarily rural-to-urban migrants, would be evaluated as *campesinos* (peasants)—in line with the 1969 legislation of the Agrarian Reform Law and the Special Statute for Peasant Communities issued by the regime of General Juan Velasco Alvarado (in office: 1968–75). Despite various locally understood markers of "indigeneity," they would not have defined themselves in this way, Leinaweaver adds—which suggests that she ethnotyped them herself.[80]

Nevertheless, despite the increase in media stirrings on ethnotyping in Peru, opinion leader Ardito Vega wrote an optimistic note in his *Reflexiones peruanas* blog (Peruvian Reflections) of May 19, 2008, edition 199.[81] He offered a brief consideration to the "Operativo Cuerazos Peruanos" manifestation of May 5, 2007 (literary: "Operation Peruvian Whippings," but the word "cuerazos" refers to the cumbia rhythms as well), in front of a few expensive clothing shops. Ardito Vega's company had been looking for publicity to denounce the overrepresentation of European people in commercial advertisements. When Ardito Vega saw the *Cosas* interview with Grupo 5, "with their features that are more *indígena* than *mestizo*," dressed in designer fashion, he asked: Was Peru changed within the year? Yes and no, he answered his own question. Change had been in the air, he thinks, after the fatal accident of the cumbia band Grupo Néctar in Argentina, May 13, 2007. The death of the band members deeply affected communities in both Peru and Argentina. Curiously, says Ardito Vega, all the publicity around this accident awakened interest in cumbia music in Euro-Peruvian Lima. For sure, he notes, in private talk, racist terms remain firmly in place, as well as in public happenings like theaters, where plays from, let's say, Denmark or England are interpreted by a "Europe-

80. Leinaweaver, *Circulation*, 11–12.

81. See Wilfredo Ardito Vega, "Reflexiones peruanas. Artículos sobre el Perú y cómo hacer que en él los derechos humanos se vuelvan realidad en la vida cotidiana," published on *Blogspot*, at http://reflexionesperuanas.blogspot.com/2008/05/reflexiones-peruanas-199-motor-y-motivo .html (accessed 6/08).

ans only" cast. But at the same time, he realizes that especially among European-rooted Limeños things actually are changing; note the *Cosas* publication and the general condemnation of Vanessa Delacroix's words on *oscuritos* and "not-serious" music.[82]

To my mind, the *choleo* is as concept not known in Mexico, but as an ethnotyping practice, however, it does of course. One example would do. In his preface to the collection of essays *Race and Classification* (2009), edited by Ilona Katzew and Susan Deans-Smith, historian William B. Taylor tells the following story: "A bitter argument erupted one day in 1964 in the staircase of my Mexico City apartment building between *portera* (concierge) of the building who lived in cramped quarters on the ground level and the inebriated male tenant of the maid's quarters on the roof. Both were middle-aged, dark complected, and living on modest means. The shouting and profanities between them went on for several minutes, culminating in what both parties regarded as the terminal insult, hurled at the *portera: india bestia*, beastial Indian. The man was dead to the *portera* from then on."[83]

7

Over the past decade, Peruvians seem to have been motivated to crystallize their ideas about the impact of the Andean migrants on the culture in Lima. Because most of them now tend to be categorized as *cholos*, this impact is usually called *cholificación*—or seen as a doing: people in Lima are *choleando*. Discussing this is Roberto de la Puente's documentary *Choleando* (2012). At minute eighty-five of *Choleando* the actress Mariananda Schempp, one of the leading characters of the documentary, comes to the conclusion that the "attitude of 'improve our race [*raza*]' expresses well how we think about racism."[84] Schempp is from German immigrant roots in Peru. Further on she says: "In Peru, we believe that races exist; in fact, we believe that there are superior and inferior races. To 'improve the race' means adopting elements of the superior race, preferably genetically." A few minutes later, her antipode character Julio Navarro has no answer. He needs to think. This ping-ponging is the major

82. Of course, the media live on such stirs. Especially the commercial media, looking for higher rates and ranking and more advertisement earnings, adjust simple incidents into stirs, blow up little ones, or stage them from the outset (link in note 81, this chapter).

83. William B. Taylor, preface to Katzew and Deans-Smith, eds., *Race* (2009), ix–xx, quote from xi. See also Sulzer, "Somos."

84. R. de la Puente, *Choleando.* Lima: Relapso Filmes and IDM, Documentary, con la participación del Taller de Antropología Visual y Cabina Subsónica, 2011.

narrative instrument of the documentary. Early in the film we are shown footage from a news item presenting President Alan García Pérez (in office: 1985–90, 2006–11). In the beginning of the documentary he had been shown making discriminatory remarks about Brazilians, Colombians, and Peruvians. But later on he speaks positively about honoring the popular leaders of Peru, honoring "the *cholo* leaders of Peru." García adds that he likes the participation of the people with the "colored skins, who are the true Peruvians." And he continues: "They will fight for social justice." In short, the *cholo* is the "colored skinned" true Peruvian. Most Peruvians, however, would be reminded of President Fujimori, who described the election campaign as a struggle of the "Chinaman and the *cholos* against the *whites*."[85] The filmmakers demonstrated not only that presidential candidates allow for the crucial weight of the *cholo* vote but above all that *cholo* is a confusing notion.

After almost ninety minutes of documentary footage, the confusion about the typical features of the ethnotype is still not resolved. And we are still poaching on the racist's preserve. Following President García's statements, Julio is now ready to respond to Mariananda's conclusion. She is right, he admits, but not fully. In Peru, Julio says, the people are proud to be ethnotyped as *cholos*. Indeed, the people he interviews agree that Peru is a *cholo* nation. He presents witnesses: A woman agrees that Peru is a *cholo* nation "because we are all *cholos*." "Are you proud to be a *chola*?" he asks her. "Of course I am!" Another girl: "Sure!" A man: "Very proud indeed!" Another one: "Of course." An office worker: "We are *cholos*, we truly are." Another girl: "In reality, we are all *cholos*, and we are proud to be so." All as if with exclamation marks. The voice behind the camera asks Julio: "What, then, is a *cholo*?" Again, Julio has no answer. In the remaining fifteen minutes, several people try to answer this question—a linguist, a few sociologists, and some of those previously interviewed. All are pointing to the provincial background of the *cholos*. Their ethnotyping says that the *cholos* live in Lima, basically, and they represent a mixture of roots which has become "one single race," as one woman expresses it. Nevertheless, at the end of the film, Julio and Mariananda still disagree about the level of racism in Peru and about whether calling someone a *cholo* is racist or not. What the viewer memorizes, however, is that the "*cholo*" category seems to get some generic value. As a viewer, I had the feeling that the people (hetero- and auto-)ethnotyped as *cholos* leave their *hurin* position to become *hanan* in Lima. This is a "turnover," sometimes seen as *pachacuti*, a cataclysm or "turning of the times." Although this witnesses a significant improvement for the *cholo* class, it also confirms the *choleo* upper-lower schema, as if there is nothing new under the sun.

85. Lee, "Putting," 49; italics added.

After decades of research, we know of course that we cannot be sure who is *indígena, mestizo,* or *cholo.* We have seen *mestizo* towns like Tepetlaoxtoc that cherished their Amerindian perhaps pre-Hispanic cognitive schemas of making community in others. We have seen "indigenous" rebels in Eastern Chiapas that refused to dress and live according to highland Maya traditions. In 1996 anthropologist Charles Hale found interesting data from Chimaltenango in central Guatemala. The town had been hard-hit by the bloody violence in the mid-1980s. By 1981 most Maya mayors who had won the municipal elections in the area in 1978 had been killed or driven into exile. The same occurred with other Maya leaders of cooperatives, unions, health programs, and liberation Catholic workers. By 1985 the army had defeated the guerrillas and decimated their following but also brutally violated Maya populations that had not chosen sides. It had its repercussions for self-identity. Hale presents an illustrative example, using marriage data for the Chimaltenango *municipio* (an administrative unit roughly equivalent to a U.S. county) between 1986 and 1990. For the middle three years, about 80 percent of the marriages each year were reported to be between Maya spouses, in keeping with the reported percentage of Maya minorities in the population. However, in 1986 the vast majority had involved people of "unknown race," and in 1990 fully half the marriages were between *ladinos,* an intriguing shift. In Guatemala, the *ladinos* are ethnotyped as *whitened mestizos,* taking sides with the European elite. In a world guided by a *ladino-indígena* binary, they are, as Hale recorded, "more than Indians."[86]

Since the fluctuations between 1986 and 1990 could not possibly correspond to actual demographic shifts, Hale concludes that the civil registry of Chimaltenango might have been in trouble establishing the "race" of the people involved. At the desk of the office, Hale heard that they had stopped keeping that information and that they no longer tried to determine who was *ladino,* Maya, or *mestizo.* "We just send the forms back with the questions left blank." Shortly thereafter, a myriad of Maya cultural activists and Maya cultural organizations, often supported by European and North American NGOs and churches, sprouted in the western Guatemalan highlands, signifying that "Guatemalan" was not a *ladino* identity but Maya as well. Or, better: Maya in particular. The militants took the liberty to frame the "blank" as Maya and attracted funding from NGOs and international development aid. The persons in charge of the organizations demanded cultural recognition and respect, but also political inclusion by law. Furthermore, discrimination by the *ladino* state representatives and the wider *ladino* society was increasingly contested. We may doubt whether the people of "unknown race" in a town like Chi-

86. Hale, *Más,* 205.

maltenango self-identify nowadays as "Maya." Hale thinks that what he had found was a fully novel development.[87] A kind of Guatemalan cholification had developed.

It seems also that Andrew Canessa discusses the "indigenous" in this way in the very first paragraphs of the introduction of his *Intimate Indigeneities* (2012). The question of the meaning of the terminology is introduced by an anecdote. He tells us how he sat one evening in an unusually cold August 2011 in the kitchen of a Bolivian highland dwelling of his informants—his friends—having a conversation with three Aymara women and a men about the hardness of life, going over gossip and scandals. Canessa informs us also that everyone spoke in Aymara and that "everyone—the anthropologist notwithstanding—was dressed in traditional [I]ndian fashion."[88] One moment, the daughter of the owner of the dwelling entered "wearing trousers, sporting a modern hairstyle."[89] When her cell phone rang, she let everyone shortly speak with her husband. Canessa ends his anecdote confirming that "any casual observer would readily identify [the scenery in the dwelling] as an indigenous family in an indigenous village."[90] In the next paragraph Canessa poses the crucial questions for him: "But what does it *mean* to be indigenous? And what does it mean to be indigenous in Bolivia, which has discriminated against Indians in the past but recently elected an indigenous president?"[91] Indeed, the way the question is posed is the key to the problem. Note: Canessa asks what does it mean to be "indigenous" to "indigenous people themselves, not only when they are running for office or marching in protest but especially when they are in the small spaces of their lives, when they are lamenting their lot, cooing with their babies, cooking in their kitchens, or talking to their husbands who are far away."[92]

At home in the discourse of difference and deference of the discursive idealists, Canessa demonstrates that the term "indigenous" itself can be contested—which makes it possible that the indigenous as identified by the outsider do not want to self-identify as "indigenous." In fact, most pages of his *Intimate Indigeneities* skillfully discuss this strategy; as, in fact, several Latin

87. Hale, "*Mestizaje*," 42–45.

88. Canessa, *Intimate*, 1; Canessa sees the word "indian" as ethnic and not a national term and therefore follows the usage of writing it in lower case (see p. 7). As far as I know, "Indian" reflects an inhabitant of the Indies and has a geographical connotation and not ethnic per se. As such, the term reflects colonial roots, which strengthens the articulations of the Indian's colonial history. That connotation is absent in most "ethnic" (self-)identifications.

89. Ibid., 1.

90. Ibid., 1–2.

91. Ibid., 2; italics in original.

92. Ibid.

American anthropologists do. However, what sinks in properly while reading his book is that being "indigenous" in our times is not only a "strategic identity" to get entrance to all kinds of public sources. No, says Canessa, also in private, even if someone is alone, the identity serves the people. By difference and deference, the "indigenous" really exists. This almost (post)structuralist heritage invites us to understand the indigenous as a person that exists in all its aspects in real life. If Canessa identifies someone as "indigenous" and this person does not self-identify in a similar way, there is a problem. Of course, the idea of people "being Indian" smacks of traditional personality theories,[93] especially if we confirm that people's self-representations are composed of personal, relational, social and collective identities,[94] identity markers and elements of self-identification that are historically and situationally determined—in time and space.

Over the past years, anthropologists recognized more and more how difficult it is to keep up with racial categories to classify people. Nevertheless, in their work they seem to try to keep these alive as crucial markers in the multicultural politics of identity and use sets of combinations, as the "pure" categories did not work. In her widely read *Indigenous Mestizos* (2000), anthropologist Marisol de la Cadena, for example, invented a combination of *indígena* and *mestizo*. She analyzes the strategic identity of "indigenous mestizos who live in the city but draw inspiration from their rural knowledge to produce the neto authentic cuzqueño culture."[95] One of them is an informant called Alejandro, a ritual specialist, whose localization as "being literate and urban identifies him as indigenous mestizo, 'mestizo neto' in local terms."[96] The "neto" here points to a social mobilization away from "pure indigenous," as "modern indigenista intellectuals imagined it"—also seen as a type of "de-indianization"—but still sufficiently "authentic by indigenous intellectuals' definitions and fiat."[97] Their "indigeneity" is strategically considered still *indígena* despite their nonrural lifestyle. Hence, De la Cadena still goes beyond ethnotyping, looking for "real" categories as a "pure" type of the "indigenous" personality—a rural dweller who has much in common with the CNSS—as well as a "pure" type of *mestizo*. The result is the "mixed" version of *indigenous mestizo*. Here old-fashioned identity theories are used to uphold the multicultural politics of identity.

93. Ibid., 5.
94. John, Robinson, and Pervin, *Handbook,* 441.
95. De la Cadena, *Indigenous,* 276.
96. Ibid., 302.
97. Ibid., 276.

8

When did ethnotyping begin? At a crucial point in de la Puente's documentary *Choleando,* a source from the Spanish era is being introduced. There is a reference in the memoirs of Garcilaso de la Vega, El Inca, *Comentarios Reales de los Incas,* published in Lisbon in 1609 and 1617. In a chapter on "new names for various racial groups" Garcilaso discusses the use and origins of words like *criollo, mestizo, mulato, montanés,* and *sacharuna.* The list is hierarchical, from *white* to *black.* The *cholo* category can be found at the bottom: "The Negro who arrives there from the Old World is called Negro or Guineo. The child of a Negro by an Indian woman or of an Indian and a Negro woman is called *mulato* or *mulata.* Their children are called *cholos,* a word from the Windward Islands: it means a dog, but is not used for a thoroughbred dog, but only for a mongrel cur: the Spaniards used the word in a pejorative and vituperative sense. The children of Spaniards by Indians are called *mestizos,* meaning that we are a mixture of the two races."[98]

Garcilaso may have been right, of course, but he wrote his piece in Spain long after he had left the Americas. However, in a general sense I believe he was wrong. We already saw that the classification of *indio* was based not on bloodlines but on legal classifications. The Spaniards categorized people according to geography and above all social classes and orders. The category of *indio* said that the person was a member of the Amerindian Order (*república de indios*) and was obliged to pay specific taxes (*tributo,* for example) in exchange for access to land to live on and live off (in a *pueblo de indios*) and juridical support by the General Indian Court of the Audiencias (*Juzgado de Indios*). Also, Spaniards formed a special category in this sense (*república de españoles*), and other categories were included with special legislation on work conditions and settlement regulations. Crucial was someone's proven or self-declared membership in what they called a "house." As in today's monarchies, a "house" was a lineage, and it had rights and duties laid down in law. This was not an early example of a multicultural politics of identity because the concept of "race" formed no part of it. For that reason it was also not a form of ethnotyping. Apart from the formal identities by legislation, a whole series of terms were used to type people according to somatic or cultural looks, known of imagined descent, real or supposed belonging, and assumed status and social rank. Because there were no strict rules, people could be typed—or indeed self-type—in many different categories. These categories were called

98. Garcilaso de la Vega, *Royal* (2006), 88; italics in original; selections made from the 1996 translation by Harold Livermore: De la Vega, *Royal* (1996).

calidades or qualities, and they were so fuzzy that people could slip in and out of categories when they wanted or could be negatively typed if others deemed it necessary. To confuse matters, terms like *indio*, *mestizo*, *negro*, and *español* could be used as *calidades*, although that could legally be mistaken.

It must be stressed: a *calidad* was not a race. The idea of categorizing people by "race" emerged during the age of modern imperialism, that euphemism for colonial expansion of the European and North American powers since the late eighteenth century. Races, classification according to bloodlines, and colonialism are hand in glove, but not as early as Spanish colonialism in the Americas (as Aníbal Quijano and his followers of the M/C Project believe). The Spanish terms like *raza* and *sangre* refer to lineage and "house"—although religion also played a role, because *limpieza de sangre* or "purity of blood" refers to direct descent from people of the "correct" religion or "pure" and Old Christians (Roman Catholic) and not the "contaminated" by Muslim, Jewish, or Amerindian ancestry New Christians. In the days of Victorian England (1837–1901) and the French Second Colonial Empire (1830–1962), "race" was introduced to explain European superiority and to categorize the "savages" in Africa and Asia. Malik again: "The term 'racism' entered the popular language for the first time in the interwar years,"[99] after the First World War. Although many in these colonizing worlds agreed on the significance of races—especially the *white* one—few authors were able to define races scientifically or even juridically, and that has remained ever since. To keep the idea in the air, they turned to cultural and social criteria in combination with somatic features. The "blood" had become biological.

The new racist wind was blowing before the Victorians and Second Colonials had begun theorizing. It was blowing also in the Spanish Empire where the French House of Bourbon had been in power since the Peace of Utrecht (1713) and was busy reorganizing a series of overseas kingdoms in proper "colonies." These Bourbon Reforms were accompanied by a zealous drift of taking stock of how their "colonies" looked. The Spanish Bourbon bureaucracy had been commissioning richly illustrated reports about nature, geography, and people. In the true Enlightenment scientific veil and literary style of the time, everything was classified and systematized in words and pictures. The authors and illustrators were keen to use local terminology and explain them. At a specific moment, the people in the Americas also needed to be treated this way. The result was a series of *cuadros de castas*, or caste paintings, showing snapshots of domestic or family life of Amerindians (*indios*), Spaniards (*españoles*), and Africans (*negros*). The idea was to illustrate the terminology

99. Malik, *Meaning*, 1.

of the *calidades*. However, apparently not fully at home in the local world and perhaps already contaminated by the racist wind, the painters took a biological stance unseen in earlier Spanish sources. In every painting of a series, they depicted one man of one "race"—as seen by the painters at the time—with a child he had produced with a woman of another "race." A small inscription on the canvas indicates how they labeled the "race" of the children and also of the children's children, eventually up to more than thirty "races."

A series of about thirty paintings on one canvas could do this very well, with the *whites* on top to the left, and then from left to right each time "lesser" ethnotypes, ending below right with black people. This was a sociocultural ladder based on the recently increasing important trait of "blood." A typical series of caste paintings began with *español* and *india* producing a *mestiza*. Next followed another *español* and the *mestiza* who produced a *castizo*; a *castizo* and an *española* produced an *español* again; a *mestizo* and an *india* produced a *coyote*; an *español* and a *negra* produced a *mulata*; an *español* and a *mulata* produced a *morisca*; a *negro* and an *india* a *lobo* (a *lobo* is a wolf); a *lobo* and an *india* a *lobo que es torna atrás* (*torna atrás* means here: step back, less pure); an *indio* and a *lobo* produces *grifo que es tente el aire* (*grifo* refers to a drunk; *tente en el aire* to "hold yourself in mid air"); a *lobo* and a *mestizo* have a *cambujo* (a *blackie*); an *español* and a *morisca* an *albino*. The painters presented these varieties as castes and stated that they formed part of a caste system, or *regimen de castas*.[100] The viewers would note the superiority of the European colonizer and the ensuing racial degeneration from top to bottom. With the Europeans on top generally living in harmony and the Africans being represented as fighters and wranglers, the series contain a clear message. Because each new *casta* "lost" something of its "racial purity," the paintings also demonstrated that no *casta* could ever cherish the idea to return to the *white* racial pole. However, although the paintings were not designed this way, someone may have seen opportunities for "whitening" and "climbing up" racially; tracking the route upward, one could indeed come very close.

Working my way through piles of documents in several colonial archives Spain, Mexico, Guatemala, Peru, and Chile for over twenty years, I gradually recognized Ángel Rama's discussion of the *letrados* in the Spanish bureaucracy and their discursive ideal to create order by classifying and categorizing; the *letrados* were the principal inhabitants of the *ciudad letrada*, or lettered city.[101] As figments of the new European elite's imagination, the thirty-one or

100. For example Katzew, *Casta*.

101. Rama, *Lettered*. Rama wrote his essay in the early 1980s, but it was posthumously published in 1984. John Chasteen concludes that Rama's untimely death—he died in the 1983 plane crash at Barajas Airport, Madrid, along with the Mexican writer Jorge Ibargüengoitia and Peru-

so *castas* were among the last products of their age-long ordering zeal. Not uncommon for discursive idealists, in their creation reality was not around. With the exception of *español*, *indio*, *mestizo*, *castizo*, *pardo*, and *negro*, I found very few *casta* categories in use in the archives. To my mind, historians have in general not found a single set of these *castas* in the documentation of state and church in Mexico, Ecuador, or Peru.[102] Indeed, on closer inspection of the sources, the *regimen de castas* in general is difficult to corroborate. Mexican historian Pilar Gonzalbo believes the idea of a caste system is a pitfall: we should not look at them as a mirror of colonial reality.[103] Not even the sceneries, because, as Ilona Katzew mentioned, the painted scenes with a man, a woman, and a child in their houses, a workshop, or in nature, mirror colonial realities "more like poets than reporters."[104] This also means that it would be difficult to establish colonial roots for some of the terms currently in use, like *cholo*, based on these series. But caste paintings were a sign of things to come. The current consensus seems to be that the paintings reflect an attempt by the *letrados* in the colonial capital cities to order life according to their new Bourbon visions. Or better, they tried to reorder the colony; because the two traditional *repúblicas* may have been useful in juridical matters, the question of social stratification required a different system, which involved ethnotyping. Indeed, the *letrados* had been designing the cultural models raised up for public conformity by simply imagining in their work an order made of rules derived from them. Rama described the lettered city as an elitist, bureaucratic, top-down, and urban mentorship that distinguishes Latin America ever since the early days of Spanish and Portuguese colonization. In line with current theoretical discourses in the 1970s and early 1980s, Rama worked with the assumption that power depends on the knowledge to perpetuate it.[105]

Referring to the new "blood-philosophy" of the caste paintings, Claudia Coca painted a comment on current ethnotyping in her *De castas y mala raza*

vian poet Manuel Scorza—"may be responsible for the interpretation's gradual loosening and relative lack of closure." See: Chasteen, "Introduction," xii.

102. Katzew, *Casta*, 6–7; Alberro and Gonzalbo, *Sociedad*; Mörner, *Race*, 59; also Majluf, ed., *Cuadros*.

103. Alberro and Gonzalbo, *Sociedad*. Although the Crown commissioned a series of caste paintings, others were commissioned by private Americans.

104. Katzew, *Casta*, 8.

105. Significantly, Rama did not use the alternative wording of *la ciudad de las letras* or the city of letters, for this would have framed a less exclusive metropolis, inhabited by signs and all those who can manipulate them; see Chasteen, "Introduction," vii–xiv. In his review, "Latin," Jeremy Adelman notes: "If the conquest yielded to the idea that Iberian empires could create modernizing peripheries according to their minds' eye, the Enlightenment, romanticism, and modernism did nothing to shake up the faith in the written word" (231).

FIGURE 5.3. *De castas y mala raza,* Claudia Coca, 2009, oil on canvas, 145 × 180 cm.

(2009; Of Castes and Bad Race). The painting could also have been entitled *No. 21. Quarterón de mestizo; con tresalba; produce mestizo salta atras,* which reads something like "A *quarter-mestizo* and *one-having-three-white-feet* Produces a *mestizo-step-backwards*"—see top of her painting (figure 5.3).[106] Coca sees herself as with *"Three White Feet";* perhaps she has three *white* grandparents. Her husband is the *quarter mestizo,* while their son Leandro is the "polluted" *mestizo*—if I may stay within the same ethnotyping. For Coca this type of classification was the cause of Peru's current careless immanent ethnotyping. Playing with this heritage to demonstrate the foolishness of this labeling—*cholear*—she presents her *cuarterón* husband as a "quarter" of some original "caste"—in this case a quarter of an *indio*—and her *tresalba* self as

106. In a 2013 book chapter on the utopia of whitening and the struggle for mestizaje, the Peruvian sociologist Gonzalo Portocarrero also assumed that the caste painters traveled through the colonies to portrait all these people. His chapter is relevant because we find it on a BlogSpot webpage created for Coca's 2007 "Globo Pop" exposition, but also useful for her retrospective "Mestiza, 2000–2014" in Lima's Museo de Arte Contemporáneo (MAC, 2014). See http://mestizajeclaudiacocablogspot.blogspot.nl/2012/04/la-utopia-del-blanqueamiento .html (accessed 4/15); Portocarrero, "Utopía," 168.

FIGURE 5.4. *Entre lo dominante y lo vestigial,* Claudia Coca, 2009, oil on canvas, 1.45 × 1.45 m.

child of three *white* grandparents and one *indígena*. She was interested in the *tresalba* qualification because of its reference to a horse with *three white legs*, an allusion to "bad breed." She told me that "*tresalba* also means *chola,* that is, *mestizo* with *india* or vice versa."[107] In her painting, Leandro is "a step backward" because his "caste" is a step further away from whiteness than his parents' "castes."

Recently, Coca also included Amerindian genes into the celebration of diversity, demonstrating that the "indigenous" can exists outside the fences set by the multicultural politics of identity. In *Entre lo dominante y lo vestigial* (2009, Between the Dominant and the Remnants), Coca paints herself again

107. Email from Claudia Coca sent to me on April 10, 2015.

next to her husband and their son Leandro (figure 5.4). Crucial is the *mancha mongólica* or melanocitosis dérmica congénita on Coca's lower back. This Mongolian blue spot, or congenital dermal melanocytosis, is a spot that looks like a bruise. Some 85 percent of newborns with Native American DNA are born with it, and the birthmark normally disappears after a few years. This particular birthmark is not limited to Native Americans, by the way, because children in Asia and Oceania are also born with it. In these regions, the birthmark is associated with non-European descent. Even in some "mixed" origins, the birthmark appears, witnessing to a dominant inheritance pattern. In Mexico the spot is referred to as *la patada de Cuauhtémoc*, the kick of the last Aztec ruler. Leandro inherited the birthmark from Coca's father. From his own father, the little boy inherited a small anomaly of the tail bone, referred to as a "remnant" by the painter, a leftover of humans who had a tail. In Peru Leandro carries the dominant inheritance of the Amerindian in his body, but, no doubt, also the cultural inheritance of the *cholo*. Reason enough not to look at Leandro as "a step backward."

9

Schema theory predicts that people act out different identities in different places ("stages") and at different moments, depending the situation and other people present (or not). There is no "indigenous" personality playing out "indigeneity" everywhere and at any time. Even people who perform as the most "traditional indigenous" persons on certain stages—in company with NGO agents, politicians, or scholars—could perform Western on a Western stage like any other person plugged into Western cognitive schemas. Since the early nineteenth century, *indios*, or *indígenas*, had been ethnotyped by outsiders as social pariahs to be kept behind a fence. It was the racialized prolongation of a semiautonomous legal constitution that had served the *indios* usually well under the Spanish monarchs but that had now turned to a dark world of exploitation in which the *indio*—now biologically ethnotyped—was less than a secondary citizen. But after the Internal Armed Conflict of the 1980s, surviving one of the most horrendous violent campaigns ever seen in modern Latin America, large groups of Andeans migrated to urban surroundings and recreated their world as a manifestation of diversity: cholification. In Peru they form the Amerindian mnemonic community with the people who stayed behind (ethnotyped as *indígenas*) and others who had arrived from the Andes before them (*mestizos*).

Painters like Coca, as well as singers, artisans, and community leaders, including the ones portrayed by Miyagui, make this community move. The agency of their art finds its quintessential purpose in making the people do things. Also, their "community" consists of a doing. As in the Mexican Texcoco towns, described in Roger Magazine's *The Village Is Like a Wheel*, classifications like "indigenous" have not defined the *cholos*. Perhaps such a classification "had to be invented for the sake of government agencies or other actors that do recognize an other through its culture."[108] The Peruvian *cholo* community celebrated by Coca and Miyagui produces itself as active subjectivity in its constituting members through artifacts and activities. Also as found by Magazine in the Texcoco towns, for the *cholos* so-called indigenous identity markers have little meaning for people.[109] Again, perhaps for that reason also the *cholos* are not seen as "indigenous" by the CNSS-sharing outsiders and classified as whitened, nonindigenous, *mestizos*. After all my reading, observations, and watching (moving) images, I have the feeling that the Andean migrants in Lima no longer auto-image themselves deeply as specific ethnotypes. They increasingly reject the negative stereotyping that may come with the *choleo*; or they are even unaware of it in the first place. It seems that over the past years, the term *cholo* has lost its demeaning connotation. We learn also from Coca that *cholificación* should be celebrated as progress.

In the Netherlands we should take notice. Perhaps, as Antonio Gramsci predicted, we indeed need "organic intellectuals" like Coca and Miyagui to finally communicate severe problems in our societies and bring us into movement. We are also struggling with similar deeply rooted forms of negative hetero-imaged ethnotyping. Our problems with Zwartepiet or Black Pete are now internationally known.[110] Zwartepiet is Sinterklaas's aid. Foreigners visiting the Netherlands around the Sinterklaas festivities are usually appalled by the *white* saint and his "African slaves," and rightly so, but most traditional Dutch families have difficulty recognizing the careless racism behind the spectacle. Children learn that Sinterklaas comes from Spain to celebrate his birthday on December 5. He gives them presents, which are delivered through a chimney by his aide. For Zwartepiet's defenders, that is why he is as black as soot. However, it seems that a few centuries ago—after the Dutch fought the Eighty Years' War of liberation with the Spaniards—Zwartepiet had been conceptualized as a Moor, providing Sinterklaas with a colored servant. During Holland's and Zeeland's slave trade of those centuries and the involvement of the colonization of Surinam—the Dutch Guyanas—Zwartepiet slowly trans-

108. Magazine, *Village*, 105; see, for the Andes, García, *Making*.
109. Magazine, *Village*, 105.
110. Wekker, *White*, 139–66.

formed into an African dressed in a Moor's clothing. In Holland we also went from a functionalist kind of imaging to a racialized colonial ethnotype.

Immigrants from Surinam have been protesting the presence of Zwartepiet for years—half of Surinam's population lives in the Netherlands—but it took a documentary and subsequent television interviews by *white* filmmaker Sunny Bergman to really place the question on the agenda of a national debate. Her film *Zwart als roet* (2014; Black as Soot) has been seen by most people in the Netherlands by now. In an interesting sequence, the film shows Sinterklaas and two Zwartepieten walking through a park in London during the summer of 2014, approaching children with gifts. The people there react angrily and violently, finding the performance offensive. A man from the Caribbean states: "You cannot put this in the face of people who have been oppressed, who've been slaves." One moment, actor and comedian Russell Brand appears on his day off, meeting by accident the three oddly dressed people and the film crew, and asks about the background. Next, he comments: "What this tradition does is it dehumanizes people that are of a different ethnicity and reduces them to a lower status, or even toys or a degenerative role as servants. In this country [England] we think of Holland as a very advanced nation, with advanced social principles. So it is very surprising to see this kind of tradition. I think it is a colonial hangover."[111] The film convinced especially the younger generations to delete Zwartepiet from public performances and replace him with multicolored assistants, including Europeans; stop ethnotyping.

111. Documentary *Zwart als roet*, by Sunny Bergman, produced by De Familie, Amsterdam, premiered on television VPRO network, December 1, 2014; excerpt "What happens when Dutch filmmaker Sunny Bergman walks through London dressed up as Black Peter," also at YouTube "Our Colonial Hangover," https://www.youtube.com/watch?v=LBLBxb29maw (accessed 12/04). Also at https://www.youtube.com/watch?v=A_GSpGmdpKs (accessed 6/16).

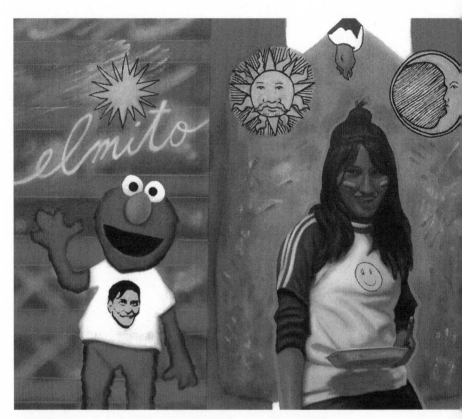

FIGURE 6.1. *Buscando al hijo de Elmo*, Jorge Miyagui, 2009, oil on canvas, 1.5 × 1.2 m.

CHAPTER 6

DISCLOSURE

ELMO'S CHILD

1

According to Jorge Miyagui, Elmo might have had a child.[1] In his painting *Looking for Elmo's Child* (2009) we see two characters happily laughing at us: Elmo to the left and a Peruvian teenager to the right. Elmo wears a white T-shirt with an image of José Carlos Mariátegui emblazed on it. Mariátegui was an early twentieth-century Peruvian author and politician, a Marxist and founder of the *Partido Socialista del Perú* (1928; Socialist Party of Peru). Standing between images of the Sun and the Moon, and below the head of a condor, the girl is wearing a T-shirt with the traditional smiley face. She seems to be painting. Above Elmo's head we note a yellow star accompanied by a neon-lettered word: *elmito*—an ambiguous entry which could mean both "Little Elmo" and "the myth." The painting encourages us to search for Elmo's child. In this painting, Elmito is Miyagui's other avatar. The girl to the right—"from Cusco," Miyagui told me—is ready to paint. Chances are that she will paint Elmo's child. Who or what does Elmo want the girl to paint?

1. In September 2013, for Miyagui's work, I could consult the following three online resources: http://jorgemiyagui.wix.com/jorgemiyagui#!inicio/mainPage; http://www .jorgemiyagui.com; http://jorgemiyagui.blogspot.com; https://www.facebook.com/#!/jorge .miyagui.1/about.

2

Little Elmo, Elmito. Who might the kid be? We know the father: Muppet per-
former Kevin Clash. Elmo is a three-and-a-half-year-old toddler Muppet who
for decades starred in the last segment of *Sesame Street*, "Elmo's World." In
fact, Elmo has been *Sesame Street*'s true star. Where he appears, there must
be happiness. He plays with friends and with famous stars like Halle Berry
and Katy Perry. The furry monster is cute and sanguine, but he is not simply a
joker. He is above all very curious. Elmo wants to know about the world, and
he walks around answering questions, sometimes posed by the public—like:
"How do you read a book?" In most episodes of "Elmo's World," he wants the
world to be a better place and, by finding answers to questions, would inspire
others to change for the better. In his autobiography Clash writes: "Elmo con-
nects with people on a level beyond any other character I've performed, and
I think I know why. Though he represents youthful curiosity and innocence,
behind his childlike simplicity you'll find the wisdom of an old soul, an unfail-
ing sense of humor (and the laugh to go with it), and a loving, lovable hero
with a heart worthy of any fairy tale. You'll also discover, as I have, that Elmo
is a teacher whose lessons can have a lasting value for adults, not just for the
countless children he reaches each day."[2]

Because *Sesame Street* is made in the United States, we may infer that his
lessons serve North American children, based on the cultural cosmology of
their country. Will we find Elmo's child in North American modernity? Do
we posit Elmo as the quintessential representation of a *white* Western and
U.S. hegemonic educational discourse of the contemporary world? However,
this is a position the producers of *Sesame Street* might contest. First, the show
may always be altered to "reflect the values and traditions of the host coun-
try's culture," as producer Gregory J. Gettas worded it.[3] "This was done [first]
in Mexico, where they had been screening the U.S. material since 1972 on
content-neutrality." To "avoid duplicating the look of the American series, the
Mexican team had a distinctive Latin-American-looking set designed, featur-
ing a neighborhood square typical of those found throughout the region."[4]
From the 1980s series onwards, *Plaza Sésamo* "features characters expressly
created to expose young Latin American children to both traditional and non-
traditional role models."[5] Also, today for example the Canadian curriculum

2. Clash, *My Life*, 3–4. On p. 9, Clash describes himself as "a forty-five-year-old six-foot
African American male with a deep voice."

3. Gettas, "Globalization," 57; other quotes *passim*.

4. Ibid., 57–58.

5. Ibid., 57, 58, 59, 60–61 and *passim*.

goals have been expanded to include multiculturalism, ecology, First Peoples, and regional diversity. Gettas continues: "In New Zealand as well, *Sesame Street* was perceived as a useful tool for increasing children's awareness of cultural diversity."[6] And they replaced the bilingual Spanish segments from the series with live-action clips and animated sequences that "dealt with the cultural heritage of the native Maori Population." Because of all the curriculum goals of the different national series, the producer argues, *Plaza Sésamo* for instance was no direct replica of *Sesame Street*. The suggestion of Elmo as a representative of U.S. imperialism is clearly oversimplified. In short, Miyagui's Elmo would probably represent a Latin American character and not a North American.

In *Looking for Elmo's Child,* Elmo is greeting us from an Andean position, standing at the left side of the painting; note: from his perspective, he stands on the right side and the girl is to his left. In the Andes, the right side (*paña/kupi*) is where the male should be, because from there he dominates the world—or better: we do things in the world. The left side (*lloque/ccheca*) dominates the heavens, a female task. But entities on this side in Andean images are also seen as subordinate to those on the other side. Here it is Elmo who should start doing things; the girl is staged as subordinate to him; Elmito must "set her in motion." Because Miyagui directs the girl to the golden Qoricancha Plate—and to the tasks to be done in the heavens—it seems the girl tries to recreate the Andean worldview. The painting, however, can also be seen as consisting of two separate halves. In that case, the girl to the right stands in the middle of a scene, with the dominant Sun to her left (seen from our point of view; from her, to her right) and the subordinate Moon to her right (for us; for her, to her left). Both left and right are subordinate to entities above them, especially if there is a pyramidlike zenith drawn there. The Center Up Above corresponds to the absolute and utmost authority in Andean thinking. Interestingly, the Andean girl is from Cusco, which as a place in Andean cosmology is Up Above relative to Lima, where Mariátgui resided.

The Qoricancha is the Inka Temple of the Sun in Cusco. The Plate is also known from an early seventeenth-century colonial manuscript written by Juan de Santa Cruz Pachacuti Yamqui Salcamaygua.[7] One wall of the Qoricancha was once decorated by the Plate. This author describes how the Maker stood central on it, flanked by the disks of the Sun and the Moon below the Southern Cross. The Sun is male and used to watch over the men of the world (at the right side of the couple), whereas the female Moon watched over the women

6. Ibid., 57.

7. Santa Cruz, *Relación,* 208–9, and MacCormack, *Religion,* 320–31.

(at the left side). The Maker, however, is a "non-iconic, abstractly conceived deity."[8] The Maker, neither a He nor a She, was to be seen as a universal god to be known through the intellect alone, not for example by revering saints or celestial bodies. Below on the Plate, the lower strata of the world could be seen, including the clouds, the morning and evening light, summer and winter phenomena, the Earth itself, and the humans—all clearly separated into male and female sides: the male side for us to the left of the Plate, but facing us, looking at us, from the right side of the male-female unity. In his painting, Miyagui replaces the Southern Cross and the Maker with a condor, believed to be the ruler of the Upper World—like the Sun. The central place between Sun and Moon suggests that the girl-from-Cusco sees the ruler of the Upper World as not defined by gender. Miyagui borrowed the Sun and the Moon from the colonial author Felipe Guamán Poma de Ayala's *Nueva Crónica y buen gobierno* (1615), another key publication in studying Andean culture.[9] The rest of the girl's cosmology in Miyagui's painting is not manifest yet. She is in the middle of reviving "the spirit of the declining order,"[10] as Mariátegui had put it, thus seeking the new myth, the next Elmito, Elmo's child. Miyagui plays with the ambiguity of this name by painting a Mariátegui icon on Elmito's T-shirt.

For modern students, Mariátegui's "Reflections" as published in *The Peru Reader* would be the first acquaintance with his work.[11] According to Mariátegui, reflecting upon the world crisis of the early 1920s, all "modern intellectual investigations" of that crisis "lead to a unanimous conclusion: bourgeois civilization suffers from a lack of myth, of faith, of hope."[12] Mariátegui found the bourgeoisie too rationalized, too depended upon reason. For humans, he argued, "Only Myth possesses the precious virtue of satisfying its deepest self." "Myths moves man in history. Without myth, the history of humanity has no sense of history. History is made by people possessed and illuminated by a higher belief, by a superhuman hope: others are the anonymous chorus of the drama."[13] Thus, to give sense to history, a meaning to life, people must be

8. MacCormack, *Religion*, 324.

9. Guamán Poma de Ayala, *Nueva crónica*, 62 (manuscript p. 79); MacCormack, *Religion*, 330.

10. Mariátegui, "Man," 386.

11. Mariátegui, "Reflections" is translated from excerpts published in his collected works, as the editors of *The Peru Reader* indicate. The pieces were published originally in the late 1920s. A piece on "El hombre y el mito" (1925) can be found in the third volume of his collected Works, *El Alma matinal* (1959), 23–28, but was published before in *Mundial*, Lima, January 16, 1925, and *Amauta* 31 (1930): 1–4.

12. Quote from "Man," 383; see note 11, this chapter. Also next quote from this page.

13. From Mariátegui, "Man," 384; see notes 11 and 12, this chapter. The version of "Reflections" reads as follows: "Myth propels men through history. Without myth, human existence has no historical meaning. Indeed, history is made by those who are possessed and illumi-

illuminated and possessed by myth, by a higher belief, by radical imagination, perhaps even of a superhuman kind. Only then is social change is possible—because social change, a socialist Peru, was eventually Mariátegui's aim. This is why Elmito put on his happy face, why there is a yellow star above his head, why we are drawn to Mariátegui's icon, and why Elmito stands at the right side of the couple on the painting, with Mariátegui ready to watch over us.

Miyagui shows us Mariátegui as a brand like Che Guevara. "And the brand's logo is the image, which represents change," says Trisha Ziff, curator of a touring exhibition on the iconography of Che.[14] "It has become [. . .] the icon of the outside thinker, at whatever level—whether it is anti-war, pro-green or anti-globalisation."[15] "The strength of revolutionaries is not in their science," Mariátegui concludes, "it is in their faith, in their passion, in their will. It is a religious, mystical, spiritual force. It is the force of myth. The revolutionary excitement [. . .] is a religious emotion."[16] Due to their rational stance, professional intellectuals would not find this path back to myth, he believes: "the masses will find it." For Mariátegui, the masses in Peru were Andean: miners and peasants, who spoke Quechua and Aymara. In Mariátegui's sense, Elmo's child would give us a myth, a story, of how to end the Colonial Divide, to fight *colonialidad*. The population data show that the masses in Peru—*cholo, mestizo, indígena*: Amerindian—still are fundamentally Andean. They also show that this is the case in Central Mexico; and they must be in Southern Mexico and Guatemala, as well as in Ecuador and Bolivia.

Elmo's task is now known: he fights with the colonized to end the persistent colonial heritage of Peru and gives Mariátegui back to the people. He might be an intervening agent. Moreover, this agent's mind is set on anti-coloniality. For Mariátegui social change happens—"history is made"—when

nated by higher beliefs, by superhuman hopes; the rest are the drama's anonymous chorus." See Mariátegui, "Reflections," 241. The original reads: "El mito mueve al hombre en la historia. Sin mito la existencia del hombre no tiene ningún sentido histórico. La historia la hacen los hombres poseídos e iluminados por una creencia superior, por una esperanza super-humana; los demás hombres son el coro anónimo del drama." See *Obras Completas de José Carlos Mariátegui, Volume 3. El alma matinal*, "El hombre y el mito," published online by the Partido Comunista del Perú, at https://www.marxists.org/espanol/mariateg/oc/el_alma_matinal/paginas/el%20mito%20y%20el%20hombre.htm

14. Quote from Trisha Ziff, "Photos, Pictures and Images of Che Guevara," published July 11, 2013, at http://www.hey-che.com/gallery-of-pictures-of-che-guevara/ (09/13). Of British descent, today filmmaker and photographer Ziff resides in Mexico City.

15. Ziff, "Photos" (2013), at http://www.hey-che.com/gallery-of-pictures-of-che-guevara/ (09/13). Ziff concludes: "There is a theory that an image can only exist for a certain amount of time before capitalism appropriates it. But capitalism only wants to appropriate images if they retain some sense of danger."

16. Mariátegui, "Man," 387.

forces guided by myth unite people around a culturally popular narrative that inspires them to collective action. "Modern man feels the urgent need for myths," he stated. This is his vision of the proletariat: "Philosophers give us a truth similar to that of poets. Contemporary philosophy has swept away the positivist mediocre edifice. [. . .] It is useless, according to these theories, to search for an absolute truth. The truth of today is not the truth of tomorrow. A truth is only valid for a period of time. We should be content with a relative truth. [. . .] But this relativist language is not accessible or intelligible to the common people. Common people are not so subtle. Humanity is reluctant to follow a truth that it does not believe to be absolute and supreme. It is futile to recommend the excellence of faith, of myth, of action. We must propose a faith, a myth, an action. *Where will we find the myth able to revive the spirit of the declining order?*"[17] Remember it was Lima, 1925. We need a new radical imagination. More than any bourgeois appropriation, this is the quest that Miyagui's painting points to.

Although Mariátegui's words smack of an elitist paternalistic attitude, they reflect the realities of today. Think of the reality of anthropological research among the pan-Maya movement in Guatemala. The latter is a group of Maya public intellectuals dedicated to building a different postwar world for their people based on identity politics. Among several scholars, Kay Warren interviewed leaders of the movement and participated in the movement's activities. Warren had conducted ethnographic research in Guatemala since the 1970s, taking sides, of course, during the violent conflict recognized as a kind of ethnic holocaust against the Maya population during the 1980s, and supporting the Maya movement in their identity politics of the 1990s; the research for her book, *Indigenous Movements and Their Critics* (1998), was meant to defend the movement's activities from critics. One of the confrontations she describes is between followers of an almost essentialized Maya philosophy versus postmodern relativist scholars, journalists, and politicians—Mariátegui's "absolute" versus "relative" truth.[18] In Mariátegui's spirit, the Mayanists found their identity in, perhaps, the "myth" of Mayaness and tried to revolutionize Guatemalan politics, whereas scholars like Warren are motivated by ultra-relativism.

One of Miyagui's early paintings, a companion to *Elmo's Child*, proposes that he understood Mariátegui's faith and passion as an inner force. Based on "the myth," the Left need to mobilize the inner force of the people they believe they are speaking for. The painting *Mariátegui* (2008), sometimes also referred to as *Waiting*, dates from the same background as *Looking for Elmo's*

17. Mariátegui, "Man," 385–86; italics added.
18. Warren, *Indigenous*, especially chapter 3, "In Dialogue: Maya Skeptics and One Anthropologist," 69–85, and the preceding illustrated pages (between 68 and 69).

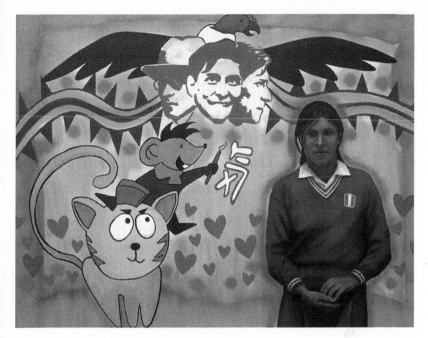

FIGURE 6.2. *Mariátegui/Waiting,* Jorge Miyagui, 2008, oil on canvas, 1.5 × 1.2 m.

Child (see figures 6.1 and 6.2).[19] At the right side of *Mariátegui* we see again another girl from Cusco, in school uniform this time—at the Andean left side. She is the one who is waiting. As a child she represents the future. The painter told me that the figures to the left (for us) are a mouse and a punk cat, working jointly at the Japanese characters in the center, which read "Inner Force." Mariátegui's image is painted in triplicate in the center, guarded by a condor. The painting sprouted from a 2002 graphic designed print, *Waiting for a New Star,* which shows a side-view black-and-white picture of Mariátegui—also present in the painting, as the right one of the three Mariáteguis—accompanied by Pikachú at the bottom and a transparent star on Mariátegui's eye. Pikachú is a character created by Satoshi Tajiri as part of the Pokémon media franchise—including video games, anime, manga, books, and trading cards. Miyagui hopes with Mariátegui that a belief in some myth would mobilize people and could probably be as popular as Pokémon. This empowering belief or myth is the internal force, an internal power. Several of Miyagui's paintings from the 2005–8 period combine Japanese and Peruvian semiotics. The idea

19. See Miyagui's website, http://www.jorgemiyagui.com/#!Mariategui/zoom/c22j5/image251e for most recent publication of this painting's title (accessed 9/13).

of setting the "Inner Force" as a transmission from the painter—the mouse
assisted by the punk cat—to the girl shows us that the "inner force" is in the
air, as if Miyagui himself is looking for the new radical imagination or "myth"
that will empower the people at places where the inner force is set in a true
revolutionary spirit. Set in the Center Up Above, Mariátegui is superior to the
others in the painting; in Andean thinking, his subordinates. He sits in the
position of greatest authority.

If Miyagui's quest would become a reality, will Peru be socialist? Peruvian
historian Alberto Flores Galindo believed so. Shortly before he died of cancer
on 14 December 1989, he published "A Self-Critical Farewell" in which he envi-
sioned a future for a socialist Peru—originally: "Reencontremos la dimensión
utópica," or "We should return to the utopian dimension." It was influenced by
the destruction occurring at the time in the Andes and in Lima: Peru could be
socialist after breaking the molds and start all over again, perhaps with some-
thing as simple as solidarity among friends. His plea was for the recovery of
the utopian dimension of socialism and the essence of critical thinking. Not
for the socialisms that were defeated, not looking for yet another formula,
not for reciting, quoting, and repeating of past works correctly, not for being
overly eager for power. In Peru, that ancient country, he thought, socialism is
a difficult encounter between the past and the future, in which the rediscov-
ery of the most distant traditions goes hand in hand with thinking in terms
of the future. "I suspect," he wrote, "that we do not have an unlimited amount
of time."[20] It was the heyday of Sendero Luminoso; the capture of its leader
Abimael Guzmán was three years in the future. "It is not inevitable that tra-
dition be destroyed. But to prevent it we must propose an alternative. The
writer and novelist José María Arguedas warned us of this. Twenty years have
passed since his death and the task for socialists remains keeping Andean tra-
dition from being destroyed. What Arguedas proposed in his novel *El Zorro
de Arriba y el Zorro de Abajo* [1971; The Fox from Up Above and the Fox from
Down Below, 2000] was not a return to the past, but the construction of a new
society. We must not limit our horizons of thought. Contrary to what many
suppose, Arguedas' book does not refer to local problems, but to changing
society as a whole."[21] The novel *El Zorro de Arriba y el Zorro de Abajo* is gener-
ally seen as unfinished and was published posthumously.

An important passage in the third chapter of *El zorro de arriba y el zorro
de abajo* describes how manager Don Ángel Rincón Jaramillo of the Nautilus
Fishing Company plant in the coastal city of Chimbote shows visitor Don

20. Flores Galindo, "Self-Critical," 9.
21. Ibid., 10.

Diego around the fish-processing machines. The latter, an Andean migrant who stands for the Fox from Up Above, was one of the first to realize that he could reconcile the Andean heritage of Peru with the urban and industrial coast—a kind of Supercholo *avant-la-lettre,* but certainly celebrating *a spirit of independence and opposition.* It made him dance:

> [Don Ángel and Don Diego] crossed the yard, the open space in which the cyclones were turning; then they entered a wide passageway where thin tubing ran through the air toward a long building with a very square door. Through that doorway they entered a gallery that was vibrating with the constrained strength of eight strange pieces of apparatus—made of copper, iron, and tin plates with buckets, wire, and ferocious compressed air, all under a rather low roof. A few steps beyond the doorway the visitor was brought to a halt. He was not breathing with his own chest, but with that of the eight machines; the surroundings were brightly lit. Don Diego began to turn around with arms outstretched; a bluish vapor began to issue from his nose; in the gloss of his hairy shoes all of the lights and pressures inside there were reflected. A musical joy resembling the joyousness of the most high-curling waves that roll up onto beaches unprotected by islands, threatening no one, developing all alone, cascading onto the sand with more power and rejoicing than the waterfalls in Andean rivers and ravines carved out by torrents—those ravines on whose banks slender plumes of flowering grass quiver—a similar joy was swirling inside the visitor's body, silently swirling; for that very reason Don Ángel and the many workmen who sat, resting against the gallery walls, drinking anchovy broth, felt that the world's strength, so centered in the ritual dance and in those eight machines, was getting to them, making them transparent.
>
> [In an intermediate paragraph, Don Ángel enthusiastically describes how the machines do their work.]
>
> [Don Diego's] extraordinarily ill-proportioned body went round and round in almost the same place, shifting only a few centimeters; but since it was asymmetrical and the speed of the turns was irregular rather than steady, [Don Diego's] shape kept changing and so did the extension and color of his frock coat. The blue vapor emanating from his nose began to fade and then suddenly was extinguished. Don Ángel saw that the [Amerindian] workmen were all standing up, clapping their hands. No sooner had the vapor ceased than they began to clap their hands, and from that moment Don Ángel's body slightly changed its music, which was no longer heard outwardly but instead inwardly—from the air toward the inside of his body, because in the silence of the gallery only the *cholos'* applause was heard; in

that same silence the dancer's cap began to change color; first it was red, then purple, then green, then yellow, and finally white, like the stones polished for thousands of years beneath the constant flow of streams, which only know how to conserve and intensify the white, greenish, and gray colors of little stones immovable in their channels into which everything plunges.[22]

The dance of joy was to unite the world from Up Above and from Down Below—Andean and Coastal, Amerindian and Euro-Peruvian, "modern" and "traditional." Arguedas wrote *El zorro de arriba y el zorro de abajo* to exhibit a new kind of modernization; not one in which the Andean was welcomed to *whiten,* but one that was both European *and* Andean. The Up Above and Down Below fused and blended but without losing their own characters. There was no longer a time perspective from the "primitive" and "backward" Andean peasant to a "modern" urban capitalist world. The Andean fitted in, as its own modernity. Arguedas gifted the foxes with the voice of diversity. By dancing, Don Diego had encoded a new memory and created meaning at the same time.

But what meaning and memory? Had Don Diego set the transfer of the power of the Andes into motion in this industry plant at the Peruvian coast? According to the psychologist Arthur Glenberg, memory is for creating "meaning in the service of action."[23] Dancing next to the machines and the Andean industrial workers, is Don Diego celebrating the end of the colonial heritage? Was he celebrating *cholificación*? In the work of Arguedas, the chaos to end is the Colonial Divide. In *The Foxes* the turnover is referred to as *alegría* or *joy.* It is Don Diego's achievement in *The Foxes* that he brings this joy—opens up a new cycle—not only for his fellow Amerindians who had migrated from the Andes to work in Chimbote but also for Don Ángel, heir to a genealogy of colonizers. Don Ángel perhaps stands for modern Euro-Peruvian capitalism so crucial for his side of the Colonial Divide, but what he celebrated was a new type of modernity that was neither Western nor Andean. Interestingly, Don Diego is a kind of effeminate character. While dancing, which lasts only an instant, he ends chaos and forces a breakthrough to start a new cycle; he performs his task as intervening agent. Indeed, he comes and he goes; and he is not the novel's central protagonist, not even one of the key characters. Arguedas had tried to do so as well with his *El zorro de arriba y el zorro de abajo,* a novel about a capitalist world in deep crisis written in the

22. Arguedas, *Fox,* 129–31; Don Diego is described as "the visitor"; italics in original. After finishing this discussion, I found out that three other scholars have singled out this passage: Beasley-Murray, "Arguedasmachine," 114; Rowe, "No hay," 76; and Hibbet, "Arguedas," 383.

23. Glenberg, "What."

form of a Quechua book like the sixteenth-century Huarochirí manuscript.[24] With his assessment of the novel, Flores Galindo had recognized Don Diego's dance. It was in his mind and in that of Arguedas's readers that Don Diego had also, or perhaps primarily, opened up *a new cycle in thinking* about the urban "modern" Andean.

3

Is this the answer to Walter Mignolo? In a way, structured around the work of Peruvian painter Jorge Miyagui, who uses the idea of coloniality as a foundation for social and political criticism, the previous chapters attempt to contribute to the current debate on coloniality in Latin America. The second chapter presented the problem: coloniality was invented by Peruvian sociologist Aníbal Quijano as a different wording of the classical internal colonialism thesis but was later adopted and adapted by the Modernity/Coloniality Project, led by Walter Mignolo, who added a psychoanalytical content to the concept and introduced "decoloniality" as a way to be liberated of "coloniality." Mignolo believed that political repression here meant also psychoanalytical repression: wiped from consciousness, seemingly into the oblivion of history but in reality haunting Latin America's modern present—*colonialidad*. But it was not lost. Tradition would not be destroyed. As on Freud's sofa, "analytical work" could do wonders. Remember (repeated here from chapter 1): "In psychoanalysis, a cure can only come from the intervention of a [psychoanalyst] during analysis, whereas decolonial healing is a process of *community formation*. The process of release is not just a personal process. In fact, it is not only mine; on the contrary it is a subjective process that takes place in communities."

Discussing the intervening agent, we did not recognize any psychoanalytically repressed communities at all. In the Amerindian worldview—a complex of cognitive schemas—"community" has never been wiped out of consciousness. It had always been there and is alive even in modern urban settlements like Tepetlaoxtoc near Texcoco and Mexico City. But the intervening agent script, or IAS, prescribes that it must be *brought into movement*. This can be done by its own municipal or confraternities' officers, which is their task anyway, or by intervening agents that suddenly come, and then go again—and are usually sacrificed after their deeds. The municipal officers are part of the communities' daily rhythms, whereas the intervening agents stand between

24. See Ávila, *Dioses.*

cycles, needed in specific times only and directed toward an "intervention" that transforms the daily rhythms because these had been fallen into chaos. The IAS can be triggered at any moment to emerge from situations of deep distress and chaos, and the Zapatistas, for instance, did. The new Maya life of the Zapatistas was a recreation of ancient Maya life, but substantially modernized socially and politically, because the traditional ways of chiefdoms, caciques, and *usos-y-costumbres* had been out of joint. As in Tepetlaoxtoc, they needed to *amerindianize* customs from abroad to recreate their lifestyle. This was a substantial adaptation of Maya cognitive schemas.

Over two decades of work in colonial archives and reading the work of my colleagues, I came to appreciate the power of the *república de indios* as a contextualizing instrument of identity. It was a formal identity, because the colonized were categorized as *indios*. It was also one of the many social identities, although people preferred varieties like *mestizo* and *pardo*. The *república de indios* as Amerindian Order influenced the people for over two hundred years at least. This must have left durable traces in the memories of the Amerindian mnemonic community. It will not be overstretching the historical evidence to assume that it was encoded as a cognitive schema: the *república de indios schema,* RdIS. As acknowledged in the previous chapters, the RdIS was based on several features. First there was the Colonial Divide, creating two administrative and legal worlds next to each other on top of the social and cultural differences that follow from being a descendant of the "colonizers" or the "colonized." But, as also argued in this book, the RdIS also learned that the Amerindians did not consider themselves to be "defeated." The *non-defeat* was one of the many pre-Hispanic schemas that were re-encoded under Spanish rule. It taught the *indios* also that their *república* meant a kind of semiautonomy under the Crown, with a strong decentralized self-rule of the basic legal units of their *república,* the *pueblos de indios.*

During most of the nineteenth century, the administrative features of the RdIS were tolerated or, as in Peru in the early twentieth century, used for special rights granted to *comunidades campesinas* (peasant communities). The heritage of these aspects of the RdIS can be recognized in the politics of autonomy of the Zapatistas—but also in the countries that have institutionalized "indigenous" rights in plurinational constitutions, like Bolivia, Ecuador, and Colombia. However, after the official abolition of Spanish laws in the 1820s and the rise of racial stereotyping during the later decades of the century, negative ethnotyping rooted in many minds. In Peru, after the Internal Armed Conflict, the major cause of distress and horror had been—and still is—the negative ethnotyping of persons from real or supposed Andean roots. Ethnotyping may lead to the categorization of "secondary citizens," even "sec-

ondary humans." The latter is a well-known strategy employed by racists: from "secondary humans" to "inferior races." The more negative consequences of the Colonial Divide—racism, privatization of communal lands, abusive labor practices on large estates—were typical of the age of modern imperialism.

Since 1938 Lima has changed from a *white-mestizo* into a predominantly Amerindian city. Its face has changed, literally, with a "deluge of people" or *desborde popular* from the Andes.[25] In a recent discussion of this new face, my colleague Annelou Ypeij, an anthropologist, mentions figures of a decreasing poverty from 32 to 14 percent between 2004 and 2010.[26] But the city brims over with social and commercial energy. Many businesses are family-based and even include experiments with the sharing economy. As we have seen, the migrants are also changing the cultural face of the city with *chicha* music, pastel-shaded posters and bills on the walls throughout the city—especially announcing *chicha* artists—in "Andino colors," as they say; with dances, festivities, and even the faces of the movies in the cinema and the soap operas on television—literally, in fact, and making it less indispensable for the producers to *whiten* them. From the fringes of the city, the Conos, the city was colorfully and swingingly conquered and continues to be in that process. Interesting, for many *cholos* this goes hand in hand with the fight against legal and social inequality and negative ethnotyping. Following the news, every reader or television watcher will notice that protests against negative ethnotyping are a daily matter. Cholification includes a movement against *racismo*. Perhaps this is even one of the crucial elements of the remnants of the RdIS inherited by the *cholos*: their activism against exploitation and abuse.

In their well-read book *Ciudad de los Reyes, de los Chávez, de los Quispe* . . . (2010; a translation would read "The City of the Kings, the Chávezes, and the Quispes," noting that the "Kings" refers to the city's Spanish heritage, the "Chávezes" to a middle-class family, and the "Quispes" to Andean migrants) Rolando Arellano and David Burgos describe the commercial potential of a new market population by *cholo* consumers and producers. If today's population is distributed according to socioeconomic level for households, the richer groups *A* and *B* form 18 percent of the population and the poorest stratum of *E* about 32 percent. This means that half the population can be mapped in the middle and lower-middle strata *C* and *D*. Arellano and Burgos also suggest that the slow but increasing growth of Peru's local economies is the migrants' achievement because very few initiatives were taken at governmental levels

25. The terminology of *desborde popular* is of course by José Matos Mar, *Desborde* (1984) and *Desborde* (2004); he also speaks of the "new face of Peru."

26. Ypeij, "Cholos," 68; which does not mean that poverty has vanished from the city.

over the past decades to stimulate the economy.[27] Curiously, this developments falls within the heritage of the RdIS, because also under Spanish rule, the *pueblos* had set in a development like this, independent from mining or haciendas. The Amerindians have always remained captains of their own soul.

The growing awareness of this struggle and the developing presence—and decreased poverty—of the *cholos* in Lima is creating a new attitude that recognizes Andean or *cholo* identity as a social movement. One example may suffice; one out of many indeed.[28] The workshop Warmichic of Qarla Quispe, for example, produces *polleras,* or white and pastel-shaded colorful skirts, for young *chola* women. They are not embroidered but painted, in the colors of the Andes; see model Kathe Jimenez photographed by Pamela Pozo for Warmichic's Facebook page. Qarla Quispe identifies herself as *artista plástica,* a graphic artist, like Claudia Coca or Jorge Miyagui. "I want to work with the theme of racism against women of Andean descent," she says in an Internet clip made by Adriana Philipps for the Instituto de Educación Superior Tecnológico Privado Charles Chaplin.[29] Her project is the *Rebellion of the Polleras* and consists of reintroducing the polleras as modern gear in the streets of Lima. Although she began with colors and patterns from Huancayo in the Central-Southern Andes, her clients are now asking for dresses based on all other Andean and even coastal regions of the country. Although Warmichic is a commercial brand, and a successful one, Qarla Quispe sees herself as an activist in the cholification movement. Other typical spokespersons like television host and actress Tula Rodríguez or actress Magaly Solier do not identify themselves this way, but they do speak out as *cholas* in very similar ways.

4

Today, the Amerindians live within their own modernity: in Peru it is called cholification; in Mexico, *mestizaje.* It is a "genre" of life, a schematic template to tell the world about it, a cognitive schema encoded in their minds. Cholification suggests that the Andeans have already begun acting in the world according to their schemas—leaving the "waiting" behind them. Like Wendy Sulca. In 2009 I saw on YouTube a video entitled "La Tetita" (2005; "The Tittie"). The Tetita video was posted at YouTube in 2008 by the family of a then

27. Arellano and Burgos, *Ciudad,* 51–52, 148–69, and especially 174–79.

28. For other examples, see the contributions in Bedoya, *Coloquio,* I and II; also: Cánepa Koch, "Disputing" and "Geopoética"; and Ypeij, "Cholos."

29. See: "Reportaje—Identidad peruana en la moda," https://www.youtube.com/watch?v=Sa6iNNxJ4Uo (accessed 10/14). For Warmichic, see http://warmichic.blogspot.nl/ and https://www.youtube.com/watch?v=mDDVz-bDOUA (both accessed 6/16).

eight-year-old girl, Wendy, who was dressed in a type of *pollera* common among the Lima folklore singers. Because hardly anyone in the Andes wears such a fully embroidered mini crinoline, this type of *pollera* is a typical case of an invented tradition. The first chords of the video are obviously taken from ABBA's "Chiquitita" (1979). Next, it shows a little girl in a typical "girly" pink bedroom, with dolls, cuddle toys, and the like. Soon, however, the camera switches to a plaza in an Andean town, showing three mothers breastfeeding. The images of Wendy in the Tetita video alternate with images from urban Peru, with Wendy shopping in a mall. In addition, we also see cows and their udders feeding their calves, a sow with suckling piglets, and, in the back on a bench, the three women giving their babies the breast. The music is produced by a band playing Andean pentatonic harp music locally called *folklore*. Wendy has the looks of the typical Andean person and plays constantly with Andean symbolics during her performance. The video was an instant sensation. The number of views increased from mid-2009, when the video received over a million and a half hits, exploded from three million by August 2010, 8.8 million by September 2012, 11.5 million by February 2014, to 17.5 million by March 1, 2017. In a second video, from the same cycle, Wendy sings about drinking beer out of sorrow. This song, "Cerveza, cerveza" (2005; "Beer, beer"), stood at 14.7 million when I last checked it (March 1, 2017).

As I write this, over eight years later, the Tetita video is still a YouTube hit. These are the lyrics of the song: "All day and all night, I would like to drink my tittie. Every time I look at my mommy, she is provoking me with her tittie. All day and all night, I would like to drink my tittie. Every time I look at my mommy, she is provoking me with her tittie. Yummy, yummy, yummy, yummy, mmmm, yummy, my tittie is very yummy." Significantly, at intervals, Wendy's singing is interrupted by a masculine voice-over: "With much love for all the children of Peru, singing for you, Wendy Sulca. Little Wendy! Oh, the children, the children of Peru and the world. If it were not for them, what would be of homes and house? We have to take care of them, we have to teach them how to live. Little Wendy! Only eight years old." At the end of the clip, a charming girl passes by the band. The voice-over changes tone: "Hey, hey, hey, where are the men? Let's see them, hands in the air, all the men, Eighteen years and older. We also like . . . Yes! That is right! Oh, my little lady. Hit it! She shall be the pride of our folkloric music. Little Wendy! Hands up in the air, Wendy! Stomping your feet like that dance. Dance, stomp, stomp. Hit it! Thank you for being here, for this first musical concert. From Wendy, for all of Peru, with love and care."[30] What to make of this? A little girl uncannily out of

30. The video is now on Wendy's YouTube channel, http://www.youtube.com/user/WendySulca (accessed 6/09; also 8/10 and 2/17), or: http://www.globalvoicesonline.org/2008/01/18/peru-wendy-sulca-child-video-sensation/ (accessed 6/09; last time, 2/14).

joint? Promoting breastfeeding? Perhaps, but we also witness at the end of the video a young and sexy Andean young woman passing by, with the members of the band immediately following her—a scene which is much less innocent.

Today, Wendy Sulca lives as the child of Andean migrants in San Juan de Miraflores, a suburb of Lima, once labeled a shantytown. She is bilingual in Spanish and Quechua. In 2014 she published her first autobiography, *La verdadera historia de Wendy Sulca: Más allá de "La tetita"* (*The True History of Wendy Sulca: Beyond "The Tittie"*). It is a story that begins with the Internal Armed Conflict and passes through all the setbacks of migration to Lima and the poverty of the struggle to survive. On her way to her unexpected and unplanned success, Wendy battled against prejudice and racism. Few commentators would use the ethnotyped label of *indígena* for Wendy Sulca—although racists' insults did. She might opt for *chola* herself. Her genealogy, however, brings us to an isolated place near Huacaña in the Andean mountains to the south of the city of Ayacucho that most traditional anthropologists without any doubt would label as *indígena*.[31] Her autobiography is based on true events, alternated by details that appear apocryphal. No doubt intensively supervised by editors Giancarlo Trigoso Higinio and Álvaro Lasso Díaz, the story with true events full of drama is told as a script for a miniseries. Nevertheless, as a tale of resurgence, of a true *spirit of independence and opposition*, we may also read it as part of the social movement of Andean recreation after violence and in urban circumstances: cholification.

Wendy's story begins one day in 1983, when in the middle of the Internal Armed Conflict—Wendy's mother Lidia Quispe was eight years old—the insurgents of Sendero Luminoso attacked Huacaña and killed the authorities. They also forced some men to join their ranks, and Lidia's father Eusebio was one of them. The town counts about 500 to 700 families, known as *comuneros*. Its major fiesta was that of San Isidro Labrador (Isidore the Farm Laborer, or Isidore the Farmer), on July 26 to 31. Lidia lived here with her nine brothers and sisters, her parents, and her grandmother, daily tilling the land, herding the animals, and doing some weaving and embroidery. Lidia's sister Marta (17) and brother Apolonio (18) went to school in the town of Aucará, twelve hours' walk from Huacaña. Brother Emiliano and sister Zenobia, the oldest children, had gone to Lima to work; the first in a bakery, the latter as a cleaning girl. Over time, four of Lidia's sisters and brothers had died, perhaps of the cold and diseases, as was not uncommon in these poverty-stricken surroundings. Sendero made Don Eusebio participate in several attacks, robberies, and killings. During one attack, Wendy tells us in her book, he and the

31. Huacaña is mentioned in this sense by Stern, *Peru's*, 64.

other *senderistas* had to eat parts of a tongue cut from one of the town's leaders. Andeans believe that if people eat human tongue, they transform into devils. Upon eating his piece, Don Eusebio vomited and was subsequently tortured by the Senderista commanders.[32] One day, he was able to escape. In the years that followed, the town of Huacaña was frequently visited by Senderistas and National Army soldiers alike, both acting violently against the population. Frightened that they would be recruited by Sendero Luminoso as well, Apolonio, Marta, Lidia, and Hidalgo decided to escape to their brother and sister and aunt Gertrudis in the poor migrant neighborhood of San Juan de Miraflores, Lima.

Organizing the fiesta of San Isidro Labrador was in Huacaña a moment of bringing the community in motion. The organizers spent more time motivating others to participate than organizing the fiesta itself. Also here, cargoes were unpaid and were regularly occupied for about a year. The cargo officers ideally alternated between civil and religious posts, thereby climbing up the cargo ladder (the civil-religious hierarchy). In 1992 the duty (cargo) to do this in Huacaña had fallen upon Lidia's brother Apolonio, who had to come over from Lima to perform his duties. He had arrived in town with several others who had fled the Internal Armed Conflict or had simply tried to find work elsewhere. One of them was Franklin Sulca (then eighteen years old). During the fiesta Franklin made friends with Lidia and fell in love with her. After some time for reflection Lidia rejected him, but she was already pregnant. Months later, she informed Franklin. By then, Franklin was about to marry another girl, but he eventually decided to join Lidia—without marrying her. The birth of Lidia's daughter on April 22, 1996, was traumatic. After her premature birth, the baby had to spend a few weeks in the hospital in an incubator, and Lidia also spent a week or so in the hospital for an infection.

At this point in the book, Lidia as Wendy's ventriloquist begins to tell the history of the hunger Wendy had as a baby and her desire to be breastfed as much as possible. Lidia was too weak to feed her. Other mothers in the hospital had to stand in. Apparently, the hospital could not support the child—or did not want to, because Lidia and Franklin were too poor to pay the bills. In the hospital, women supported Lidia, calling loudly to her if they could spare some breast milk: "Is the woman nearby who needs a tittie for her nipper?" Eventually there was a girl who had just lost her own child who would step in. This was, *La verdadera historia* tells us, the incentive for the Tittie song and video.[33] After the baby had survived the birth period, Franklin went to regis-

32. Sulca, *Verdadera*, 13.
33. Ibid., 44–50.

ter his child, calling her Wendy. Lidia, by the way, had thought about calling her Ana Paula, but it was fathers who registered their children in Peru—and also in my part of the world, it must be said. Wendy, the book says, was being breastfed until she was about two and a half years old.

The living conditions in the migrant neighborhoods in Lima in the early 1990s were very difficult indeed. People lived in shacks in the desert hills that surround the old city, without water and electricity. Nine months after Wendy's birth, however, Lidia and Franklin did something many young couples in Lima still do today: hire a room in a private house nearby. The slums of Lima slowly developed into neighborhoods with newer dwellings, where there were always rooms available on the top floors. The Sulca residence was a room on the second floor of the house of Lidia's father in San Juan de Miraflores. About the same time, Franklin tried to get hold of a small piece of land in the Pamplona Alta area of the city to build his own home. From shacks and a tiny wooden dwelling to a many-storyed house, he eventually succeeded; it is the house they live today. It became the base for their musical career.

Like many Andean migrants, the couple imported Andean customs into their daily routines in Lima. In this case it was the *huayno con arpa,* a huayno—a combination of traditional rural folk music and popular urban dance music, with a distinctive rhythm in which the first beat is stressed, followed by two short beats and accompanied by high-pitched female vocals—played with the Andean harp. Played at family and local fiestas in Lima and surroundings, this type of folklore music became Franklin's job, who played the harp and the drums in his folklore band Los Pícaros del Escenario. Uncle Hidalgo was a musician in the band, singing and playing the Andean harp. They practiced in Franklin's house in Lima. Working very hard, Lidia and Franklin had been able to pay for Wendy's school. The couple returned regularly to their towns in the Andes during fiesta time, where Wendy learned to love the local music and dances. At a very young age, and supported by Lidia, Wendy began to participate. She developed a variation on the high-voiced nasal singing style that bore many resemblances to the Andean style, as was the custom in Huacaña. On Sundays Wendy sang in the band and developed her own career as a local child star.

Music alone was not sufficient. Franklin opened a liquor store, selling mostly beer. He had contracted a loan with a local bank, which he used to finance the shop but also to pay off the loans he had previous contracted with his family and friends. Lidia found a job in a toy factory and also worked as a tailor of *polleras,* the colorful hoop petticoat used by folklore singers. Franklin's beer business did not go well, however, and after a row with Lidia he went for a few weeks to Huacaña, perhaps also to escape from the bank and other

creditors. In *La verdadera historia,* Wendy states that several persons motivated her to pursue a career in music. One of them was Rómulo Huamaní Janampa, a.k.a. Qori Sisicha, a nationally famous scissor dancer from the Ayacucho area, who stated that someone should make a video clip.[34] The scissor dance is one of the key identity markers of "indigeneity" in the area, danced individually by at least two dancers as a kind of acrobatic battle between them. The writer José María Arguedas presents the scissor dancers regularly in his work as one of the "true" indigenous manifestations of the area. Scissor dancers also migrated to Lima, where they recreated their cultural role—cholificación. The scissor dancer is an integrated part in this type of celebration. In his last novel, Arguedas made Don Diego dance perhaps as a scissor dancer.

In 2013 the entertainer, television, and radio host Carlos Galdós played a one-man show in the theaters of Lima called "Cholo Power." It was about people like Franklin Sulca, who came to Lima to recreate his centuries-old culture in the city, inventing new entrepreneurship built on the traditions of and knowledge from the Andes. To promote his performance, he talked to newspapers, and one interviewer asked him: "Why Cholo Power?" "Well," Galdós answered, "I tell the audience we are a new type of human species, cooked by all the politicians of our country. Some thirty years now we have been preparing ourselves through one setback after another. We have had such bad governments, that today we can bear anything. The theory now says: 'the more you will be badly governed, the more you develop cholo power.' We see it work between us today because we are now a country with an incredible number of enterprising people."[35] Most economists agree today that this is true. In Lima the number of people entering the middle classes is growing, year by year but also bit by bit. There are many small businesses in the migrant neighborhoods of the city from where all kinds of products flow into the market. Increasingly, these artisanal, industrial, or artistic products bear the hallmark of Andean roots: form, colors, taste, sound, and so forth.[36] The color of Lima has literally changed, as has its sound and taste. The *cholos* are modern, new, and progressive—children of a New Peru. But if there ever was a *cholo* auto-imaged ethnotyping, Galdós's words are.

Another person who helped the Sulcas was the mayor of the San Juan de Miraflores neighborhood, Paulo Hinostroza, a.k.a. El Churre, a former football player. After a singing contest in the neighborhood, won by Wendy, he offered

34. Ibid., 63.

35. From the interview "Sin pelos en la lengua," *Diario La Primera* (October 6, 2013), at http://www.laprimeraperu.pe/online/entrevista/sin-pelos-en-la-lengua_151402.html (accessed 8/15).

36. Ypeij, "Cholos."

to be her *compadre* or godfather, arranging a place for her in a respectable secondary school. He also arranged a job for Franklin, now returned home from the Andes.[37] Wendy told a journalist that the first time she expressed a wish to sing as well, her father beat her up. Her mother had helped her out. It was a good decision because soon Wendy was winning local singing contests. One of the first prizes had been the filming of a video clip, but the producers were not too keen to work with an eight- or nine-year-old girl, apparently, because the filming of the clip only happened after Franklin's deadly accident with a *mototaxi* in April 2005.[38] Wendy had to perform to pay for the funeral. After Franklin's death, Lidia nearly died from a gallbladder operation gone wrong. In the meantime, Mayor Hinostroza paid for proper construction of the walls and roof of the house and offered Lidia a job. Lidia also fell to the task of taking care of Wendy's singing career. During this sad period, the Tetita video was shot, in Wendy's mother former residence, near Huacaña, in the Andean mountains to the south of the city of Ayacucho. Wendy's nephews performed as the band. Along the road they had filmed a cow with her calf. In the barn of the grandmother, they filmed the pig and her piglets. Filming the video, Lidia invited three women from the town to nurse their babies on a bench on the town square. After all, the song was about breastfeeding. In short, what the Sulcas wanted us to know is that the "tittie" had arrived quite innocently in the song.

Eventually, four clips were filmed in Huacaña: "La tetita," "Pobre soy," "Papito," and "Cerveza, cerveza." A DVD with twelve songs was recorded in Lima. Lidia sold about 800 copies in Wendy's neighborhood. Two years later, in 2008, it was her uncle who decided to post the Tetita video on YouTube— "to see what would happen." Soon this bit of the Huacaña-styled Lima migrant culture traveled across the world. Next, the uncle also decided to use footage of Wendy's father's funeral for another video. Wendy sang: "Daddy, why did you leave me when I was so young? Now I look for you everywhere, but I can't find you. I miss your kisses and your hugs. Daddy. Don't leave me!" In one of her other songs, filmed in her sandy and hilly neighborhood, she sings obviously from experience, but with a very charming smile: "I'm poor, so very poor. Because I'm poor no one respects me. My God, why is my life so sad? I'll keep fighting to become somebody in life."[39] At first, response seemed slow.

37. This paragraph: Sulca, *Verdadera*, 51–76.

38. The story of his death is told in chapter 5 of Sulca, *Verdadera*, 77–86.

39. This can be found at *Vice,* a documentary TV series on HBO, and the Internet-based Vice Channel, created and hosted by Shane Smith of Canadian *Vice* Magazine. It is a short documentary by Santiago Stelley, "Wendy Sulca: The Peruvian Youtube Prodigy," camera: Bernardo Loyola, James Parvin; editor: Jorge Duran, Paulo Padilha; VICE.COM, 12 min (2011),

Only after a few years did Wendy realize that she was a YouTube hit when schoolmates told her about the thousands of viewers. At the time, she had no computer at home to check it out.[40]

In May 2009 Wendy appeared on national television in the *El francotirador* (The Sniper) Sunday late-night talk show at the Frecuencia Latina network. During the period 2006–10 the show was hosted by journalist and writer Jaime Bayly.[41] Now sixteen, Wendy had matured. As an artist she was still wearing her typical folklore dress. Her video had become a global phenomenon, but Bayly had heard about the Tittie song for the first time in Buenos Aires, Argentina, he said, not in Peru. During the interview, Wendy was oozing self-confidence and ended her performance with a freestyle in Quechua. A few weeks later, in June, Wendy was the main guest of the program *Sábados tropicales* (Tropical Saturdays) of Panamericana TV, again self-consciously performing her song as "Queen of YouTube." Due to the active presence of the scarcely dressed and big-breasted host Karen Dejo, this performance undeniably gained a double meaning. Dejo realized it soon enough and felt visibly uncomfortable with her big-breasted posture before the camera next to the girl performing her innocent song. Dejo asked her why she still went for her mother's breast at her age. Well, Wendy responded, she preferred it to her mother's cooking—yet another explanation.

Because Wendy began her career on the Internet, most of her viewers were non-Peruvian. Reading the reactions, there is every reason to believe that Wendy owes her success to her innocent appearance and the ostensible bizarreness of the video in Western eyes, as if the world was laughing at her. Although they were not laughing at Wendy in San Juan de Miraflores—in Peru the Tetita video did not cause much of a stir; the girl seemed not out of joint at all—there are grounds to ask: Was Wendy's culture being made fun of? On the Internet, people were complaining about the rotten image of Peru, denigrating the country's folklore. On Twitter a series of trolling comments accompanied her videos. "I want to be taken seriously," Wendy told journalist Víctor Núñez in Madrid.[42] And to HBO Vice Channel filmmaker Santiago Stelley: "No matter what happens, we always keep going. My mom says that

VBS IPTV, LLC. On Vice at HBO, see http://www.hbo.com/vice/index.html#/vice/about/index .html, and for the Vice Channel, see http://www.vice.com/video (both accessed 2/14).

40. Many details mentioned in this paragraph also come from Núñez Jaime, "La niña cantante," *Milenio*, published at http://www.milenio.com/hey/Wendy_Sulca-cantante_peruana -Wendy_Sulca_en_Mexico-milenio_dominical_0_337766336.html (accessed 7/14).

41. *El Francotirador* aired in 2001 and between 2006 and 2010.

42. V Núñez Jaime, "La niña cantante que creció en YouTube," *Milenio*, published at http://www.milenio.com/hey/Wendy_Sulca-cantante_peruana-Wendy_Sulca_en_Mexico -milenio_dominical_0_337766336.html (accessed 7/14).

we should never give up and that we have to keep our heads high to get what we have always wanted."[43] No defeat.

Encouraging support came from singer Residente (René Pérez Joglar) of the high-esteemed Puerto Rican band Calle 13, from the Argentine singers Dante Spinetta and Fito Páez, and from the Uruguayan Dani Umpi. Today Wendy is a young woman performing covers of Madonna's "Like a Virgin" (1989) and Miley Cyrus's "Wrecking Ball" (2013), two rather naughty songs for this in-every-way obedient girl. Wendy has performed in clubs and on television in Spain, Argentina, Chile, Colombia, and Mexico. In 2014 Wendy Sulca collaborated with two Mexican producers, Pável Martínez and Luis Rivas, forming the Elektrpoppers duo, singing that she had changed into a more "hardcore" girl, "Me Pongo Hardcore."[44] The video was filmed in Mexico City, financed by Doritos Mexico, and displayed a much matured young woman in a rock outfit singing accompanied by a modern Western disco beat. To underscore the change, the room in the opening scene looked very similar to the one in the Tetita video. However, it was just a fancy dress party, because following Wendy's media performances it is entirely clear that if there are two Perus, on two sides of the Colonial Divide, her version did not incorporate the Western one. Her *cholified* presence now incorporated a more urban and wider Latin American self. As a self-confident insider to her own world, in *a spirit of independence and opposition,* Wendy went on, quite imperturbable, with her performances and video sessions year after year. This resilience interests me. This is probably one of the main things we might have learned about the Amerindian Cognitive Unconscious.

Support for this vision can be found in the comments on a video issued in April 2010. Wendy baffled the world again with an un-ironic camp performance in the video "En tus tierras bailaré" ("In Your Lands I'll Dance").[45] The video was made by three Argentine producers of Jewish background: Picky Talarico, who lives in New York (and usually works with Julio Iglesias, Juanes, or Nelly Furtado); and Gaby Kerpel and Daniel Martín, both from Buenos Aires, Argentina. The Buenos Aires advertising man Gastón Cleiman, along with Sebastián Muller, wrote the lyrics as "a song against prejudice." It has been his idea. Kerpel makes serious progressive music, among others as "King

43. Stelley's documentary, referred to above, "Wendy Sulca," http://www.hbo.com/vice/index.html#/vice/about/index.html (accessed 2/14).

44. At YouTube Doritos MX, https://www.youtube.com/watch?v=bTdxjL1vZkM (accessed 8/14).

45. Still to be found at http://www.youtube.com/watch?v=TuSSlFZ8cfA (accessed 10/13). The song has a *Wikipedia* page, "En tus tierras bailaré," http://en.wikipedia.org/wiki/En_tus_Tierras_Bailar%C3%A9 (accessed 10/13).

Coya" with singer La Yegros—they had a hit with the song "Cariño." Kerpel also performed regularly at the weekly Buenos Aires night club @Zizek Urban Beats Club, where young producers and DJs with new ideas in electronic dance music are given the floor. Kerpel's King Coya contribution to the progressive Latin American scene consists of a combination of Argentinian rhythms and melodies with *cumbias,* the *mestizaje musical,* or musical fusion. The three Argentines wanted to work with the Andean YouTube celebrities Wendy Sulca; her aging but surgically enhanced colleague Judith Bustos, a.k.a. La Tigresa del Oriente (who was about sixty-five then, "The Tigress of the East"—the *oriente* here is the Peruvian Amazon region near the city of Iquitos); and the Ecuadorian singer Delfin Quishpe, known as Delfin Hasta el Fin, or "Delfin All the Way Till the End."[46] The Argentines said they had recognized "something new that relies on authenticity" in their work. Furthermore, creator Cleiman, composer Kerpel, and director Talarico had recognized the "outsiders" position of the Andeans—because as Jews they saw themselves also as "outsiders" in the contemporary world, says *Salon* staff writer Irin Carmon; their wistful peering "in awe," and coming from "a country that has always held itself apart from Latin America."[47]

Carmon's 2010 article on "En tus tierras bailaré" suggests more unfortunate motives behind the production of the video. Director Talarico told her: "I have this concept of art as being when you manage to do something without your mind interfering, without being led by preconceptions and prejudices. For me, there's always an opinion, there's always self-consciousness. *I think these people don't have that.* So, I think they're *true* artists."[48] "After 200 music videos and 400 commercials, it was like an undoing," said Talarico. "A deconstruction." Carmon writes that Talarico recalled how pleased he was when Muller forwarded him YouTube comments "complaining that the video looked like the work of a beginner student, and a not very good one." Cleiman said he tried to "mimic the imperfect rhyming and simplicity of the singers' previous work": "I'm trying to remember a phrase of Pablo Picasso's—*It*

46. About his name, Delfin told the *Ecuador Times* why his parents named him Delfin, published December 17, 2011, at http://www.ecuadortimes.net/2011/12/17/delfin-quishpe-%e2%80%9ci%e2%80%99ll-always-be-an-author-and-composer-whether-people-like-it-or-not%e2%80%9d/ (accessed 2/14), that he is the youngest of four brothers, hence: "el del fin". (the one in the end). "My parents chose this beautiful name and I enjoy it every day."

47. Irin Carmon, "Viral Zionism: How an Israel-Promoting Web-video Phenomenon Bloomed in Latin America," *Tablet Magazine,* July 2010, http://www.tabletmag.com/jewish-life-and-religion/38292/viral-zionism (accessed 2/14). *Tablet Magazine* is a daily online magazine of Jewish news, ideas, and culture. Launched in June 2009, it is a project of Nextbook Inc. and online at http://www.tabletmag.com/.

48. Ibid.; italics added.

took many years for me to learn how to paint like a child.[49] The Argentine "adult" sees the Andean artists he would invite to sing his lyrics as "child-like"? Worse: Cleiman's partner Sebastián Muller, who studied film at Tel Aviv University, said to Carmon: "I feel they are doing something new that relies on authenticity." Discussing "the combination of authenticity, of pop-culture kitsch and the bizarre," he concluded that artists like Wendy Sulca, Delfin, and La Tigresa "haven't learned the rules of how to communicate with images. It's a kind of dogma without consciousness."[50] In their eyes Wendy is apparently not capable of making a correct "Western" video and was used by the jokers as a symbol of backwardness. In addition, Talarico stated that Wendy, Delfin, and La Tigresa made their videos in general "without her mind interfering," without self-consciousness ("I think these people don't have that"), "the work of a beginner student," but nevertheless, "something new that relies on authenticity."[51] The Argentines spoke about "honesty," "striving for a better world," and a "return to being childish." Wendy's world was different, playful, innocent, and therefore perhaps "better" than our own. Confirming the cognitive noble savage schema (CNSS), they suggest that if the *white* world is adult, Amerindian, or "indigenous" then Wendy's is indeed "childlike." Note that remarks like "without consciousness" and "without her mind interfering" sound a lot like Freudian thinking, as if the Andeans act directly motivated by their Unconscious, because they "don't have" a Conscious.

After finishing the video, the Argentine producers made themselves invisible. It worked. "En tus tierras bailaré" was received as a genuinely naive work. Calle 13's Residente affirmed this by calling the trio "the best line-up" he had seen on YouTube. "It is as if Madonna, Lady Gaga and Michael Jackson performed together." Furthermore, he saw the video as the "We Are the World" of YouTube. "This music comes from an honest heart striving for a better world," he concludes. "We should understand that the beauty of the theme lies in its misinformation, for which the performers are not to blame but the circumstances of life in Latin America. This is a message of love and equity."[52] Oddly, "En tus tierras bailaré" celebrates love for the land and people of Israel: "How pretty Israel is! Israel, in your lands one day I'll dance." The singers seemed completely misinformed about the situation in the Middle East and were perhaps used by the Argentine producers for this awkward promotion video. However, the three Andeans expressed that they were not misinformed

49. Ibid.; italics in the original.

50. Ibid.

51. Ibid.

52. Singer Residente of Calle 13 in *El Comercio* at http://elcomercio.pe/noticia/465296/ (accessed 8/10).

at all and demonstrated some hesitation in collaborating with the Argentines. Eventually, they had been won over by the argument that their new visual language is seductive and breaks the audiences away from prejudice, both against preconceived notions about Israel and their own Internet performances. Wendy, Delfin, and La Tigresa said they had little to do with the video, because, as they recalled, the idea had arrived in their e-mail inbox as did the lyrics and some instructions. They did not see much harm in its message of peace and love, they said. The three did not meet, because Talarico had ordered the tracks separately in Peru and Ecuador.[53]

The footage of "En tus tierras bailaré" was shot by local directors who were given only the loosest instructions in order to keep the "authenticity" high. Journalist Alma Guillermoprieto, known for her astute and well-informed observations on Latin American culture and politics, recognized the "authenticity" in a piece in *The New York Review of Books*. Uninformed about the true origins of the video, she writes: "Anyone who has spent a little time in the open-air markets on the outskirts of Lima or Quito, with their ramshackle array of used car parts and buttons, embroidered toilet seat covers, and chipped tin cups, will recognize the wildly enterprising spirit of the video's producers. Those who have traveled by car in those cities (or tried to cross the street) might feel that there is some of La Tigresa's bombs-away cheerfulness in Limeños' driving style. And anyone who has ever agonized over issues of cultural authenticity and the impingement of modern commercial values on ethnic traditions will be flummoxed at first by the juxtaposition of Wendy's stately sequined skirts with the wiggling sequined buttocks of La Tigresa's backup dancers."[54] Guillermoprieto concludes that the self-confidence of the three singers and their optimism can only be envied by the Western observer, baffled indeed as they are by the lyrics. These performers have lives "we can barely imagine (how much did the rural violence provoked by Peru's Shining Path guerrillas influence Wendy's parents' decision to migrate to the capital?);

53. See the discussion in Kalir, "Development"; also Carmon, "Viral," (link in note 47, this chapter). It should be kept in mind that there has been a strong link between Ecuador and Israel for decades. For many Ecuadorians, Israel is a migration country where they substituted Palestinian workers. Estimates from the Israel Central Bureau of Statistics and Kav La'Oved put the total number of undocumented migrants from Latin America at around 15,000, of which around 5,000 were Ecuadorians. For several of these migrants, despite all included hardships, Israel indeed had been a kind of Promised Land of well-paid labor. For Delfin's comments on the origins of the video, see http://www.eluniverso.com/2010/05/05/1/1378/delfin-quishpe-el -grito-me-identifica.html, and for La Tigresa's, http://www.eltiempo.com.ec/noticias-cuenca/ 39702-contina-a-el-a-xito-de-delfa-n-quis (both accessed 2/14).

54. Alma Guillermoprieto's suggestive article "What Is That Monkey Doing Behind the Rowboat?" is at http://www.mybook.com/blogs/nyrblog/2010/jun/09/what-monkey-doing -behoind-rowboat (accessed 8/10).

FIGURE 6.3. Wendy Sulca. Still from *Coach,* feature by Leonardo Medel, Chile, 2016.

they make choices that to us seem inscrutable (what is that monkey doing behind the rowboat?)." The video shows a "chaotic transformation of a culture that has always had an infinite and joyful capacity for self-invention." And she believes that "it is we who stand on the outside, peering wistfully at the screen."[55]

Knowing about the role played by Kerpel and Cleiman, these words are perhaps of little value anymore for an analysis of this video, but they are beyond any doubt all the more so for the Tetita video and Wendy's world more generally. Guillermoprieto had recognized Wendy's role in cholification, although it was difficult for her to grasp its essence, or even to name it. This is an indication that also Guillermoprieto was hostage to this dominant model of cultural interpretation, the CNSS. According to the CNSS, Wendy's world is not considered "indigenous," or *indígena*. This is curious of course, because Wendy's world is literally transplanted from the southern Peruvian Andes, where most of the people usually are classified as *indígenas*. Apparently, for most non-Amerindians the move from a rural town like Huacaña to the urban

55. Ibid.

surroundings of Lima has *de-indigenized* Wendy's family. Following the CNSS, the *indígena* is predominantly a rural dweller. For the Argentine producers of the "En tus tierras bailaré" video, the CNSS was basically encoded in Wendy's "childlike" being, and for them the urban-rural component was irrelevant. To witness diversity as crucial to *cholificación*, we may note that in Wendy's auto-imaged world, as the Tetita video witnesses alternating images from Huacaña smoothly with Wendy's home in Lima, the difference between town and city, this classical marker of Peruvian multiculturalism, is not made at all. Today, Wendy is an internationally popular singer, touring several Latin American and acting in television series and fiction films in Peru and Chile. Her performance in the Chilean movie *Coach* (2016) was generally acclaimed by critics (see figure 6.3).

5

The *cholos* in Peru share this spirit of independence and opposition with Amerindians in other countries. In Bolivia, for example, we recognize this self-confidence in a painting by Rosmery Mamani Ventura—sometimes signed Kurmi (Rainbow). In *Retrato de mi hermano,* or *Portrait of My Brother,* she depicts her brother Portugal Mamani Ventura as a veteran of the Aymara struggles in the city of El Alto (see figure 6.4). The background shows all kinds of references to the Aymara victory in the city, even in the country. We read "años de lucha" or "years of struggle," we see politicians of El Alto and a series of newspaper articles that refer to the new situation that exists since Evo Morales's rise to power. These images even take possession of the brother's leather jacket as if he is fully embedded in these Aymara struggles. The brother has his portrait painted as a modern type of activist, who has adopted—in this case: amerindianized—the symbols that accompany the engagement of these youngsters in the first decade of the twenty-first century. Another possibility is that he is a metal rocker, a true devotee of heavy metal. On his personal Face-book page he shows photographs of himself in rocker and in political dress; wearing T-shirts with the image of Che Guevara, for instance. There is also a photograph of the cap and the glasses he is wearing in the painting made by his sister.[56] In either case, the brother is not a traditional Aymara peasant.

56. Posted August 31, 2013; https://www.facebook.com/photo.php?fbid=234828226666498 &set=pb.100004179669975.-2207520000.1445349422.&type=3&theater. And: https://www. facebook.com/photo.php?fbid=228528050629849&set=pb.100004179669975.-2207520000 .1445349422.&type=3&theater (both accessed 10/15).

FIGURE 6.4. *Retrato de mi hermano,* Rosmery Mamani
Ventura, 2011, oil on wood, 100 × 80 cm.

Rosmery Mamani Ventura also painted a long series of more traditional
portraits of elderly people, poor Aymaras, and even representations of sym-
bolical thinking. For example, her work in issue 37 (July 2015) of the Bolivian
social science journal *Tinkazos,* published by the PIEB—Programa de Inves-
tigación Estratégica en Bolivia—in La Paz, is illustrated with twenty of her
paintings and drawings. The issue is dedicated to the publication of the multi-
volume General History of Bolivia, entitled *Bolivia, su historia* (2015; Bolivia,
Its History).[57] Interestingly, the *Tinkazos* volume discussing this important
national project—which was four years in preparation—acknowledges the
faces of the country as painted by this young Aymara painter from El Alto.
Three years earlier, in December 2012, the journal *La Migraña, Revista de
Análisis Político* (Migraine, Journal of Political Analysis), published by the
Bolivian vice-presidency, was illustrated with nineteen of her paintings and
drawings. However, while the cover of *La Migraña* shows us a smoking Old

57. Four volumes of *Bolivia, su historia* were published in 2015 in La Paz, by the Coordina-
dora de Historia and the daily *La Razón, el Diario Nacional de Bolivia.* The volumes were edited
by X. Medinacelli (pre–Hispanic Conquest), E. Bridikhina (sixteenth–seventeenth centuries),
M. L. Soux (1700–1825), and R. Barragán (1825–1925).

Kallawaya man—the Kallawaya are known as healers—*Tinkazos*'s cover shows Mamani Ventura's painting *Madre Tierra,* or *Mother Earth,* a reference to Pachamama, one of Bolivia's political key concepts in the legislation of environmental protection. The painting shows a pregnant Aymara woman, wearing local dress and a head full of flowers, looking at us with her hands on her abdomen, as if she is holding her child. Actually, we also magically see the child, shining through her clothing, lying on its front, sleeping, and covered up with maize leaves. Behind and around the woman are clouds, pigeons, and landscape. The painting is rather dark, as if she is waiting for sunset. These recent publications of Mamani Ventura's work by the Bolivian establishment are not only a huge recognition of a painter who once was very poor; her art is above all the very result of the Amerindians' emancipation in Bolivia.

It did not look like that in 1998 when Mamani Ventura and her family settled in El Alto. Born in the town of Cajiata at the banks of Lake Titicaca, she is of Aymara descent. In Cajiata she enjoyed a country life, guarding sheep and cows, fishing in the lake; catching pejerrey and trout, which her mother then went to sell in the city.[58] As is common with teenage girls from these towns, fourteen- to sixteen-year-old girls migrate to the city—in this case: El Alto—to work as domestic maids or in any other low-paying job, and to be educated. At the time, for the young girl the city exposed its wonders. El Alto has the country's major airport. There are many buses, microbuses, and cars. Like so many before her, and like tourists like me, she admired the city lights of La Paz below El Alto at the edge of the city. Mamani Ventura had several jobs, including kitchen help and nanny. In her spare hours, she went to school. This confirms the image of El Alto as an extension of its rural and semiurban hinterland. Like most rural migrants entering the city this way, she had not been very interested in art. However, after she got a good teacher in the visual arts, her future changed: "In his first class we did a pastel portrait, and that moment was amazing. Our first homework assignment was to do portraits, and I went home excited and did two drawings of Julia Roberts because the teacher said: go home and look for pictures with lights and shadows, and I looked through the paper and found something of Julia Roberts from a movie. I did the portrait, and it looked a little bit like her, and when I took it to the

58. This remark, as several more observations in this section, is from the interview "Drawing the Dispossessed: Bolivian Artist Rosmery Mamani Ventura," by Sara Shahriari, for *Indian Country Today Media Network,* published May 25, 2013: http://indiancountrytodaymedianetwork .com/2013/05/25/drawing-dispossessed-bolivian-artist-rosmery-mamani-ventura-149506 (accessed 10/15).

teacher he said 'It's really good,' and the other kids were all 'wow,' and I don't think I've stopped drawing since."[59]

When Mamani Ventura informed her parents that she would like to study the arts, they responded negatively: "You are going to die of hunger!" Hence, she did a few years of accounting at the UPEA. One night in 2005, lying contemplating in bed, Mamani Ventura decided to risk everything and study art at the city's Escuela Municipal de las Artes (Municipal College of the Arts)—a free education—where she became a pupil of the well-known watercolorist Ricardo Pérez Alcalá. This opportunity was part of the cultural politics of Mayor José Luis Paredes Muñoz, a.k.a Pepelucho (in office: 2000–2004), which also included the creation of the Municipal Museum of Art and the Municipal Symphonic Orchestra of El Alto. Hearing about her decision, Mamani Ventura's father said that she could do what she wanted with her life but that he would not support a career in art. Nevertheless, Mamani Ventura completed her studies in 2009 and immediately began to show her work in Bolivian galleries and museums. Today, known in Europe as well as in the United States and recognized with awards several times, she can live on her art, and she realizes that her family is proud now. "My mom goes to parties, weddings, and she says 'My daughter is an artist!'"[60] Interestingly, the parallel with Wendy Sulca's life is close. I believe there are many similarities between the Mamani Venturas in El Alto and people like Wendy Sulca, Magaly Solier, and Qarla Quispe in Lima. The latter are seen as *cholas,* the former as Aymaras. Wendy and Magaly speak Quechua with their parents or grandparents and Spanish outside the home. Rosmery and her brother speak Aymara natively but are fluent in Spanish, too. All live similar urbanized lives and enjoy and actively propagate and disseminate their Andean descent. Therefore, it is strange that the Mamani Venturas would be positively ethnotyped as *indígena* in the social media, the printed press, and the academic world, whereas Wendy, Magaly, and Solier would be negatively ethnotyped in these spaces. Their bodies are seen differently.

Like the migrant neighborhoods of Lima, El Alto was a migrant neighborhood of Bolivia's capital city of La Paz, founded some thirty years ago on the windswept puna highlands north of La Paz at an average elevation of 4,150 meters. In the early years of its existence, El Alto grew rapidly to more than 700,000 inhabitants—La Paz having 800,000—and more than doubled between 1988 and 2002; over half settled without running water or electricity. The migrants were coming from the Quechua and Aymara highlands and val-

59. Ibid.
60. Ibid.

leys in such numbers that they changed El Alto into a new Amerindian stage. The migrants cherish their roots in the traditional Amerindian towns of their origins—of their parents and grandparents—and took their cultural scripts, their schematic templates, including their norms and values, with them to the urban surroundings. In 2001 in El Alto, 74 percent identified as Aymara, and 6 percent as Quechua; in La Paz the figures were 50 and 10 percent respectively.[61] "Sixty-two per cent of the Bolivian population identified themselves as indigenous in the national census of 2001."[62] However, after almost two terms of President Morales's politics, the same self-identifying method resulted in a lower figure in the 2012 national census, when 41 percent of the Bolivians had self-identified as *indígena*, a decrease of 20 percent due to diminished popularity of the ethnotype among the middle classes.[63]

One of the most internationally known bands from El Alto is Wayna Rap, and one of its three original members, Abraham Bojórquez, expressed its rationale this way: "We sing about coca, about poverty. Our singing is revolutionary. We protest without marches or strikes. We do it through music, to reach as many people as possible."[64] He told the journalist and historian Benjamin Dangl that it all began at the radio station Wayna Tambo. Dangl sat down with Bojórquez: "We opened up a bag of coca leaves and began to talk about what he calls a new 'instrument of struggle.'"[65] Chewing on a few leaves, Bojórquez said, "We want to preserve our culture through our music. With hip hop, we're always looking back to our indigenous ancestors, the Aymaras, Quechuas, Guarani. [The rappers show] the reality of what is happening in our country. Through our lyrics we criticize the bad politicians that take advantage of us. With this style of hip hop, we're an instrument of struggle, an instrument of the people. [. . .] More than anything our music is a form of

61. Canessa, "Postcolonial," 150–51; Lazar, "El Alto"; Arbona, "Sangre."

62. Schilling-Vacaflor, "Bolivia's," 17n4. The figure is based on self-identity, not, as usual, on language—50.6 percent of the Bolivians had Spanish as their mother tongue. This means, nationwide, a distribution of 25 percent Aymara (although only 14 percent spoke the language), 31 percent Quechua (but only 21 percent mastered the language), and 6 percent belonging to thirty-one other Amerindian groups; this figure would be 66 percent if children are included.

63. Commentators disclosed the politics behind this, of course: discontent with President Evo Morales's policies. See the editorial "Por decreto Censal Bolivia no es más de mayoría indígena," *Pukara* 84 (2013), 2; or the article by W. Farfán, "Surge polémica por la identidad indígena hoy," in *La Razón*, August 4, 2013, at http://www.la-razon.com/sociedad/Surge-polemica-identidad-indigena-hoy_0_1881411946.html (accessed 9/13).

64. Forero, "Young Bolivians," at http://www.nytimes.com/2005/05/26/world/americas/young-bolivians-adopt-urban-us-pose-hiphop-and-all.html?_r=0 (accessed 10/15).

65. Benjamin Dangl, "Rapping in Aymara: Bolivian Hip Hop as an Instrument of Struggle," *Upside Down World*, September 11, 2006, http://upsidedownworld.org/main/bolivia-archives-31/427-rapping-in-aymara-bolivian-hip-hop-as-an-instrument-of-struggle (accessed 10/15). See also Dangl, *Price*, and *Precio*, 219–27.

protest, but with proposals. We unite, we organize. We look for unity, not division. We want to open the eyes of people with closed eyes. The music is a part of life."[66] The rappers and hip-hoppers had chosen to adopt or amerindianize the rebel warrior appearance and performance popular among Hispanics and African Americans in the United States. And rebels they were. In 2005 the memory of the 2003 struggles in Bolivia that rappers had participated actively in was still fresh.[67] In 2003 there were first violent confrontations in El Alto between the municipality and radical organizations and later between organizations and the state—El Alto played a key role in the Gas War of 2003 that eventually paved the way for Evo Morales's presidency.

At first I identified the brother in the *Portrait of My Brother* as an El Alto rapper. Dressed and positioned like this, the guy most certainly looks like a member of a band like Wayna Rap. Without any problem, the brother could participate in the video of their wonderful songs "Revolución Kaltasky" or "Chamakat Sartasiry."[68] Since hip-hop exploded onto the youth scene in the United States in the 1970s, the art form has been associated with gangsters, fighters, and warriors—violent behavior to pursue their aims. These aims usually can be found in oppositional and social justice causes. From the United States, it spread out over the world as a weapon of the weak, as a voice of the subaltern, especially of the excluded urban youth. For over a decade, El Alto has been host to a flourishing politically charged rapper and hip-hop culture. Journalist Juan Forero wrote in 2005: "El Alto—a flash point for protest and the capital of indigenous Bolivia—is seething, and a growing number of young Aymara are expressing their anger in a hard-driving rap, complete with rapid-fire lyrics excoriating Bolivia's leaders and venting about the dire social conditions of the country's [Ameri]ndian majority. Adopting the trappings of American hip-hop, young Aymara wear baggy pants and baseball caps and strike the pose of urban America, hand signs, cocky talk and all."[69] According to social anthropologists Rocio Ramírez Ballivían and Linda Herrera, hip-hop raps in El Alto are more than just an art form adapted from the United States. The youngsters have learned to narrate their life histories, criticize local circumstances and the politics of the state, and offer solutions and alternatives of behavior, consciousness, and attitude. Therefore, Ramírez Ballivían and Her-

66. Dangl, "Rapping in Aymara" (link in note 65, this chapter).

67. Dangl, *Precio,* 219–23; Lazar, *El Alto,* 19–21.

68. Wayna Rap, "Revolución Kaltasky," https://www.youtube.com/watch?v=22HonqaXji4; and "Chamakat Sartasiry," https://www.youtube.com/watch?v=lmIf_NXFHJo&feature=youtu .be (both accessed 10/15).

69. Juan Forero, "Young Bolivians Adopt Urban US. Pose, Hip-Hop and All," *New York Times,* May 26, 2005, available online at http://www.nytimes.com/2005/05/26/world/americas/ young-bolivians-adopt-urban-us-pose-hiphop-and-all.html?_r=0 (accessed 10/15).

rera see them as public pedagogues of the street.[70] Seen through the lenses of the El Alto hip-hoppers and rappers, the portrait of Rosmery Mamani Ventura's *Brother* might also have been an instrument of struggle. To underscore the idea of art as an instrument of struggle—of emancipation—it goes without saying that her paintings participate. From that perspective I suggest that we call Rosmery Mamani Ventura's brother Don Diego.

6

Now comes a more tentative and speculative part, although most observations are stooled on solid research. First question: What is cholification? To recapture the ideas discussed so far: cholification is motored by the urbanization of the former rural population in Peru, not unlike *mestizaje* in Mexico after the Revolution of the 1910s and similar developments elsewhere on the continent (*mayanización* in Guatemala, for instance), and it consists of the implication of Amerindian cognitive schemas—adapted to the new surroundings. Because of the developing social and economic position of the *cholos, mestizos,* and *indígenas,* who embody cholification, the struggle against exclusion on the basis of economic and social grounds intensifies. Next to the remnants of Spanish rule, especially the heritage of the nineteenth and twentieth centuries, internal colonialism and its immanent racism has become a target. Because the Amerindians share the history of colonization and form a mnemonic community based on this, cholification is also built on cognitive schemas that feed an attitude of nondefeat, of caring and being cared for (remarkably usually in the form of cooperatives[71]), of motivating communities, of believing in cyclical time and the crucial involvement of intervening agents. And of course, the *cholos* brought with them their music, dancing, fiestas, dress, colors, and so forth, which today are conquering the streets, radios, concert halls, and, above all: television—in news shows, gossip shows, and soap operas. The *way to do things* in Lima is changing; cognitive schemas are being attuned.

The question now is: can cholification be identified as a social movement? At first sight, the idea of a "cholification movement" is difficult to reconcile with Mariátegui's or Flores Galindo's socialist utopia. Problem is, these utopian times seem over. Seen from a cognitive stance, a social movement looks very much like an embodied cognitive schema, whereas an uprising, rebellion, or revolt is the spitting image of a script. From this position, the

70. Ramírez Ballivían and Herrera, "Schools."

71. De Waardt and Ypeij, "Peruvian."

Zapatista uprising of 1994 followed a schematic template—indeed, the intervening agent script, or IAS—while the period since the Peace Accord of San Andrés in 1996 follows a social movement schema, or SMS, deeply influenced by Subcomandante Marcos and his collaborators. The SMS is also more of a schematic template than a script but may contain scripts for uprisings and actions; it basically captures a way of thinking, even a way of life, of the many people involved. The Zapatistas' shared cognitive mental representation, based on real or imagined knowledge of them, their lifestyle, dress, narratives, wall paintings, and behavioral codes, are taught to the visitors who participate in the Zapatista Escuelita or Little School. They learn that a new society based on communal lands, local culture, gender equality, cooperative self-defense, resources for all, and above all dignity is possible.

This is not to say that the moment of active activism during 1994 was merely an uprising. Different from the CCRI's intervening role, the EZLN proclaimed to fight for a socialist revolution in Mexico. Like Mariátegui, they belong to the first level of social movements. This was made up of the old social movements of the socialists, communists, and anarchists of the late nineteenth and early twentieth centuries. In their heyday, especially after the Second World War, their members influenced governments and national politics. In the West, they were incorporated little by little into mainstream establishment governing circles. Curiously, this took place during the same period of modern colonialism, the age of modern imperialism; and the first level of social movement's demise, ending in co-optation, occurred at the same time as the last decade of international colonialism. During that period, the late 1980s, in the Americas social movements from below were fighting for land reforms and a politics of "positive discrimination" in favor of Amerindian and Afro-American populations. In Latin America, Asia, and Africa, the decline of these first-level movements began after the dictatorships and authoritarian rule of the 1980s. The EZLN uprising took place during the aftermath of this period.

However, already in the 1980s and 1990s, a second level of social movements was set in motion. This movement can best be seen as "identity politics." Eventually, in the West it followed the same track of developing from oppositional movements into established parties, sometimes with responsibilities of government as in Bolivia and Ecuador, for example. Their co-optation means that by the beginning of the twenty-first century, identity politics also had become mainstream, conservative, and hegemonic. This one culminated in Latin America in our times into the establishment of multicultural and plurinational states, recognizing the constitutional rights of indigenous populations. Although the Zapatistas did not receive these rights, their demands of

autonomy and "indigenous citizenship," is typical of this second-level type of movement. Like the first level, the second had been typical of the governments of nation-states, perhaps even of the parliamentary nation-states. They had direct interactions with the political systems in the countries, concentrating on influencing politics directly as much as they could. This meant that they needed to be well organized institutionally and work with a recognizable leadership for negotiations. Many of these social movements turned themselves into political parties, and their leaders became politicians. Often, the social movements bridged the gap between the government and the people to avoid revolutions that would turn the system upside down. In short, the ruling elites need this type of social movements.

Cholification cannot be identified with one of these two movements. Interestingly, this is what it shares with what might be seen as the third level of social movements. In 2011 a collective of third-level activists published *Moments of Excess: Movements, Protest and Everyday Life,* an insiders' collection of texts on a different version of globalization and the slow creation of what came to be known as the Movement of Movements, or MoM. This movement began with the Stop the City protests and the Global Street Party during the twenty-fourth G8 summit in Birmingham, England, in 1998, followed by the J18 Carnival against Capitalism in London directed against the twenty-fifth G8 summit in Cologne, Germany. Important also were the WTO Seattle meeting in November 1999 and the antiglobalization protests in Genoa and Gothenburg in 2001. Furthermore, of crucial significance was Occupy in the early 2000s. This created an emerging worldwide network of activists against neoliberal globalization, the destruction of the commons, racism, and sexism.[72] These actions had been like scripts but were parts of a schematic

72. Holloway, *Change*; Schechner, "Occupy"; Chomsky, *Occupy*; Gitlin, *Occupy*; Juris, "Reflections"; Mitchell, "Preface"; Calhoun, "Occupy"; Linebaugh, *Magna* and *Stop*; and Haiven, *Crises*. Occupy "did not spring into being spontaneously," says sociologist Craig Calhoun, "Occupy," 28, it just profited from a momentum. Inspired by the Greek and Spanish anticorpocrats on Athen's Syntagma Square and Madrid's Sol, the Canadian AdBusters Media Foundation organized a demonstration in Wall Street, New York, on September 17, 2011, which described the new tactic as "a fusion of Tahrir with the *acampadas* of Spain." Oleg Komlik, "The Original Email That Started Occupy Wall Street," *Economic Sociology and Political Economy,* published December 14, 2014, at https://economicsociology.org/2014/12/27/the-original-email -that-started-occupy-wall-street/ (accessed 12/15), and the quote from AdBusters online journal, "#OccupyWallStreet," http://www.adbusters.org/blogs/adbusters-blog/occupywallstreet .html (accessed 11/12). In fact, several organizations and networks experienced by years of mobilizations against corporate-dominated forms of globalization had found their way to Wall Street. The protesters built up a camping site in the Zuccotti Park, Lower Manhattan, New York. The hacker collective Anonymous is said to have spread the word of the event and thanks to them the Guy Fawkes mask was chosen as the movement's major symbol. As most of us still know, it was part of an international wave of mobilization including a series of similar protests,

template for daily practice for the activists of establishing the parameters of a new way of life. Crucial is the attitude of creating a world of dignity and humanity without taking power.[73] Over the past decades, critics argue, the Left has found its "inner force" again after years of seeing the Right celebrating the "end of history."[74] All around the globe groups with new radical imaginations came into action. Have we found Elmo's child?

We should not forget the influence of the sudden emergence of Movimiento 15-M in Madrid. Spain had been hit hard by the financial crisis of 2007–8, and frustration with corrupt politicians and far-too-greedy bankers had run high. The participants—the *indignados* or indignant—occupied the streets of Madrid on May 15, 2011, significantly on the eve on regional and local elections. The protests were directed toward the involvement of the European Union with Spanish politics, toward corrupt Spanish politicians, and the lack of political transparency. They ended up occupying Madrid's central plaza Puerta del Sol, where they began a series of popular meetings. Under the banner of "Democracia Real YA!" or "NOW Real Democracy!" the participants came up with a series of propositions to reform Spain into a more open, democratic and egalitarian society, largely disconnected from the influence of the international banking system. Thus, the 15-M expressed more than simple rejection of a system. "This is something intellectuals like Zygmunt Bauman could not see, but which was obvious for anyone present,"[75] writes Spanish philosopher and writer Amador Fernández-Savater. "Within days we were not there only to scream out our indignation, but for the beauty and power of being together, showing how to do something together for the

Occupy camping sites, and other manifestations and performances in public spaces worldwide. "That there was a world-wide wave of protests gave added weight and significance to each," Calhoun concludes. The Guy Fawkes mask "has now become a common brand and a convenient placard to use in protest against tyranny—and I'm happy with people using it, it seems quite unique, an icon of popular culture being used this way." Says illustrator David Lloyd, a British graphic novel artist who created the original image of the mask for a comic strip written by Alan Moore. See Rosie Waites, *BBC News Magazine*, "V for Vendetta masks: Who's Behind Them?" October 20, 2011, at http://www.bbc.co.uk/news/magazine-15359735 (accessed 4/14). Guy Fawkes, of course, was a sixteenth-century British rebel who plotted to blow up English Parliament and kill the king.

73. Holloway, *Change*, 20.

74. This was after Francis Fukuyama's book *The End of History and the Last Man* (1992), about the triumph of the liberal parliamentary democracies in Europe. However, Fukuyama's suggestion that no other system was possible and that Leftist politics would be defeated always was contradicted with the recognition of the rapidly growing income gaps in many countries where the liberal democracies prevail.

75. Fernández-Savater, "Nacimiento," 676–77 (quote); Lara, "Virgil Starkwell"; Moreno-Caballud, "Imaginación." Zygmunt Bauman was a Polish-British sociologist-philosopher who used Freud's Death Drive to explain almost everything in the world.

common cause."[76] The participants experienced the 15-M meetings as a course in democracy in the open air. It spread out over Spain, and then Europe. Eventually it reached Wall Street. For Fernández-Savater it meant the birth of a new social force.

As before, also the first goal of the third level of social movements is greater equality and social justice for all. But this time it sets in against the so-called 1 percent. Most of us will be familiar with the Occupy slogan: "We are the 99 percent." This problem burdens the present. My own country is an example. The richest 1 percent of the Netherlands owns almost a quarter of the total capital here (2012). Because in 2008 this capital had "only" been about 20 percent, the rich have profited strongly from the crisis.[77] Status competition, one of the driving forces behind the vertical social system, drives "a great deal" of consumption, say Richard Wilkinson and Kate Pickett in their plea for greater equality, *The Spirit Level* (2010). Reading Robert Frank's book *Falling Behind* (2007), with its instructive subtitle *How Rising Inequality Harms the Middle Class,* they conclude: "For most of us it probably feels less like being competitive and more like a kind of defensiveness: if we don't raise our standards, we get left behind and everything starts to look dowdy, shabby and out of date. [. . .] What really makes the difference is what [the rich's] purchases say about them relative to the rest of us."[78] It also reduces the satisfaction with what the "rest of us" have, "by showing it up as inferior—as less than the best."[79] "The consumer has triumphed over the citizen," British sociologist Colin Crouch says.[80] Rising inequality in the United States and Britain came with long-term decline in savings and a rise in debt. Due to increased pressures to consume, saving less and borrowing more, families fell into bankruptcy, and the middle classes began experiencing a downward spiral.[81]

The second goal of the third level of social movements is to create connectivity by being together. The MoM exists as a wider network but organizes events, which include marches, occupations, and even riots; it also organizes meetings, exchange information, and comments on Facebook postings. The "movements" of the MoM may take a range of actions, from moderate to radical. They may act locally only or travel from event to event with what they call the Caravan of Activists. The MoM is what Paul Hawken, an envi-

76. Fernández-Savater, "Nacimiento," 676–77.

77. See http://www.volkskrant.nl/vk/nl/2680/Economie/article/detail/3633892/2014/04/12/Rijkste-1-procent-bezit-bijna-een-kwart-van-alle-vermogen.dhtml (accessed 4/14).

78. Wilkinson and Pickett, *Spirit,* 226–27; also Frank, *Falling,* viii–ix.

79. Wilkinson and Pickett, *Spirit,* 227; also Layard, *Happiness.*

80. Crouch, *Post-Democracy,* 49.

81. Wilkinson and Pickett, *Spirit,* 228–30.

ronmentalist, calls the "largest movement in the world." In his *Blessed Unrest* (2007) he describes how it came into being and why no one saw it coming.[82] Almost unrecognized as social movement but with the potential to improve the planet, the MoM functions without charismatic leaders and follows no unifying ideology. Nevertheless, whatever their differences, the participants in the MoM share the ideals of general equality, social justice, a sustainable economy and the protection of the environment, and they are willing to stand up to large corporations and nation-states if necessary. The members of the MoM adjust their lifestyles to include more sharing and to privilege common approaches to solutions. In a way, the MoM operates as an interaction ritual chain, which is a *doing* by people who share a place, a moment, and an action and who create emotional energy (EE) while doing it.[83]

The third goal of the third level of social movements is to act with the present in mind; better now than later. Media theorist Douglas Rushkoff recently said that shortly after the turn of the present century the leaning toward the future became more of standing up into the present. "People stopped thinking about where things were going and started to consider where things were."[84] In the financial world, connected with a downward spiral of the markets, an investment's future value began to matter less than its current value. The transformation was profound. The first and second levels of social movements were the ones privileging the long term. With other "isms"—including Protestantism, fascism, utopian messianism, and late twentieth-century freemarketism—they built their actions on a narrative that did not promise any successes in the short term but a revolution with equality for all in the long term. Strict disciplined behavior according to a hierarchized power structure and leadership and usually a "book" with instructions to follow meant hardship along the way to "liberation," including all kinds of violence against enemies—real or fictitious—and dissidents. The "isms" promised to end the sufferings of today, which were all too real, and liberation, salvation, peace and happiness somewhere "tomorrow."[85] This, Rushkoff concludes, has lost its credit today. The "end" as more wealth, more democracy, an egalitarian society, redemption from sin, or speaking out your desire, is being amputated from the schematic narrative templates. The *past → present → future* template is giving way to *past → present* narratives. Presentism triumphs, as a *doing*.

There may be a fourth goal of the third level of social movements in the making: commoning. Back to the "commons" means away from "enclosures,"

82. Hawken, *Blessed*.
83. Collins, *Interaction*, 7, 47–64.
84. Rushkoff, *Present*, 10.
85. Ibid., 12.

away from the privatization and commodification of the world. For a series of theorists of this third level of social movements, looking for prospects for a "new society" built on these experiences and developments—the sustainability in a posteviction phase—the EZLN's Subcomandante Marcos's writings appear to be critical. For example, historian Peter Linebaugh stated that he wrote his influential book on the history and relevance of the commons, *The Magna Carta Manifesto* (2008), because he thought Subcomandante Marcos referred to the *Magna Carta,* the Great Charter of Liberties agreed upon between King John of England, the Archbishop of Canterbury, and a group of rebel barons in 1215. Although Linebaugh soon realized that the Mexicans referred to the constitution of their country as the *magna carta,* Subcomandante Marcos's insistence on the two "winds" of contemporary societies prompted him to proceed with his project.[86] The "wind from above," consisting of the forces of the rulers and the elites, was sucking out the resources and life force from the "wind from below," made up by the workers and the peasants. Linebaugh read in these words that the Zapatista resist the attack on the commons or, as usually agreed, the attack by private property and privatization of resources of all kinds, natural and cultural. This wave of privatization of the late twentieth century and the first decade of the present century was coined in style: the new enclosures.[87]

Most social and political movements are utopian in a way—they adhere to a "new myth"—and in the Occupy inversion this displayed better working conditions, more equal sharing of work and capital, proper salaries that could make corruption unnecessary, dignified quality education also directed against greed, a world without xenophobia, tearing down the "walls between individually kept gardens" to improve solidarity, and full participatory democracy. "End the Wars and Tax the Rich!"[88] Occupy Wall Street has developed into this new mnemonic community. Manifestations, encampments, and other performances by Occupiers were multiracial, eventually also multigenerational, multigender, multisexual, and, as Angela Davis expressed enthusiastically, "multi-everything,"[89] in short: a celebration of *diversity.* The state reacted by surrounding the sites by police and quarantining them. Most occupied sites were eventually closed by force, but the participants are convinced that its spirit lives on in social networks like Facebook, YouTube, and especially Twitter. "Its most important impact may lie in culture not movement organization. It may lie in readiness to look seriously and critically at inequality and at the

86. Linebaugh, *Magna,* 1–2.
87. Linebaugh, *Stop,* 143.
88. Juris, "Reflections," 259.
89. Davis, "On Occupy," 76.

question of whether actual democratic institutions are really working. It may lie in changing, at least a little, what people think is possible."[90] For sociologist Jeffrey Juris, "the recent shift toward more decentralized forms of organizing and networking may help to ensure the sustainability of the Occupy movements in a posteviction phase."[91] A Google search still yields hundreds of millions of entries.[92]

The project is building the alternative. Although public media sometimes complained about the lack of a political program, the Occupiers expressed that this could be found in the inversion of their grievances and the way they expressed themselves. In art, for example. Note what the philosopher and activist Angela Davis says:

> Art drives movements for radical social change. Art helps us to find our way into new dimensions. Art helps to give expression to what might be considered impossible in the world that is. It shows us the possibility of a new world. Art helps us to negotiate our way through dimensions that we cannot yet articulate in the kind of expository language that we use. . . . There are no clear demands. But I don't think there should be any demands right now. [Consider] the connection with Egypt—Cairo and Tahrir Square. I was reading a message that came from participants in that movement, and there was something very moving in that message. It said, [people ask] what are our demands? But there's no one left to [ask demands of]. There's no one left to ask for reforms. And so, therefore, we have to create that which we would like to see in the future. We have to create what we want, as opposed to asking somebody else to give it to us.[93]

For many participants, a fifth goal of the third level of social movements would be to stay outside the enclosures of official politics. From radical to moderate, the activists do not want to be co-opted by institutionalized second-level social movements or official political parties. It is worth recalling here the popularity of *Change the World without Taking Power* (2002), by the Mexican-based Irish sociologist John Holloway. Holloway had read, again, Subcomandante Marcos's interventions. In due course since 1994, during his

90. Calhoun, "Occupy," 37–38.

91. Juris, "Reflections," 259, abstract.

92. Schechner, "Occupy"; Chomsky, *Occupy*; Gitlin, *Occupy*; Juris, "Reflections"; Mitchell, "Preface"; Calhoun, "Occupy."

93. Davis, "On Occupy," 76; brackets in original because the article is an edited excerpt from an interview. Memory is short: of course, Tahrir Square refers here to the plaza in central Cairo as the focal point of the 2011 Egyptian Revolution against former president Hosni Mubarak, when over 50,000 protesters first occupied the square on January 25.

reborn life as Zapatista speaker ("reborn" because he did not die in 1994, he said), Subcomandante Marcos tuned in to the emerging theoretical debates on social movements. As far as I can judge from recent literature, he not only succeeded but was also able to guide it in certain directions. Orive Berlinguer's (Maoist) teachings of full participation of all eventually turned into the idea that the state as a top-down working institute has had its time. This was a blow to the typical Latin American legalism which prescribed to revolutionaries and other politicians that the state must be conquered first in order to issue decrees and legislation that would change the world. Subcomandante Marcos and his team argued that this position did not work. The world cannot be changed top-down but by general consent only. This stance is supported by Subcomandante Marcos's arguments supported by jokes, stories for children, and celebrations full of dancing. His texts and presentations broke away from the serious reasoning of the leaders of the first- and second-level social movements. He sacrificed the narratives of the "isms" for the celebration of the present. The compelling perspective of *past → present → future* is left behind in the "offices" of Subcomandante Marcos in the Lacandón. The "possible other world" must be *today*.

Because of the assumed and by many recognized poor state of participation in current parliamentary democracies and other countries around the world, theorists began stipulating that taking power in the form of getting elected to government or by revolution could be avoided as a goal per se because recent history has made clear that these attempts could be doomed to reproduce violence, exploitation, and oppression. Holloway: "This, then, is the revolutionary challenge at the beginning of the twenty-first century: to change the world without taking power. This is the challenge that has been formulated most clearly by the Zapatista uprising. The Zapatistas have said that they want to make the world anew, to create a world of dignity, a world of humanity, but without taking power."[94] A revolution against (neo-)liberalism can only be successful, Holloway thinks, if the revolutionaries avoid the seizure of state apparatuses and instead live a life of abject day-to-day refusal of (neo-)liberal society. For many theorists this offered a door to new theorizing about alternative activist politics. In his *Crises of Imagination, Crises of Power* (2014), media scholar Max Haiven elaborates on this position, once more referring to the pioneering work of the Zapatistas. The new utopias should be found as a form of "exodus" from neoliberal capitalism, not by an explosive revolution but by a walking away from exploitation and enclosures. The idea is from Sub-

94. Holloway, *Change*, 20.

comandante Marcos: we must "think while we walk."[95] The Colonial Divide so made conscious by the Zapatistas had been included in the worldwide third level of social movements, the MoM, to do away with the new enclosures of the endless privatization of the commons. And correctly so, because the latter is the outcome of a long history of capitalism and colonialism, first within Europe and then all over the globe. This might be the answer to the question of *colonialidad.*

But can we include cholification in the MoM? Speculative question. Looking at the five goals above, we recognize a deep wish for greater equality and social justice for all, especially worded in the *cholos*'s and *indígenas*'s fight against negative ethnotyping. Cholification is about opportunities for all, with full cultural diversity but without legal boundaries. The recent past has demonstrated that the *cholos*'s protests against ethnotyping underpins that they have no time to lose, wanting quick results, making their actions presentist. There is also no need to doubt *cholos*'s wish to create connectivity by being together, although they do not march as *cholos,* protest, or occupy—although there have been quite some antiracist stirs and an occasional public gathering in protest. Networking, however, especially through the new media is critical today. But based on this criterion alone, few theorists of the first and second levels of social movements would be prepared to look at cholification as a movement.[96] Nevertheless, the LGBT, the feminist, and the environmental movements worldwide have been working along similar lines as the *cholos* in Peru today: demanding sustainability, cultural recognition, equal rights, and social justice. Seen from that stance, we may expect second-level social movements of cholification soon, headed by NGOs or political active groups. However, most consciousness-raising activists of cholification, like Claudia Coca, Tula Rodríguez, or Qarla Quispe, may opt for changing the world without taking power. In this sense, the paintings discussed in this book incite to action. They inspire to direct action; or to create a simulation in the mind; and to change the world today, while living (*doing*), and not waiting for the future.

Deeply rooted in the present, the thinking of the people forming the third level of social movements is directed toward a doing, preferably today. Their utopia, Elmo's child, is action in the present. It is no longer supported by some sacred text or narratives of liberation. They build communities where they can, but, contrary to Mignolo's M/C Project, without a "return of the repressed." Directed against the greed of the 1 percent, the movement's ideol-

95. Haiven, *Crises,* 161 and 246.

96. Although there are politicians in parliament who self-identify as *cholos,* most people would stay out of politics based on ethnotypes if only because a short while during his dictatorship former president Alberto Fujimori was associated with cholification.

ogy has much in common with the moral economy of provision as worded by historian E. P. Thompson in the 1960s.[97] For a long time the moral economy of provision—against greed!—as a "latent moral economy ethic" was studied in the context of riots and rebellions only. The ethic provided the motivation for class struggle, and even today this is the background of the actions against the 1 percent. However, it is not necessarily a movement against capitalism per se, as in Mignolo's utopian modeling. Personally, I believe that Miyagui's *Looking for Elmo's Child* points to the motivation and actions of the movements involved in the third level of today. It is here that we find the Amerindian Cognitive Unconscious in use for a present solution—including the intervening agent, the stimulus of bringing the world in movement against racism and to tear down the walls of the Colonial Divide—with the "audience" in the "theater of the mind" actively directing their "actor in the spotlight." In the preceding chapters I have tried to demonstrate how this works.

Thanks to the EE of the interaction ritual, the movements are embodied and encoded into several cognitive schemas, thereby creating simulations for future action. Once you have been in a movement like this, it will not leave you. Whether we agree about cholification as a social movement or not, the people involved do increasingly self-identify as *cholos,* react with approval to complaints about negative ethnotyping—which strengthens their bonding as *cholos*—and feel associated with people like Wendy Sulca, Tula Rodríguez, or Grupo 5 who have success; or with a consciousness-raising pro-MoM art like Claudia Coca's and Jorge Miyagui's. There might be a Cholo Cognitive Unconscious. In Peru, people of Andean descent behave like the backbenchers of the LGBT movement and the feminist movements: they are *cholos,* they share a common background (Native American origins), whether they like it or not, and you read and hear all over Peru that they should be proud of themselves.[98] In his classic *The Body in the Mind* (1987), the philosopher Mark Johnson says that an identity like this is never "only a matter of reflection, using finitary propositions, on some preexistent, already determinate experience."[99] On the contrary: *"understanding is the way we 'have a world,' the way we experience our world as a comprehensible reality.* Such understanding, therefore, involves *our whole being*—our bodily capacity and skill, our values, our moods and

97. Thompson, *Making,* 68–73, and "Moral"; also in *Customs.*

98. See, for a recent action, the PROMSEX (Centro de Promoción y Defensa de los Derechos Sexuales y Reproductivos) campaign against sexual and racial discrimination, voiced by cholos and not by Euro-Peruvians, as would have been the case a decade ago, published on their Facebook page https://www.facebook.com/promsex/videos/10155075532884127/ (accessed 2/17).

99. M. Johnson, *Body,* 102.

attitudes, our entire cultural tradition, the way in which we are bound up with a linguistic community, our aesthetic sensibilities, and so forth. In short, our understanding *is* our mode of 'being in the world.'"[100]

7

This is where we are at the end of this book. The book defends the hypothesis that we recognize an Amerindian mnemonic community in the Spanish American region, which is founded on shared social/cultural memories encoded in cognitive schemas. Of course, we share many, many cognitive schemas as humans all over the world, and also in geographically bounded groups ("communities"). Over Latin America, with its huge geographical and cultural differences, diversity prevails. The ethnotype of *indígena* or *mestizo* in Mexico is not a replica of that of *indígena* or *mestizo* in Guatemala, Ecuador, Peru, or Bolivia. Nevertheless, we can also make generalizations; as, by the way, happens constantly in using ethnotypes like this all over the continent in a similar way. The category of *Amerindian* has been privileged throughout for a wider population than simply *indígena, mestizo,* or *cholo.* First, and most important, because as a mnemonic community Amerindians share a past in their biological and cultural genealogy that includes pre-Hispanic times, the three centuries under Spanish rule, and almost two centuries of internal colonial relationships. The latter include racism and exclusion on the basis of real or supposed geographical and genealogical origins. This is due to the Colonial Divide, which made possible all kinds of exploitation but also, under Spanish rule, the *república de indios,* with its semiautonomous *pueblos de indios.* The Amerindians also share a spirit of nondefeat and independence from and opposition to the formerly colonizing elites. This confidence is, among other things, rooted in the cognitive schema of a cyclical view of time, which influences a trust in the character of the intervening agent and a spirit of reciprocal exchange. Another feature is the idea of *doing* and becoming in community matters and the process of creation.

This is just a small selection of typical cognitive schemas active in what we may think of as an Amerindian Cognitive Unconscious. Contrary to Mignolo's belief in a Dynamic Unconscious—which is not founded on scholarly evidence or theories—the Amerindians do not need therapeutic assistance to "recall" their spirit of community into consciousness. That spirit has never died anyway—"repression" is a nineteenth-century romantic myth—and

100. Ibid.; italics in original.

encoded in their cognitive schemas motivate their actions on a daily basis. Going over Latin American history we may recognize the cognitive noble savage chema, or CNSS, in the activities of people living at the colonizers' or former colonizers' side of the Colonial Divide. The many errors of the CNSS warrant a separate discussion in another book, but we saw that the Amerindians never were only rural dwellers; most of them lived and continue to live in urban worlds. They were also never egalitarian as in the Western Paradise, because they share with the vast majority of human societies a tendency to social and political hierarchies. They do realize, of course, that as long as the Colonial Divide exists they do not live in the "center" of time, power, and wealth but in the "corners." Interestingly, there seems to be a confidence that time will turn into their advantage. The elites in the center will lose legitimacy, lose their power to keep the entire world turning (also seen as community), and must leave their place on the throne to make room for some group from one of the corners; or from all groups in the corners. This "upside down," or *pachacuti* in Quechua Peru, will bring a new era but includes everything learned from the past. It will not be a revival of a pre-Hispanic, precolonial culture. But as Rivera Cusicanqui expressed—"To speak about 'demolition' instead of 'deconstruction,' and 'anticolonial' instead of 'decolonial'"[101]—the center will need to break down their (colonial) institutions and make room for new ones, set up by the new power holders. This Amerindian takeover may favor the idea of setting the community or society in movement but is not automatically egalitarian or anticapitalist. Although multicultural politics of identity is still important in national politics and must be rewarding for the populations who prefer to self-identify as "indigenous," it is above all the features of an Amerindian Cognitive Unconscious that are included in the Cognitive Unconscious of *colonialidad*.

101. Rivera Cusicanqui, "Potosí."

FILMOGRAPHY

Amador. Directed by Fernando León de Aranoa; written by Fernando León de Aranoa. Spain: Reposado Producciones, Mediapro, 2010.

Ángeles caídos. Directed by Joaquín Ventura and Felipe Degregori; written by JADAT. Peru: JADAT, 2005.

Blackthorn. Directed by Mateo Gil; written by Miguel Barros. Spain: Ariane Maraía Films, Arcadia Motion Pictures et al., 2011.

Choleando. Directed by Roberto de la Puente; written by Roberto de la Puente. Peru: Relapso Filmes e IDM Taller de Antropología Visual y Cabina Subsónica, 2011.

Coach. Directed by Leo Mendel; written by Leo Mendel. Chile: Juan Pablo Fernández, productor, 2016.

De niña a mujer. Directed by Joaquín Ventura; written by JADAT. Peru: JADAT, 2006.

Días de Santiago. Directed by Josué Méndez; written by Josué Méndez. Peru: Chullachaki Producciones, 2004.

Días en la vida. Directed by Joaquín Ventura; written by JADAT. Peru: JADAT, 2001.

Dioses. Directed by Josué Méndez; written by Bárbara Acosta and Tito Bonicelli. Peru and Argentina: Chullachaki Producciones, Lagarto Cine and TS Productions, 2008.

Historias marcadas. Directed by Jorge Ventura and Javier Farfán; written by JADAT. Peru: JADAT, 2003.

Inside Out. Directed by Pete Docter and Ronnie Del Carmen; written by Pete Docter and Ronnie Del Carmen. USA: Walt Disney Pictures and Pixar Animation Studios, 2015.

Karen llora en un bus. Directed by Gabriel Rojas Vera; written by Gabriel Rojas Vera. Colombia: Caja Negra Producciones, Ciclope Films, and Schweizen Media Group, 2011.

La nana. Directed by Sebastián Silva; written by Sebastián Silva. Chile: Forastero, Diroriro and Film Tank, 2009.

La teta asustada. Directed by Claudia Llosa Bueno; written by Claudia Llosa Bueno. Spain and Peru: Generalitat de Catalunya ICIC, Ministerio de Cultura de España, Oberón Cinematográfica, Vela Producciones, Wanda Visión, TVE, TV3, 2009.

Madeinusa. Directed by Claudia Llosa Bueno; written by Claudia Llosa Bueno. Peru and Spain: Oberón Cinematográfica, Vela Producciones and Wanda Visión, 2006.

Men in Black. Directed by Barry Sonnenfeld; written by Lowell Cunningham and Ed Solomon. USA: Colombia Pictures Corporation, 1997.

Temporada de patos. Directed by Fernando Eimbcke; written by Fernando Eimbcke and Paula Markovitch. Mexico: CinePantera, Esperanto Filmoj, Fidecine, IMCINE, Lulú and Titán Producciones, 2004.

Un mundo sin colores. Directed by Joaquín Ventura; written by JADAT. Peru: JADAT, 2007.

Y tu mamá también. Directed by Alfonso Cuarón; written by Alfonso and Carlos Cuarón. Mexico: Anhelo Producciones, Besame Mucho Pictures and Producciones Anhelo, 2001.

Zwart als roet aka *Our Colonial Hangover.* Directed by Sunny Bergman; written by Sunny Bergman and Fatihya Abdi. The Netherlands: De Familie, 2014.

BIBLIOGRAPHY

Acevedo-Muñoz, Ernesto R. "Sex, Class, and Mexico in Alfonso Cuarón's *Y tu mamá también*." *Film and History: An Interdisciplinary Journal of Film and Television Studies* 34.1 (2004): 39–48.

Ackroyd, Peter. *London: The Biography.* London: Vintage, 2000.

Adelman, Jeremy. "Latin American Longues Durées." *Latin American Research Review* 39.1 (2004): 223–37.

Alberro, Solange, and Pilar Gonzalbo. *La sociedad novohispana. Estereotipos y realidades.* Mexico City: El Colegio de México, Centro de Estudios Históricos, 2013.

Alcoff, Linda M. "Mignolo's Epistemology of Coloniality." *CR: The New Centennial Review* 7.3 (2007): 79–101.

Aldama, Frederick L. "Cognition, Emotions, and Literature: Critical New Directions." *Interdisciplinary Literary Studies* 6.1 (2004): 117–20.

———. *Why The Humanities Matter: A Commonsense Approach.* Austin: University of Texas Press, 2008.

Aldama, Frederick L., and Patrick Colm Hogan. *Conversations on Cognitive Cultural Studies: Literature, Language, and Aesthetics.* Columbus: The Ohio State University Press, 2014.

Allen, Catherine J. "Patterned Time: The Mythic History of a Peruvian Community." *Journal of Latin American Lore* 10.2 (1984): 151–73.

Alquicira, Mario, and María Alejandra de la Garza, eds. *Psicoanálisis y cine. Antología del cine comentado y debatido.* Volume 3. Mexico: CPM, 2011.

American Psychiatric Association. *Diagnostic and Statistical Manual of Mental Disorders—DSM III.* Washington, DC: APA, 1980.

———. *Diagnostic and Statistical Manual of Mental Disorders—DSM IV.* Washington, DC: APA, 1994.

Arbib, Michael A. *How the Brain Got Language: The Mirror System Hypothesis.* Oxford: Oxford University Press, 2012.

Arbona, Juan Manuel. "'Sangre de minero, semilla de guerrillero': Histories and Memories in the Organisation and Struggles of the Santiago II Neighbourhood of El Alto, Bolivia." *Bulletin of Latin American Research* 27.1 (2008): 24–42.

Archibald, Priscilla. *Imagining Modernity in the Andes*. Lewisburg, PA: Bucknell University Press, 2010.

Arellano Cueva, Rolando, and David Burgos Abugattás. *Ciudad de los Reyes, de los Chávez, de los Quispe* . . . Lima: Arellano Marketing and Planeta, 2010.

Arellano Hoffman, Carmen. *"Hanan/urin:* reflexiones acerca de un viejo concepto dual inka y su aplicación en el Chinchaysuyu." In *50 Años de estudios Americanistas en la Universidad de Bonn. Nuevas contribuciones a la arqueología, etnohistoria, etnolingüística y etnografía de las Américas,* edited by S. Dedenbach-Salazar Sáenz, C. Arellano Hoffmann, E. König, and H. Prümers, 473–93. Bonn: Markt Schwaben A. Saurwein, 1998.

———. *Notas sobre el indígena en la Intendencia de Tarma. Una evaluación de la visita de 1786,* Bonn: Seminar für Völkerkunde, Universität Bonn, 1984.

Arguedas, José María. *The Fox from Up Above and the Fox from Down Below.* Critical edition, translated by F. Horning Barraclough from *El zorro de arriba y el zorro de abajo,* Lima: De Esta Edición 1990; orig. 1971, with an introduction by J. Ortega, coordinator, and critical essay by W. Rowe, Ch. Fernández and S. Castro-Klarén. Pittsburgh: University of Pittsburgh Press, 2000.

———. "I Am Not an Acculturated Man . . ." In *The Fox from Up Above and the Fox from Down Below,* by José María Arguedas. Critical edition, translated by F. Horning Barraclough, 268–70. Pittsburgh: University of Pittsburgh Press, 2000.

———. "The Pongo's Dream." In Starn, Degregori, and Kirk, eds., *The Peru Reader: History, Culture, Politics,* 258–63; repr. in *The Peru Reader: History, Culture, Politics.* 2nd edition, revised and updated, 273–78. Durham, NC: Duke University Press, 2005.

———. *El sueño del pongo: cuento Quechua.* Lima: Ediciones Salqantay, 1965; reprinted as "Pongoq mosqoynin (Qatqa runapa willakusqan). El sueño del pongo (cuento quechua) (1965)," in *Obras Completas I,* 249–58. Lima: Editorial Horizonte, 1983.

Arnauld, Marie-Charlotte, Linda Manzanilla, and Michael E. Smith. *The Neighborhood as a Social and Spatial Unit in Mesoamerican Cities.* Tucson: University of Arizona Press, 2012.

Assmann, Aleida. *Erinnerungsräume. Formen und Wandlungen des kulturellen Gedächtnisses.* München: Beck, 1999.

Assmann, Jan. "Collective Memory and Cultural Identity." *New German Critique* 65 (1995): 125–33.

———. "Communicative and Cultural Memory." In Erll and Nünning, eds., *Companion,* 109–25.

———. *Das kulturelle Gedächtnis. Schrift, Erinnerung und politische Identität in frühen Hochkulturen.* München: Beck, 1992.

———. *Moses the Egyptian: The Memory of Egypt in Western Monotheism.* Cambridge, MA: Harvard University Press, 1997.

Atkinson, Rita L., Richard C. Atkinson, Edward E. Smith, Daryl J. Bem, and Susan Nolen-Hoeksema. *Hilgard's Introduction to Psychology.* 12th ed. Fort Worth, TX: Harcourt Brace College, 1996.

Aubry, Andrés. "La 'lenta acumulación de fuerzas' del movimiento zapatista." San Cristóbal de Las Casas, Mexico: Paper Inaremac, 1994.

(Autonomedia). *¡Zapatistas! Documents of the New Mexican Revolution (December 31, 1993—June 12, 1994).* New York: Autonomedia, 1994.

Ávila, Francisco de. *Dioses y hombres de Huarochirí.* Bilingual edition by José María Arguedas, and bibliographical study by Pierre Duviols. Lima: Museo Nacional de Historia and Instituto de Estudios Peruanos, 1966.

Baars, Bernard J. "In the Theatre of Consciousness: Global Workspace Theory, a Rigorous Scientific Theory of Consciousness." *Journal of Consciousness Studies* 4.4 (1997): 292–309.

———. *In the Theater of Consciousness: The Workspace of the Mind.* New York: Oxford University Press, 1997.

Baber, R. Jovita. "Categories, Self-Representation and the Construction of the *Indios*." *Journal of Spanish Cultural Studies* 10.1 (2009): 27–41.

Bacigalupo, Ana Mariella. "Identidad, espacio y dualidad en los *perimontun* de *machis* mapuches." *Scripta Ethnológica* 18 (1996): 37–63.

———. "Imágenes de diversidad y consenso: la cosmovisión Mapuche a través de tres *machis*." *Mitológicas* 11 (1996): 41–64.

———. "Rethinking Identity and Feminism: Contributions of Mapuche Women and *Machi* from Southern Chile." *Hypatia* 18.2 (2003): 32–57.

———. *Shamans of the Foye Tree: Gender, Power, and Healing among Chilean Mapuche.* Austin: University of Texas Press, 2007.

———. "Variación del rol de machi dentro de la cultura mapuche: tipología geográfica, adaptiva e iniciática." *Revista Chilena de Antropología* 12 (1993–94): 19–43.

Bakhtin, Mikhail M. *Problems of Dostoevsky's Poetics.* Edited and translated by Caryl Emerson; introduction by Wayne C. Booth. Minneapolis: University of Minnesota Press, 1984; orig. *Problemy tvorchestva Dostoevskogo.* Leningrad, SU: Priboi, 1929.

———. *Speech Genres and Other Late Essays.* Translated by Vern W. McGee; edited by Caryl Emerson and Michael Holquist. Austin: University of Texas Press, 1986; orig. *Éstetika slovesnogo tvorchestva,* Mosciw: Iskusstvo, 1979.

Bámaca, Mayra Y., Adriana J. Umaña-Taylor, Nana Shin, and Edna C. Alfaro. "Latino Adolescents' Perception of Parenting Behaviors and Self-Esteem: Examining the Role of Neighborhood Risk." *Family Relations* 54.5 (2005): 621–32.

Bargh, John A., and Ezequiel Morsella. "The Unconscious Mind." *Perspectives on Psychological Science* 3.1 (2008): 73–79.

Baron-Cohen, Simon. *Mindblindness: An Essay on Autism and Theory of Mind.* Cambridge, MA: MIT Press, 1995.

Barrett, Louise. *Beyond the Brain: How Body and Environment Shape Animal and Human Minds.* Princeton, NJ: Princeton University Press, 2011.

Barsalou, Lawrence W. "Grounded Cognition." *Annual Review of Psychology* 59 (2008): 617–45.

Bartlett, Sir Frederick C. *Remembering: A Study in Experimental and Social Psychology.* Cambridge: Cambridge University Press, 1932.

Beasley-Murray, Jon. "Arguedasmachine: Modernity and Affect in the Andes." *Iberoamericana* 30 (2008): 113–28.

Bedoya, Susana, ed. *Coloquio: Lo Cholo en el Perú. Tonmo I. Visiones de la modernidad desde lo cholo.* Lima: Biblioteca Nacional del Perú, 2009.

———. *Coloquio: Lo Cholo en el Perú. Tomo II. Migraciones y mixtura.* Lima: Biblioteca Nacional del Perú, 2009.

Beller, Manfred, and Joep Leerssen, eds. *Imagology: The Cultural Construction and Literary Representation of National Characters. A Critical Survey.* Amsterdam: Rodopi, 2007.

Bem, Sandra L. "Gender Schema Theory: A Cognitive Account of Sex Typing." *Psychological Review* 88 (1981): 354–64.

———. *The Lenses of Gender: Transforming the Debate on Sexual Inequality.* New Haven, CT: Yale University Press, 1993.

Benjamin, Thomas. *A Rich Land, a Poor People: Politics and Society in Modern Chiapas.* Albuquerque: University of New Mexico Press, 1989.

Beuys, Joseph. "I Am Searching for Field Character." In *Energy Plan for the Western Man—Joseph Beuys in America,* edited by Carin Kuoni, 34. New York: Four Walls Eight Windows, 1993.

Bloom, Paul. *How Pleasure Works: The New Science of Why We Like What We Like.* New York: Norton, 2010.

Bolin, Inge. *Growing Up in a Culture of Respect: Child Rearing in Highland Peru.* Austin: University of Texas Press, 2006.

———. *Rituals of Respect: The Secret of Survival in the High Peruvian Andes.* Austin: University of Texas Press, 1998.

Bonfil Batalla, Guillermo. *México profundo. Una civilización negada.* Mexico City: Secretaría de educación pública and Centro de Investigaciones y Estudios Superiores en Antropología Social, 1987.

———. *México Profundo: Reclaiming a Civilization.* Translated by Philip A. Dennis. Austin: University of Texas Press, 1996.

Borah, Woodrow W. *Justice by Insurance: The General Indian Court of Colonial Mexico and the Legal Aides of the Half Real.* Berkeley: University of California Press, 1983.

Borch-Jacobsen, Mikkel, Jean Cottraux, Didier Pleux, and Jacques Van Rillaer, eds. *Libro negro del psicoanálisis. Vivir, pensar y estar mejor sin Freud.* Buenos Aires, ARG: Editorial Sudamericana, 2005; Translation of: *Le livre noir de la psychoanalyse: vivre, penser et aller mieux sans Freud,* edited by Mikkel Borch-Jacobsen [and others]; direction Catherine Meyer. Paris: Arènes, 2005.

Borch-Jacobsen, Mikkel, and Sonu Shamdasani. *The Freud Files: An Inquiry into the History of Psychoanalysis.* New York: Cambridge University Press, 2012.

Bordwell, David. *Making Meaning: Inference and Rhetoric in the Interpretation of Cinema.* Cambridge, MA: Harvard University Press, 1989.

Bordwell, David, and Kristin Thompson. *Film Art: An Introduction.* 8th ed. Boston: McGraw-Hill, 2008.

Borsdorf, Axel, Jürgen Bähr, and Michael Janoschka. "Die Dynamik Stadtstrukturellen Wandels in Lateinamerika im Modell der Lateinamerikanischen Stadt." *Geographica Helvetica* 57.4 (2002): 300–10.

Borsdorf, Axel, Rodrigo Hidalgo, and Rafael Sánchez. "A New Model of Urban Development in Latin America: The Gated Communities and Fenced Cities in the Metropolitan Areas of Santiago de Chile and Valparaíso." *Cities* 24 (2007): 365–78.

Bossy, John. *Christianity in the West, 1400–1700.* Oxford: Oxford University Press, 1985.

Bourdieu, Pierre. *Esquisse d'une théorie de la pratique, précédé de trois études d'ethnologie kabyle.* Genève: Libraire Droz, 1972.

———. *Outline of a Theory of Practice.* Cambridge: Cambridge University Press, 1977; orig. 1972.

Boyd, Brian. *On the Origin of Stories: Evolution, Cognition, and Fiction.* Cambridge, MA: Belknap Press of Harvard University Press, 2009.

———. "Why We Love Fiction." *Axess On-Line,* September 11, 2012, http://axess.se/magasin/english .aspx?article=762 (accessed 9/12).

Brading, David A. "Manuel Gamio and Official Indigenismo in Mexico." *Bulletin of Latin American Research* 7.1 (1988): 75–89.

Brainsky, Simón. *Psicoanálisis y cine. Pantalla de ilusiones.* Bogotá: Grupo Editorial Norma, 2000.

Brenneman, Robert. *Homies and Hermanos: God and Gangs in Central America.* New York: Oxford University Press, 2012.

Bricker, Victoria R. *The Indian Christ, the Indian King: The Historical Substrate of Maya Myth and Ritual.* Austin: University of Texas Press, 1981.

Bruce, Jorge. *Nos habíamos choleado tanto. Psicoanálisis y racismo.* Lima: Universidad de San Martín de Porres, Fondo Editorial, 2007.

Brysk, Alison. *From Tribal Village to Global Village: Indian Rights and International Relations in Latin America.* Stanford, CA: Stanford University Press, 2000.

Burkhart, Louise M. *Holy Wednesday: A Nahua Drama from Early Colonial Mexico.* Philadelphia: University of Pennsylvania Press, 1996.

———. *The Slippery Earth: Nahua-Christian Moral Dialogue in Sixteenth-Century Mexico.* Tucson: University of Arizona Press, 1989.

Buss, David M. *Evolutionary Psychology: The New Science of the Mind.* Boston: Allyn and Bacon, 1999.

Calhoun, Craig. "Occupy Wall Street in Perspective." *The British Journal of Sociology* 64.1 (2013): 26–38.

Cancian, Frank. *The Decline of Community in Zinacantán: Economy, Public Life, and Social Stratification, 1960–1987.* Stanford, CA: Stanford University Press, 1992.

Cánepa Koch, G. "Disputing *Limeño* Historical and Cultural Heritage." *PMLA* 122.1 (2007): 301–5.

———. "The Fluidity of Ethnic Identities in Peru." Oxford: CRISE Working Paper 46, 2008.

———. "Geopoética de identidad y lo cholo en el Perú. Migración, geografía y mestizaje." *Cronicas Urbanas* 11.12 (2007): 29–42.

Canessa, Andrew. "Fear and Loathing on the *Kharisiri* Trail: Alterity and Identity in the Andes." *Journal of the Royal Anthropological Institute*, n.s., 6 (2000): 705–20.

———. *Intimate Indigeneities: Race, Sex, and History in the Small Spaces of Andean Life.* Durham, NC: Duke University Press, 2012.

———. "A Postcolonial Turn: Social and Political Change in the New Indigenous Order of Bolivia." *Urban Anthropology* 36.3 (2007): 145–59.

———. "Who Is Indigenous? Self-Identification, Indigeneity, and Claims to Justice in Contemporary Bolivia." *Urban Anthropology* 36.3 (2007): 195–237.

———, ed. *Natives Making Nation: Gender, Indigeneity, and the State in the Andes.* Tucson: University of Arizona Press, 2005.

Casas, Armando, Alberto Constante, and Leticia Flores Farfán, eds. *Escenarios del deseo. Reflexiones desde el cine, la literatura, el psicoanálisis y la filosofía.* Mexico: Universidad Nacional Autónoma de México, 2009.

Catoni, M. Luisa. "From Motion to Emotion: An Ancient Greek Iconography between Literal and Symbolic Interpretations." In *Bodies in Action and Symbolic Forms: Zwei Seiten der Verkörperungtheorie*, 99–120. Berlin: Akademie Verlag, 2012.

———. "Mimesis and Motion in Classical Antiquity." In *Bilder animierter Bewegung—Images of Animate Movement*, edited by Sigrid Leyssen and Pirkko Rathgeber, 199–220. Paderborn, Germany: Wilhelm Fink, 2013.

————. *Schemata. Comunicazione non verbale nella Grecia antica*. Pisa, Italy: Edizioni della Normale, 2005.

Changeux, Jean-Pierre. "Art and Neuroscience." *Leonardo* 27.3 (1994): 189–201.

Chasteen, John C. Introduction to *Lettered City*, by Á. Rama, vii–xiv. Durham, NC: Duke University Press, 1996.

Chemero, Anthony. *Radical Embodied Cognitive Science*. Cambridge, MA: MIT Press, 2009.

Chiozza, Gustavo. *Un psicoanalista en el cine*. Buenos Aires: Libros del Zorzal, 2006.

Chomsky, Noam. *Occupy*. Brooklyn, NY: Zuccotti Park, 2012.

Christenson, Allen J. *Art and Society in a Highland Maya Community: The Altarpiece of Santiago Atitlán*. Austin: University of Texas Press, 2001.

Clark, Andy, and David J. Chalmers. "The Extended Mind." *Analysis* 58.1 (1998): 7–19.

Clash, Kevin. *My Life as a Furry Red Monster: What Being Elmo Has Taught Me about Life, Love and Laughing Out Loud*. Written with G. Brozek; illustrations by L. H. Mitchell. New York: Broadway Books, 2006.

Cole, Michael. *Cultural Psychology: A Once and Future Discipline*. Cambridge, MA: Belknap Press of Harvard University Press, 1996.

Collier, George A. "Reforms of Mexico's Agrarian Code: Impacts on the Peasantry." *Research in Economic Anthropology* 15 (1994): 105–27.

Collins, Randall. *Interaction Ritual Chains*. Princeton, NJ: Princeton University Press, 2004.

Correa, Marta Elena. *Formas de la resistencia. Una mirada desde el psicoanálisis, la poesía, el cine y los habitantes de la calle*. Medellín, Colombia: Universidad Pontificia Bolivariana, 2012.

Cortez, Enrique. "Writing the Mestizo: José María Arguedas as Ethnographer." *Latin American and Caribbean Ethnic Studies* 4.2 (2009): 171–89.

Cosmides, Leda, and John Tooby. "Consider the Source: The Evolution of Adaptations for Decoupling and Metarepresentations." In *Metarepresentations: A Multidisciplinary Perspective*, edited by Dan Sperber, 53–116. New York: Oxford University Press, 2000.

Crews, Frederick. *Freud: The Making of an Illusion*. New York: Metropolitan Books, Henry Holt and Company, 2017.

Crombag, Hans F. M., and Harald L. G. J. Merckelbach. *Hervonden herinneringen en andere misverstanden*. Amsterdam: Contact, 1996.

Crouch, Colin. *Post-Democracy*. London: Polity, 2004.

Csikszentmihalhy, Mihaly. *The Evolving Self: A Psychology for the Third Millennium*. New York: HarperCollins, 1993.

Currie, Gregory. *Image and Mind: Film, Philosophy and Cognitive Science*. Cambridge: Cambridge University Press, 1995.

CVR (Comisión de la Verdad y Reconciliación [Comisión de Entrega de la CVR]). *Hatun Willakuy. Versión abreviada del Informe Final de la Comisión de la Verdad y Reconciliación*. Lima: Comisión de la Verdad y Reconciliación, 2004.

————. *Yuyanapaq. Para recordar. Relato visual del conflicto armado interno en el Perú, 1980–2000*. Lima: Comisión de la Verdad y Reconciliación, 2003.

Damasio, Antonio. *Descartes' Error: Emotion, Reason, and the Human Brain*. New York: Penguin, 1994.

———. *The Feeling of What Happens: Body and Emotion in the Making of Consciousness.* New York: Harcourt, 1999.

———. *Looking for Spinoza: Joy, Sorrow, and the Feeling Brain.* New York: Harcourt, 2003.

———. *Self Comes to Mind: Constructing the Conscious Brain.* New York: Pantheon, 2010.

D'Andrade, Roy. *The Development of Cognitive Anthropology.* Cambridge, MA: Cambridge University Press, 1995.

Dangl, Benjamin. *El precio del fuego. Las luchas por los recursos naturales y los movimientos sociales en Bolivia.* La Paz: Plural editores, 2009.

———. *The Price of Fire: Resource Wars and Social Movements in Bolivia.* Oakland, Canada: AK Press, 2007.

Davis, Angela, Steve Williams, María Poblet, Rinku Sen, James Lawson, and SylviaFederici. "On Occupy." *Race, Poverty & the Environment* 18.2 (2011): 76–83.

Davis, Patricia. *Cognition and Learning: A Review of the Literature with Reference to Ethnolinguistic Minorities.* Dallas, TX: Summer Institute of Linguistics (SIL), 1991; reprinted as SIL e-book, 2013.

Dawkins, Richard. *The Extended Phenotype: The Long Reach of the Gene.* Oxford: Oxford University Press, 1982.

De Cesari, Chiara, and Ann Rigney. Introduction to *Transnational Memory: Circulation, Articulation, Scales,* edited by Chiara De Cesari and Ann Rigney, 1–25. Berlin: de Gruyter, 2014.

De la Cadena, Marisol. "Alternative Indigeneities: Conceptual Proposals." *Latin American and Caribbean Ethnic Studies* 3.3 (2008): 341–49.

———. *Indigenous Mestizos: The Politics of Race and Culture in Cuzco, Peru, 1919-1991.* Durham, NC: Duke University Press, 2000.

De la Vega, Garcilaso, El Inca. *Royal Commentaries of the Incas and General History of Peru: Abridged.* Translated by H. V. Livermore; edited, with an introduction, by Karen Spalding. Indianapolis, IN: Hackett, 2006; orig. 1609 and 1617.

———. *Royal Commentaries of the Incas and General History of Peru.* Translated by H. V. Livermore. 2 vols. Austin: University of Texas Press, 1966.

De Mare, Heidi. "Het huis en de regels van het denken. Een cultuurhistorisch onderzoek naar het werk van Simon Stevin, Jacob Cats en Pieter de Hooch." PhD diss., Vrije Universiteit, Amsterdam, 2003.

———. *Huiselijke taferelen. De veranderende rol van het beeld in de Gouden Eeuw.* Nijmegen, Netherlands: Vantilt, 2012.

de Munck, Victor. *Culture, Self, and Meaning.* Prospect Heights, IL: Waveland, 2000.

De Vos, Jan. *La paz de Dios y del rey. La conquista de la selva lacandona, 1525-1821.* Mexico City: Secretaría de Educación y Cultura de Chiapas, Fondo de Cultura Económica, 1988.

———. *No queremos ser cristianos. Historia de la resistencia de los Lacandones, 1530-1695, a través de testimonios españoles e indígenas,* Mexico City: Dirección General de Publicaciones del Consejo Nacional para la Cultura y las Artes, Instituto Nacional Indigenista, 1990.

———. *Oro verde. La conquista de la Selva Lacandona por los madereros tabasquenos, 1822-1949,* Mexico City: Fondo de Cultura Económica, 1988.

———. *Viajes al desierto de la soledad. Cuando la Selva Lacandona aún era selva,* Mexico City: CIESAS, 1988.

———. *Vivir en frontera. La experiencia de los indios de Chiapas,* Tlalpan, DF: Centro de Investigaciones y Estudios Superiores en Antropología Social, 1994.

De Waardt, Mijke F. "In the Name of the Victims? Victim-Survivor Associations Negotiating for Recognition in Post-Conflict Peru." PhD diss., Vrije Universiteit, Amsterdam, 2014.

De Waardt, Mijke F., and Annelou Ypeij. "Peruvian Grassroots Organizations in Times of Violence and Peace: Between Economic Solidarity, Participatory Democracy, and Feminism." *Voluntas: International Journal of Voluntary and Nonprofit Organizations* 11.04 (2016): 1–21.

Deacon, Terence. *The Symbolic Species: The Co-evolution of Language and the Brain.* New York: Norton, 2006; orig. 1998.

Dennett, Daniel C. *Consciousness Explained.* London: Penguin, 1991.

Dijksterhuis, Ap. *Het slimme onbewuste. Denken met gevoel.* Amsterdam: Uitgeverij Bert Bakker, 2007.

Drzewieniecki, Joanna. "Peruvian Youth and Racism: The Category of 'Race' Remains Strong.": Paper presented at the 2004 Meeting of the Latin American Studies Association, Las Vegas, NV, October 7–9.

Dufresne, Todd. *Tales from the Freudian Crypt: The Death Drive in Text and Context.* Stanford, CA: Stanford University Press, 2000.

Dussel, Enrique. *Ética de la liberación en la edad de la globalización y la exclusión.* Madrid: Trotta, and Iztapalapa, Mex: Universidad Autónoma Metropolitana México, 1998.

———. *Filosofía ética latinoaméricana. De la erótica a la pedagógica de la liberación.* Vol. 6/ III. Mexico City: Editorial Edicol, 1977.

Eakin, Paul John. *How Our Lives Become Stories: Making Selves.* Ithaca, NY: Cornell University Press, 1999.

———. "Living Autobiographically." *Biography* 28.1 (2005): 1–14.

———. *Living Autobiographically: How We Create Identity in Narrative.* Ithaca, NY: Cornell University Press, 2008.

Earle, Duncan. "Indigenous Identity at the Margin. Zapatismo and Nationalism." *Cultural Survival Quarterly* 18.1 (1994): 26–30.

Edman, Jeanne L., and Velma A. Kameoka. "Cultural Differences in Illness Schemas: An Analysis of Filipino and American Illness Attributions." *Journal of Cross-Cultural Psychology* 28.3 (1997): 252–65.

Edmonson, Munro S. "The Mayan Faith." In *South and Meso-American Native Spirituality: From the Cult of the Feathered Serpent to the Theology of Liberation,* edited by Gary H. Gossen, 65–85. New York: Crossroad, 1993.

Eisenstadt, Todd A. "Introduction: Reconciling Liberal Pluralism and Group Rights: A Comparative Perspective on Oaxaca, Mexico's Experiment in Multiculturalism." In *Latin America's Multicultural Movements: The Struggle Between Communitarianism, Autonomy, and Human Rights,* edited by Todd A. Eisenstadt, Michael S. Danielson, Moisés J. Bailón Corres, and Carlos Sorroza Polo, 3–17. Oxford: Oxford University Press, 2013.

Engler, Barbara. *Personality Theories: An Introduction.* 9th ed. Belmont, CA: Wadsworth Cengage Learning, 2014; orig. 2009.

Erll, Astrid. "Cultural Memory Studies: An Introduction." In Erll and Nünning, eds., *Cultural Memory Studies,* 1–17.

———. *Memory in Culture*. London: Macmillan, 2011; translated by Sara B. Young, orig.: *Kollektives Gedächtnis und Erinnerungskulturen: eine Einführung*. Stuttgart, Germany: Verlag J. B. Metzler, 2011.

———. "Travelling Memory." *Parallax* 14.4 (2011): 4–18.

Erll, Astrid, and Ansgar Nünning, eds. *A Companion to Cultural Memory Studies*. Berlin: de Gruyter, 2010.

———. *Cultural Memory Studies: An International and Interdisciplinary Handbook*. Berlin: de Gruyter, 2008.

———. *Mediation, Remediation, and the Dynamics of Cultural Memory*. Berlin: de Gruyter, 2009.

Erwin, Edward. *A Final Accounting: Philosophical and Empirical Issues in Freudian Psychology*. Cambridge, MA: MIT Press, 1996.

———. *The Freud Encyclopedia: Theory, Therapy, and Culture*. New York: Routledge, 2002.

España, Pablo, and Mario Alquicira. *Tres grandes sueños de pasión, locura y seducción. una visión psicoanalítica*. Mexico: Círculo Psicoanalítico Mexicano, 2002.

———, eds. *Psicoanálisis y cine. Antología del cine comentado y debatido*. 2 vols. Mexico: Círculo Psicoanalítico Mexicano, 2002.

Fabricant, Nicole. "Good Living for Whom? Bolivia's Climate Justice Movement and the Limitations of Indigenous Cosmovisions." *Latin American and Caribbean Ethnic Studies* 8.2 (2013): 159–78.

Fanon, Frantz. *Black Skin, White Masks*. Translation by Charles Lam Markmann. New York: Grove, 1967; orig. 1952.

———. *The Wretched of the Earth*. Translation by Constance Farrington. New York: Grove Weidenfeld, 1963; orig. 1961.

Farriss, Nancy. *Maya Society under Colonial Rule: The Collective Enterprise of Survival*. Princeton, NJ: Princeton University Press, 1984.

———. "Remembering the Future, Anticipating the Past: History, Time, and Cosmology among the Maya of Yucatan." *Comparative Studies in Society and History* 29.3 (1987): 566–93.

Fazio, Carlos. *Samuel Ruiz, el caminante*. Mexico City: Espasa-Calpe, 1994.

Feldman, Jerome A. *From Molecule to Metaphor: A Neural Theory of Language*. Cambridge, MA: MIT Press, 2006.

Feliciano, Cynthia, Rennie Lee, and Belinda Robnett. "Racial Boundaries among Latinos: Evidence from Internet Daters' Racial Preferences." *Social Problems* 58:2 (2011): 189–212.

Fernández-Savater, Amador. "El nacimiento de un nuevo poder social." *Hispanic Review* 80.4 (2012): 667–81.

Fiske, Susan T. "Social Cognition and Social Perception." *Annual Review of Psychology* 44 (1993): 155–94.

———. "Thinking Is for Doing: Portraits of Social Cognition from Daguerreotype to Laserphoto." *Journal of Personality and Social Psychology* 63.6 (1992): 877–89.

Flores Galindo, Alberto. *Dos ensayos sobre José María Arguedas*. Lima: SUR, 1992.

———. *In Search of an Inca: Identity and Utopia in the Andes*. Edited and translated from the Spanish by C. Aguirre, C. F. Walker, and W. Hiatt. Cambridge: Cambridge University Press, 2010, orig.: *Buscando un Inca: identidad y utopia en los Andes*. La Habana: Casa de las Américas, 1986.

———. "A Self-Critical Farewell: An Open Letter by Alberto Flores Galindo." *NACLA: Report on the Americas* 24.5 (1991): 8–10.

Flynn, Peter, Joep Leerssen, and Luc van Doorslaer. "On Translated Images, Stereotypes and Disciplines." In *Interconnecting Translation Studies and Imagology,* edited by Luc van Doorslaer, Peter Flynn, and Joep Leerssen, 1–18. Amsterdam & Philadelphia: John Benjamins, BTL Vol. 119, 2015.

Ford, Joseph. "Introduction: Transnational Memory and Traumatic Histories." *Forum: University of Edinburgh Postgraduate Journal of Culture and the Arts* 4 (2015): 1–6.

Foucault, Michel. *The Order of Things: An Archaeology of the Human Sciences.* New York: Pantheon Books, 1970; orig.: *Les mots et les choses. Une archéologie des sciences humaines.* Paris: Gallimard, 1966.

Franco, Jean. "Alien to Modernity: The Rationalization of Discrimination." *A Contracorriente* 3.3 (2006): 1–16; http://www.ncsu.edu/project/acontracorriente/spring_06/Franco.pdf.

Frank, Robert H. *Falling Behind: How Rising Inequality Harms the Middle Class.* Berkeley: University of California Press, 2007.

The Free Association. *Moments of Excess: Movements, Protest and Everyday Life.* Oakland, CA: PM Press, 2011.

Freedberg, David, and Vittorio Gallese. "Motion, Emotion and Empathy in Esthetic Experience." *Trends in Cognitive Sciences* 11.5 (2007): 197–203.

Freidel, David, Linda Schele, and Joy Parker. *Maya Cosmos: Three Thousand Years on the Shaman's Path.* New York: Morrow, 1993.

Frijda, Nico. *The Emotions.* Cambridge: Cambridge University Press, 1986.

Fukumoto, Mary Nancy. *Hacia un Nuevo sol. Japoneses y sus descendientes en el Perú.* Lima: Asociación Peruano Japonesa del Perú, 1997.

Fukuyama, Francis. *The End of History and the Last Man.* New York: Free Press, 1992.

Funder, David C. "Personality." *Annual Review of Psychology* 52 (2001): 197–221.

Funkenstein, Amos. *Perceptions of Jewish History.* Berkeley: University of California Press, 1993.

Gallese, Vittorio. "Bodily Selves in Relation: Embodied Simulation as Second-Person Perspective on Intersubjectivity." *Philosophical Transactions of the Royal Society. Series B, Biological Sciences* 369 (2014): 1–10.

———. "Mirror Neurons and Art." In *Art and the Senses,* edited by F. Bacci and D. Melcher, 441–49. Oxford: Oxford University Press, 2010.

———. "Seeing Art . . . Beyond Vision: Liberated Embodied Simulation in Aesthetic Experience." In *Seeing with Eyes Closed,* edited by Alexander Abbushi, Ivana Franke, and Ida Mommenejad, 62–65. Venice: Association for Neuroesthetics Symposium, Guggenheim Collection, 2011.

García, María Elena. "Introduction: Indigenous Encounters in Contemporary Peru." *Latin American and Caribbean Ethnic Studies* 3.3 (2005): 217–26.

———. *Making Indigenous Citizens: Identities, Education, and Multicultural Development in Peru.* Stanford, CA: Stanford University Press, 2005.

———. "The Politics of Community: Education, Indigenous Rights, and Ethnic Mobilization in Peru." *Latin American Perspectives* 30.1 (2003): 70–95.

García Márquez, Gabriel. *Of Love and Other Demons.* Translated by Edith Grossman. New York: Knopf; distr. Random House, 1995; transl. of *Del amor y tros demonios.* Santafé de Bogotá: Norma, 1994.

———. "The Solitude of Latin America. Nobel Lecture, 8 December, 1982." In *Nobel Lectures, Literature 1981–1990*, edited by Tore Frängsmyr. Singapore: Editor Sture Allen, World Scientific, 1993; available at http://www.nobelprize.org/nobel_prizes/literature/laureates/1982/marquez -lecture.html (accessed 1/14).

García Martínez, Bernardo. "*Pueblos de Indios, Pueblos de Castas*: New Settlements and Traditional Corporate Organization in Eighteenth-Century New Spain." In *The Indian Community of Colonial Mexico: Fifteen Essays on Land Tenure, Corporate Organizations, Ideology and Village Politics*, edited by Arij Ouweneel and Simon Miller, 103–16. Amsterdam: CEDLA, 1990.

———. *Los pueblos de la Sierra. El poder y el espacio entre los indios del norte de Puebla hasta 1700*. Mexico City: El Colegio de México, 1987.

Gareis, Iris. "'República de Indios'—'República de Españoles': reinterpretación actual de conceptos andinos." *Jahrbuch für Geschichte von Staat, Wirtschaft. und Gesellschaft Lateinamerikas* 30 (1993): 259–77.

Garrett, David T. *Shadows of Empire: The Indian Nobility of Cusco, 1750–1825*. Cambridge: Cambridge University Press, 2005.

Gazzaniga, Michael S. *Who's In Charge? Free Will and the Science of the Brain*. New York: HarperCollins, 2011.

Geertz, Clifford. *The Interpretation of Cultures: Selected Essays*. New York: Basic Books, 1973.

Gell, Alfred. *Art and Agency: An Anthropological Theory*. Oxford: Clarendon, 1998.

Gerrig, Richard J. *Experiencing Narrative Worlds: On the Psychological Activities of Reading*. Boulder, CO: Westview, 1998; orig. 1993.

Gettas, Gregory J. "The Globalization of 'Sesame Street': A Producer's Perspective." *Educational Technology Research and Development* 38.4 (1990): 55–63.

Gibbs, Raymond W., Jr. *Embodiment and Cognitive Science*. Cambridge: Cambridge University Press, 2005.

Gibson, James J. "The Ecological Approach to the Visual Perception of Pictures." *Leonardo* 11 (1978): 227–35.

———. *The Ecological Approach to Visual Perception*. Boston: Houghton Mifflin, 1979.

Giddens, Anthony. *The Constitution of Society: Outline of Theory of Structuration*. Oxford: Polity, 1984.

Gilbert, Daniel. *Stumbling on Happiness*. New York: Knopf, 2006.

Gillespie, Susan D. *The Aztec Kings: The Construction of Rulership in Mexican History*. Tucson: University of Arizona Press, 1989.

Ginzburg, Carlo. *Clues, Myths, and the Historical Method*. Baltimore, MD: The Johns Hopkins University Press, 1986.

———. *No Island Is an Island: Four Glances at English Literature in a World Perspective*. New York: Columbia University Press, 2000.

———. *Das Schwert und die Glühbirne. Eine neue Lektüre von Picassos Guernica*. Frankfurt am Main: Suhrkamp, 1999.

———. "The Sword and the Lightbulb: A Reading of *Guernica*." In *Disturbing Remains: Memory, History and Crisis in the Twentieth Century*, edited by Michael S. Roth and Charles G. Salas, 111–77. Los Angeles: Getty Research Institute, 2001.

Gitlin, Todd. *Occupy Nation, the Roots: The Spirit and the Promise of Occupy Wall Street*. New York: HarperCollins, 2012.

Glenberg, Arthur M. "Embodiment as a Unifying Perspective for Psychology." *Wiley Interdisciplinary Reviews: Cognitive Science* 1.4 (2010): 586–96.

———. "What Memory Is For." *Behavioral and Brain Sciences* 20 (1997): 1–55.

Glezer, Laurie S., Judy Kim, Josh Rule, Xiong Jiang, and Maximilian Riesenhuber. "Adding Words to the Brain's Visual Dictionary: Novel Word Learning Selectively Sharpens Orthographic Representations in the VWFA." *Journal of Neuroscience* 35.12 (2015): 4965–72.

Goffman, Erving. *The Presentation of Self in Everyday Life.* London: Penguin Books, 1959; orig. 1969.

———. *Stigma: Notes on the Management of Spoiled Identity.* London: Penguin Books, 1963; repr. 1990.

Goldstein, Daniel M. *The Spectacular City: Violence and Performance in Urban Bolivia.* Durham, NC: Duke University Press, 2004.

Gombrich, Ernst H. *Art and Illusion: A Study in the Psychology of Pictorial Representation.* London: Phaidon, 1959; 6th ed. (with new preface), 2002.

———. *Aby Warburg: An Intellectual Biography.* London: Warburg Institute, 1970.

Gómez-Rodulfo, Marta. *Alas de maguey. La lucha de Eufrosina Cruz Mendoza,* with a preface by Elena Poniatowska. México: Casa de las Palabras, 2012.

González, Olga. *Unveiling Secrets of War in the Peruvian Andes.* Chicago: University of Chicago Press, 2011.

González, Raúl. "Coca's Shining Path." *NACLA: Report on the Americas* 22.6 (1989): 22–24.

Gose, Peter. *Invaders as Ancestors: On the Intercultural Making and Unmaking of Spanish Colonialism in the Andes.* Toronto: University of Toronto Press, 2008.

Gosner, Kevin, and Arij Ouweneel, eds. *Indigenous Revolts in Chiapas and the Andean Highlands.* Amsterdam: CEDLA LAS 77, 1996.

Gossen, Gary H. *Chamulas in the World of the Sun: Time and Space in a Maya Oral Tradition.* Cambridge, MA: Harvard University Press, 1974.

———. "Comments on the Zapatista Movement." *Cultural Survival Quarterly* 18.1 (1994): 19–21.

———. "Maya Zapatistas Move to the Ancient Future." *American Anthropologist* 98.3 (1996): 528–38.

———. *Telling Maya Tales: Tzotzil Identities in Modern Mexico.* New York: Routledge, 1999.

———. "Who Is the Comandante of Subcomandante Marcos?" In Gosner and Ouweneel, eds., *Indigenous Revolts,* 107–20.

Gottschall, Jonathan. *The Storytelling Animal: How Stories Make Us Human.* Boston: Houghton Mifflin Harcourt, 2012.

Gow, David D. "The Roles of Christ and Inkarrí in Andean Religion." *Journal of Latin American Lore* 6.2 (1980): 279–96.

Graeber, David. "Dead Zones of the Imagination: On Violence, Bureaucracy, and Interpretive Labor." *HAU: Journal of Ethnographic Theory* 2.2 (2012): 105–28.

———. *Inside Occupy.* Translated from the English by Bernhard Schmid. Frankfurt: Campus Verlag, 2012.

Grandin, Greg. *The Blood of Guatemala: A History of Race and Nation.* Durham, NC: Duke University Press, 2000.

——. *The Last Colonial Massacre: Latin America in the Cold War.* Chicago: University of Chicago Press, 2004; updated edition, with a new preface by the author and an interview with Naomi Klein. Chicago: University of Chicago Press, 2011.

Graziano, Frank. *Cultures of Devotion: Folk Saints of Spanish America.* New York: Oxford University Press, 2006.

Griffin, Ernest, and Larry Ford. "A Model of Latin American City Structure." *Geographical Review* 70.4 (1980): 397–422.

Gruzinski, Serge. *La colonisation de l'imaginaire, Sociétés indigènes et occidentalisation dans le Mexique espagnol, XVIe–XVIIIe siècle.* Paris: Gallimard, Bibliothèque des Histoires, 1988.

Guamán Poma de Ayala, Felipe. *Nueva crónica y buen gobierno.* Edición de J. V. Murra, R. Adorno y J. Urioste. Madrid: Historia 16, 1987; orig. 1615.

Guillermoprieto, Alma. "Letter From Mexico: Zapata's Heirs." *New Yorker,* May 16, 1994, 52–63.

——. "The Shadow War." *New York Review of Books* 42.4 (1995): 34–43.

Habermas, Jürgen. *Knowledge and Human Interest,* translated by Jeremy J. Shapiro. Boston: Beacon, 1971; orig.: *Erkenntnis und Interesse.* Frankfurt am Main: Suhrkamp, 1968.

Haiven, Max. *Crises of Imagination, Crisis of Power: Capitalism, Creativity and the Commons.* Halifax, Canada: Fernwood; London: Zed Books, 2014.

Halbwachs, Maurice. *Les cadres sociaux de la mémoire.* Paris: Presses Universitaires de France, 1952; orig. in *Les Travaux de L'Année Sociologique.* Paris: F. Alcan, 1925.

Hale, Charles. "Consciousness, Violence and the Politics of Memory in Guatemala." *Current Anthropology* 38.5 (1997): 817–38.

——. "Does Multiculturalism Menace? Governance, Cultural Rights and the Politics of Identity in Guatemala." *Journal of Latin American Studies* 32.1 (2002): 115–44.

——. *Más Que un Indio: Racial Ambivalence and Neoliberal Multiculturalism in Guatemala.* Santa Fe, NM: School of American Research Press, 2006.

——. "*Mestizaje,* Hybridity and the Cultural Politics of Difference in Post-Revolutionary Central America." *Journal of Latin American Anthropology* 2.1 (1996): 34–61.

Harris, Judith R. *No Two Alike: Human Nature and Human Individuality.* New York: Norton, 2006.

——. *The Nurture Assumption: Why Children Turn Out the Way They Do.* New York: Touchstone, 1999; orig. 1998.

Harvey, Neil. *The Chiapas Rebellion: The Struggle for Land and Democracy.* Durham, NC: Duke University Press, 1998.

——. "Personal Networks and Strategic Choices in the Formation of an Independent Peasant Organization: The OCEZ of Chiapas, Mexico." *Bulletin of Latin American Research* 7.2 (1988): 299–312.

——. *Rebellion in Chiapas: Rural Reforms, Campesino Radicalism, and the Limits to Salinismo.* San Diego: Center for U.S.–Mexican Studies, University of California, 1994.

Haskett, Robert. *Indigenous Rulers: An Ethnohistory of Town Government in Colonial Cuernavaca.* Albuquerque: University of New Mexico Press, 1991.

Hawken, Paul. *Blessed Unrest: How the Largest Movement in the World Came into Being and Why No One Saw It Coming.* New York: Viking, 2007.

Hayden, Tom, ed. *The Zapatista Reader.* New York: Thunder's Mouth, 2002.

Hemming, John, and Edward Ranney. *Monuments of the Incas.* Albuquerque: University of New Mexico Press, 1982.

Herman, David. "Editor's Column: The Scope and Aims of *Storyworlds.*" *Storyworlds: A Journal of Narrative Studies* 1 (2009): vii–x.

Herman, Ellen. "How Children Turn Out and How Psychology Turns Them Out." *History of Psychology* 4.3 (2001): 297–316.

Hernández Navarro, Luis. *Chiapas. La nueva lucha India.* Madrid: Talasa, 1998.

———. "The Chiapas Uprising." In *The Chiapas Rebellion: The Struggle for Land and Democracy,* edited by Neil Harvey, 44–56. Durham, NC: Duke University Press, 1994.

———. "The Escalation of the War in Chiapas." *NACLA: Report on the Americas* 31.5 (1998): 7–10.

Hibbett, Alexandra. "Arguedas' Joy: Opening History in *The Fox from Up Above and the Fox from Down Below.*" *Journal of Latin American Cultural Studies* 21.3 (2012): 379–89.

Hilton, James L., and William von Hippel. "Stereotypes." *Annual Review of Psychology* 47 (1996): 237–71.

Hoekstra, Rik. *Two Worlds Merging: The Transformation of Society in the Valley of Puebla, 1570–1640.* Amsterdam: CEDLA Latin American Studies, 1993.

Hogan, Patrick Colm. *Affective Narratology: The Emotional Structure of Stories.* Lincoln: University of Nebraska Press, 2011.

———. *Cognitive Science, Literature, and the Arts: A Guide for Humanities.* New York: Routledge, 2003.

———. *The Mind and Its Stories: Narrative Universals and Human Emotion.* Cambridge: Cambridge University Press, 2003.

Hogg, Michael A., and Graham M. Vaughan. *Social Psychology: An Introduction.* London: Prentice Hall, 1995.

Holland, Dorothy C., William Lachicotte Jr., Debra Skinner, and Carole Cain. *Identity and Agency in Cultural Worlds.* Cambridge, MA: Harvard University Press, 1998.

Holloway, John. *Change the World without Taking Power: The Meaning of Revolution Today.* London: Pluto, 2002; new ed. 2005.

———. *Crack Capitalism.* London: Pluto, 2010.

Hume, David. *A Treatise of Human Nature.* Edited by Sir L. A. Selby-Bigge and P. H. Nidditch. Oxford: Clarendon, 1978; orig. 1738.

Iacoboni, Marco. *Mirroring People: The New Science of How We Connect with Others.* New York: Farrar, Straus and Giroux, 2008.

James, William. *The Principles of Psychology.* Vol. 1. New York: Dover, 1918; orig. 1890.

———. *Psychology: The Briefer Course.* Notre Dame, IN: University of Notre Dame Press, 1985.

Jarquín Ortega, María Teresa. *Formación y desarrollo de un pueblo novohispano. Metepec en el Valle de Toluca.* Metepec, Edo Mexico: Colegio Mexiquense, y H. Ayuntamiento de Metepec, 1990.

John, Oliver P., Richard W. Robinson, and Lawrence A. Pervin. *Handbook of Personality: Theory and Research.* 3rd ed. New York: Guilford, 2008.

Johnson, Christopher C. *Memory, Metaphor, and Aby Warburg's Atlas of Images.* Ithaca, NY: Cornell University Press and Cornell University Library, 2012.

Johnson, Mark. *The Body in the Mind: The Bodily Basis of Meaning, Imagination, and Reason.* Chicago: University of Chicago Press, 1987.

Jones, Oakah, Jr. *Guatemala in the Spanish Colonial Period*. Norman: University of Oklahoma Press, 1994.

Jost, John T., and Mahzarin R. Banaji. "The Role of Stereotyping in System-Justification and the Production of False Consciousness." *British Journal of Social Psychology* 33 (1994): 1–27.

Juan Martínez, Víctor L. "What We Need Are New Customs: Multiculturality, Autonomy, and Citizenship in Mexico and the Lessons of Oaxaca." In *Latin America's Multicultural Movements: The Struggle Between Communitarianism, Autonomy, and Human Rights*, edited by Todd A. Eisenstadt, Michael S. Danielson, Moisés J. Bailón Corres, and Carlos Sorroza Polo, 135–68. Oxford: Oxford University Press, 2013.

Juris, Jeffrey S. "Reflections on #Occupy Everywhere: Social Media, Public Space, and Emerging Logics of Aggregation." *American Ethnologist* 39.2 (2012): 259–79.

Jussim, Lee. "Social Perception and Social Reality: A Reflection-Construction Model." *Psychological Review* 98.1 (1991): 54–73.

Kalir, Barak. "The Development of a Migratory Disposition: Explaining a 'New Emigration.'" *International Migration* 43.4 (2005): 167–96.

Kansteiner, Wulf. "Finding Meaning in Memory: A Methodological Critique of Collective Memory Studies." *History and Theory* 41 (2002): 179–97.

Kansteiner, Wulf, and Harald Weilnböck. "Against the Concept of Cultural Trauma (or How I Learned to Love the Suffering of Others without the Help of Psychotherapy)." In Erll and Nünning, eds., *Companion*, 229–40.

Katzew, Ilona. *Casta Painting: Images of Race in Eighteenth-Century Mexico*. New Haven, CT: Yale University Press, 2004.

Katzew, Ilona, and Susan Deans-Smith, eds. *Race and Classification. The Case of Mexican America*. Preface by W. B. Taylor. Stanford, CA: Stanford University Press, 2009.

Kenny, Michael G. "A Place for Memory: The Interface between Individual and Collective History." *Comparative Studies in Society and History* 41.3 (1999): 420–37.

Khanna, Ranjana. *Dark Continents: Psychoanalysis and Colonialism*. Durham, NC: Duke University Press, 2003.

Kirk, Robin. "'Good Enough' Human Rights: The Issue of Balance in Protecting Human Rights in Peru." *Dispositio* 23.50 (1998): 77–86.

Klarén, Peter F. *Peru: Society and Nationhood in the Andes*. New York: Oxford University Press, 2000.

Kokotovic, Misha. *The Colonial Divide in Peruvian Narrative: Social Conflict and Transculturation*. Brighton, UK: Sussex Academic, 2005.

Kolata, Alan L. *The Tiwanaku: Portrait of an Andean Civilization*. Cambridge, MA: Blackwell, 1993.

Korsten, Frans Willem. *Lessen in literatuur*. Nijmegen, Netherlands: Uitgeverij Vantilt, 2002.

Kunda, Ziva, and Paul Thagard. "Forming Impressions from Stereotypes, Traits, and Behaviors: A Parallel-Constraint-Satisfaction Theory." *Psychological Review* 103.2 (1996): 284–308.

Lacan, Jacques. *Écrits: A Selection*. Selection and translation from the French by Alan Sheridan. London: Tavistock, 1977.

Lakoff, George. *Moral Politics: How Liberals and Conservatives Think*. Chicago: University of Chicago Press, 2002.

———. *The Political Mind: Why You Can't Understand 21st-Century Politics with an 18th-Century Brain*. New York: Viking, 2008.

———. *Women, Fire, and Dangerous Things: What Categories Reveal about the Mind.* Chicago: University of Chicago Press, 1987.

Lakoff, George, and Mark Johnson. *Metaphors We Live By.* Chicago: University of Chicago Press, 2003; orig. 1980.

Lakoff, George, and Mark Turner. *More than Cool Reason: A Field Guide to Poetic Metaphor.* Chicago: University of Chicago Press, 1989.

Lambie, George. "Poetry and Politics: The Spanish Civil War Poetry of César Vallejo." *Bulletin of Hispanic Studies* 49 (1992): 153–70.

Lara, Ángel Luis. "Virgil Starkwell en la Puerta del Sol: públicos en revuelta, políticas hacia el ser por venir." *Hispanic Review* 80.4 (2012): 651–65.

Larsen, Randy J., and David M. Buss. *Personality Psychology: Domains of Knowledge about Humen Nature.* 3rd ed. New York: McGraw-Hill, 2008; orig. 2002.

Layard, Richard. *Happiness.* London: Allen Lane, 2005.

Lazar, Sian. "El Alto, Ciudad Rebelde: Organisational Bases for Revolt." *Bulletin of Latin American Research* 25.2 (2006): 183–99.

———. *El Alto, Rebel City: Self and Citizenship in Andean Bolivia.* Durham, NC: Duke University Press, 2008.

Ledgard, Melvin R. *De Supercholo a Teodosio. Historietas peruanas de los sesentas y setentas.* Lima: Instituto Cultural Peruano Norteamericano, Galería ICPNA San Miguel, 2004.

LeDoux, Joseph. *The Emotional Brain: The Mysterious Underpinnings of Emotional Life.* New York: Touchstone, 1996.

Lee, Rebecca L. "Putting a Face on Free-Market Economics: The Politicisation of Race and Ethnicity in Peru." *Race and Class* 51.3 (2010): 47–58.

Leerssen, Joep. "Imagology: On Using Ethnicity to Make Sense of the World." *Revue Iberic@l* 10 (2016): 13–31.

———. *National Thought in Europe: A Cultural History.* Amsterdam: Amsterdam University Press, 2006.

Leinaweaver, Jessaca B. *The Circulation of Children: Kinship, Adoption, and Morality in Andean Peru.* Durham, NC: Duke University Press, 2008.

Lemaire, Ton. *De indiaan in ons bewustzijn. De ontmoeting van de Oude met de Nieuwe Wereld.* Baarn: Ambo, 1986.

Levi, Primo. *The Drowned and the Saved.* London: Abacus, 1989; translated by Raymond Rosenthal from *I sommersi e i salvati [i delitti, i castighi, le pene, le impunità].* Torino, Italy: Einaudi, 1986.

Leyva Solano, Xóchitl. "Catequistas, misioneros y tradiciones en Las Cañadas." In *Chiapas. Los rumbos de la historia,* edited by Juan Pedro Viqueira and Mario H. Ruz, 375–405. Mexico City: Centro de Estudios Mayas del Instituto de Investigaciones Filológicas y Coordinación de Humanidades (UNAM), Centro de Investigaciones y Estudios Superiores en Antropología Social, Centro de Estudios Mexicanos y Centroamericanos, [Guadalajara], and Universidad de Guadalajara, 1995.

Linebaugh, Peter. *The Magna Carta Manifesto: Liberties and Commons for All.* Berkeley: University of California Press, 2008.

———. *Stop Thief! The Commons, Enclosures, and Resistance.* Oakland, CA: PM Press, 2014.

Lombardo, Sonia. "Las pinturas de Cacaxtla." *Historias* 12 (1986): 3–21.

López Corral, Miguel. "Barcelona y Madrid. Dos realidades distintas ante el fenómeno de las bandas latinas." *Revista Cidob d'Afers Internacionals* 81 (2008): 191–206.

MacCormack, Sabine. *Religion in the Andes: Vision and Imagination in Early Colonial Peru.* Princeton, NJ: Princeton University Press, 1991.

MacEóin, Gary. *The People's Church: Bishop Samuel Ruiz of Mexico and Why He Matters.* New York: Crossroad, 1996.

Macmillan, Malcolm. *Freud Evaluated: The Completed Arc.* Cambridge, MA: MIT Press, 1997; orig. 1991.

Magazine, Roger. *The Village Is Like a Wheel: Rethinking Cargos, Family and Ethnicity in Highland Mexico.* Tucson: University of Arizona Press, 2012.

Majluf, Natalia, ed. *Los cuadros de mestizaje del Virrey Amat. La representación etnográfica en el Perú colonial.* Lima: Museo de Arte de Lima, 2000.

Malik, Kenan. *The Meaning of Race: Race, History and Culture in Western Society.* London: Macmillan, 1996.

———. *Multiculturalism and Its Discontents: Rethinking Diversity after 9/11.* London: Seagull Books, 2013.

———. *Strange Fruit: Why Both Sides Are Wrong in the Race Debate.* Oxford: Oneworld, 2008.

Mandler, George. *Mind and Body: The Psychology of Emotion and Stress.* Hillsdale, NJ: Lawrence Erlbaum, 1984.

Mandler, Jean M. *Stories, Scripts, and Scenes: Aspects of Schema Theory.* Hillsdale, NJ: Lawrence Erlbaum, 1984.

Manzanilla, Linda, and Ignacio Pérez-Duarte. *Teotihuacan.* New York: Scholastic, 1994.

Mar, Raymond A., and Keith Oatley. "The Function of Fiction Is the Abstraction and Simulation of Social Experience." *Perspectives on Psychological Science* 3.3 (2008): 173–92.

Mariátegui, José Carlos. *7 ensayos de interpretación de la realidad peruana.* Lima: Sociedad Editorial Amauta, 1928.

———. *El alma matinal, y otras estaciones del hombre de hoy.* Lima: Empresa Editora Amauta, 1959.

———. *José Carlos Mariátegui: An Anthology.* Translated and edited by H. E. Vanden and M. Becker, New York: Monthly Review Press, 2011.

———. "Man and Myth." In *José Carlos Mariátegui: An Anthology,* edited by Harry E. Vanden and Marc Becker, 383–88. New York: Monthly Review, 2011.

———. "Reflections." In Starn, Degregori, and Kirk, eds., *The Peru Reader,* 2nd ed., 240–45.

———. *Seven Interpretive Essays on Peruvian Reality.* Austin: University of Texas Press, 1971; orig. 1928.

Markowitsch, Hans J. "Cultural Memory and the Neurosciences." In Erll and Nünning, eds., *Companion,* 275–83.

Markus, Hazel R. "Self-Schemata and Processing Information about the Self." *Journal of Personality and Social Psychology* 35.2 (1977): 63–78.

Marx, Karl. "Theses on Feuerbach." In *Marx/Engels Collected Works, April 1845–April 1847, including German Ideology,* compiled and printed by Progress Publishers of the Soviet Union in collaboration with Lawrence & Wishart (London) and International Publishers. New York, 1975, 5:6–8.

Matos Mar, José. "Algunas consideraciones acerca del uso del vocablo mestizo." In *El indio y el poder en el Perú*, edited by J. Matos Mar. Lima: Instituto de Estudios Peruanos, 1970, 198–201; previously published in *Revista Histórica* 28 (1965).

———. *Desborde popular y crisis del Estado. El nuevo rostro del Perú en la década de 1980*. Lima: Iinstituto de Estudios Peruanos, 1984.

———. *Desborde popular y crisis del estado. Veinte años después*. Lima: Fondo Editorial del Congreso de la República, 2004.

Matos Moctezuma, Eduardo. *Teotihuacan*. Mexico City: Fondo de Cultura Económica, 2009.

Mattiace, Shannan. "¡Zapata Vive! The EZLN, Indian Politics and the Autonomy Movement in Mexico." *Journal of Latin American Anthropology of the SLAA* 3.1 (1997): 32–71.

Mayer, Enrique. "Peru in Deep Trouble: Mario Vargas Llosa's 'Inquest in the Andes' Reexamined." *Cultural Anthropology* 6.4 (1991): 466–504.

McLean, Cheryl A. "A Space Called Home: An Immigrant Adolescent's Digital Literacy Practices." *Journal of Adolescent and Adult Literacy* 54:1 (2010): 13–22.

McNally, Richard J. *Remembering Trauma*. Cambridge, MA: Belknap Press of Harvard University Press, 2003.

Medina, Andrés. *En las cuatro esquinas, en el centro. Etnografía de la cosmovisión mesoamericana*. Mexico City: Instituto de Investigaciones Antropológicas, Universidad Nacional Autónoma de México, 2000.

Meier, Brian P., Simone Schnall, Norbert Schwarz, and John A. Bargh. "Embodiment in Social Psychology." *Topics in Cognitive Science* (2012): 1–12.

Melgar Bao, Ricardo. "Las utopías indígenas en América. Lectura de un año nefasto." *Memoria* 62 (1994): 24–31.

Michalak, Katja. "Schema." In *International Encyclopedia of Political Science*, edited by Bertrand Badie, Dirk Berg-Schlosser and Morlino Leonardo. Thousand Oaks, CA: Sage, 2011, 7:2362–64.

Mignolo, Walter. "Frantz Fanon y la opción decolonial: el conocimiento y lo político." In Frantz Fanon, *Piel negra, máscaras blancas*, with introductions by S. Amin and I. Wallerstein, and an Appendix with essays by J. Butler, L. R. Gordon, R. Grosfoguel, N. Maldonado-Torres, W. Mignolo, and S. Wynter, 309–26. Madrid: Akal, 2009.

———. "The Geopolitics of Knowledge and the Colonial Difference." *South Atlantic Quarterly* 10.1 (2002): 57–96.

———. *Local Histories / Global Designs: Coloniality, Subaltern Knowledges, and Border Thinking*. Princeton, NJ: Princeton University Press, 2012.

Minissale, Gregory. *The Psychology of Contemporary Art*. Cambridge: Cambridge University Press, 2013.

Mitchell, W. J. T. "Preface to 'Occupy: Three Inquiries in Disobedience.'" *Critical Inquiry* 39.1 (2012): 1–7.

Moore, Jerry D. *Architecture and Power in the Ancient Andes: The Archaeology of Public Buildings*. Cambridge: Cambridge University Press, 1996.

Moreno-Caballud, Luis. "La imaginación sostenible: culturas y crisis económica en la España actual." *Hispanic Review* 80.4 (2012): 535–55.

Morimoto, Amelia. *Población de origen japonés en el Perú: perfil actual*. Lima: Comisión Conmemorativa del 90° aniversario de la inmigración japonesa al Perú, 1991.

Mörner, Magnus. *Race Mixture in the History of Latin America*. Boston: Little, Brown, 1967.

Moromisato Miasato, Doris, and Juan Shimabukuro Inami. *Okinawa. Un siglo en el Perú.* Lima: Ediciones OKP, 2006.

Morson, Gary Saul, and Caryl Emerson. *Mikhail Bakhtin: Creation of a Prosaics.* Stanford, CA: Stanford University Press, 1990.

Morris, Craig, and Adriana von Hagen. *The Inka Empire and Its Andean Origins.* New York: Abbeville, 1993.

Moshman, David. "Identity as a Theory of Oneself." *The Genetic Epistemologist: The Journal of the Jean Piaget Society* 26.3 (1998): 1–9.

Nakamaki, Hirochika. *Japanese Religions at Home and Abroad.* New York: Routledge and Curzon, 2003.

Nash, June. "Press Reports on the Chiapas Uprising: Towards a Transnationalized Communication." *Journal of Latin American Anthropology of the SLAA* 2.2 (1996): 42–75.

Neisser, Ulric. *Cognition and Reality: Principles and Implications of Cognitive Psychology.* Cranbury, NJ: Freeman, 1976.

Niedenthal, Paul M., Lawrence W. Barsalou, Piotr Winkielmam, Silvia Krauth-Gruber, and François Ric. "Embodiment in Attitudes, Social Perception, and Emotion." *Personality and Social Psychology Review* 9.3 (2005): 184–211.

Nisbett, Richard E., and Timothy D. Wilson. "Telling More Than We Can Know: Verbal Reports on Mental Processes." *Psychological Review* 84.3 (1977): 231–59.

Nishida, Hiroko. "A Cognitive Approach to Intercultural Communication Based on Schema Theory." *International Journal of Intercultural Relations* 23.5 (1999): 753–77.

Noë, Alva. *Action in Perception.* Cambridge, MA: MIT Press, 2004.

Nora, Pierre. "Between Memory and History: Les Lieux de Mémoire." *Representations* 26 (1989): 7–25.

———. *Les lieux de mémoire.* 3 vols. Paris: Gallimard, 1984–86.

———. *Realms of Memory: Rethinking the French Past.* 3 vols. New York: Columbia University Press, 1996–98.

Nugent, José Guillermo. *El laberinto de la choledad.* Lima: Fundación Friedrich Ebert, 1992.

———. "El laberinto de la choledad, años después . . ." *Quehacer* 170 (2008): 86–95.

Oatley, Keith. "The Mind's Flight Simulator." *The Psychologist* 21.12 (2008): 1030–32.

Oatley, Keith, Raymond A. Mar, and Maja Djikic. "The Psychology of Fiction: Present and Future." In *Cognitive Literary Studies: Current Themes and New Directions,* edited by Isabel Jaen and Julien Jacques Simon, 235–49. Austin: University of Texas Press, 2012.

O'Brien, Karen L. *Sacrificing the Forest: Environmental and Social Struggles in Chiapas.* Boulder, CO: Westview, 1998.

Olick, Jeffrey K. "Collective Memory: The Two Cultures." *Sociological Theory* 17.3 (1999): 333–48.

———. "From Usable Pasts to the Return of the Repressed." *The Hedgehog Review* 9.2 (2007): 19–31.

Olick, Jeffrey K., Vered Vinitzky-Seroussi, and Daniel Levy. Introduction to *The Collective Memory Reader,* edited by Jeffrey K. Olick, Vered Vinitzky-Seroussi, and Daniel Levy, 3–62. New York: Oxford University Press, 2011.

Oliver-Smith, A. "The Pishtaco: Institutionalized Fear in Highland Peru." *The Journal of American Folklore* 82.326 (1969): 363–68.

Ortiz, Fernando. *Cuban Counterpoint: Tobacco and Sugar.* Translated from the Spanish by Harriet de Onís, introduction by Bronislaw Malinowski, prologue by Herminio Portell Vilá. New York: Knopf, 1947.

Ortner, Sherry.B. *Anthropology and Social Theory: Culture, Power and the Acting Subject.* Durham, NC: Duke University Press, 2006.

Ouweneel, Arij. *Alweer die Indianen. De jaguar en het konijn in Chiapas.* Amsterdam: Thela Tesis, 1994.

———. "Away From Prying Eyes: The Zapatista Revolt of 1994." In Gosner and Ouweneel, eds., *Indigenous Revolts,* 79–106.

———. *Ciclos interrumpidos. Ensayos sobre historia rural Mexicana, Siglos XVIII–XIX.* Zinacantepec: El Colegio Mexiquense, 1998.

———. *The Flight of the Shepherd: Microhistory and the Psychology of Cultural Resilience in Bourbon Central Mexico.* Amsterdam: Aksant, 2005.

———. *Freudian Fadeout: The Failings of Psychoanalysis in Film Criticism.* Jefferson, NC: McFarland, 2012.

———. "From *Tlahtocayotl* to *Gobernadoryotl*: A Critical Examination of Indigenous Rule in 18th-century Central Mexico." *American Ethnologist* 22.4 (1995): 756–85.

———. "One Block at a Time: Performing the Neighbourhood." In *Housing and Belonging in Latin America,* edited by Christien Klaufus and Arij Ouweneel, 294–319. New York: Berghahn CLAS 105, 2015.

———. *The Psychology of the Faceless Warriors: Eastern Chiapas, Early 1994.* Amsterdam: Cuadernos del Cedla 10, 2002.

———. *Shadows over Anáhuac: An Ecological Interpretation of Crisis and Development in Central Mexico, 1730–1800.* Albuquerque: University of New Mexico Press, 1996.

———. *Terug naar Macondo. Het spook van* Honderd jaar eenzaamheid *en het inheemse innerlijk van de mesties.* Amsterdam: Rozenberg, 2007.

———, ed. *Andeans and Their Use of Cultural Resources: Space, Gender, Rights and Identity.* Amsterdam: Cuadernos del CEDLA 25, 2012.

Ouweneel, Arij, and Rik Hoekstra. *Las tierras de los pueblos de indios en el altiplano de México, 1560–1920. Una aportación teórica interpretativa.* Amsterdam: CEDLA, 1998.

Ouweneel, Arij, and Simon Miller, eds. *The Indian Community of Colonial Mexico: Fifteen Essays on Land Tenure, Corporate Organizations, Ideology and Village Politics.* Amsterdam: CEDLA, 1990.

Owens, Timothy J., Dawn W. Robinson, and Lynn Smith-Lovin. "Three Faces of Identity." *Annual Review of Sociology* 36 (2010): 477–99.

Pandit, Lalita. "Emotion, Perception and Anagnorisis in *The Comedy of Errors*: A Cognitive Perspective." *College Literature* 33.1 (2006): 84–126.

Paredes, Martiza. "Fluid Identities: Exploring Ethnicity in Peru." Oxford: CRISE Working Paper 40, 2007.

Pasupathi, Monisha. "The Social Construction of the Personal Past and Its Implications for Adult Development." *Psychological Bulletin* 127.5 (2001): 651–72.

Piglia, Ricardo. *Crítica y ficción.* Buenos Aires: Seix Barral, 2000.

Pinker, Steven. *The Better Angels of Our Nature: Why Violence Has Declined.* New York: Viking, 2011.

———. *How the Mind Works*. New York: Norton, 1997.

Pinzón Bonilla, Samuel. *Hombres: Psicoanálisis, Cine*. Mexico: Ultradigital, 2015.

Plantinga, Carl. "Moving Pictures." *The Forum for European Philosophy*. Posted November 21, 2016, at http://blogs.lse.ac.uk/theforum/moving-pictures/.

Plomin, Robert, and Denise Daniels. "Why Are Children in the Same Family So Different from One Another?" *Behavioral and Brain Sciences* 10 (1987): 1–60.

Portocarrero Maisch, Gonzalo. *Racismo y mestizaje y otros ensayos*. Lima: Fondo Editorial del Congreso del Perú, 2009.

———. "La utopía del blanqueamiento y la lucha por el mestizaje." In *Hegemonía cultural y políticas de la diferencia*, edited by Alejandro Grimson and Karina Bidaseca, 165–200. Buenos Aires: El Consejo Latinoamericano de Ciencias Sociales, 2013; also in *Sombras coloniales y globalización en el Perú de hoy*, edited by Gonzalo Portocarrero, 59–93. Lima: Red para el Desarrollo de las Ciencias Sociales en el Perú, 2013.

Protzel, Javier. *Imaginarios sociales e imaginarios cinematográficos*. Lima: Fondo Editorial Universidad de Lima, 2009.

Quijano, Aníbal. "Colonialidad y modernidad/racionalidad." *Perú Indígena* 13.29 (1992): 11–20.

———. "Coloniality of Power, Eurocentrism, and Latin America." *Nepantla: Views from the South* 1.3 (2000): 533–80.

Rama, Ángel. *La ciudad letrada*. Hanover, NH: Ediciones del Norte, 1984.

———. *The Lettered City*. Introduction by John C. Chasteen. Durham, NC: Duke University Press, 1996.

Ramírez Ballivían, Rocio, and Linda Herrera. "Schools of the Street: Hip-Hop as Youth Pedagogy in Bolivia." *International Journal of Critical Pedagogy* 4.1 (2012): 172–84.

Ramos Medina, Manuel, ed. *Historia de la Ciudad de México en los Fines de Siglo (XV–XX)*. Mexico City: Grupo Carso, 2001.

Randall, Robert. "Qoyllur Rit'i, an Inca Fiesta of the Pleiades: Reflections on Time and Space in the Andean World." *Bulletin de l'Institut Français d'Études Andines* 11.1–2 (1982): 37–81.

Rappaport, Joanne. *The Disappearing Mestizo: Configuring Difference in the Colonial New Kingdom of Granada*. Durham, NC: Duke University Press, 2014.

Rich, A. "Notes Toward a Politics of Location." In *Blood, Bread, and Poetry: Selected Prose 1979–1985*, 210–31. New York: Norton, 1986.

Rigney, Ann. "The Dynamics of Remembrance: Texts Between Monumentality and Morphing." In Erll and Nünning, eds., *Companion*, 345–53.

Rivera Cusicanqui, Silvia. *Ch'ixinakax utxiwa. Una reflexión sobre prácticas y discursos descolonizadores*. Buenos Aires: Tinta Limón, 2010.

———. "Liberal Democracy and *Ayllu* Democracy in Bolivia: The Case of Northern Potosí." *Journal of Development Studies* 26.4 (1990): 97–121.

———. "The Potosí Principle: Another View of Totality." *e-Misférica* 11.1 (2014), published online at http://hemisphericinstitute.org/hemi/en/emisferica-111-decolonial-gesture/e111-essay-the-potosi-principle-another-view-of-totality.

Rizzolatti, Giacomo, and Laila Craighero. "The Mirror-Neuron System." *Annual Review of Neuroscience* 27 (2004): 169–92.

Rizzolatti, Giacomo, and Corrado Sinigaglia. *Mirrors in the Brain: How Our Minds Share Actions and Emotions*. New York: Oxford University Press, 2008.

Romero Jacobo, César. *Los Altos de Chiapas. La voz de las armas*. México City: Grupo Editorial Planeta, 1994.

Ronfeldt, David F., John Arquilla, Graham Fuller, and Melissa Fuller. *The Zapatista "Social Netwar" in Mexico*. Santa Monica, CA: Rand, 1998.

Rosales, Raúl. "Lo Cholo en San Borja: mas allá del sólido paradigma dual sobre la ciudad." In *Coloquio: Lo Cholo en el Perú.Tomo II. Migraciones y mixtura*, edited by Susana Bedoya, 77–83. Lima: Biblioteca Nacional del Perú, 2009.

Ross, John. *Rebellion from the Roots: Indian Uprising in Chiapas*. Monroe, ME: Common Courage, 1995.

Rothberg, Michael. "Afterword: Locating Transnational Memory." *European Review* 22.4 (2014): 652–56.

Roudinesco, Élisabeth. *Sigmund Freud en son temps et dans le nôtre*. Paris: Éditions du Seuil, 2014.

Rovee-Collier, Carolyn. "The Capacity for Long-Term Memory in Infancy." *Current Directions in Psychological Science* 2 (1993): 130–35.

Rowe, William. "No hay mensajero de nada. La modernidad andina según los *Zorros* de Arguedas." *Revista de Crítica Literaria Latinoamericana* 36.72 (2010): 61–96.

Rumelhart, David E., and Andrew Ortony. "The Representation of Knowledge in Memory." In *Schooling and the Acquisition of Knowledge*, edited by Richard C. Anderson, Rand J. Spiro, and William E. Montague, 99–135. Hillsdale, NJ: Lawrence Erlbaum, 1977.

Rushkoff, Douglas. *Present Shock: When Everything Happens Now*. New York: Current, 2013.

Rus, Jan. "The 'Comunidad Revolucionaria Institucional': The Subversion of Native Government in Highland Chiapas, 1936–1968." In *Everyday Forms of State Formation: Revolution and the Negotiation of Rule in Modern Mexico*, edited by Gilbert Joseph and Daniel Nugent, 265–300. Durham, NC: Duke University Press, 1994.

———. "*Jelavem Skotol Balamil* / The Whole World Has Changed: The Reordering of Native Society in Highland Chiapas, 1974–1994." Mexico City: Paper Museo Nacional de Antropología, 1994.

Ryan, Marie-Laure. "Still Pictures." In *Narrative across Media: The Languages of Storytelling*, edited by Marie-Laure Ryan, 139–44. Lincoln: University of Nebraska Press, 2004.

———, ed. *Narrative across Media: The Languages of Storytelling*. Lincoln: University of Nebraska Press, 2004.

Sand, Rosemarie S. *The Unconscious without Freud*. Lanham, MD: Rowman & Littlefield, 2014.

Sanjinés, Javier. *Embers of the Past: Essays in Times of Decolonization*. Foreword by Walter Mignolo. Translated by David Frye. Durham, NC: Duke University Press, 2013.

Santa Cruz Pachacuti Yamqui Salcamaygua, Juan de. *Relación de antigüedades deste Reyno del Piru*. Estudio etnohistórico y lingüístico de Pierre Duviols y César Itier. Lima: Institut Français d'Études Andines, 1993.

Saterstein, Aliya, and Andrew M. Penner. "The Race of a Criminal Record: How Incarceration Colors Racial Perception." *Social Problems* 57.1 (2010): 92–113.

Schacter, Daniel L. *Searching for Memory: The Brain, the Mind, and the Past*. New York: Basic Books, 1996.

Schacter, Daniel L., and Rajendra D. Badgaiyan. "Neuroimaging of Priming: New Perspectives on Implicit and Explicit Memory." *Current Directions in Psychological Science* 10.1 (2001): 1–4.

Schafer, Roy. "Narration in the Psychoanalytic Dialogue." *Critical Inquiry* 7.1 (1980): 29–53.

Schama, Simon. *Landschap en herinnering*. Amsterdam: Contact, 1995; orig.: *Landscape and Memory*. New York: Knopf; distributed by Random House, 1995.

Schank, Roger C. "Scripts." In *Encyclopedia of Social Psychology*, edited by Roy F. Baumeister and Kathleen D. Vohs, 727–28. London: Routledge, 2007.

Schechner, Richard. "Occupy Solidarity." *TDR The Drama Review* 56.1 (2012): 7–9.

Scheff, Thomas J. *Goffman Unbound! A New Paradigm for Social Science*. Boulder, CO: Paradigm, 2006.

Schilling-Vacaflor, Almut. "Bolivia's New Constitution: Towards Participatory Democracy and Political Pluralism?" *European Review of Latin American and Caribbean Studies* 90 (2011): 3–22.

Schmidt, Siegfried J. "Memory and Remembrance: A Constructivist Approach." In Erll and Nünning, eds., *Companion*, 191–201.

Seal, Graham. "The Robin Hood Principle: Folklore, History and the Social Bandit." *Journal of Folklore Research* 46.1 (2009): 67–89.

Shakespeare, William. *Mr. William Shakespeares Comedies, Histories, & Tragedies: Published According to the True Originall Copies*. London: Printed by Tho. Cotes, for Robert Allot [John Smethwick, William Aspley, Richard Hawkins, and Richard Meighen], and are to be fold at his shop at the signe of the Blacke Beare in Pauls Church-yard, 1632.

Shaw, Edward. *Pintura contemporánea latinoamericana*. Santiago de Chile: Quad Graphics and Celfin Capital, 2011.

Shweder, Richard A. "'You're Not Sick, You're Just in Love': Emotion as an Interpretive System." In *The Nature of Emotion: Fundamental Questions*, edited by Paul Ekman and Richard J. Davidson, 32–44. New York: Oxford University Press, 1994.

Sillar, Bill. "The Social Agency of Things? Animism and Materiality in the Andes." *Cambridge Archaeological Journal* 19.3 (2009): 369–79.

Simerka, Barbara. *Knowing Subjects: Cognitive Cultural Studies and Early Modern Spanish Literature*. West Lafayette, IN: Purdue University Press, 2013.

Solomon, Jack F. *The Signs of Our Time: The Secret Meanings of Everyday Life*. Los Angeles: Tarcher, 1988.

Spears, Russell, Penelope J. Oakes, Naomi Ellemers, and S. Alexander Haslam. "Introduction: The Social Psychology of Stereotyping and Group Life." In *The Social Psychology of Stereotyping and Group Life*, edited by Russell Spears, Penelope J. Oakes, Naomi Ellemers, and S. Alexander Haslam, 1–19. Oxford: Blackwell, 1997.

———, eds. *The Social Psychology of Stereotyping and Group Life*. Oxford: Blackwell, 1997.

Spence, Donald P. *Narrative Truth and Historical Truth: Meaning and Interpretation in Psychoanalysis*. New York: Norton, 1982.

Sperber, Dan, ed. *Metarepresentations: A Multidisciplinary Perspective*. New York: Oxford University Press, 2000.

Staerklé, Christian, Jim Sidanius, Eva G. T. Green, and Ludwin E. Molina. "Ethnic Minority-Majority Asymmetry in National Attitudes around the World: A Multilevel Analysis." *Political Psychology* 31:4 (2010): 491–519.

Stafford-Clark, David. *What Freud Really Said*. Harmondsworth, UK: Penguin Books, 1967; first Macdonald, 1965.

Starn, Orin. "Maoism in the Andes: The Communist Party of Peru-Shining Path and the Refusal of History." *Journal of Latin American Studies* 27.2 (1995): 399–421.

———. *Nightwatch: The Politics of Protest in the Andes.* Durham, NC: Duke University Press, 1999.

———. "To Revolt Against the Revolution: War and Resistance in Peru's Andes." *Cultural Anthropology* 10.4 (1995): 547–80.

———. "Villagers at Arms: War and Counterrevolution in the Central-South Andes." In *Resistance, Rebellion, and Consciousness in the Andean Peasant World, 18th to 20th Centuries,* edited by S. Stern, 224–53. Madison: University of Wisconsin Press, 1987.

Starn, Orin, Carlos Iván Degregori, and Robin Kirk, eds. *The Peru Reader: History, Culture, Politics.* Durham, NC: Duke University Press, 1995.

———. *The Peru Reader. History, Culture, Politics.* 2nd ed.; revised and updated. Durham, NC: Duke University Press, 2005.

Stephen, Lynn. *We Are the Face of Oaxaca: Testimony and Social Movements.* Durham, NC: Duke University Press, 2013.

———. "The Zapatista Army of National Liberation and the National Democratic Convention." *Latin American Perspectives* 22.4 (1995): 88–99.

———. "The Zapatista Opening: The Movement for Indigenous Autonomy and State Discourses on Indigenous Rights in Mexico, 1970–1996." *Journal of Latin American Anthropology of the SLAA* 2.2 (1996): 2–41.

Stern, Steve J. *Peru's Indian Peoples and the Challenge of Spanish Conquest: Huamanga to 1640.* Madison: University of Wisconsin Press, 1982.

———, ed. *Resistance, Rebellion, and Consciousness in the Andean Peasant World, 18th to 20th Centuries.* Madison: University of Wisconsin Press, 1987.

———, ed. *Shining and Other Paths: War and Society in Peru, 1980–1995.* Durham, NC: Duke University Press, 1998.

Straub, Jürgen. "Psychology, Narrative, and Cultural Memory: Past and Present." In Erll and Nünning, eds., *Companion,* 215–28.

Strocka, Cordula. "Piloting Experimental Methods in Youth Gang Research: A Camping Expedition with Rival *Manchas* in Ayacucho, Peru." In *Youth Violence in Latin America: Gangs and Juvenile Justice Perspective,* edited by Gareth A. Jones and Dennis Rodgers, 105–32. New York: Palgrave Macmillan, 2009.

———. *Unidos nos hacemos respetar. Jóvenes, identidades y violencia en Ayacucho.* Lima: Instituto de Estudios Peruanos, 2008.

Stroud, Scott R. "Simulation, Subjective Knowledge, and the Cognitive Value of Literary Narrative." *Journal of Aesthetic Education* 42.3 (2008): 19–41.

Sulca, Wendy. *La verdadera historia de Wendy Sulca. Más allá de La tetita.* Lima: Help Aerolíneas Editoriales and Editorial Estruendomundo, 2014.

Sulzer, Birgit. "'Somos migrantes en nuestro propio país': Identity-Expression of Indigenous Migrants in Mexico City (2008–2009)." In *Las agencias de lo indígena en la larga era de globalización. Microperspectivas de su producción y representación desde la época colonial temprana hasta el presente,* edited by Romy Köhler and Anne Ebert, 147–65. Berlin: Gebr. Mann Verlag and Ibero-Amerikanisches Institut, 2015.

Sumbadze, Nana. *The Social Web: Friendship of Adult Men and Women.* Leiden: DSWO Press of the University of Leiden, 1999.

Tajfel, Henri, ed. *Social Identity and Intergroup Relations.* Cambridge: Cambridge University Press, 1982; repr. 2008.

Takenaka, Ayumi. "The Japanese in Peru: History of Immigration, Settlement, and Racialization." *Latin American Perspectives* 31.3 (2004): 77–98.

Taylor, Diana. "Transculturating Transculturation." *Performing Arts Journal* 13.2 (1991): 90–104.

Taylor, William B. *Magistrates of the Sacred: Priests and Parishioners in Eighteenth-Century Mexico.* Stanford, CA: Stanford University Press, 1996.

Thomson, Sinclair. *We Alone Will Rule: Native Andean Politics in the Age of Insurgency.* Madison: University of Wisconsin Press, 2002.

Thompson, Edward P. *Customs in Common: Studies in Traditional Popular Culture.* New York: New Press, distributed by Norton, 1993.

———. *Making of the English Working Class.* New York: Pantheon Books, 1963.

———. "The Moral Economy of the English Crowd in the Eighteenth Century." *Past and Present* 50 (1971): 76–136.

———. *The Poverty of Theory & Other Essays.* New York: Monthly Review, 1978.

———. "Time, Work-Discipline and Industrial Capitalism." *Past and Present* 38 (1967): 56–97.

Thompson, Stephen I. "Survival of Ethnicity in the Japanese Community of Lima, Peru." *Urban Anthropology* 3.2 (1974): 243–61.

Tice, Dianne M. "Self-Concept Change and Self-Presentation: The Looking Glass Self Is Also a Magnifying Glass." *Journal of Personality and Social Psychology* 63 (1992): 435–51.

Titiev, Mischa. "The Japanese Colony in Peru." *The Far Eastern Quarterly* 10.3 (1951): 227–47.

Trafimow, David, Ellen S. Silverman, Ruth Mei-Tai Fan, and Josephine Shui Fun Law. "The Effects of Language and Priming on the Relative Accessibility of the Private Self and the Collective Self." *Journal of Cross-Cultural Psychology* 28.1 (1997): 107–23.

Triantafyllou, Michael, and George Triantafyllou. "An Efficient Swimming Machine." *Scientific American* 272.3 (1995): 64–70.

Tutino, John. "Creole Mexico: Spanish Elites, Haciendas and Indian Towns." PhD diss., University of Texas at Austin, 1976.

Twanama, Walter. "Cholear en Lima." *Márgenes. Encuentro y debate* 5.9 (1992): 206–40.

Uleman, James S. "Introduction: Becoming Aware of the New Unconscious." In *The New Unconscious,* edited by Ran R. Hasin, James S. Uleman, and John A. Bargh, 3–15. Oxford: Oxford University Press, 2005.

Urbano, Henrique O. "Mythic Andean Discourse and Pilgrimages." In *Pilgrimage in Latin America,* edited by N. Ross Crumrine and E. Alan Morinis, 339–56. New York: Greenwood, 1991.

———. "Del sexo, incesto y los ancestros de Inkarrí: mito, utopía e historia en las sociedades andinas." *Allpanchis Phuturinqa* 17–18 (1981): 77–103.

Vallejo, César. *España, aparta de mí este cáliz.* Mexico City: Séneca, 1940; also: La Habana, Cuba: Dirección de Cultura del Ministerio de Educación, 1961.

Van Akkeren, Ruud. *La vision indígena de la conquista.* Guatemala: Serviprensa, 2007.

Van der Haar, Gemma. *Gaining Ground: Land Reform and the Constitution of Community in the Tojolabal Highlands of Chiapas, Mexico.* Amsterdam: Rozenberg, 2002.

Van Eck, Caroline. "Living Statues: Alfred Gell's Art and Agency, Living Presence Response and the Sublime." *Art History* 33.4 (2010): 642–59.

Van Oss, Adriaan C. "Catholic Colonialism: A Parish History of Guatemala, 1524–1821." PhD diss., University of Texas at Austin, 1982.

———. *Catholic Colonialism: A Parish History of Guatemala, 1524–1821*. Cambridge: Cambridge University Press, 1986.

———. *Church and Society in Spanish America*. Amsterdam: CEDLA and Aksant Academic Publishers, 2003.

Velasco Godoy, María de los Ángeles. *La historia de un cambio en el Valle de Ixtlahuaca. La formación de un pueblo colonial*. Toluca, Edo Mex.: Universidad Autónoma del Estado de México, 2005.

———. *Ixtlahuaca: población, haciendas, pueblos y sistemas de trabajo colonial (1640–1711)*. Toluca, Edo Mex.: Universidad Autónoma del Estado de México, 2012.

Vermeule, Blakey. "The New Unconscious: A Literary Guided Tour." In *The Oxford Handbook of Cognitive Literary Studies*, edited by Lisa Zunshine, 463–83. Oxford: Oxford University Press, 2015.

Vich, Víctor. *El cannibal es el Otro. Violencia y cultura en el Perú contemporáneo*. Lima: Instituto de Estudios Peruanos, 2002.

———. "Desobediencia simbólica. Performance, participación y política al final de la dictadura fujimorista." In *La cultura en las crisis latinoamericanas*, edited by Alejandro Grimson, 63–80. Buenos Aires: El Consejo Latinoamericano de Ciencias Sociales, 2004.

Vogt, Evon. "Possible Sacred Aspects of the Chiapas Rebellion." *Cultural Survival Quarterly* 18.1 (1994): 34.

———. *Tortillas for the Gods: A Symbolic Analysis of Zinacanteco Rituals*. Cambridge, MA: Harvard University Press, 1976.

Vološinov, Valentin Nikolaevich. *Freudianism: A Marxist Critique*. Translated by I. R. Titunik and edited in collaboration with Neal H. Bruss. New York: Academic Press, 1976; orig. *Frejdizm: kritičeskij očerk*. Moscow: Gosudarstvennoe izd., 1927.

von Hagen, Adriana, and Craig Morris. *The Cities of the Ancient Andes*. London: Thames and Hudson, 1998.

Võsu, Ester, Ene Kõresaar, and Kristina Kuutma. "Mediation of Memory: Towards Transdisciplinary Perspectives in Current Memory Studies." *Trames* 12.62/57 (2008): 243–63.

Vygotsky, Lev S. *Mind in Society: The Development of Higher Psychological Processes*, edited by Michael Cole and others. Cambridge, MA: Harvard University Press, 1978.

Wade, Lizzie. "People from Mexico Show Stunning Amount of Genetic Diversity." *Science Magazine*, June 12, 2014. http://www.sciencemag.org/news/2014/06/people-mexico-show-stunning-amount-genetic-diversity (accessed 12/2016).

Wagman, Jeffrey B., Craig A. Taheny, and Takahiro Higuchi. "Improvements in Perception of Maximum Reaching Height Transfer to Increases or Decreases in Reaching Ability." *American Journal of Psychology* 127.3 (2014): 269–79.

Walther, Olivier, and Laurent Matthey. "The City as Body." *Articulo: Journal of Urban Research* (2010), http://articulo.revues.org/1304.

Warman, Arturo. *"We Come to Object": The Peasants of Morelos and the National State*. Baltimore, MD: Johns Hopkins University Press, 1978; repr. 1980.

Warren, Kay B. *Indigenous Movements and Their Critics: Pan-Maya Activism in Guatemala*. Princeton: Princeton University Press, 1998.

Wartofsky, Marx W. *Models: Representation and Scientific Understanding*. Dordrecht, Netherlands: Reidel, 1979.

Webster, Richard. *Freud*. London: Weidenfeld and Nicolson, 2003.

———. *Why Freud Was Wrong: Sin, Science and Psychoanalysis.* Rev. ed. London: Harper Collins, 1996; orig. 1995.

Wekker, Gloria. *White Innocence: Paradoxes of Colonialism and Race.* Durham, NC: Duke University Press, 2016.

Wells, C. Gordon. *Dialogic Inquiry: Towards a Sociocultural Practice and Theory of Education.* Cambridge: Cambridge University Press, 1999.

Wertsch, James W. "A Clash of Deep Memories." *Profession* (2008): 46–53.

———. "Collective Memory and Narrative Templates." *Social Research* 75.1 (2008): 133–56.

———. "The Narrative Organization of Collective Memory." *Ethos* 36.1 (2008): 120–35.

———. "Specific Narratives and Schematic Narrative Templates." In *Theorizing Historical Consciousness,* edited by Peter Seixas, 49–62. Toronto: University of Toronto Press, 2004.

———. *Voices of Collective Remembering.* New York: Cambridge University Press, 2002.

White, Aaronette M. "Talking Feminist, Talking Black: Micromobilization Processes in a Collective Protest against Rape." *Gender and Society* 13.1 (1999): 77–100.

White, Harrison C. *Identity and Control: How Social Formations Emerge.* Princeton, NJ: Princeton University Press, 2008.

Widmayer, Sharon Alayne. "Schema Theory: An Introduction." *Saber2.net,* 2005, http://www.saber2.net/Archivos/Schema-Theory-Intro.pdf (accessed 12/16).

Wilkinson, Richard, and Kate Pickett. *The Spirit Level: Why Equality Is Better for Everyone.* Published with revisions. London: Penguin Books, 2010; orig. 2009.

Williams, Raymond. *The Long Revolution.* London: Chatto and Windus, 1961.

Winter, Jay. "The Generation of Memory: Reflections on the 'Memory Boom' in Contemporary Historical Studies." *Archives and Social Studies: A Journal of Interdisciplinary Research* 1.0 (2007): 363–97; also published by *GHI Bulletin* 21 (2000), available at https://www.ghi-dc.org/publications/ghi-bulletin/issue-27-fall-2000/bulletin-27-fall-2000.html?L=0#c20340.org/bulletin27F00/b27winterframe.html.

Wojciehowski, Hannah C. "Interview with Vittorio Gallese." *California Italian Studies* 2.1 (2011). http://escholarship.org/uc/item/56f8v9bv or http://eprints.cdlib.org/uc/item/56f8v9bv (both accessed 6/16).

Wolf, Eric. *Peasants.* Englewood Cliffs, NJ: Prentice Hall, 1966.

Wolfe, Tom. *I Am Charlotte Simmons.* London: Jonathan Cape, 2004.

Wood, Christopher S. "Art History Reviewed VI: E. H. Gombrich's 'Art and Illusion: A Study in the Psychology of Pictorial Representation,' 1960." *The Burlington Magazine* 151 (2009): 836–39; repr. in *The Books That Shaped Art History,* edited by Richard Shone and John-Paul Stonard, 116–27. London: Thames and Hudson, 2013.

Wood, Stephanie G. *Transcending Conquest: Nahua Views of Spanish Colonial Mexico.* Norman: University of Oklahoma Press, 2003.

Ypeij, Annelou. "Cholos, Incas y Fusionistas: El Nuevo Perú y la Globalización de lo Andina." *European Review of Latin American and Caribbean Studies* 94 (2013): 67–82.

———. "Women and the Informal Economy: Cultural Boundaries and Resources in Lima, Peru." In *Andeans and Their Use of Cultural Resources: Space, Gender, Rights and Identity,* edited by Arij Ouweneel, 43–62. Amsterdam: Cuadernos del CEDLA 25, 2012.

Yzerbyt, Vincent, Steve Rocher, and Georges Schadron. "Stereotypes as Explanations: A Subjective Essentialistic View of Group Perception." In Spears et al., eds., *The Social Psychology of Stereotyping and Group Life,* 20–50.

Zerubavel, Eviatar. *Social Mindscapes: An Invitation to Cognitive Sociology.* Cambridge, MA: Harvard University Press, 1997.

Zubillaga, Verónica. "Gaining Respect: The Logic of Violence among Young Men in the Barrios of Caracas, Venezuela." In *Youth Violence in Latin America: Gangs and Juvenile Justice Perspective,* edited by Gareth A. Jones and Dennis Rodgers, 83–103. New York: Palgrave Macmillan, 2009.

Zuloaga Rada, Marina. *La conquista negociada: guarangas, autoridades locales e imperio en Huaylas, Peru (1532–1610).* Lima: Instituto de Estudios Peruanos and Institut Français d'Études Andines, 2012.

Zunshine, Lisa. *Getting Inside Your Head: What Cognitive Science Can Tell Us about Popular Culture.* Baltimore, MD: Johns Hopkins University Press, 2012.

———. "Introduction: What Is Cognitive Cultural Studies?" In *Introduction to Cognitive Cultural Studies,* edited by Lisa Zunshine, 1–33. Baltimore, MD: Johns Hopkins University Press, 2010.

———. *Strange Concepts and the Stories They Make Possible: Cognition, Culture, Narrative.* Baltimore, MD: Johns Hopkins University Press, 2008.

———. *Why We Read Fiction: Theory of Mind and the Novel.* Columbus: The Ohio State University Press, 2006.

Zunshine, Lisa, ed. *Introduction to Cognitive Cultural Studies.* Baltimore, MD: Johns Hopkins University Press, 2010.

INDEX

Africa(n), 72, 92, 125, 133, 187, 215–16, 221–22; African American, 207, 256

agency, 25, 39, 40, 89–90, 93, 96, 114, 155, 221

Almoloya del Río (Mexico), x, 63–64, 66, 83

Amerindian Cognitive Unconscious. *See* Cognitive Unconscious: Amerindian

amerindianization, 23, 130, 141, 150, 236, 251, 256

Andean (sometimes Andino), 11, 13–14, 15, 16, 18, 19, 30–31, 54, 55, 57, 58, 73, 77–78, 108, 120, 122, 125–27, 131, 133, 134, 179, 180–82, 197, 200, 202–4, 205, 206–7, 209, 220, 221, 227–29, 231–35, 236, 237–42, 243–44, 247–48, 254, 267

Anderson, Perry, 94

Andes, 16, 29, 30, 31, 70, 73, 79, 90, 99, 122, 126, 129, 131, 185, 187, 189, 201, 203, 205, 220, 227, 232, 234, 237, 238–39, 242–44, 250. *See also* Andean (sometimes Andino)

andino. *See* ethnotypes: *andino*

ANFASEP (Asociación Nacional de Familiares de Secuestrados, Detenidos y Desaparecidos de las Zonas Declaradas en Estado de Emergencia del Perú; National Association of Kidnapped, Disappeared and Detained Relatives of Zones that were Officially Declared in a State of Emergency), 30–31, 129, 130, 131, 175. *See also* Mamá Angélica

Ángeles caídos (JADAT), 64, 65 fig. 2.2, 66, 73, 75

Arbib, Michael, 106

archeology, 1, 89, 90

Ardito Vega, Wilfredo, 199, 208

Arellano, Rolando, 187, 237

Arguedas, José María, 11, 13–14, 16, 18, 23, 232, 234–34, 243; *El Zorro de Arriba y el Zorro de Abajo*, 232–34

Aristocratic Republic (Peru), 57, 182. *See also* age of imperialism; internal colonialism

Asia(n), 54, 92, 141, 187, 188, 215, 220, 258

Assmann, Aleida, 82; Jan, 82, 83

Averno, Centro Cultural El, 58–59, 60

Ayacucho (Huamanga) (Peru), 30, 31, 74, 77, 126, 129–31, 175, 185, 199, 208, 240, 243–44

Aymara (Bolivia), 22, 126, 212, 229, 251–53, 254–56

Baars, Bernard, 101–3; Global Workspace Theory (GWT), 101–2. *See also* metaphor: theater

Bacigalupo, Ana Mariella, 192–93

Bakhtin, Mikhail M., 42, 83–85, 87, 88

Bargh, John, 100

Barsalou, Lawrence, 113

Bartlett, Frederick, 7, 83, 86

Belaúnde Terry, Fernando (President of Peru: 1980–85), 126

Bem, Sandra L., 168

Bergman, Sunny, 222

COGNITIVE APPROACHES TO CULTURE

Frederick Luis Aldama, Patrick Colm Hogan, Lalita Pandit Hogan, and Sue Kim,
Series Editors

This series takes up cutting edge research in a broad range of cognitive sciences insofar as this research bears on and illuminates cultural phenomena such as literature, film, drama, music, dance, visual art, digital media, and comics, among others. For the purpose of the series, "cognitive science" is construed broadly to encompass work derived from cognitive and social psychology, neuroscience, cognitive and generative linguistics, affective science, and related areas in anthropology, philosophy, computer science, and elsewhere. Though open to all forms of cognitive analysis, the series is particularly interested in works that explore the social and political consequences of cognitive cultural study.

Resilient Memories: Amerindian Cognitive Schemas in Latin American Art
ARIJ OUWENEEL

Permissible Narratives: The Promise of Latino/a Literature
CHRISTOPHER GONZÁLEZ

Literatures of Liberation: Non-European Universalisms and Democratic Progress
MUKTI LAKHI MANGHARAM

Affective Ecologies: Empathy, Emotion, and Environmental Narrative
ALEXA WEIK VON MOSSNER

A Passion for Specificity: Confronting Inner Experience in Literature and Science
MARCO CARACCIOLO AND RUSSELL T. HURLBURT